THE GREAT
DIVIDE

Walking the Continental Divide Trail

TIM VOORS

gestalten

For Cato, Antonia, Tom,
and Herminia

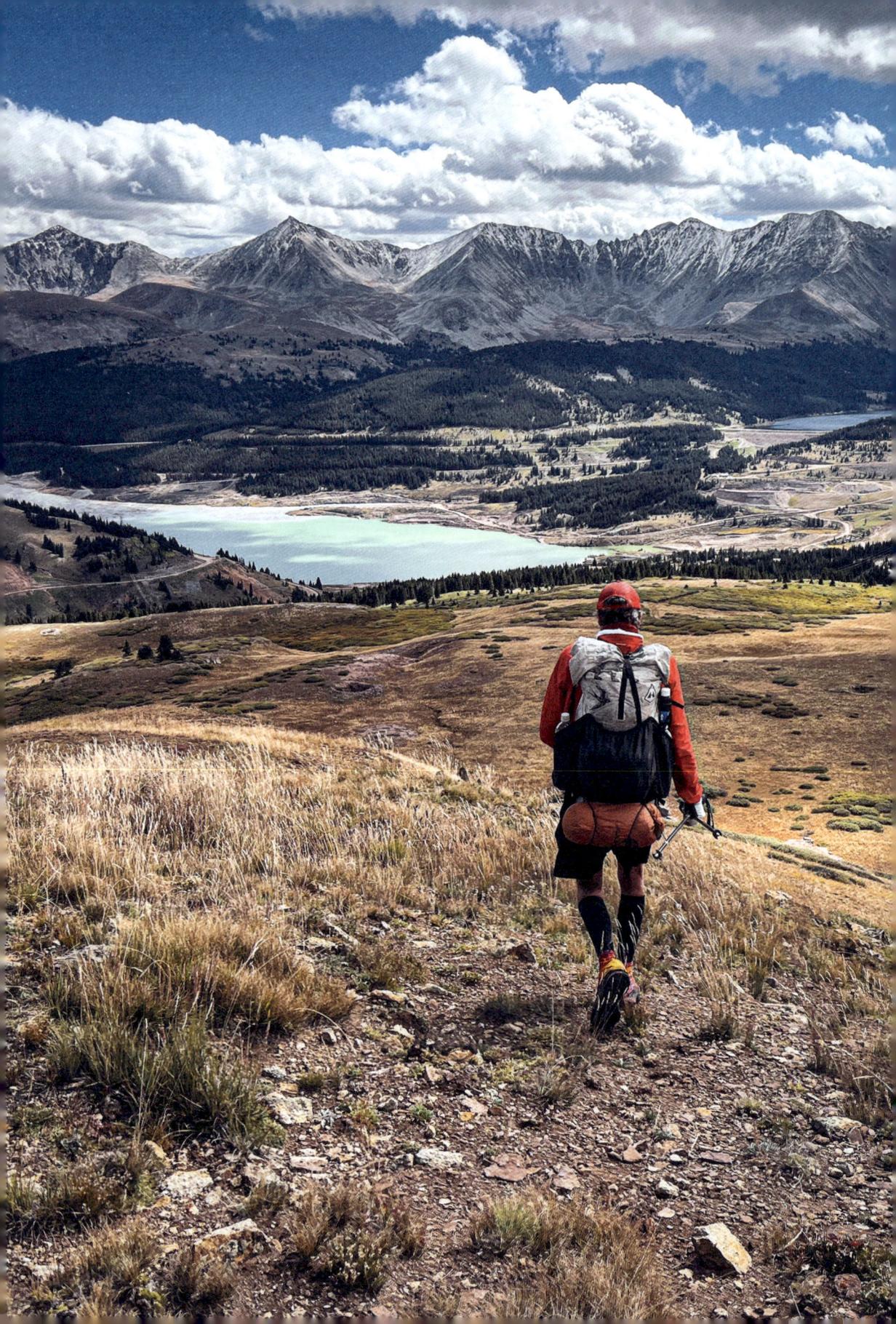

Table of Contents

CDT Gear List

Base Weight (weight of back-pack without consumable items): 13.89 pounds (6.3 kg). 5.07 pounds (2.29 kg) of which I had lost since the start of the trail.

Body Weight: 143.3 pounds (64.9 kg). 19.84 pounds (9 kg) of body weight lost since the start of the trail.

Big Four:

Shelter: Zpacks Duplex tent, burnt orange
Sleeping bag: Rab 400 Mythic 400 sleeping bag (which was a bit too cold)
Sleeping mat: Therm-a-Rest NeoAir large sleeping mat
Backpack: Hyperlite Mountain Gear 3400 Southwest, white

Cooking System:

· TOAKS titanium 750ml pot
· Sea to Summit titanium spoon
· MSR PocketRocket 2 stove
· Lighter
· Sponge
· Drying cloth

Clothing:

· Handmade linen Hawaiian shirt
· Icebreaker merino wool long-sleeved base layer
· Melanzana fleece hoodie
· Montane Men's Featherlite windproof jacket
· Montbell Versalite rain jacket
· Montbell Plasma 1000 Alpine Down parka
· Outdoor Research ActiveIce sun gloves
· Fila base gloves
· Neoprene fishing gloves
· Latex dish gloves
· Nike FC Barcelona soccer shorts
· Darn Tough Hiker Micro Crew Midweight hiking socks
· High compression socks
· La Sportiva Ultra Raptor trail running shoes (×5)
· Dirty Girl gaiters
· Homies Foundation sun hat
· A-dam boxer briefs
· Icebreaker Men's Merino 260 Tech thermal leggings
· ZPacks Dyneema rain pants
· Sleeping beanie
· Buff

Extra Equipment:

- Black Diamond Distance Carbon Z trekking poles
- Walmart umbrella
- Tyvek wallet
- Credit card & cash
- EXPED stuff sacks × 4
- Postcard aquarelle watercolor painting paper
- Dark blue watercolor paint
- Dark yellow watercolor paint
- Two paintbrushes
- Petrified resin necklace (gift from Mom & Dad)

Medical Kit, Toiletries, & Misc.:

- Deuce of Spades trowel
- Toilet paper
- Hand sanitizer
- Tick tweezers
- Aqua Mira water treatment drops
- Ibuprofen Betadine antiseptic
- Alcohol wipes
- Duct tape
- Adhesive bandages
- Medical gauze
- Needle & thread
- Swiss Army knife classic with scissors
- Tent repair kit
- Tenacious Tape
- Sleeping pad repair patches
- Superglue
- Sharpies: black and silver
- Honey lip balm
- Toothbrush, toothpaste, and Soft-Picks
- BIC pen
- Earplugs
- Norit (diarrhea medicine)
- Antihistamine
- Foot tape
- Pain relief cream
- Paracetamol
- Safety pins
- Giardia antibiotics (purchased in Pinedale)

Safety and Emergency Gear:

- Garmin inReach satellite device
- Compass
- Bear spray
- Noise grenade
- Emergency whistle
- Passport
- Sunscreen
- Pit Viper sunglasses

Electronics:

- Anker power bank 20,000mAh
- Sony headphones
- Apple cordless headphones
- iPhone 13 mini on a leash
- Anker dual-port power charger
- Headlamp with three batteries

Water System:

- Sawyer water filter & back-flushing kit
- Two 1 L Smartwater bottles
- Platypus 2 L bladder
- SteriPEN Ultra UV purification system
- Uribag travel urinal

The Continental Divide Trail in Numbers

LONGEST DAILY MILEAGE
58 MILES (93 KM)

4.5 MONTHS
ON TRAIL

20 ZEROS
(REST DAYS)

14 LBS (6 KG)
BASE WEIGHT

AGE
50

3,100 MILES (4,989 KM) LONG
EQUIVALENT TO 15 X MOUNT EVEREST IN ELEVATION GAIN AND LOSS

7 MILLION
STEPS

5
PAIRS OF SHOES

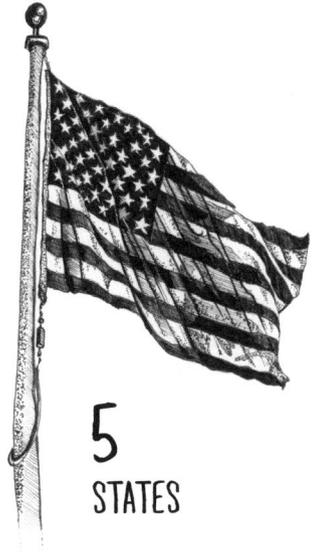

5
STATES

50 HAMBURGERS

100 BEERS

100 CHIPMUNKS
+ 1 GRIZZLY BEAR, 3 BLACK BEARS, 12 WOLVES, 5 MOOSE, 5 ELK, 50 DEER, 1 BALD EAGLE, 5 SNAKES, 1 MILLION MOSQUITOES

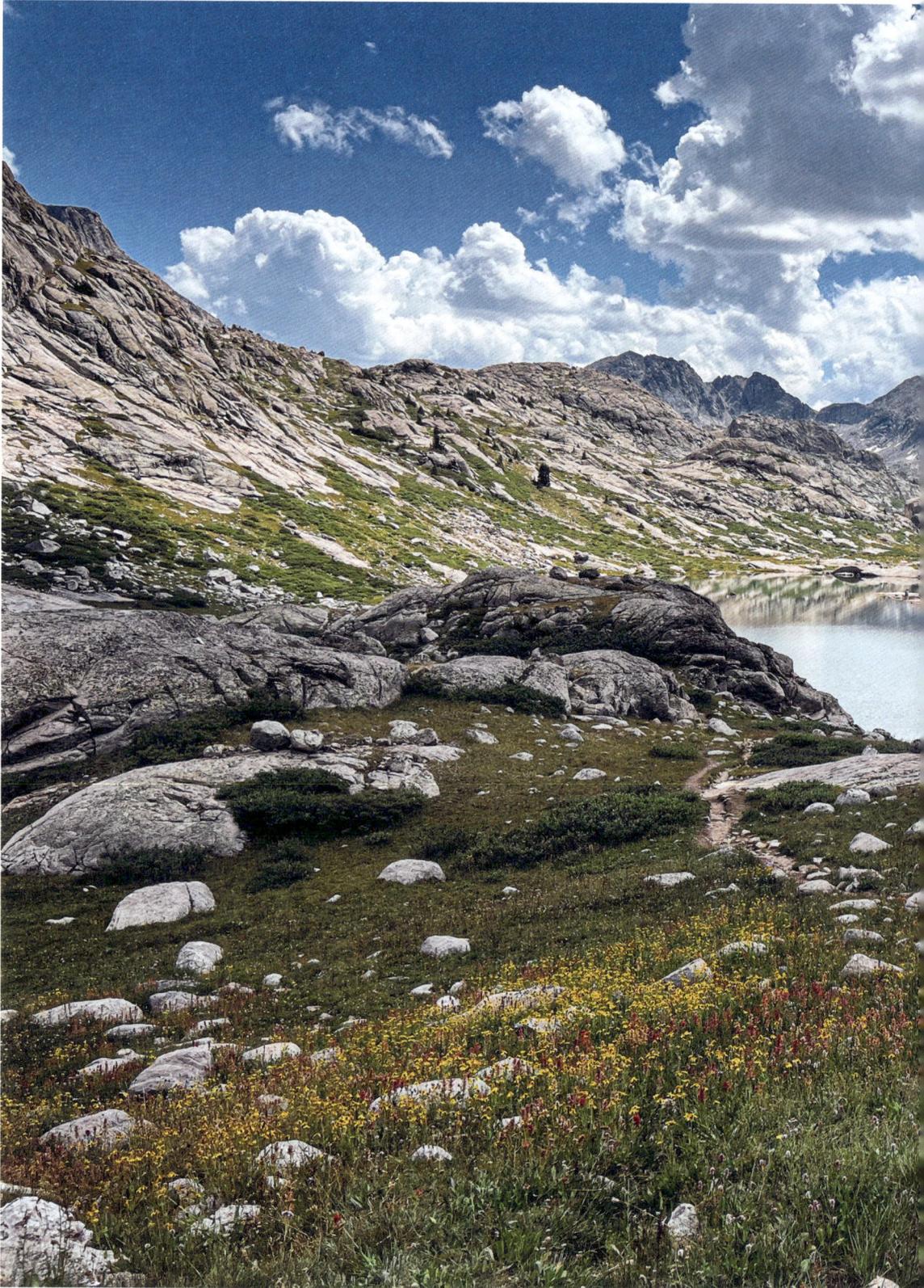

The Continental Divide Trail follows the Rocky Mountains across the length of the U.S.

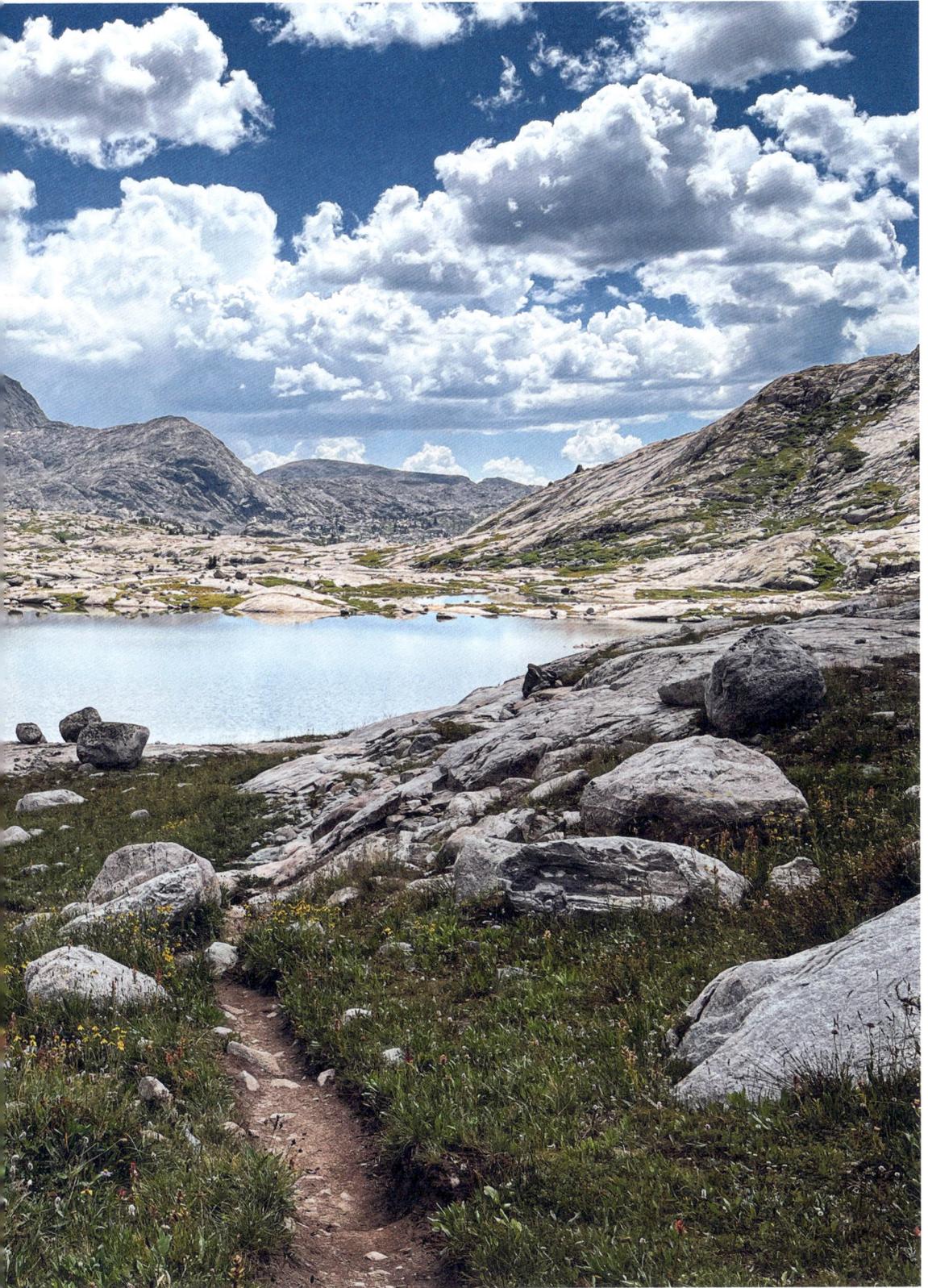

Prologue

"Sorry, sir, you can't walk through the park right now. There's a bear buffet going on out there." The park ranger glanced down and reviewed my paperwork. I had been waiting outside the ranger station since 4:00 in the morning to be the first in line for one of the sacred backcountry camping permits for Glacier National Park.

"Bear buffet?" I replied with a puzzled frown, wondering whether I was lost in translation or if I had misunderstood the ranger. The man took a long sip from his thermal coffee mug.

"Yeah, there are too many grizzlies up in the lower section of the park. You see, a bunch of cows got caught out by an early blizzard last fall. They have been frozen solid all winter, but now that the spring is warming everything up, the grizzlies have come from all over to feast on the carcasses. We've had to close that part of the park. It's far too dangerous out there right now." The ranger took another swig of his coffee and looked at me blankly.

"Pfff" was all I could reply. My mind raced from bear anxiety to relief that they seemed to know what they were doing up here, closing the park to protect hikers. I was disappointed not to be able to walk the entire length of the park, as Glacier National Park is one of the highlights of the Continental Divide Trail. But as this part of the world was all new to me, I wasn't too worried about missing out on some mountains. I was excited and grateful to be out here at all.

"You're lucky! I managed to block the last campsites for you," the ranger said, brushing his thumb and index finger across his bushy mustache. He reached down to the printer under his desk and handed me the details of my assigned campsites

designated with red circles. All were a good distance away from the bear buffet, each with specific dates: June 24, 25, and 26, 2022. I thanked him for his help and glanced down at the map. "OK. Quite ambitious," I thought. I left the station and added up the miles between each of the campsites. 28 miles (45 km), 32 miles (51.5 km), and 25 miles (40 km). Not exactly the mileage I was hoping to be doing on my first few days on the trail, especially in the high mountains, covered in snow. My mind flashed back to five days ago when I was still working in an office building. My body was simply not prepared for this much mileage right off the bat. But I counted my blessings. This was the last permit they had. I folded up the map, tucked it away safely in my pocket, and stuck out my thumb.

As this part of the world was all new to me, I wasn't too worried about missing out on some mountains. I was excited and grateful to be out here at all.

"Hi, wanna ride? I'm heading to town, but first I have to pick up my bib for the half-marathon I'm running here tomorrow." The lady leaned out the window of her car. "I'm Laura, by the way." She offered a hand with polished red nails. Her red lipstick was equally bright. Climbing into the car, I saw she wore red cowboy boots.

"Thanks, I appreciate that," I said.

The car's interior was brand new, straight from the production line, and the sticker on the dashboard revealed it was a rental.

"I've never picked up a hitchhiker before, but now I thought, what the heck—I've got all day, and you don't look that scary." Her face broke into a big smile, but I noticed she still took a moment to size me up to check whether she hadn't made a mistake. After all, this was the USA; she knew that better than I did. She hit the gas, and we were off, idly chatting about her race the whole time.

After picking up her race number, she drove me back down into the valley to the small village of Saint Mary, where I had camped the previous night. As I stepped out of the car, she handed me a piece of paper with her number scrawled on it.

"When you walk through Colorado, give me a holler. You're always welcome to stay over. Happy trails." She smiled and waved goodbye.

I thanked her and waved back. As she sped off, I walked down Saint Mary's main street, which was no more than a few houses, a general store, and a gas station. I was happy to have my permit in my pocket, even if some of the park was closed. I could hardly believe it; the official start of my CDT was less than 12 hours away! I pictured my first moments on the trail, at the Canada-U.S. border. And just then, the ground disappeared underneath me. I heard a painful *cr-cr-crack* in my left ankle.

I shrieked as my legs gave way, collapsing on the sidewalk, and instinctively clutching my left ankle to assess where the pain was. The fall happened so fast, yet it also felt like I collapsed in slow motion. I was fully aware as my foot lost balance in a pothole, my ankle rolled, and my knees gave way. My body gave way too, like a high-rise building collapsing in a controlled demolition. Great!

Lying on the hard cement, I slowly regained my senses, I gasped for air to soothe the initial pain, and glanced at my elbow and knee to assess the damage. My shirt and pants slowly turned red as the blood began to flow. I was stunned: the blood didn't hurt one bit, but my ankle was another story. I looked at the ground, seeing just a tiny pothole. My body was clearly

not very flexible yet, and my new hiking shoes were a little rigid. Whatever the cause, the damage was done. No turning back the clock now. I thought of how ambitious the coming hike was. 3,000 miles (4,828 km) from Canada to Mexico across the Rocky Mountains, beginning in Blackfoot territory. If I was going to pull this off, I'd have to spend less time dreaming and more time paying attention to where I was going.

Lying on the hard cement, I slowly regained my senses, I gasped for air to soothe the initial pain, and glanced at my elbow and knee to assess the damage.

After the initial shock of falling, I took a few careful steps and was happy to see that I could walk, even if it was more of a hobble. It was too soon to know how bad it was.

Luckily, I was in front of the only gas station in town. Out front, a deep freezer stood with the words "ICE BOX" in large letters across it. Ice! I opened the box, pulled out a big bag, slung it over my shoulder, and hobbled inside to pay.

The campsite was only half a mile down the road, but it was already clear that my foot needed a lot of love, rest, and ice. The walk back took me twice as long as the previous morning,

and it was only when I reached the safety of my tent that I took off my shoes and socks to see what my ankle actually looked like.

"Oy, what happened to you?" said a familiar voice behind me. Necktie, my old friend and hiking buddy, leaned in close. "That doesn't look good, my friend." Looking down and assessing my ankle from all angles, I could see it had already swollen up to the size of an orange. I hastened to put ice on it and ripped my scarf to swaddle my wound and keep the ice in place. My mind was still racing, perhaps playing games with me, as I still hoped the cold and a good night's sleep would be enough to restore my strength and get me ready for the next day.

The campsite was only half a mile down the road, but it was already clear that my foot needed a lot of love, rest, and ice.

Necktie was a hiking friend with whom I hadn't ever hiked a mile. We'd met six years earlier in Bishop, California, while we'd both been hiking the Pacific Crest Trail. A mutual friend, Tater Tot, introduced us, and after a few beers at a local brewery, we'd headed back to the hostel to play music together long into the night. Either because Necktie is a skillful musician on the guitar or because we'd had quite a few beers, the memory of that night has stayed with me. We kept in touch after that, and now, six years later, were both attempting the CDT, southbound, with a starting permit for tomorrow. What were the odds? We shared quite a few other similarities, as we had both grown up in the rolling hills of southern England and had attended schools no more than five minutes away from each other. But I was twice his age: Necktie was just 25, and I would be turning 50 this year.

"Do you think I'll make it tomorrow?" I asked and looked hopefully at Necktie, who was tending to a campfire by gently blowing the embers to give it some extra air.

"Tomorrow?" He hesitated for a moment, looking down at my foot. "No way, my friend." For him, it was clear I was going nowhere. I was still in denial. After all, I had my permit, and getting another could prove quite tricky. I had to start. I just had to. But my body clearly had other plans.

Planning, yes, that was something I was good at back home. I'd been planning this trip for four years. But out here in America's wilderness, everything I had planned for and expected seemed to go right out of the window. As soon as I landed in the United States after leaving my home in the Netherlands, the news seemed to report one disaster after the other: flash flooding and wildfires daily. And now my ankle. It was as if the CDT was warning me not to start.

"I tell you where you are going, old chap; I'm taking you to Luna's. That's where you are going. Not up some crazy mountain with that foot of yours." Necktie stared into the flames, not even considering my pleas to the contrary.

"But our permits?" I tried one last time, although I knew it was hopeless.

"Screw the permits. What you need is rest."

I raised my feet up on a log, reluctant to accept the truth.

And so began my long hike across the Continental Divide Trail.

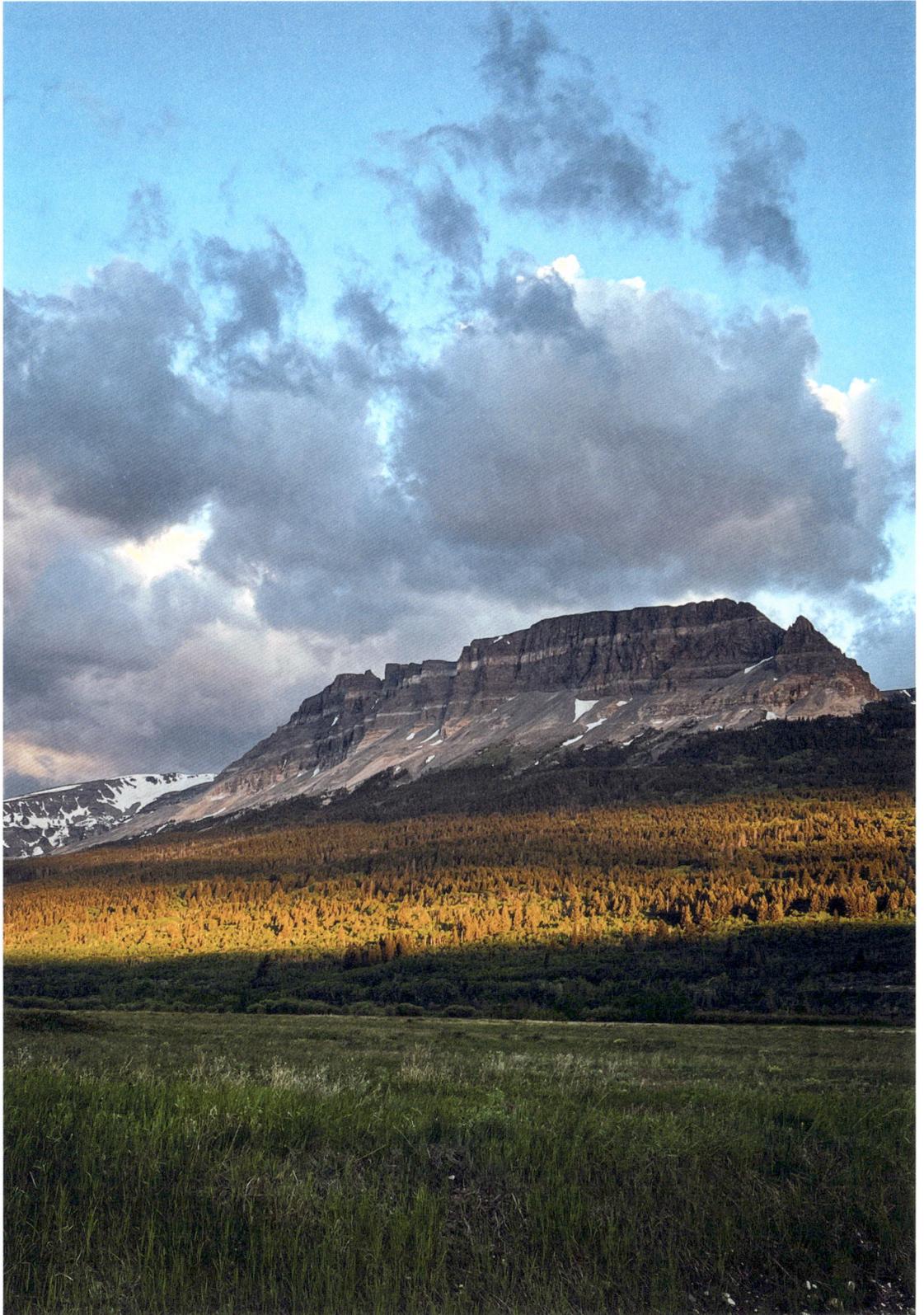

The sun rises over the Canada-U.S. border as I wait for
my precious Glacier National Park backcountry permit.

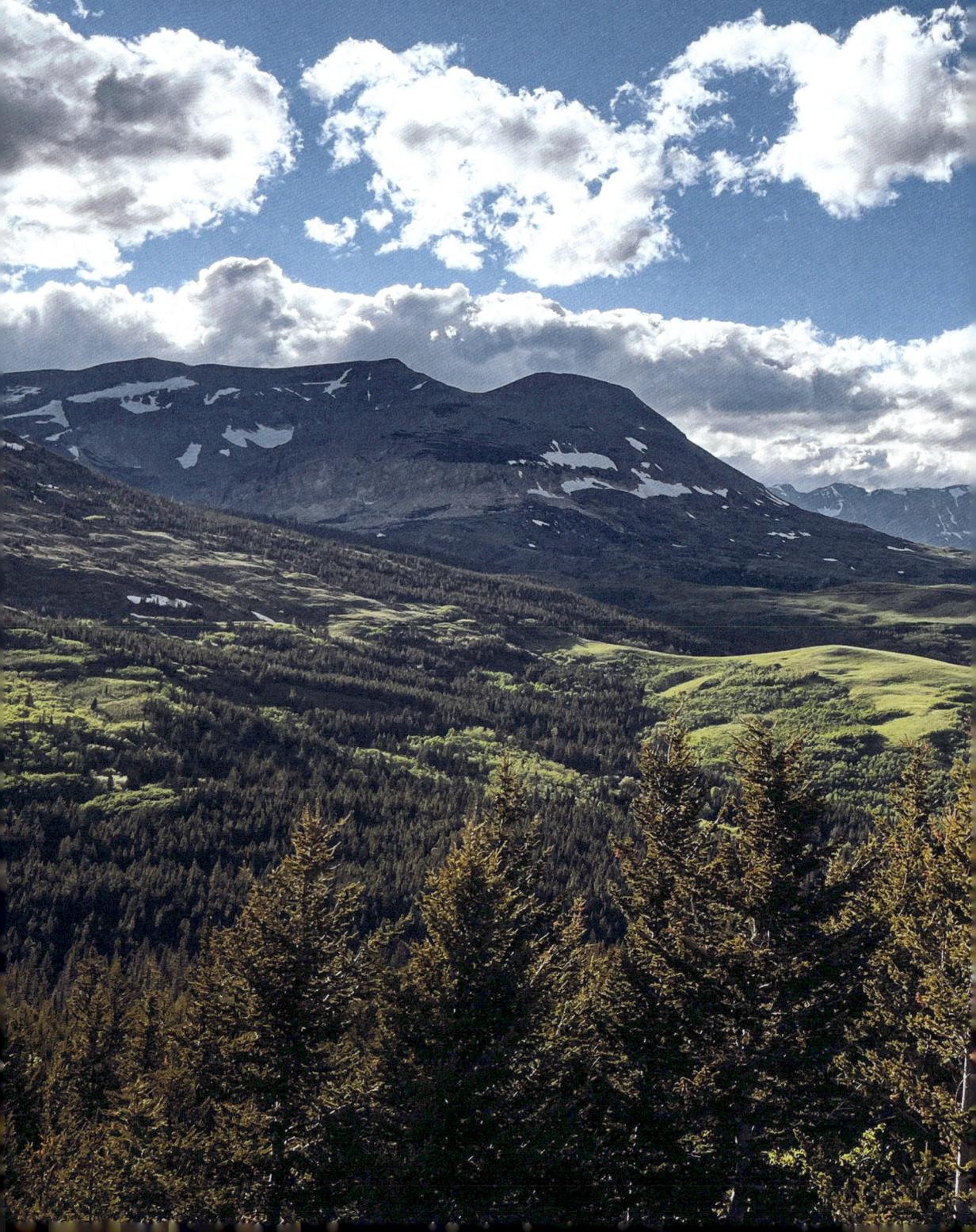

The Physical Journey

Mile 0 - 738

I knew the bears were out there
although I couldn't see them.
There was a palpable abundance
of wildlife around me.

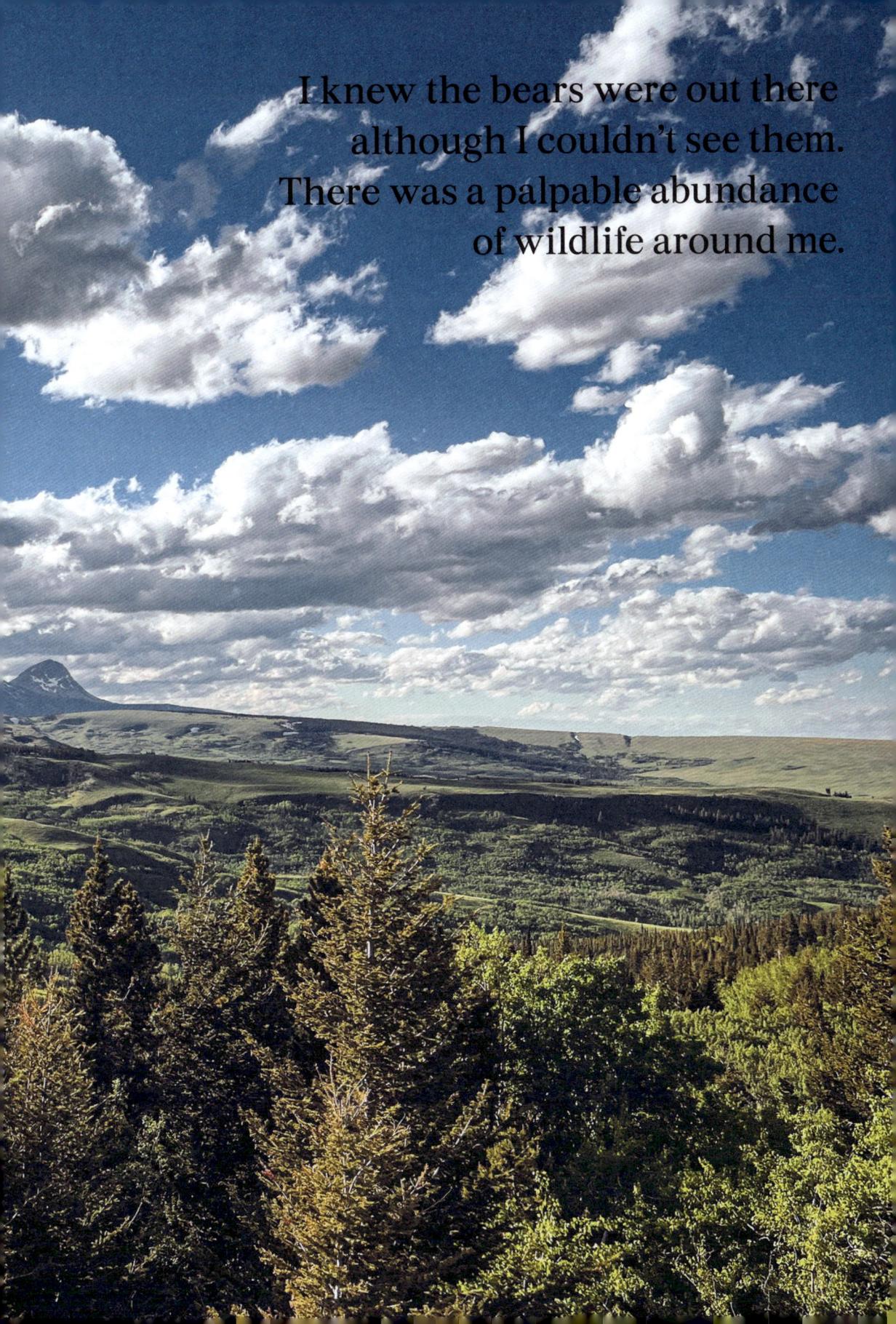

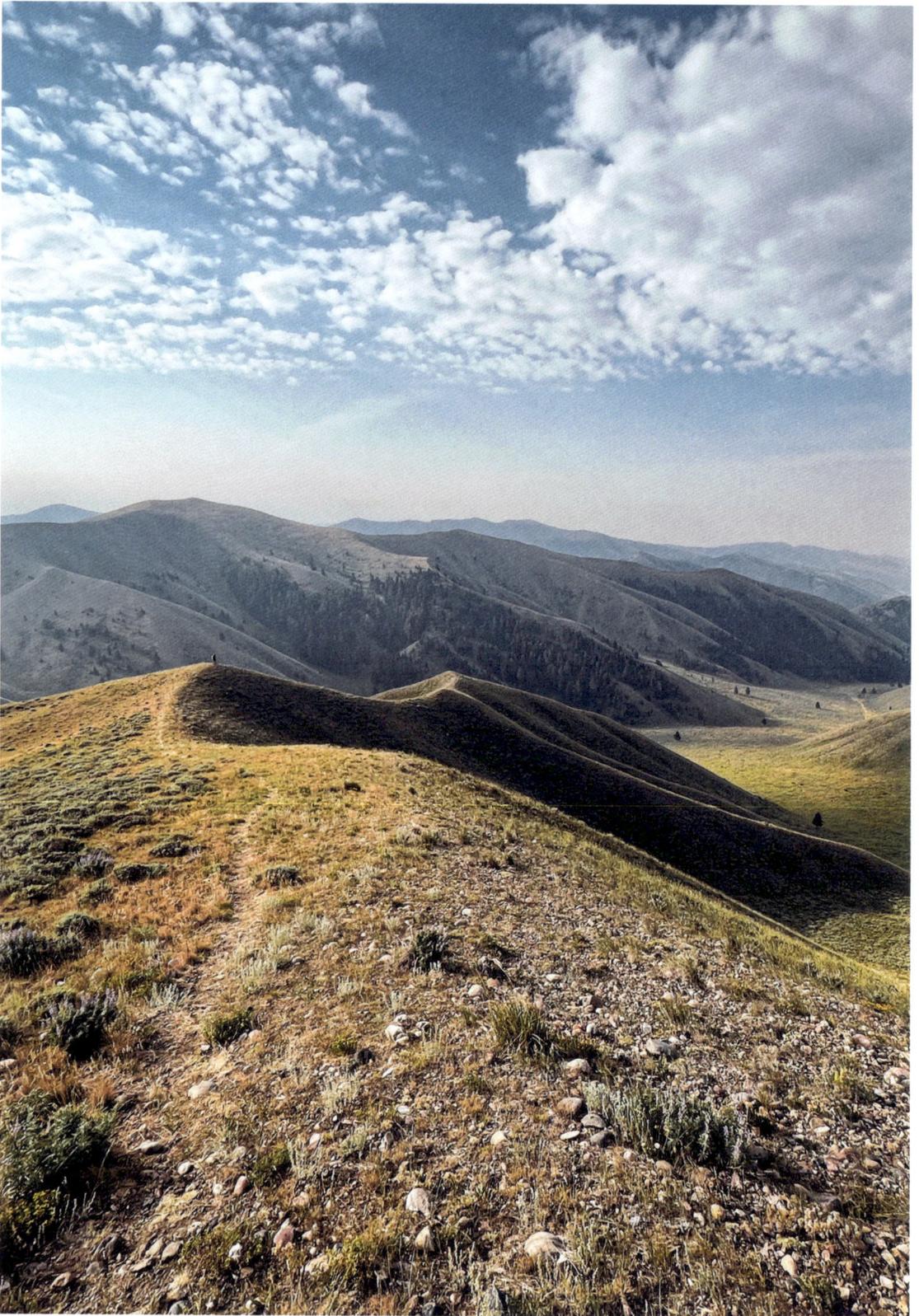

The Continental Divide Trail stretches
3,100 miles (4,989 km) from Canada to Mexico.

R.I.C.E.

Mile 0

"R.I.C.E. is your prescription. Rest. Ice. Compression. Elevation. Not the mountain. Not the trail." Necktie said as he pointed to a spot on the floor. He'd organized a ride from Saint Mary down to East Glacier Park Village, where he checked us into Luna's hostel. The large log cabin along the quiet High Street had once served as a restaurant but had since become an oasis for hikers, each licking their wounds after attempting to hike through the treacherous Glacier National Park mountains. I was clearly not the only one tending to an injury. Taking a quick glance around the room, I counted four other people, surprisingly young, also resting their feet, elevated with bags of ice. But not everyone was injured, and as my eyes adapted to the darkness in the lowly lit open space, I saw about twelve others going about their business, preparing their sleeping mats for the night or cooking some dinner in the restaurant's kitchen. It was pretty bizarre to take in; all the restaurant's tables and benches had been removed, and in their place, a rumble-tumble bunch of people of all ages lay on the floor, each in their own sleeping bag, as if it was the most normal thing in the world.

"Do you mind if I give it a try?" Necktie asked politely, gesturing toward the guitar poking out of my backpack.

"Sure. Please play," I said, trying to conceal my enthusiasm. Of course, it was something I had secretly hoped would happen. Hearing Necktie play the guitar was always special. I'd bought the small guitar a few days earlier in Kalispell, the last Montana city I went through on my journey north to reach the beginning of the CDT at the Canadian border. An acoustic six-string Fender Sonoran Mini Acoustic Natural guitar, weighing no more than nine pounds (4 kg). I'd be on the trail for four or five months, so figured I might as well use all that time wisely. What better way to use my time than to improve my guitar skills? And of course, having Necktie around to play made it even more worthwhile.

The atmosphere in the room changed as Necktie gently plucked the strings and broke into a quiet song. Everyone stopped what they were doing for a few minutes, sat down, and listened intently to the dreamy sound of his voice. He wasn't performing, yet he had captivated an audience simply through the harmony of his voice with this instrument. I knew I had to carry that damn thing on my back into the wilderness, but at this magical moment, I had no doubt that I had made the right decision in buying the guitar.

After just a few days of lying on the floor of the hostel, it became obvious that the CDT did not like people. One by one, I saw hikers come down from the Glacier Mountains, each with their own recent experience of snowstorms, grizzly encounters, and even coming across a pack of 12 wolves. Everyone exchanged stories in excited voices. Some retreated to a quiet corner to recuperate and tend to their new injuries, be it their Achilles tendon or an ankle twisted traversing the steep snowfields. Somehow these stories connected us, even though I hadn't even begun my hike. It felt so normal to be sleeping on the floor with people in sleeping bags from all corners of the world. Sharing trail stories. All strangers becoming friends.

I spent four days resting and sleeping in the same place, only getting up to hobble carefully to the toilet and back. Days and nights morphed into one another. I still had jetlag and had suddenly landed 4,000 feet (1,219 m) higher than I was used to, as I live six feet (1.8 m) below sea level back home in the Netherlands. Nausea, headaches, and general fatigue were something I had not taken into account during my planning.

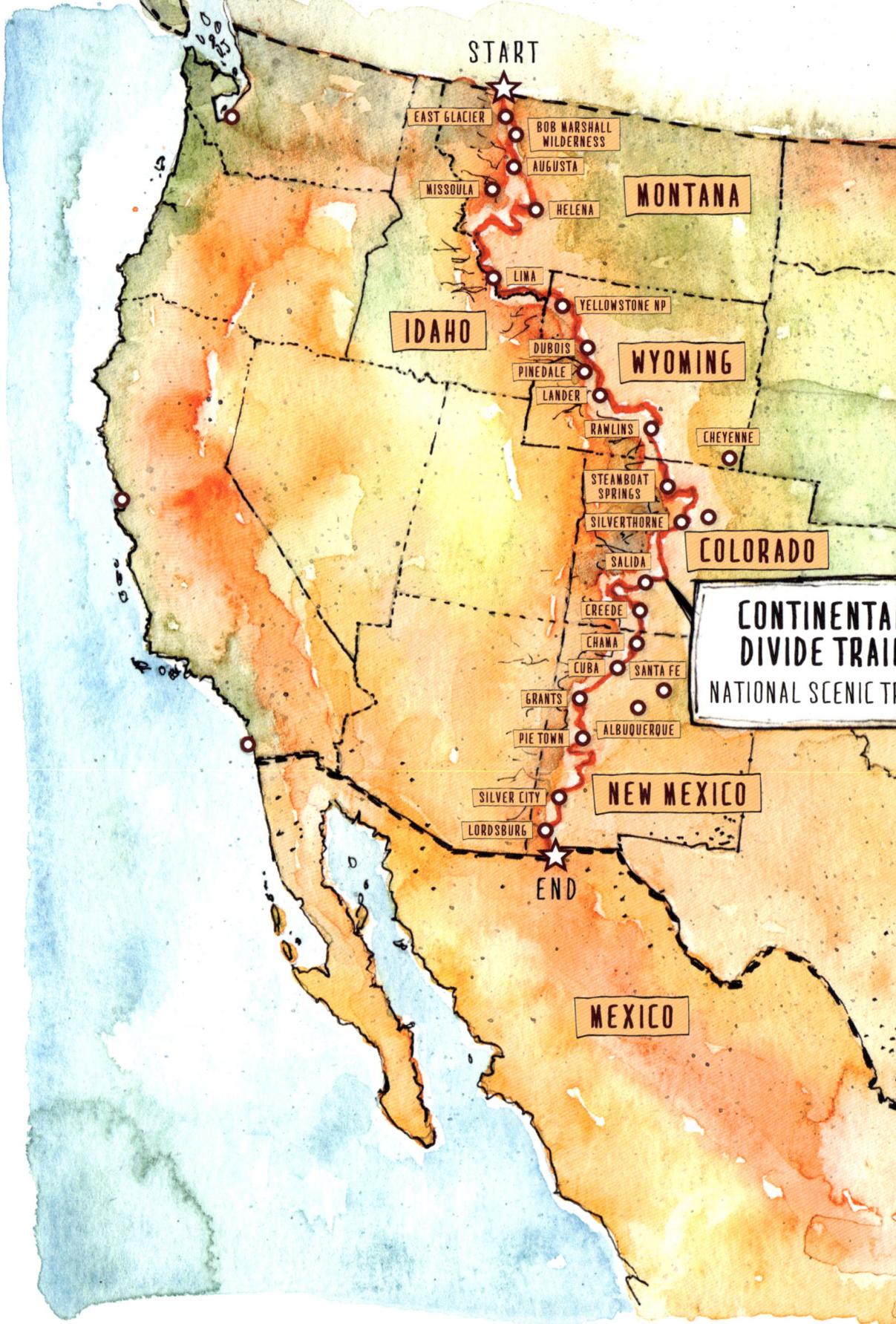

START

EAST GLACIER
BOB MARSHALL WILDERNESS
AUGUSTA
MISSOULA
HELENA
MONTANA

LIMA
YELLOWSTONE NP

IDAHO

DUBOIS
PINEDALE
LANDER
WYOMING

RAWLINS
CHEYENNE

STEAMBOAT SPRINGS
SILVERTHORNE
COLORADO
SALIDA

CREEDE
CHAMA
CUBA
SANTA FE

GRANTS
PIE TOWN
ALBUQUERQUE

CONTINENTAL
DIVIDE TRAIL
NATIONAL SCENIC TR

SILVER CITY
NEW MEXICO
LORDSBURG

END

MEXICO

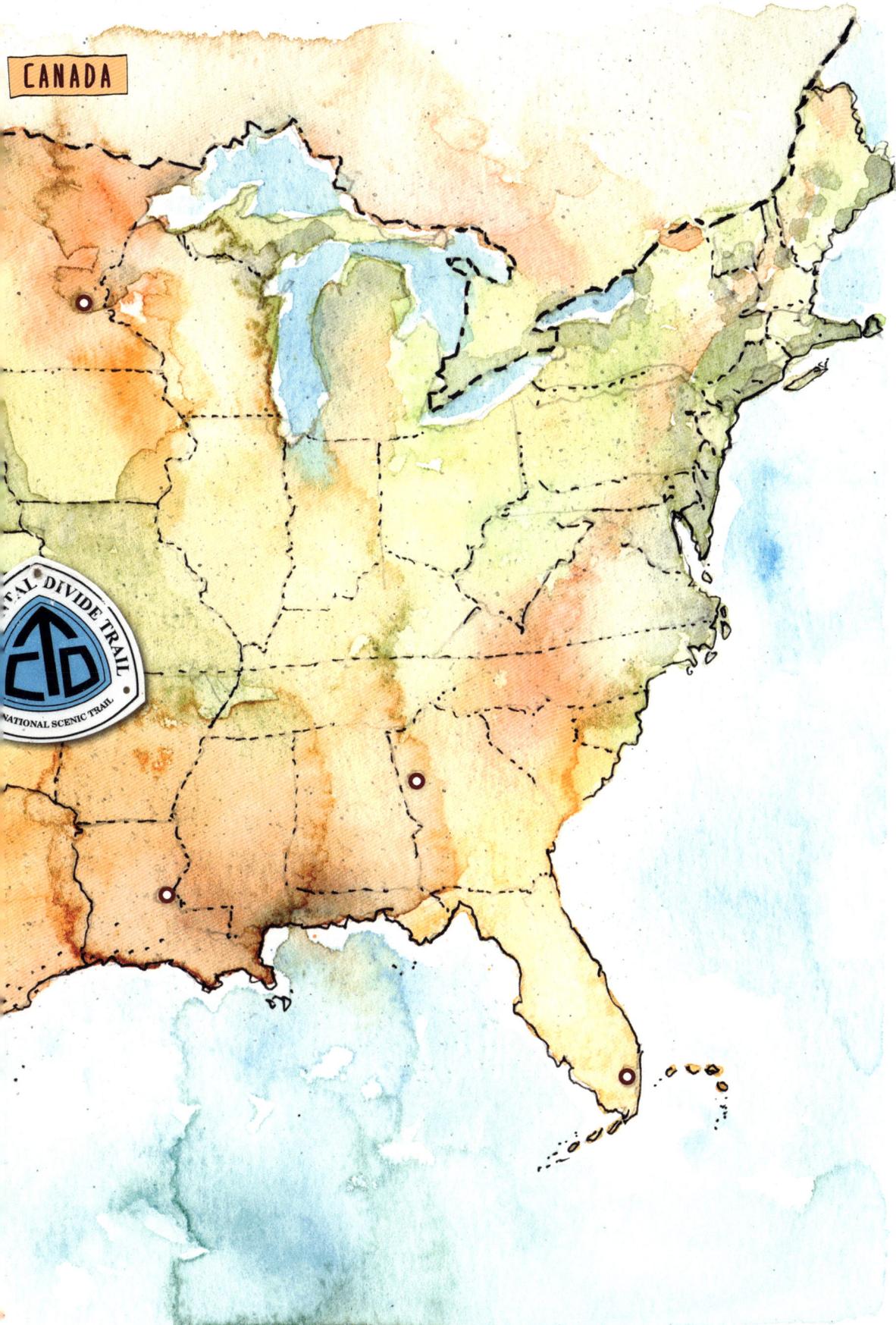

CANADA

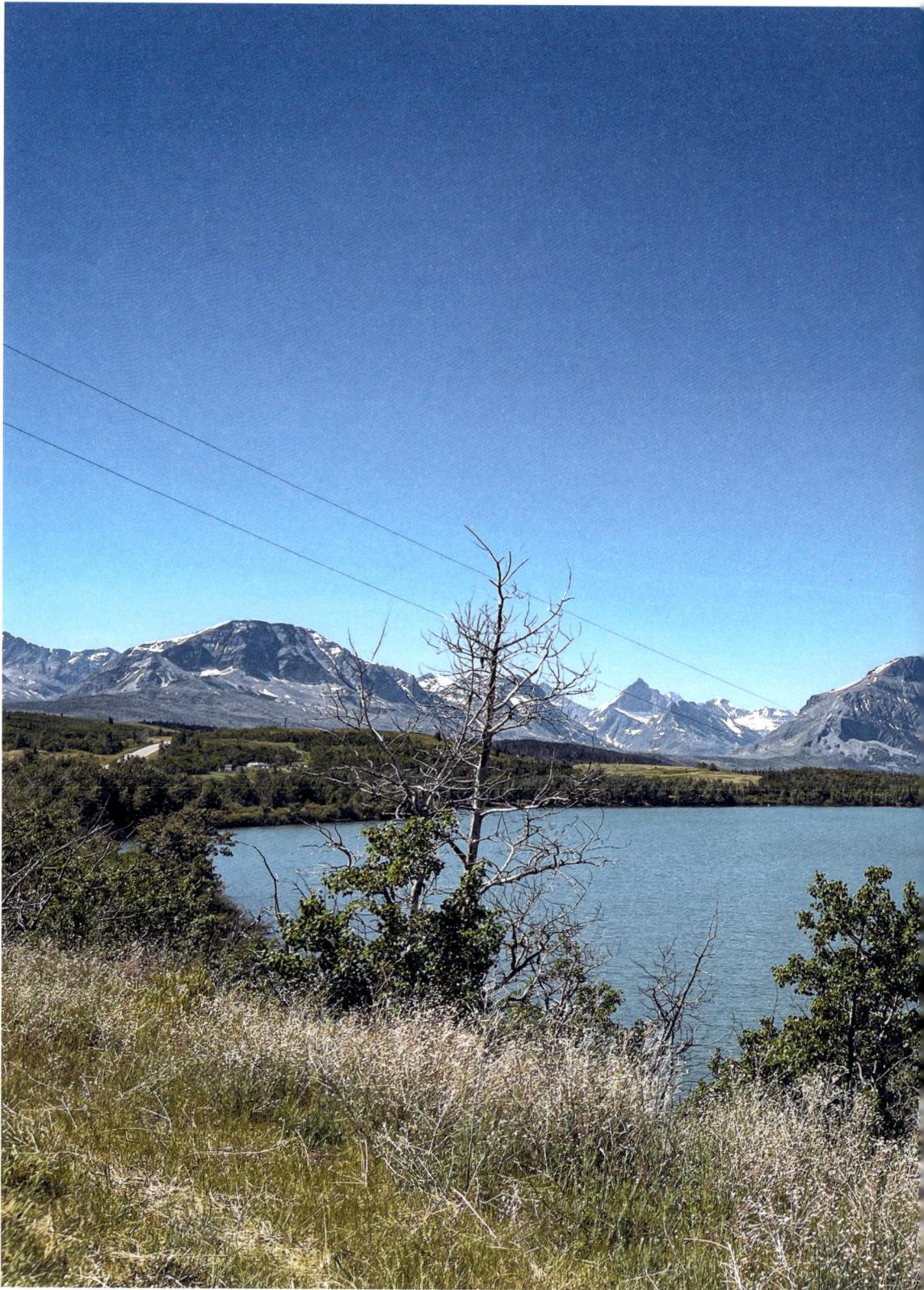

The trail crosses Montana, Idaho,
Wyoming, Colorado, and New Mexico.

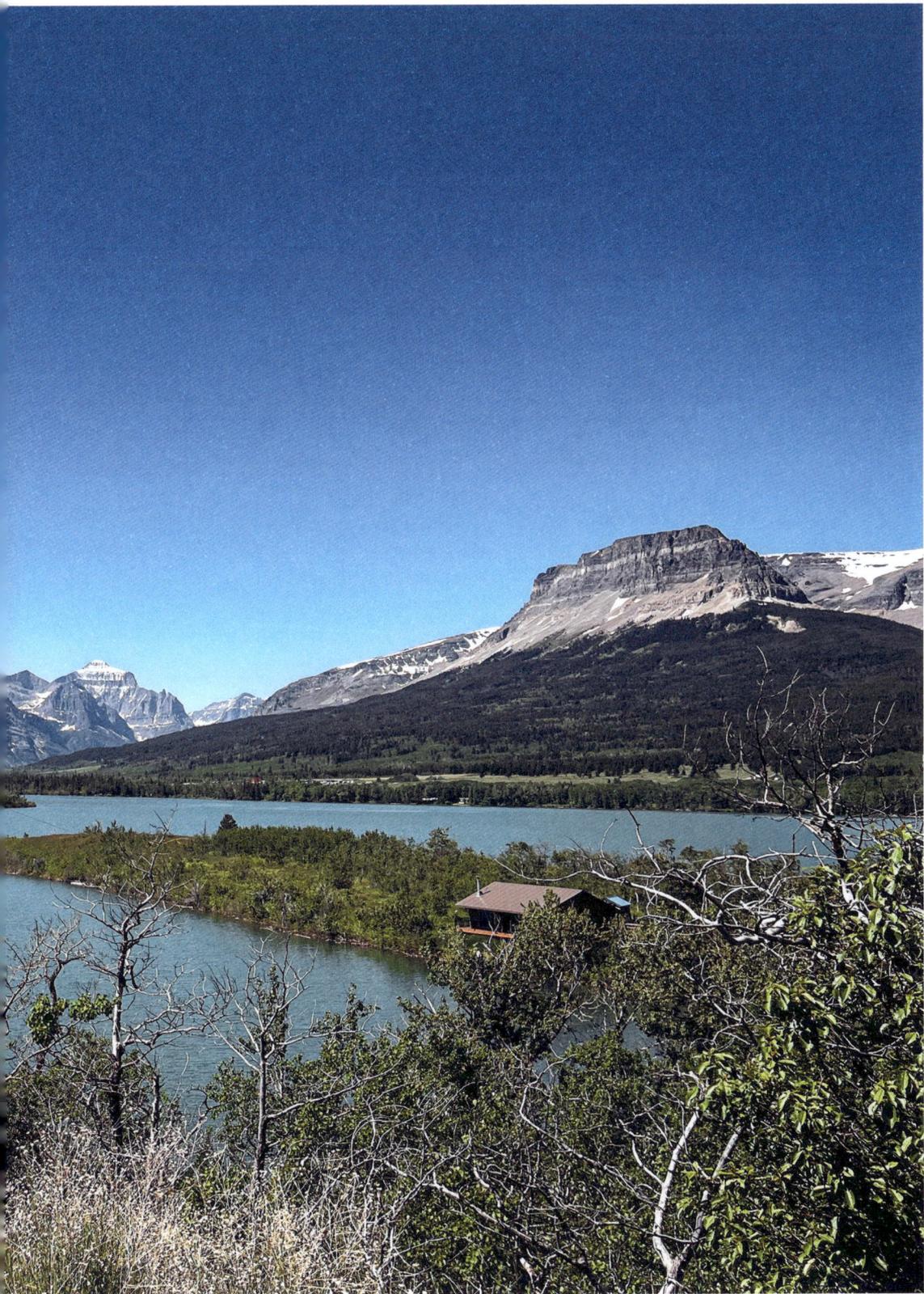

My body needed time to adjust. Perhaps my ankle injury was a blessing in disguise.

But while I was at Luna's, there was always a festive, happy mood in the room. It was fascinating to see all the comings and goings of hikers from all around the world, all excited to head out and embark on their very own CDT.

"Hi, I'm WoW. I bet I'm the oldest one in here tonight," a tall retiree said, laughing loudly as he introduced himself to Luna.

"Well, age doesn't mean a thing to me!" Luna replied, giving the man a welcoming hug. "Young, old, tall, small, everyone is welcome at our place." She offered a radiant smile, turning to 18-year-old Nina from Canada. "And you must be one of our youngest this year."

At the hostel, I went by Van Go, the trail name given to me six years earlier during my first American thru-hike along the Pacific Crest Trail. I have used it ever since, whenever I set foot on a trail. Even for just one night, I slip into my other persona.

It was easy to feel at home. Luna and her family welcome hundreds of smelly, hairy hikers to sleep on her restaurant's floor or pitch their tents in her garden each year. She saw all the southbound hikers (SOBOers) begin in June, and later, would see all the northbound hikers (NOBOers) finish in September. And somehow, she managed to remember all our trail names. Luna was the mother of all Trail Angels.

One morning, I awoke to find she had laid out a fat black permanent marker and a large white sheet of Tyvek on the restaurant floor, practically filling the entire space. It must have been 20 × 40 feet (6 × 12 m).

"Good morning, Van Go." Her eyes looked red, as though she'd been crying. "I have a task for you today." Luna had learned that I was an artist and went on to tell me that the day before, the U.S. Supreme Court had overturned the Roe v. Wade abortion law. She had a strong, stubborn defiance in her voice as she told me about it and about her anger. I picked up the pen, unsure of what I'd make. But if Luna needed a banner, she was going to get one.

Coming from Europe, I hadn't followed the news too closely. But I have two daughters, and the idea of someone being pregnant against their own will and unable to decide to get an abortion was against my beliefs. I made some sketches and decided on a simple design. A woman's fist with long nails and a wrist morphing into the female gender symbol. The text in bold black letters next to the emblem read: "My body! My choice!"

What was my body trying to tell me? Perhaps the fall had been a good thing to slow me down after all the hard work of the past months back home.

When she saw it, Luna shrieked and clasped her two hands before her mouth, crying again. I looked up from my work in shock, fearing I'd made a spelling mistake or that she didn't like the design or slogan.

"What is it?" I asked, as she still hadn't said a word.

"I... I love it. I love it so much. Thank you, thank you."

Luna gave me an enormous staple gun, and together we hung it across the thick logs on

the cabin's exterior. I took a step back to see if the text was straight enough. Looking around me, I was struck by the number of women who happened to be at Luna's that day. Each a solo hiker. Ready to start their own adventure within the next few days.

"Let's take a picture together, girls," Luna yelled, inviting all the women to join her in front of the banner with her fist up high. It was a beautiful sight to behold, and when the men joined for a big family photo, the tears came back to Luna's eyes. The day had been an emotional roller coaster for everyone involved.

Upon waking on the fourth day, I felt antsy and determined to try my foot. I couldn't stay here forever, and seeing one after the other hiker heading out the past few days had been frustrating. I had to at least try, but the snowcapped mountains of Glacier Park were perhaps a bit much for my first trail day with a weak, still-purple ankle. I imagined having to traverse a mile-long snowfield at a 30-degree angle. No way. Instead, I decided to "slackpack" the first 15 miles (24 km) of the Bob Marshall Wilderness section alone, leaving most of my stuff back at the hostel. Necktie had returned to the Canadian border a few days earlier to begin his hike, and with his starting permit no longer valid, he decided to road walk all the way down from the border back toward Luna's. We had agreed to see each other down the trail, as it was pretty apparent that he would catch up with me anyway. So, I decided to start my trail the next day: I'd get up early and hitch down the road where I could walk the 15 miles (24 km) back to Luna's. I'd carry only a light daypack with some food, water, and bear spray, just in case I saw a bear on my first day out there.

All that waiting had given me lots of time to think. Was I really going to start tomorrow? What was my body trying to tell me? Perhaps the fall had been a good thing to slow me down after all the hard work of the past months back home. I was anxious to begin my CDT at last.

Hey Bear!
First 15 Miles

"Eeee-yooow!" I yelled out loud, hoping to alert any large creature with long claws and white teeth that may have been lurking ahead.

It was time to test my foot, and with only a light load on my back, I felt confident to give it a try. I followed a leisurely trail through the woods back to East Glacier Park Village. But though I set out by myself, I was still very aware I was not alone. For the past years, I had been preparing and reading about the trail and knew from all the previous hikers' stories that there were a lot of bears out there. Not black bears like on the Pacific Crest Trail (PCT) or the Appalachian Trail (AT), but grizzly bears. Grizzlies have a totally different temperament and are more inclined to attack. Although I had never seen one, the fear of an encounter was real already.

My foot actually held up pretty well, to my delight. I was in a happy state of shock, deep in nature with the towering, snowcapped mountains of Glacier to my left and the wide-open skies of Montana stretching to my right. It all felt surreal and yet so familiar. Every few hundred yards, I yelled again to let the animals know I was coming. With my bear spray hooked to the straps of my daypack, I felt like John Wayne, ready to

pull my weapon at any moment should a bear surprise me.

I knew they were out there, although I couldn't see them. There was a palpable abundance of wildlife around me. The scent of their droppings blended with fungi and sweet pine needles—it woke up my sleeping city senses. As I walked, I saw a few bighorn sheep with curled horns, a weasel, and some squirrels fighting in the pine trees above me. High above, a brown eagle circled, waiting to zoom in on its prey. This was a gentle beginning; no other animals showed up that day. The mountain lions and the grizzly bears would appear sooner or later, but that was also part of the trail. I hoped that by treating them with respect, they would leave me alone. Only time would tell. With each step, I found my rhythm again and soon found my bear anxiety replaced by smiles. Before I knew it, I was dancing through a meadow of flowers to the tune of *The Sound of Music*.

Upon reaching Luna's, my foot throbbed. But I was relieved that I had managed to keep a relatively even pace without having to limp and put unnecessary strain and pressure on it. I felt ready at last. "Let the adventures begin," I whispered to no one but myself.

Watch Your Step

Mile 15

I packed up my belongings, strapped my guitar to my pack, gave Luna one last hug, and thanked her for her hospitality. This detour was unexpected, but I couldn't have wished for a better start to my trip. I had gained a lot of confidence from all the other hikers and their stories.

I crossed the road and stuck out my thumb to hitchhike to Marias Pass. All the packing and saying goodbye had taken longer than I had expected, and it was already noon when a car stopped to offer me a ride.

A young woman sat behind the steering wheel, and next to her, a guy with a scruffy beard and heavy black mustache. "CDT? Hop in. We're heading to Marias Pass," he said.

What were the odds? I climbed into the backseat and pulled in my oversized backpack.

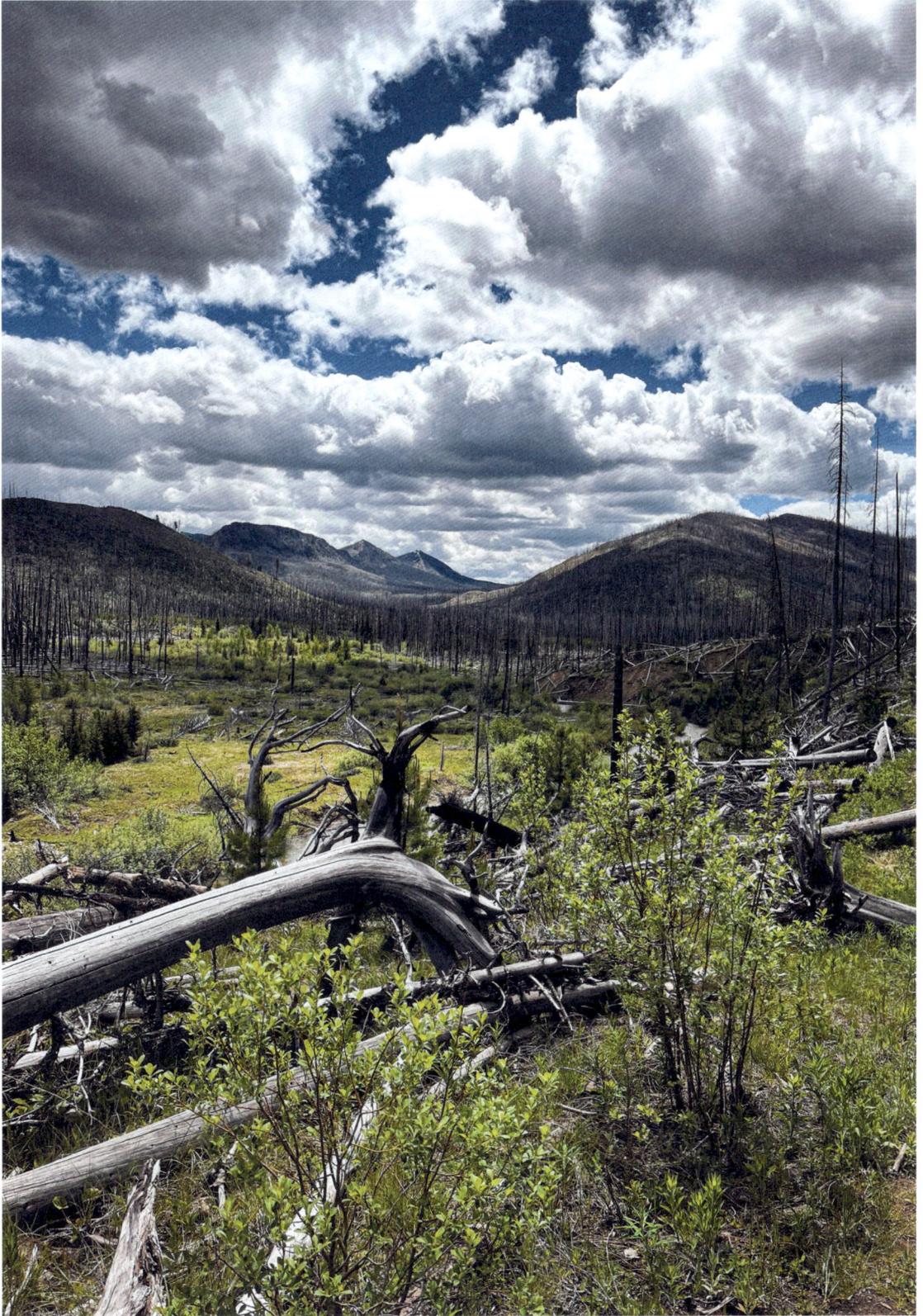

Endless miles of blowdowns stretch out in front of me in the Bob Marshall Wilderness.

"I'm Spiceybite. You doing the CDT too?" he continued, reaching to shake my hand. With a name like that, he was definitely a thru-hiker. "I'm glad I won't be starting alone after all," Spiceybite continued, not knowing I felt even more relieved. I'd been dreading the first few days alone.

When we reached Marias Pass, his sister Jenn pulled into the trailhead parking lot and brought the car to a gradual halt. "Well, that's it, boys. I'm not walking into that crazy bear territory. You guys are nuts. You do know that, right?"

And so, having just met, we set off side by side up a dirt road through the dense pine trees, both in high spirits, excited to finally start our adventure. Spiceybite was probably 20 years younger than me and carried a considerably larger backpack. And I thought my bag—with food supplies for at least nine days—was heavy! It looked like he had enough equipment to shoot an entire Netflix series. His professional camera around his neck, bright shirt, and cap made him look a bit like an American tourist. But he didn't care a bit.

We concentrated on walking, slowly getting into a rhythm. There wasn't much to see around us as the path led us through the forest, gradually climbing up through the thicket. It felt springy underfoot, the legacy of thousands of pine needles working their way into the ground, and bright green shoots of spring flowers poked through every so often. The sun shone through the trees, and life was good.

"Damn. Blowdown already!" Spiceybite puffed in disappointment. Our honeymoon had lasted no more than an hour or two. In front of us was a vast open area of dead trees stretching out to the horizon. Not one of the sun-bleached trees was still standing. It was like a wild open sea, not with high waves but an obstacle course of fallen trees. Right from the start, the trail vanished under the logs, and although we had our GPS maps, it was unclear if we were on the trail or totally lost. But each finding our rhythm, Spiceybite and

I slowly drifted apart as we navigated the now-invisible trail.

"Watch your step. Watch your step!" I repeated to myself, knowing my ankle was still not very stable, and one misstep could set me back far more than I dared to think. But to be fair, things were going all right, and I soon began to get the hang of it, judging each tree trunk, sometimes crawling under on all fours, but mostly climbing over them.

"Heeeeey-Bear!" Spiceybite yelled from somewhere behind me. I wasn't alone, and somehow that made every difference. It gave me a sense of security.

"Eeeeee-Ooooo!" I echoed, reassuring him I was still alive and within shouting distance. More quietly, I cursed to myself as a sharp branch tore a considerably deep gash across my leg. Nothing serious, so I kept moving.

Half an hour later, I heard a familiar voice yell. "Yo! Van Goooo!" It was the first time Spiceybite had used my name, so I decided to go down and check if everything was alright. When I found him, he was sitting next to a stream amid the fallen trees, his pack on the ground.

"Yo, thanks for waiting up." Spiceybite sounded tired. "I think I've done a thing." He glanced at his ankle.

"A thing?" By the expression on his face, it didn't seem like good news.

"You know, I've just recovered from a twisted ankle myself. I'm no doctor, but I'm afraid your foot doesn't look very good," I said carefully, without wanting to worry him.

"Oh really, you too?" Spiceybite looked surprised but kept looking at his own foot as it slowly changed shape. "It's not good. I think I should head back to town and give it some rest. I hate it, but it's probably the wisest thing to do. Especially with all these damn blowdowns!" he cursed, glancing over his shoulder at the graveyard of trees surrounding us.

"Shall I bring you back to the road?" I asked, not knowing what was wise for me in this situation.

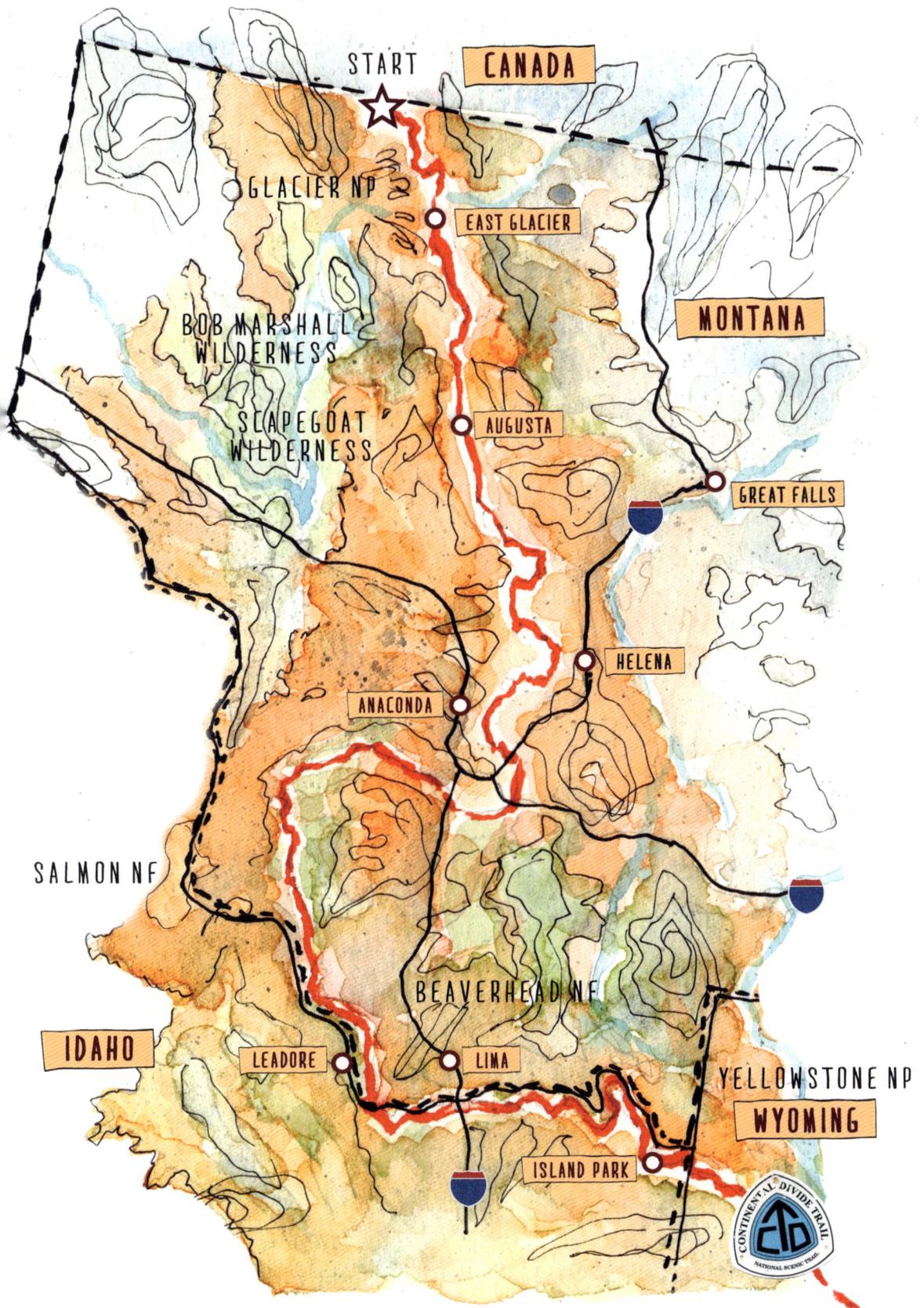

START

CANADA

GLACIER NP

EAST GLACIER

MONTANA

BOB MARSHALL
WILDERNESS

SCAPEGOAT
WILDERNESS

AUGUSTA

GREAT FALLS

HELENA

ANACONDA

SALMON NF

BEAVERHEAD NF

IDAHO

LEADORE

LIMA

YELLOWSTONE NP

WYOMING

ISLAND PARK

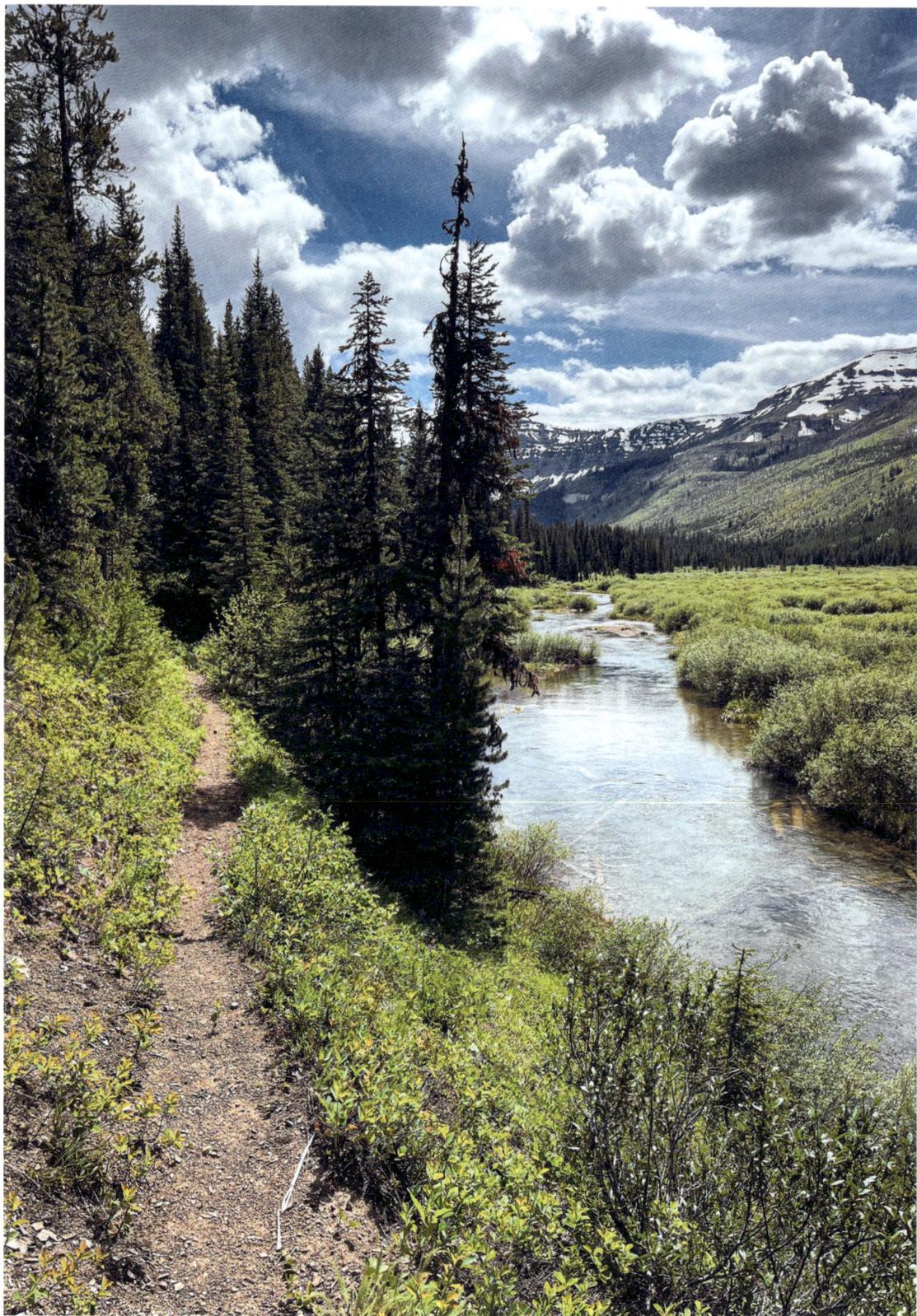

The Bob Marshall Wilderness is totally cut off from society,
without any form of connection to the outside world.

"No, dude. I'll be fine. Really, it's just a few miles downhill," he insisted firmly. After all, it was only 4.5 miles (7 km) from the road and 130 miles (209 km) ahead of us. But I hesitated and thought about it for a while. What would I want someone to do?

"Well, let's at least exchange our satnav numbers so you can always text me if you need help. And when you get back to town, please message me to tell me you are OK. OK?" I was still unsure if I was doing the right thing, letting him return with a sprained ankle. Plus, there was a new reality dawning on me: I would be going into grizzly country alone on my very first day, and on top of that, I'd be spending my first night alone in the wilderness too. My mind raced as I juggled the options. "Let me see you walk with your backpack on first," I suggested, buying time. He walked over an open space and climbed over a tree. I was relieved he wasn't limping heavily, but his going was slow and careful.

"Go. You've gotta go on. I'll be fine," Spicey-bite reassured me. "I'll send you a message in a few hours. Really, my foot is fine. It just needs a few days of rest before I head out again. I'm sure we'll see each other later down the road."

"Sure?" I said, still not a hundred percent convinced.

"Yes. I'm sure." We exchanged numbers and sent a quick test message to make sure we were connected.

"Be safe!" I yelled as he slowly moved down the hill.

"*You* be safe," he shouted without turning his head. Only when he was totally out of sight did I turn my attention to myself. Be safe. Yes. I hauled my backpack back on and turned southward to restart my journey alone. Honestly, it was an adjustment I was unprepared for. But I'd probably be alone quite a bit in the coming months, so I needed to get used to it from the start.

It was getting late and I had only covered four miles (6.5 km). There was nowhere to pitch my tent. To make things worse, I kept getting lost.

I concentrated so hard on climbing over or under the fallen trees that I got sidetracked and lost all sense of where I was. Upon checking my GPS, I often discovered I was totally off trail and had to backtrack to find the route again.

Not one of the sun-bleached trees was still standing. It was like a wild open sea, not with high waves but an obstacle course of fallen trees.

"Eeeeeo-Oooo!" I shouted every quarter of an hour, although it was hard to imagine how a 600-pound (272-kg) bear could get through this mess. My guitar kept getting caught between branches, striking the occasional false chord. My legs took a beating. I couldn't have been averaging more than a mile an hour. Frustration welled up. "Please, please make it stop. Please stop," I yelled in despair. Then, on a slight misstep, I felt my ankle twitch and got very angry at myself for not paying more attention. I pushed on, swearing and hoping the maze of blowdowns would end.

"Focus!" I kept repeating. God, I was already talking to myself out loud on day one. Wasn't that the first sign of madness? But I had other things to worry about: I worried I'd get lost again, worried it would get dark soon, worried I'd have to sleep in this blowdown hellhole, and that a bear would eat me in my sleep. It's strange how fast the effects of solitude can grip and flip a man's mind.

When I thought things couldn't get any worse, it suddenly started to rain, and within minutes I heard the first crack of thunder rumble in the mountains ahead of me. Just my luck. If there's one thing I really dislike, it's a thunderstorm in the mountains, with nowhere to hide, especially if I'm alone. Somehow that makes it twice as bad. But strangely, I had no space left in my mind to worry about yet another thing. The storm would

have to do whatever it wanted; I had to focus on escaping this hellhole and staying alive.

I was already talking to myself out loud on day one. It's strange how fast the effects of solitude can grip and flip a man's mind.

Finally, after eight miles (13 km) of blow-downs and hardly having touched the ground, jumping from tree to tree, I heard the sound of a large river. I hoped to find a flat spot to camp on its banks. When I reached it, I was too tired to re-move my shoes and socks and waded across up to my knees in the cold water. I would have to camp alone on my first night in grizzly country. At 21:30, after nearly 10 hours of grueling clambering and climbing, I found a flat spot. An old abandoned fireplace and a patch of flattened long grass in-dicated others had camped here before. "Always camp on the far side of the river," I remembered, as the water level can rise overnight.

Once I set camp, I was wary of cooking and attracting all kinds of animals with my warm meal, so I opted to eat two of my precious Snickers bars instead. I could catch up on eating tomorrow. Who needs food when you're living on pure adren-aline anyway? It took me 21 breaths to blow up my air mattress; I counted and fluffed up my sleep-ing bag. As everything was set, the sky turned a vibrant orange, heralding a new night.

There was only one thing left: I still had to hang my food. Accidents with bears had dramat-ically decreased after the Forest Service imple-mented the food hanging policy. I did have some experience, but it was some years ago. I needed to figure out if it was like riding a bike, or if I would have to learn all over. I used my pack liner as a bag to put all my edibles and smellables in; appar-ently, bears can smell sunscreen and toothpaste, too. A suitable tree, half-fallen, stood about 50 feet (15 meters) away from my tent. To my surprise,

it was all fairly easy: I slingshotted my stake sack with a rock in it high over the 45-degree angle of the tree on my first throw. I looked around, but of course no one was around to applaud me.

It was only when I walked back to my tent that, to my utter surprise, I saw that someone else had set camp nearby. The same type of tent as mine, in the same color. What were the odds? What were the odds?

"Hello … Anybody there?" I said, receiving no reply. Only when I poked my finger inside the fly of the other tent did my eyes meet those of a wide-eyed, hairy man. I jumped back, both of us frightened. Neither of us had expected to see any-one out here.

"Who are you?" a sleepy low voice said as he poked his head out of his tent. He seemed familiar.

"Chester? Right?" I was sure I'd seen him at Luna's a few nights ago. Chester was a gentle giant, sitting in the same chair for over two days back in the restaurant, always with a White Claw by his side. "I'm Van Go. I'm camped out next to the river over there," I added sheepishly. "Are you doing the CDT?" I asked.

"Yeah. I'm flip-flopping the CDT; I've already done New Mexico but had to flip up north because of the wildfires down south. Anyway, we'll talk tomorrow. Nice to meet you." He clearly wanted to sleep.

"Sleep well! Sorry to wake you up," I said and walked back to my tent.

"No worries," said the rumbling voice.

Just before I hit the sack, I got a message on my satnav device from Spiceybite, saying he was safe and well back in town. What a relief. As I undressed and crawled into my sleeping bag, I somehow felt a lot better knowing another human soul was nearby. There must be strength in numbers, and two tents must be more intimidating for a grizzly bear than just one, I thought. It had been a full, eventful day, totally different than I had expected. I was exhausted but happy to be alive. And happy to finally be on the trail.

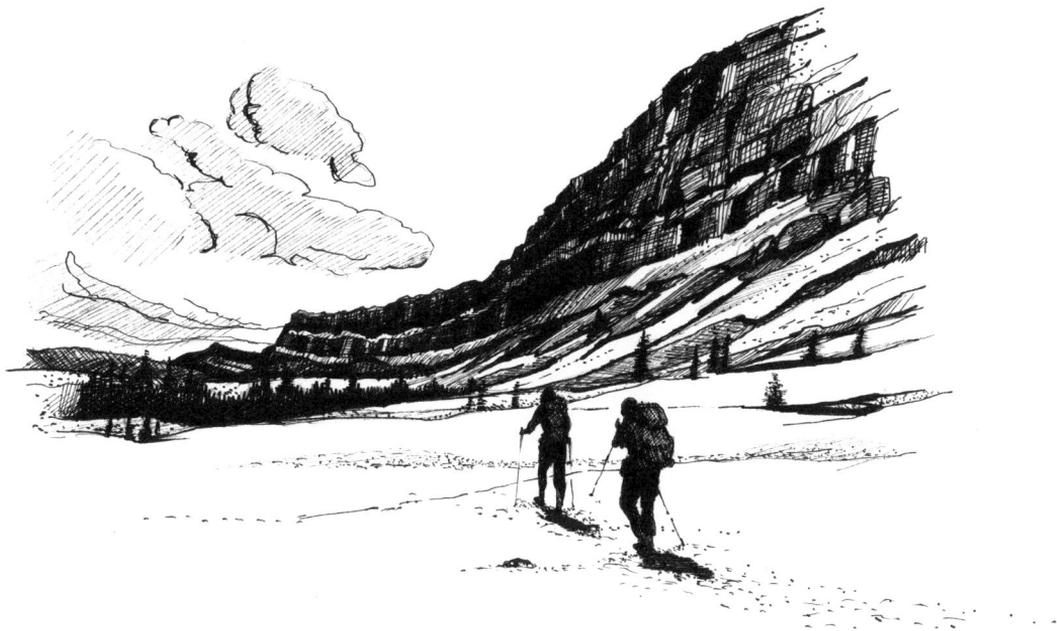

The Chinese Wall

Mile 220

I woke the following morning to rustling in the shrubbery and opened the fly to see Chester retrieving his food bag from a tree above me. In the darkness of nightfall, I'd failed to see his food bag above where I had chosen to pitch my tent. A curious bear would have walked right over me trying to reach Chester's food. I pushed the thought out of my mind.

I was eager to head out of camp and chat with him, so I packed up. I decided to hang my tent on the outside of my pack, freeing up a lot more space for all my gear and food. This way, it didn't feel or look so bulky, and if it rained, my tent would perhaps get wet, but that didn't matter so much; the region had suffered years of droughts, so I wasn't expecting too many showers.

By the time I was packed and set to leave, Chester was nowhere to be seen. I nearly stumbled over myself to get back on trail, hoping to catch up with him. Now that I had found another human being, I was eager to connect, even if it was just for sharing a campsite at night. Strength in numbers. But as fast as I walked, there was no sign of the gentle giant.

Today the trail was relatively flat, following a boggy valley along a wide river. The trees were young, lush, and green, and although there was still the occasional blowdown across the trail, it was nothing compared to the hell of yesterday.

"Eeeeeo-oooo!" I returned to my loud mantra every few minutes, still uncertain what lay ahead. All was quiet until suddenly I got the shock of my life.

"Booo!" An unfamiliar voice yelled from behind a bush, followed by a person jumping out with her hands held high, fingers gripped toward me like giant claws. Her face was scrunched up to mimic an angry bear. "Gotcha!" I tried not to look too scared.

"Van Go, right?" she continued. "Didn't you make that banner at Luna's? I loved that."

The woman stretched out her arm to introduce herself with the familiar hiker fist bump. "I'm Rip," she said, smiling wide.

"Dude!" I said. "Don't ever do that again." I dropped my trekking poles to the ground, relaxing a little and laughing at my own reaction.

"How did you get in front of me? I haven't seen a soul for two days," Rip continued, tearing open a breakfast bar with her bright white teeth. Although the sun was out, she was clad in rain gear from top to toe. She pulled back her hat to reveal long, straight, brown hair on either side of a young face covered in mud. "I guess I must have gotten lost and taken the high muddy route. Damn, those blowdowns, they've ripped up my legs." She glanced down at her pants, which were covered in mud.

"I guess," I said, unaware there had been a high or a low route.

"Shall we?" She walked ahead silently as we followed the trail up through the valley. When we had to cross the river again, neither of us hesitated, wading on through in our trail shoes. We followed the path as it meandered through a narrow gorge, its vertical rock face stretching more than 50 feet (15 meters) high, following the river farther upstream. The high gorge blocked the morning sunlight, and the dense pine canopy above darkened the feel of the forest. I noticed two chipmunks dive into a shallow puddle to take a morning bath and a family of white-tailed deer suddenly look up from their drink as we walked by. It was clear that we were guests in this animal realm. In far distance, we could hear a large waterfall as the river's sound raged.

Although I was no longer alone, I was still aware that we were walking deeper and deeper into bear territory, and despite the beauty of the place, somehow the rock walls on either side gave me a sense of claustrophobia. Weren't rivers the perfect place for bears to drink, eat, and rest? Yet Rip didn't seem worried and made no attempt to let the bears know she was approaching.

I couldn't help but yell "Eeee-Oooo!"

"Dude! You could have warned me," she called back, startled by my cry, looking over her shoulder with a cheeky grin.

"Aren't you worried about the bears?" I asked, feeling very European all of a sudden.

We followed the path as it meandered through a narrow gorge, its vertical rock face stretching more than 50 feet (15 meters) high, following the river farther upstream.

"Sure, I know they're out here; I saw a bunch of them up in Glacier, but a lot of good all that yelling is going to do. If it's my time, it's my time." Her face was serene, and she cheerfully walked on, humming to a country tune on her headphones. That's one way to look at it, I thought, and immediately tried to adopt her perspective. Although I couldn't resist the occasional "Eeee-oooo!" once in a while.

Eventually, we reached white water. Two hikers sat on the other side of the river, eating an early lunch. One of the guys pointed downstream, indicating a large blowdown, a bridge across the dangerous rapids. Rip returned a thumbs up and carefully made her way toward the downed tree. She nimbly stretched out her trekking poles and walked across the slippery log to the other side. I gave it a second look and knew this was not for me. I was not willing to risk my fear of heights, my weak ankle, and that slippery surface on my second day out here. Perhaps I lacked her youthful courage. Whatever it was, I headed farther downstream to find a suitable place to wade through the river.

Having reached the other side of the water, I scrambled back to the others. Rip had joined them to eat.

"This is Dom and Freddy. They are from England, just like you," she said.

"Hi, I'm Van Go, but I'm not English. I only grew up there," I said and gave the two guys a fist bump.

"I thought you were from England, with that accent and all?" Rip looked puzzled.

"No. I'm from Holland."

"Oh, that's why they call you Van Gogh, I guess," Dom replied.

"That's so cool that you are doing this together." Rip turned toward the two hikers. "I did the first week up in Glacier with my sister, but unfortunately, she had to go back to work," she added.

Freddy asked what other hikes we'd done before.

"Oh, this is my very first thru-hike," Rip said smiling. "Everyone I spoke to who had already done the CDT warned against it. Or at least that I start NOBO. And definitely not walk it alone. Well, all that talk fueled me to do just the opposite, and here I am, and I'm loving it. Apart from those damn blowdowns, that is." She stroked her right calf through a long rip in her rain pants.

"Yeah, right," Dom agreed, gesturing to the scratches down his legs. We all had our fair share of Bob Marshall battle wounds, but strangely, were all still smiling. This was what we had signed up for. It was real, far away from everything we knew, and we were no longer alone. Shared drama is always twice the fun, however much it sometimes hurts.

"Where in England are you guys from?" I asked the two brothers, who looked around 25 years old.

"Tunbridge Wells," Dom, the older and more talkative of the two, replied in a refined British accent.

"Royal Tunbridge Wells!" I replied in astonishment. "My dentist was in Tunbridge Wells; I grew up half an hour away from there." What were the odds?

Rip looked somewhat lost in translation.

"It's right between London and the English Channel," Dom clarified.

"Well, I'm from Flagstaff, Arizona. Welkom to 'Merca y'all." Rip tipped her baseball cap, got to her feet, and marched on ahead. And with that, the talking was over, and everyone set about packing their stuff to keep moving.

It felt good to be high in the mountains, surrounded by snow and rocks, warming our feet around the fire as the temperature dropped.

The four of us continued together, a 30-foot (9 m) gap between each of us, but always keeping one another in view. There wasn't any talking, and their pace was considerably faster than mine, but I felt renewed, having found others to hike with.

We continued following the trail until the sky turned pink, and dusk fell like a blanket over the mountains. There hadn't been a clear spot large enough for four tents for hours, so when night came we settled on a flat patch covered in snow. There was a creek nearby where everyone had a quick wash. Dom collected some dry sticks and made a campfire. I took my guitar out, and quickly tuned it by ear, strumming a little to see how the sound carried through the mountains. I'm not much of a musician, and I find it hard to remember the words of most songs, but I can strum the basic four chords most beginners can. No one seemed particularly bothered, as everyone was busy setting up their little shelter and preparing dinner.

It felt good to be high in the mountains, surrounded by snow and rocks, warming our feet around the fire as the temperature dropped. Together and yet peacefully alone.

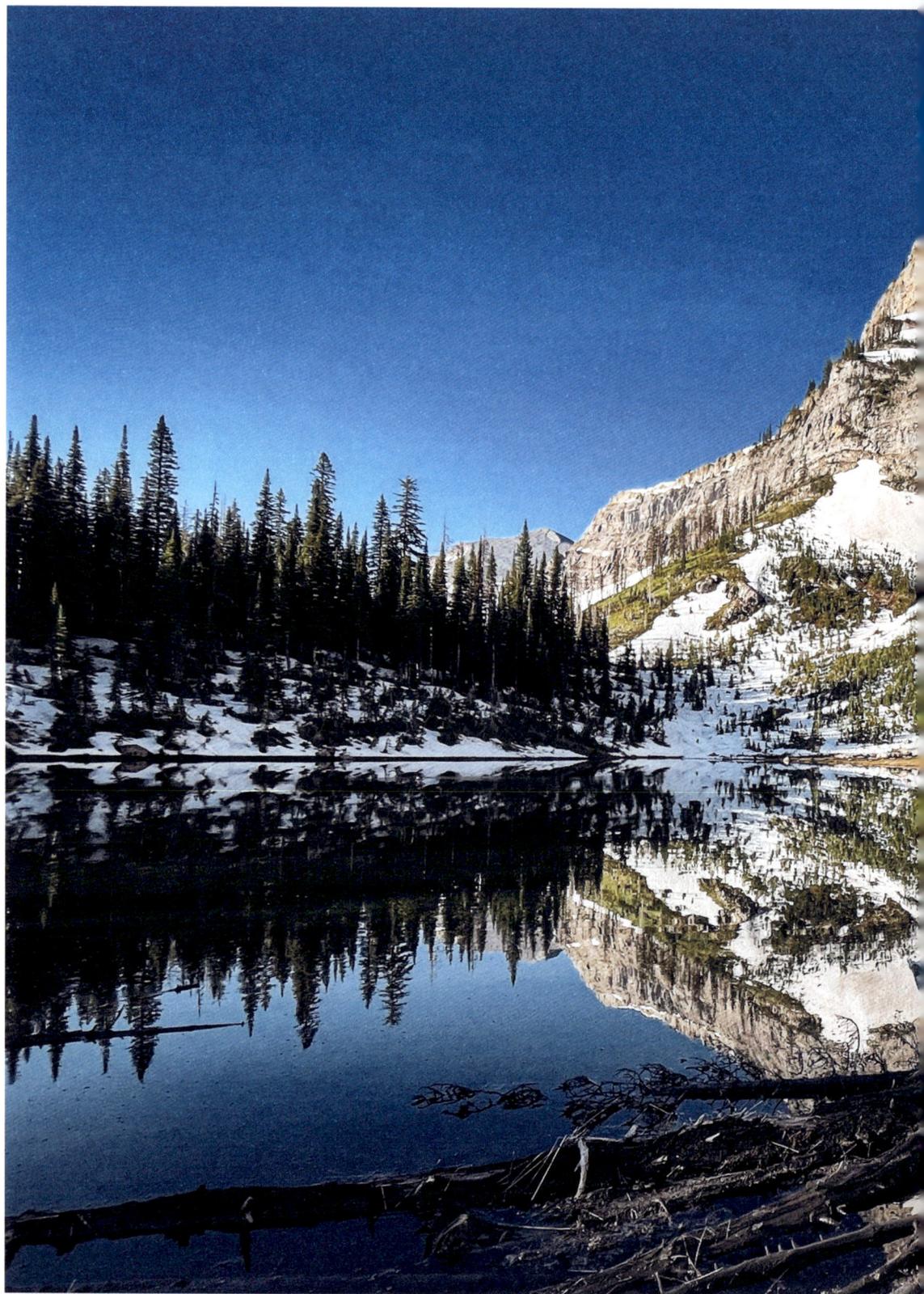

We stop for a quick swim, with
the Chinese Wall looming above.

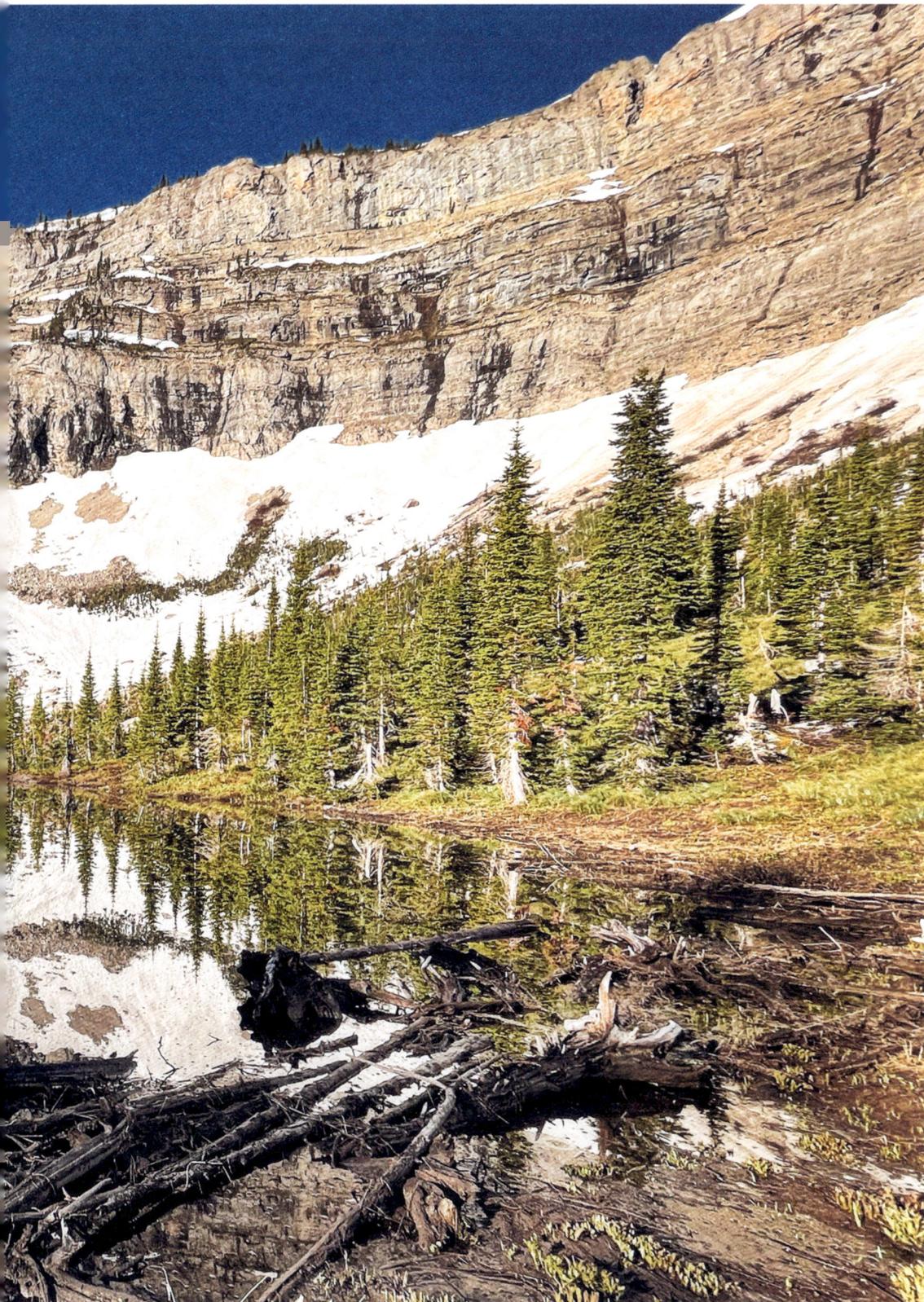

The four of us were all zipped up and curled in our sleeping bags when I heard a heavy thud fall to the ground.

"What was that?" I heard Rip's voice some 50 feet (15 m) away. Was it a rock falling from the mountain? Was it a heavy animal? I unzipped my tent fly and peeked out into the darkness. All I could see was a red headlamp.

"Chester?" I asked, shielding my eyes from the red glare.

"Yo," he replied. And that was that. A man of few words. But after all, what was there to say? I crept back inside my tent and heard the rustle of tent fabric, a rock pounding six pegs into hard ground.

Chester generally wasn't all that talkative, but the next morning, we finally got to know one another a bit. Rip and the British brothers had headed out early into the morning dawn with their headlamps, so it was just the two of us, carefully packing our gear. It struck me that Chester was very orderly compared to me, packing each piece of gear into a separate sack. My pack was more chaotic, and although I had a different stuff sack for clothes and electronics, it was nowhere near as neat.

When all was packed and saddled, I followed Chester onto the trail. As we fell into a rhythm, it soon became apparent he was much faster than me. Chester told me that he had already nearly done two months of the CDT northbound from the Mexican border.

"I finished the AT right before starting the CDT. Only had a few months in between. You probably wouldn't recognize me before." He gestured to his body. "I've lost over 70 pounds in the past year." That's an incredible 32 kilos, I thought as I converted it to metric. I thought of my 156 pounds (71 kg), how I'd disappear if I lost so much on trail. Chester was about 10 years younger than me and practically covered from head to toe in ink.

"Ha, some I love, some I hate. I got most of my first tats drunk as a bat when I was 16, so I have had to do a lot of coverups over the years. Man, they were so embarrassing." He gave a cheeky smile, looking back over his shoulder. When we reached another river, he sat down and started taking his heavy leather hiking boots and socks off.

"Forgive me, but what's the story behind those? They're beautiful," I asked, pointing to the collection of blue pictograms on his forearms.

"Oh, they are a reminder of my cooking days," he said with a melancholy tone. "It's an entire page from my favorite French cookbook." The gentle giant didn't speak much, but when he did, there was no stopping him. "I used to be a chef. Even owned a restaurant with a few stars once, but that was only after years of brutal training in France, New York, and L.A. I worked day and night and even turned up on my days off. But in the end, running a business with your best friends wasn't the best idea. I'm retired now. Hiking is my new cooking. I've been hiking back-to-back trails over two years now, and once I finish the CDT will probably head straight down to the Arizona Trail." His eyes twinkled.

"FREE WILL?" I gestured to the bold letters inked across his knuckles.

"Yeah. Things haven't always been easy. Not everyone gets me, I guess. Got kicked out of loads of schools when I was young and ended up in a strict military boarding school. We had to wear army uniforms! They were the worst days of my life, but they taught me discipline. Thank God I can do what I want now." He sighed heavily, and it was evident that he had done enough talking for the day.

I slowed my pace, letting him go on ahead, as all his stories percolated in my mind. How different our childhoods must have been.

Toward the end of the afternoon, we bumped into the whole crew again as they were slowly traversing across a large snowfield that interrupted the trail. There was no option to walk up or around it, and as no one had been here before us, we had to painstakingly create new footsteps deep into the steep ice wall. As the

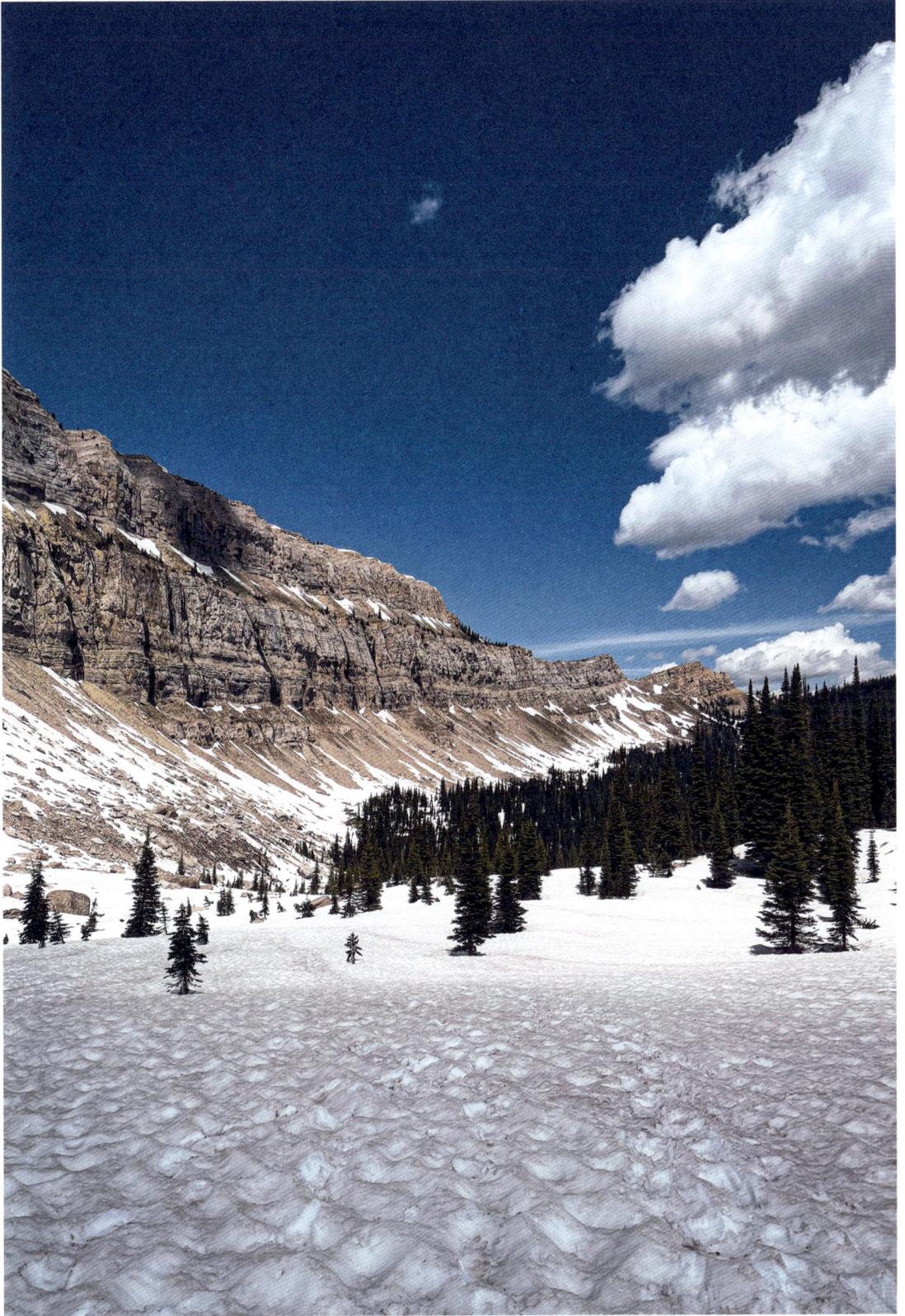

The Chinese Wall stretches out for miles,
as we plod on south through the snow.

trail dropped back down into the valley again, there were countless river crossings, some really powerful, and I thought how irresponsible it would actually have been to be out here by myself. My fear of grizzly bears vanished into thin air.

As we walked ever deeper into the Bob Marshall Wilderness, we grew to know each other better and better.

Together, we marched down the hill to where we could see a plume of smoke rising near a lake. Someone was down there. Not just that: there was someone singing. But it wasn't English; it was a French song. When we finally made it to the lake below, a man was standing naked in the water, washing his armpits. Sensing the presence of five strangers at the lakeside, he turned, waved, and greeted us enthusiastically.

"Bonsoir!" Here was Fred, a fellow European.

When we all gathered around the fire to prepare our food, I was surprised to see how the middle-aged Frenchman prepared a three-course dinner and drank pure olive oil from a small glass bottle. He had clearly imported all his goods from home.

"It's important to eat well," he said, licking his fingers. "I don't trust all that American food." He glanced at our preprocessed mashed potatoes and pasta. "That's all full of fat, sugar, and salt. I believe you need healthy food. I'm just too French, I suppose."

The following morning started with more blowdowns across the trail. We stuck together as a group, but the Frenchman was nowhere to be seen, having packed up very early to head out alone. We needed to stay close together; fresh grizzly bear scat dotted the trail. We couldn't see them, but they were definitely out there. "Safety in numbers, safety in numbers," I thought.

"Bonjour," Freddy called out of nowhere.

"おはよう (Ohayō)," answered Dom, with a cheeky smile on his face.

"What's all this, y'all?" Rip cut in. I was just as puzzled.

"Oh, we're both doing this language course," Dom began. "It's an audio app, and you have to repeat everything they say. Sorry about that. It must have sounded bloody weird. He's learning French, and I'm giving Japanese a go."

"You guys should join! I'm allowed three additional people on my subscription. Feel free to pick a language," Freddy offered kindly. The younger of the two British brothers, Freddy was a 22-year-old PhD student from Durham University in North East of England. It seemed fitting that he'd learn a language out on trail. Even so, I was impressed by his discipline.

"Thanks. I like the idea, Freddy. I'll think about it." I said, and we walked on in silence, broken only by the occasional "Comment vas-tu aujourd'hui?" and "今日は元気ですか (Kyō wa genkidesuka)". I liked the idea of learning a language while out walking; after all, we had a lot of time on our hands, and what better way to use it than to learn a language for an hour each day?

I decided on Spanish, as I'd lived in Barcelona in the past and dreamed of living in Spain again in the future. Plus, we were hiking toward Mexico! I had to know how to order my cervezas and tacos correctly. When we regrouped to stop for lunch, I asked Freddy if I could sign up.

As we walked ever deeper into the Bob Marshall Wilderness, we grew to know each other better and better. Although everyone preferred hiking alone, it was often at lunch breaks and at evening campsites that we stuck together. We were a surprisingly quiet bunch, quieter than I'd experienced in previous groups I'd hiked with. I'm generally very talkative, much to others' annoyance at times. But now, in all this silence within the group, I grew to appreciate it as something new.

"It's funny, there are four introverts and one extrovert in this group," Rip observed one evening

while we were having a quiet meal around the campfire. "Usually, it's the other way around." No one answered. My physical appearance, bright clothes, Hawaiian shirt, and obnoxious guitar, which I rarely played, may have been clues as to who the extrovert was.

The following day I quickened my pace to catch up with Rip. I wanted to ask what she felt the definition of an introvert was. As an extrovert, I had never really given it much thought, which in its own right was quite typical for extroverts.

As I walked around a giant boulder, I saw it for the first time. It was still far, far away, but with no trees obstructing my view, I could see it in all its glory: the Chinese Wall.

"I may appear bubbly and loud to most," she explained, "but really I enjoy quiet time at home with my dog more. Introverts generally recharge their energy while they are alone, while extroverts get it by being with others. Being in a big group like this is great, but I need my daily alone time too."

I wanted to ask her more—how she could tell who was who, and what it was like to feel this way, because I'd never really given it much thought before. But having explained a little, Rip increased her pace somewhat as we moved up the mountain. I was left to contemplate our differences alone.

Having spent more than six days in the wilderness, my backpack finally felt a little lighter. The trail led us up along a steep gorge until we reached the tree line. This often brought snowfields onto our path, as the winter snow was far from gone at this altitude.

Then suddenly one day, as I walked around a giant boulder, I saw it for the first time. It was still far, far away, but with no trees obstructing my view, I could see it in all its glory: the Chinese Wall. The closer I got, the clearer the graphic features of the wall became. A vertical dark stone wall stretched ahead of me for more than 50 miles (80 km), with contrasting snow on the horizontal ledges along the rock face's length. It reminded me of millions of Oreo cookies stacked out into the distance. The escarpment must have been 300 feet (91 m) tall, and it felt like it went on forever.

When we finally reached the foot of the wall, the trail disappeared under a flat bed of deep snow, which we had to trudge through for miles and miles. The going was slow, and we frequently had to backtrack as the fresh snow covered any previous tracks others may have created. But the two brothers reveled in the task of creating new tracks and powered up through the endless snowfields, finding suitable routes around or over sketchy snowbridges, as we often had to cross hidden creeks. Only the gushing sound of the water warned us of the lurking danger below. We walked close to one another and waited for each other as we navigated the terrain.

I was often the last in our group, but this had more to do with the countless photos I stopped to take as we walked under the Chinese Wall. My eyes couldn't get enough of it, and with the silhouettes of the four hikers in front of me adding to the graphic landscape and giving scale to the cinematic scene, there was a shot everywhere I looked.

Just before hitting the top of White River Pass, I turned to take one last look at the Chinese Wall and realized that millions of tourists would visit this extraordinary sight if it were reachable by car. But with a four-hour hike to even get a glimpse of it, it remains one of America's truly hidden gems.

Ultimately, we didn't make it to town that night, instead opting to camp next to a river, sharing the remainder of our food. A green tent was already pitched nearby, and a woman was sitting on a log strumming a small mandolin.

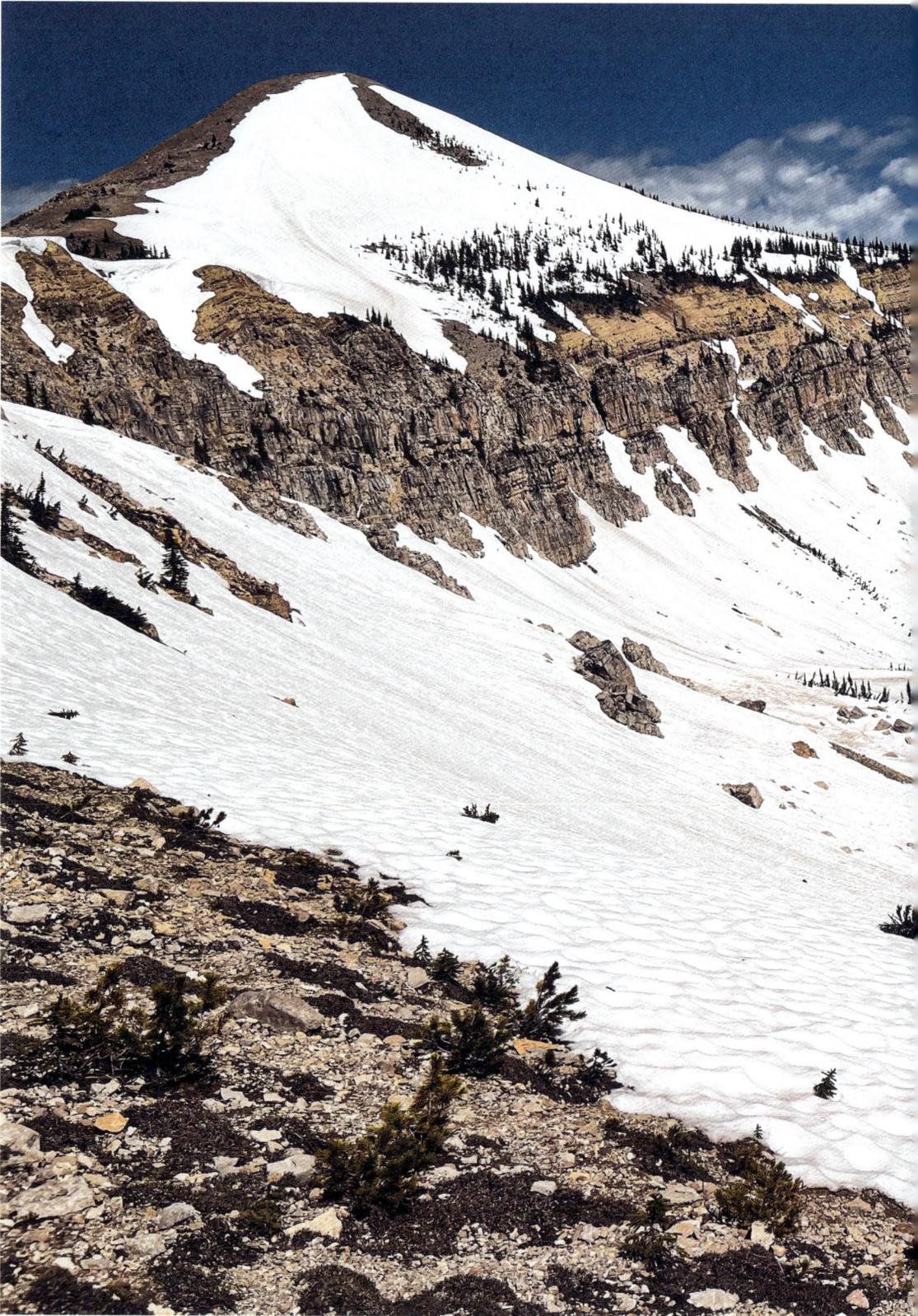

The Bob Marshall Wilderness stretches
out in front of us in all its glory.

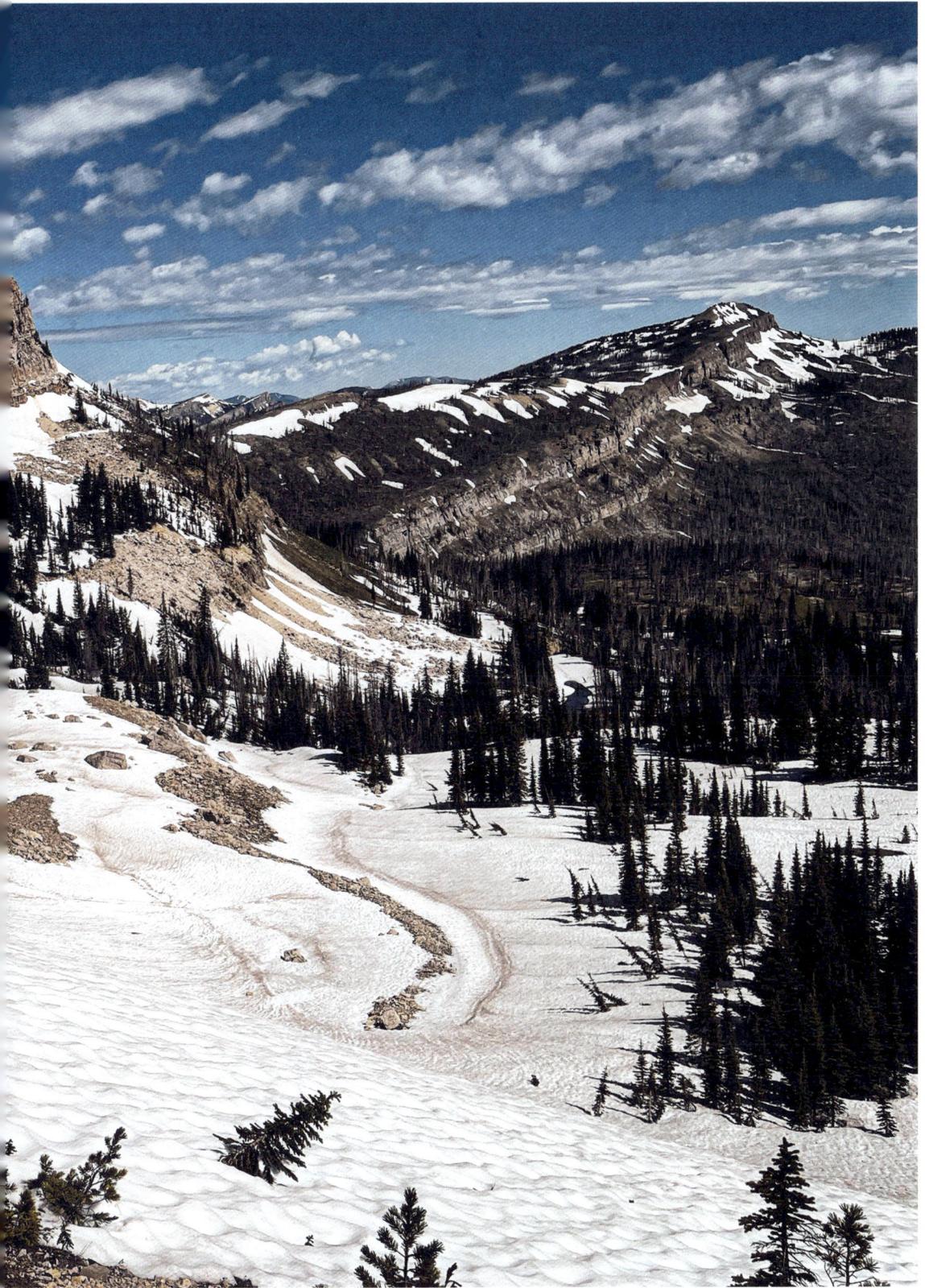

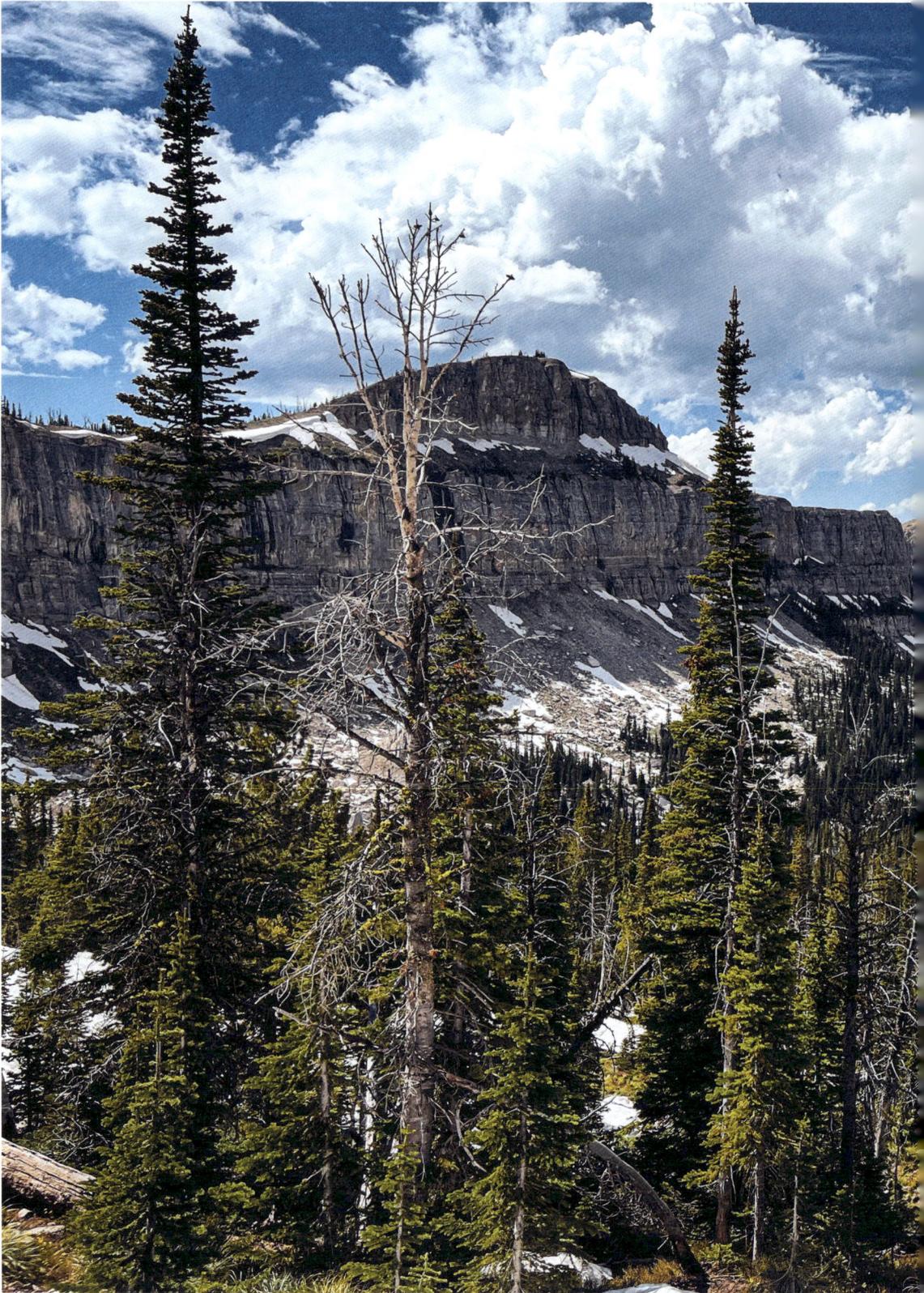

Having nearly completed the Bob Marshall Wilderness,
I look back to see the Chinese Wall one last time.

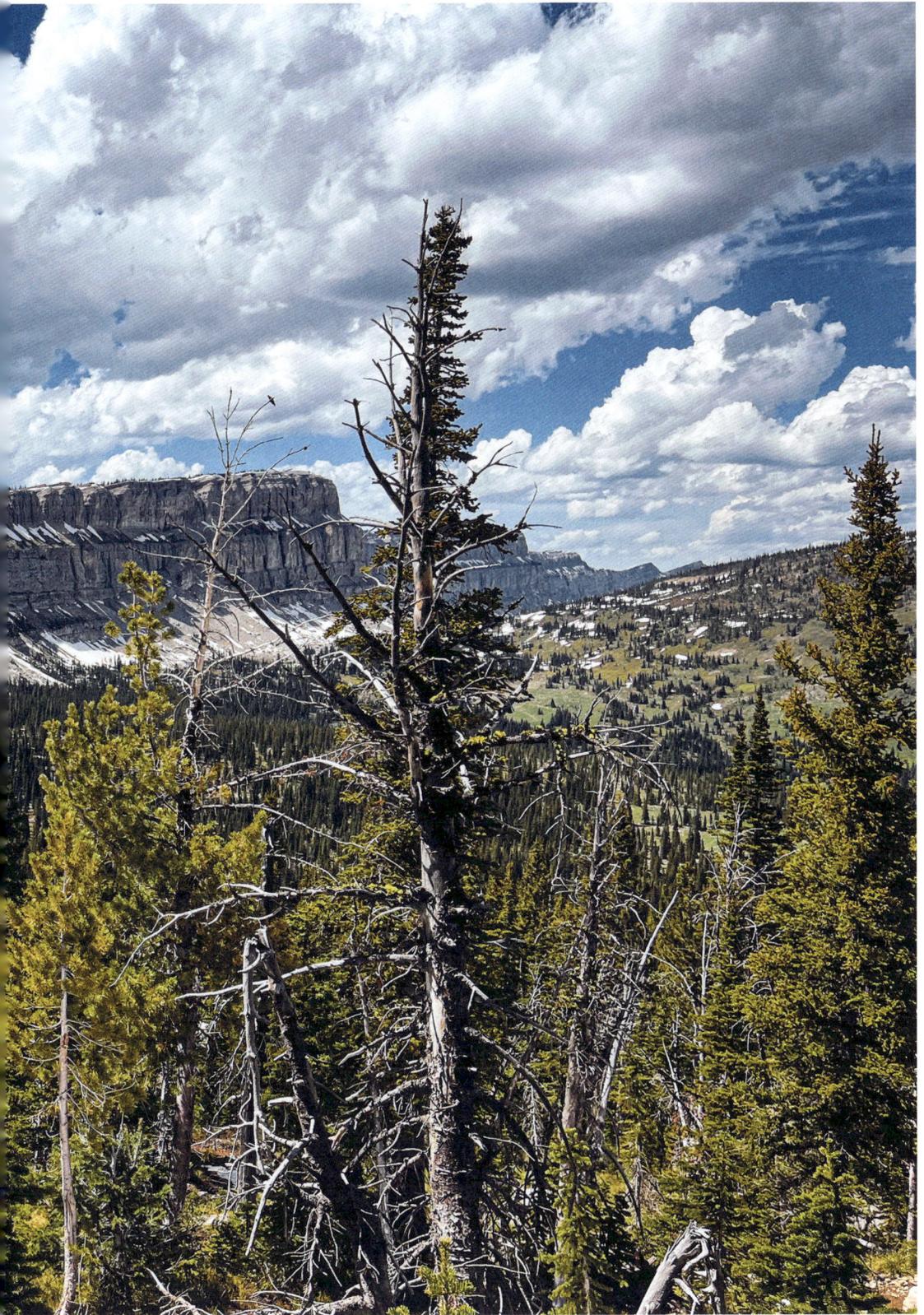

Dom set about making another campfire, and we joined the woman.

Piper, a retired computer programmer from Santa Barbara, had also been at Luna's. I whipped out my scratched mini guitar to accompany her mandolin as well as I could. I had cursed the damn thing every step of the Bob. But now, joining Piper, it felt appropriate and appreciated. Together, we at least sounded like *something*. Long into the night, we sat enjoying simple folk and country tunes, staring into the campfire's flames.

The following morning, Piper was nowhere to be seen, probably having left at the crack of dawn, as the five of us packed up and headed farther down the muddy track back to civilization. It was the seventh and final day of our hike through the Bob Marshall Wilderness, and we finally had some good trail without any blowdowns so could thankfully pick up our pace. We walked steadily, until Dom whispered out of nowhere.

"Stop." We all nearly bumped into the back of him as he raised his hand.

"What?" I said, the last to come to a standstill.

"Shhhhh. Bear!" Rip whispered, pointing to a brown bear a few feet ahead of Dom. It was sitting right on the trail.

It felt like a scene from a cartoon, with the five of us bunched up, holding our breath, waiting for the next move. As Dom slowly moved backwards, we followed him in slow motion, eager not to attract the bear's attention. Then suddenly, the bear shot up and darted toward the hill behind the trees, the five of us shouting and clapping to scare it off.

"Shhhhh. Bear!" Rip whispered, pointing to a brown bear a few feet ahead of Dom. It was sitting right on the trail.

"A bear! A freakin' bear!" We shrieked at each other in excitement. "Was it a grizzly?" one

of us asked. "It had a long pointy nose and was light brown; it must've been," another replied.

In all the excitement, I glanced over my shoulder to see the bear still staring right down at us from a higher vantage point. There was calm for a brief split second as the bear and I looked into one another's eyes.

"Bear! Bear!" I yelled, waking up to the reality of the situation. Just as I did, another voice cut into the chaos.

"Bear! Another one!" A smaller black bear ran up to the brown bear, and they subsequently both ran off and disappeared into the woods behind us. I couldn't believe my eyes. Here I was, not having seen a single bear all week, suddenly seeing two within seconds of each other.

Wide-eyed and excited, we left the scene as quickly as we could. We hastened down the hill, keeping a close-knit group, our eyes peeled. My adrenalin was pumping high, yet the whole encounter had not frightened me. Somehow being with the group had given me more confidence than I had imagined.

A few hours later, we finally made it down to the trailhead and were lucky to flag down a large pickup that offered us a ride into town. Piper was nowhere to be seen; we hoped she'd gotten a hitch from another car earlier. With three of us in the truck's front cabin and the others back in the open bed, we sped down a bumpy gravel track for more than 10 miles (16 km) before eventually hitting smooth tarmac. The high mountains soon disappeared behind us, and the road gradually meandered into vast rolling plains. The isolation of the recent days became even more distant.

"We just saw a grizzly and a black bear together. Does that often happen?" I asked Frank, the truck's driver, hoping his local knowledge would give insight into what we'd just encountered.

"That'll be a black bear tanned by the sun," Frank replied, hardly looking at the road. "You never see a griz and a black bear together; each has its own territory. The griz have all come down from the mountains to feed here in the plains.

Y'all won't be seeing too many of them up there for a while. It'll be mostly black bears." Frank knew the area well; he was a Trail Angel and often shuttled hikers along this road.

"I tell you what. Y'all look pretty tired and smelly," Frank laughed out loud as he lowered all the windows in his truck to let in some fresh air. "Wanna stay in my friend's cabin? It's a lot nicer than those pricey motels. I'll make sure he gives you a friendly price."

"Sure. Sounds great," Rip answered immediately. "We'll take it."

"Deal." Frank hit the car horn. Minutes later, we entered the small settlement of Augusta, a cowboy town in the middle of the plains. He pulled to a halt in front of an old wooden cabin. "This is it."

We all piled out of the car, our legs already stiff. It was time for some rest, a hot shower, and to tend to our wounds with bags of ice. And, of course, some good food and local beers.

"We'll take two nights," Rip said conclusively.

Fourth of July

Mile 289

It was still early when Frank dropped us off at the cabin in Augusta, giving us the entire day to rest. Still, we didn't move for most of the day, each licking our wounds, icing and elevating our feet, enjoying one beer after another. After more than seven days out in the Bob Marshall Wilderness, it felt great to finally have a long shower and a cold White Claw in my hand.

With ice on both my ankles, I inspected my feet. My big toenail appeared to have gone black and was slowly coming off. A large blood blister was developing behind the nail, pushing the toenail out. I'd never experienced this

before, but it didn't hurt as badly as it looked. I had underestimated the effect of walking in double socks. The extra layer had helped to ease the pain of my healing ankle, but as a result, my shoes were now a size smaller. You can never win.

After more than seven days out in the Bob Marshall Wilderness, it felt great to finally have a long shower.

"Toenails are just a luxury," Chester said, glancing at my big toe. "You'll probably lose more than one. It won't hurt. You won't be needing them anyway, and it saves weight." He chuckled and gently rubbed my back to show he cared.

"Tonight I'm having a big fat steak," Freddy declared.

"Hear, hear!" Dom echoed.

"Knowing you, you'll probably have two steaks," Rip laughed. Freddy seemed to eat twice as much as any of us each night. "I don't know how you do it. Carrying all that extra food, as well as eating it all," she gave him a playful nudge. Cabin life was good. Everyone seemed very happy not to be hiking for a change.

"Two nights in town," I gasped with disbelief and pleasure. Two full days and two full nights without having to carry a backpack.

"And it's the Fourth of July tomorrow, right?" Dom's eyes widened. "We can finally get to see some good old American culture."

"Rodeo and fireworks, y'all!" Rip shouted.

That evening, dressed and hungry, we hobbled into town to find our steaks. The Buckhorn, recommended to us by Frank the Trail Angel, was busy, bustling with locals wearing ten-gallon cowboy hats. I was surprised to see so many other hikers in the bar, too. I recognized WoW and Honey, an older Englishman I'd seen at Luna's two weeks earlier. There was a retired couple from New Zealand and quite a few young Americans.

Chester had called ahead to book us a table, so we all set to the task of indulging in much-needed salt, fat, and sugar. Rare steaks, burgers, White Claw, and hot wings. More food than we'd seen in days, followed by a good night's sleep.

The following day, I felt regenerated. I wandered into Augusta, taking the small town in: everyone was making last-minute preparations for their Fourth of July barbecues, and you could feel an excited buzz of anticipation for the festivities. I bumped into Frank, our shuttle driver, and gave him my guitar to give to Luna's daughter over in East Glacier Park Village. After my Bob Marshall ordeal, I was not carrying that damn thing one more mile.

After making it down to the general store and stocking up on five days of resupply food for the next section, I set to work on an idea that had been brewing. I wanted to do a Fourth of July photoshoot and had the thought that I could hang an American flag at the bar and photograph people in front of it. To my delight, the bar's owner was receptive.

"Sure, honey. Go ahead, hang the flag wherever you wish," she said with a proud smile, unsure what this foreigner with a funny-sounding British accent was planning to do in her bar. After walking around and scouting out a suitable place in the restaurant, I finally settled for the hallway leading up to the restrooms. This was the only place that offered some privacy, as I didn't want the whole village looking on as I photographed my friends. I had brought along some duct tape and affixed a flag to the wall, covering some dated posters for a country band that had played in the bar three months before. When everything was ready, I returned to our group and asked Chester to join me.

He was a little hesitant, as he was never one to stand in the spotlight, but we had developed sufficient trust over the week. He followed me to my makeshift studio and awaited my directions. As I adjusted the spotlight on the wall to add some dramatic lighting and took the first test photos

with my smartphone, it struck me how photogenic he was. His long beard elongated his face. As he turned toward the camera, I asked him to gaze up toward a far corner of the ceiling behind me, giving him that thousand-mile stare into eternity.

Rip came along next. I asked her to stand with one foot in front of the flag, a dramatic pose. But I didn't need to give her much direction; with her smile and the vibrant energy in her eyes, she was a natural.

"Have you done this before?" I asked as I took a few more shots, asking her to look over her shoulder toward the camera.

"Not really, only once on my high school's prom night. I was one of three girls paraded around the football stadium in a convertible. It was super awkward." Her reminiscence seemed a world away from her current adventures. But then, this experience was out of the ordinary for all of us.

I thanked her for the photos and continued with the two English brothers. But I had one more wish: I wanted to photograph a few locals. I didn't know how they would react, but I plucked up my courage and approached a middle-aged couple having a drink at the bar.

"May I take a picture of you?" I asked gently.

"Oh, not me. I never look good in any photo," the woman replied.

"I think you look great together," I offered.

I thought back on the American troops who had given their lives, and I too felt goosebumps run down my spine.

"Okay, why not?" She poked an elbow into her husband's side, and I guided them to my makeshift studio. They had to stand close, holding one another for me to get their heads in the frame. The awkwardness of the situation soon gave way to laughter as I shot as many pictures

as possible. When I was done, I told them I'd email them copies of the photos and thanked them for their time.

Everyone was heading outside to catch the fireworks. Rip was keen to show us Europeans some American pride. And that's exactly what we got: the local softball team stepped onto the podium to sing "God Bless America." It was so American that we Europeans first glanced at one another, cringing slightly. But when the chorus came around for the second time, I thought back on the American troops who had given their lives to liberate my occupied homeland back in 1944 during the Second World War. And I too felt goosebumps run down my spine.

Scapegoat Wilderness

Mile 289

"High or low route?"

"Which is shorter?" I asked.

"The low route," Rip replied, taking the role of navigator together with Dom. They were both well organized, and as this was their first thru-hike, they both took the navigation quite seriously. I'm a terrible navigator, and on the other hand, I never really make any concrete plans when I am out hiking and enjoy simply going with the flow. I've found it refreshing to follow other people's plans, as I do enough team leadership back home at work.

"There are a million alternate routes we can take on the CDT," Dom explained. "There are high and low routes; some even just follow the road to cut some miles. You can basically pick and choose whenever you want." He stared down at his navigation app, examining the pros and cons of the upcoming Scapegoat Wilderness.

"I'll take the easy route," I said, glad to see Chester and the others nod to back me up. Personally, I wasn't interested in doing the official red route all the way down to Mexico. On previous hikes in New Zealand and along the PCT back in 2016, I had been a purist, eager to do continuous footsteps from border to border. But now I didn't feel this purist urge. After all, the CDT had thrown a curveball at me on day one, and with my twisted ankle, I had decided not to walk the first six days of the trail through Glacier National Park. I wasn't going back and doing those miles later in the year, so I felt much freer to make up the trail along the way. I had nothing to prove. And the CDT was tough enough as it was.

Along the PCT back in 2016, I had been a purist, eager to do continuous footsteps from border to border. But now I didn't feel this purist urge.

"Low route it is," Rip said and marched along the river.

We followed the creek through the valley, and soon it was just the five of us trekking deeper into no-man's-land. We had heard plenty of stories about bear encounters from other hikers who had seen several grizzlies and even a mountain lion, so we kept our eyes peeled. When I came across the first pile of bear scat full of berries, I knelt down to take a picture of it. As the day continued, I noticed more and more different types of animal droppings on the trail, and my scat collection swiftly grew. Some droppings had fur in them, others berries, and others feathers. Animal droppings in all the colors of the rainbow, ranging from black to white, red, green, and even blue. And a whole universe of insects fed off the animal droppings.

"Not too fresh. Probably a day or two old." Chester poked another pile of bear droppings.

"We may not see them right now, but they're definitely out there." Having recently hiked the Appalachian Trail, he had been living in the woods for nearly two years and evidently knew much more than I did about the game and wildlife out here. Judging by the abundance of droppings I came across, there was a lot of movement around us. Later, I decided to show a hunter my collection of shit pics and ask him to help me decipher which scat belonged to what beast. I remember hearing of a guy who took pictures of his own feces along his entire trail, but this felt a little unnecessary and a little too personal, as I already knew the beast within me.

But it was not only scat that caught my eye. I became slightly more anxious when I encountered bear prints etched deep into the mud before me. Again, I knelt down to examine the size of the print by placing my hand over it. My eyes automatically widened when my stretched palm and fingers disappeared into the footprint. These guys must have been enormous. The depth and detailed markings told me how heavy they were. But as my shock subsided, it was replaced by a feeling of wonder and adventure, and my curiosity grew. Strangely, despite my fear, I was looking forward to seeing all these creatures.

The ground under my feet finally felt decent: well packed, without all the obstacles of the days before. I could actually walk at a good pace. I could reflect and think and just be, enjoying the magnificent landscape. I felt my whole body sigh with relief now that we had left the blowdowns behind us. But a voice at the back of my mind whispered, "For how long?"

The trail led us up and over an isolated ridge, and I glanced back over my shoulder to see the high white peaks of Glacier National Park slowly disappearing behind me. In front of me, dry, barren mountains. I got a clear impression of where we had come from and where we were going.

And then it came. "F*ck, F*ck, F*ck," I heard someone yell in front of me. "More blowdowns," another voice added.

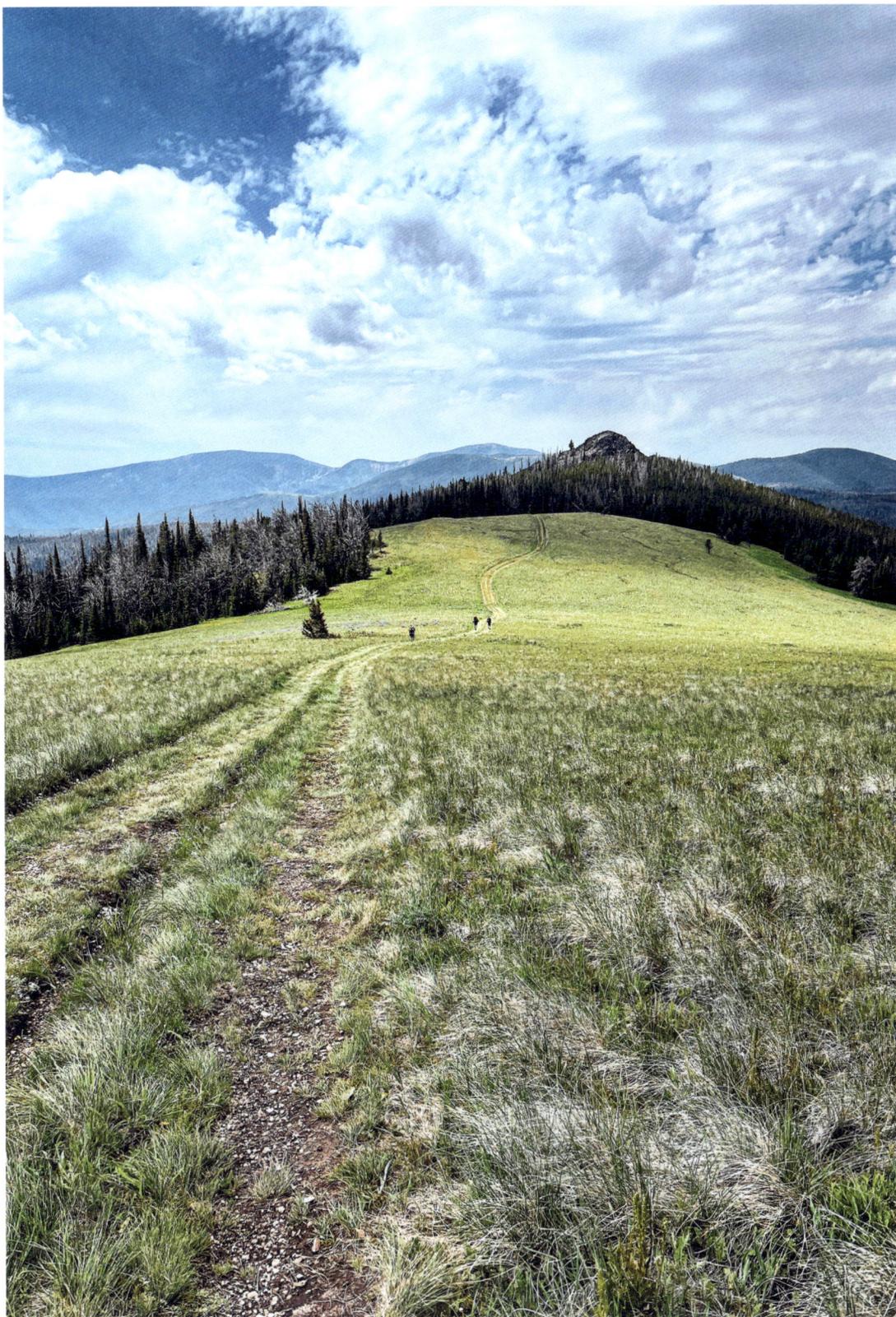

The Scapegoat Wilderness stretches out
in front of us with some easy grasslands.

"It's as if we're walking across the back of a sleeping dragon as it goes down the length of the Rocky Mountains."

"Embrace the suck," Rip teased as she removed her backpack and crawled under an enormous tree blocking our path.

"Well, there's plenty of suck where that came from," one of the British brothers said from in front. They were always leading the way, scouting out the route.

"I thought it was 'embrace the brutality?'" I said. "But you're right, this sucks big time." I prepared to crawl through the mud. As the brothers raged and raced on, I fell back together with Chester. He knew a lot about the history of the Continental Divide Trail and the nature it passed through.

"Everything about the CDT sucks," he told me, "but it's also so epic. It's as if we're walking across the back of a sleeping dragon as it goes down the length of the Rocky Mountains. Embrace the brutality, man." Chester pointed his index and pinky finger like a rocker.

"Less than 50 percent will make it border to border," Chester continued. "It's mostly mental stuff that pulls people off the trail. But there's also a fair number of broken legs, twisted ankles, and giardia that put an end to the fun." He dove under the branch of a low-hanging tree. Well, I knew a thing or two about twisted ankles and reminded myself to pay more attention to my footing as I climbed up and over another blowdown. "The cool thing about the CDT is that it's a four-month ridge walk in some ways," he concluded.

I liked the sound of that, as there's nothing I love more than ridge walking with open views on either side. Chester was so quiet most of the time, but once he got to talking about the natural world, it was like he came to life.

"You see, the Rockies divide this country of ours in two," he said. "Every drop of water that

falls from the sky above us—unfortunately that isn't much these days—flows down either side of this mountain range. The rivers on our right will flow into the Columbia or Colorado Rivers and eventually end up in the Pacific. The rivers to our left will connect to the Mississippi and flow into the Gulf of Mexico down south. Isn't that cool?" He looked back over his shoulder, as if to punctuate his explanation. "Too many bad things divide our people right now, but I love that the CDT divides the water."

The following morning I woke to the sound of a gas burner. I joined Dom on a log around the dead firepit we had sat around during dinner the past evening.

"Breakfast ramen?" I asked with a teasing grin.

"Breakfast ramen. Is that a good or a bad sign?"

Dom was a banker back in London, and although this was his first full thru-hike, he quickly adapted to the peculiar lifestyle of living in the woods. And if you crave salt for breakfast, why not start the day with some 50-cent noodles? It would give him the well-needed salt he would be losing in the coming hours. There was another long climb ahead of us.

We got underway quickly after breakfast. The trail led us up through a dense pine forest, and after about two hours, we suddenly came across a lonely cabin in the middle of the forest, right along the trail itself. I was slightly startled, as we rarely encountered any buildings this remote. And to my surprise, we were suddenly no longer alone. Around seven other hikers had camped around the log cabin, probably because there was a clean water source outside that was free to use. I went inside the small wooden cabin to see what all the fuss was about. To my bewilderment, I realized that it was a fully stocked outdoor supply shop—here, in the middle of nowhere.

Just my luck. I needed a new trekking pole, and a few other items needed replacing after the Bob Marshall onslaught. "Don't buy too much!

Don't buy too much," I commanded myself, as I was well aware that I would have to carry it. Plus, it was not cheap. The memories of my most recent shakedown were still too fresh, as I had recently sent home a box filled with microspikes and unnecessary clothes. The postage back to Europe cost $100, and the import tax on the other end would probably be about the same.

The trail led us up through a dense pine forest, and after about two hours, we suddenly came across a lonely cabin in the middle of the forest, right along the trail itself.

"Hi there, I'm Dave. Let me know if you need any help," an elderly gentleman welcomed me from behind the counter. He was sitting on what looked like a bed, and it also appeared to be where he slept during the night. He had filled the cabin with the latest ultralight thru-hike gear. To be fair, I had never seen such a complete collection. I could have bought everything there, but I had to restrain myself.

"I just need one trekking pole to match this one," I said, placing my only carbon pole on his counter, hoping he may have one to match.

"Sure, I have those trekking poles, but they only come in pairs. Sorry, buddy." He pointed to a rack with several lightweight trekking poles.

"No worries." I headed to the rack to inspect the options. I quickly decided I would get the same poles I had started with. Although they were a bit expensive, I had grown accustomed to their weight and feeling in my hands. Plus, I simply needed them to hold up my tent at night. I also found some replacements for my gaiters and topped up on some dehydrated food. When I returned to Dave to pay, he offered me the gaiters and a cold soda for free. I watched as he typed all the items

I'd bought into his meticulous Excel sheet. Dave catered only to hikers and bike packers along the CDT. As a result, he had exactly two busy times of the year: when all the SOBOers passed through, and later when all the NOBOers came in need of warm clothes for the approaching snow.

I left Dave's shop quite a few dollars lighter and a few ounces heavier, but I was happy that I had been able to replace a few items. I wasn't the only one going shopping. Rip soon walked out of the cabin, holding up a brand-new white backpack, new shoes, and an array of other shining items. She really had gone to town.

"Don't say a word," she said, joining us with a very content—and slightly guilty— smile.

Outside, it was fun to see all the other hikers seated around the large picnic table, and I enjoyed my cold drink and cooked myself a warm meal—pad thai for brunch. Not a bad way to start the day, and some of the extra calories I'd need for the trail ahead. As my pad thai slowly rehydrated, I got out my painting gear and a small piece of watercolor paper. Just like Luna, I felt Dave was an important, integral part of the trail community. Although he wasn't strictly a Trail Angel, I thought it would be nice to make him one of my quick watercolor paintings as a token of appreciation. Painting for people I met along the trail had become something of a tradition for me on my previous long hikes. I always carry two paint tubes, dark blue and golden yellow, and two fine paintbrushes, a kit that weighs no more than a couple of ounces (50 g). You could call them luxury items, but they give both myself and those that I meet along the trail happiness. And so often, as hairy, smelly hikers, we are shown such warm, unconditional hospitality in the form of rides into town, free showers, and even free places to stay. Gifting a painting was a small way of showing my gratitude for the trail and the people along it.

Once I was done, I popped back into the store and handed Dave the small impression of his warm cabin tucked among the dark trees.

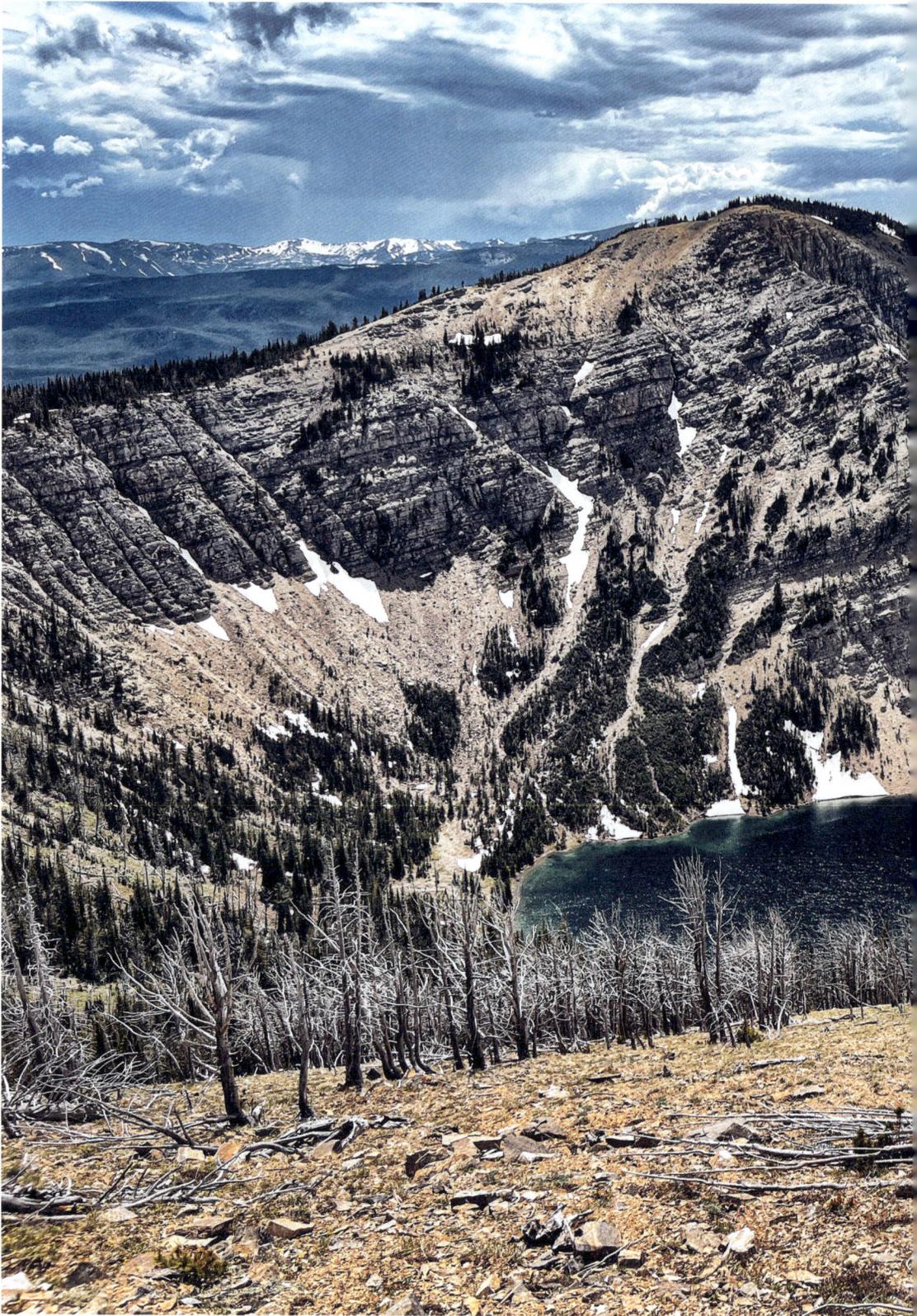

Dead trees for miles remind us of recent forest fires, as we leave the Bob Marshall Wilderness and enter the Scapegoat Wilderness.

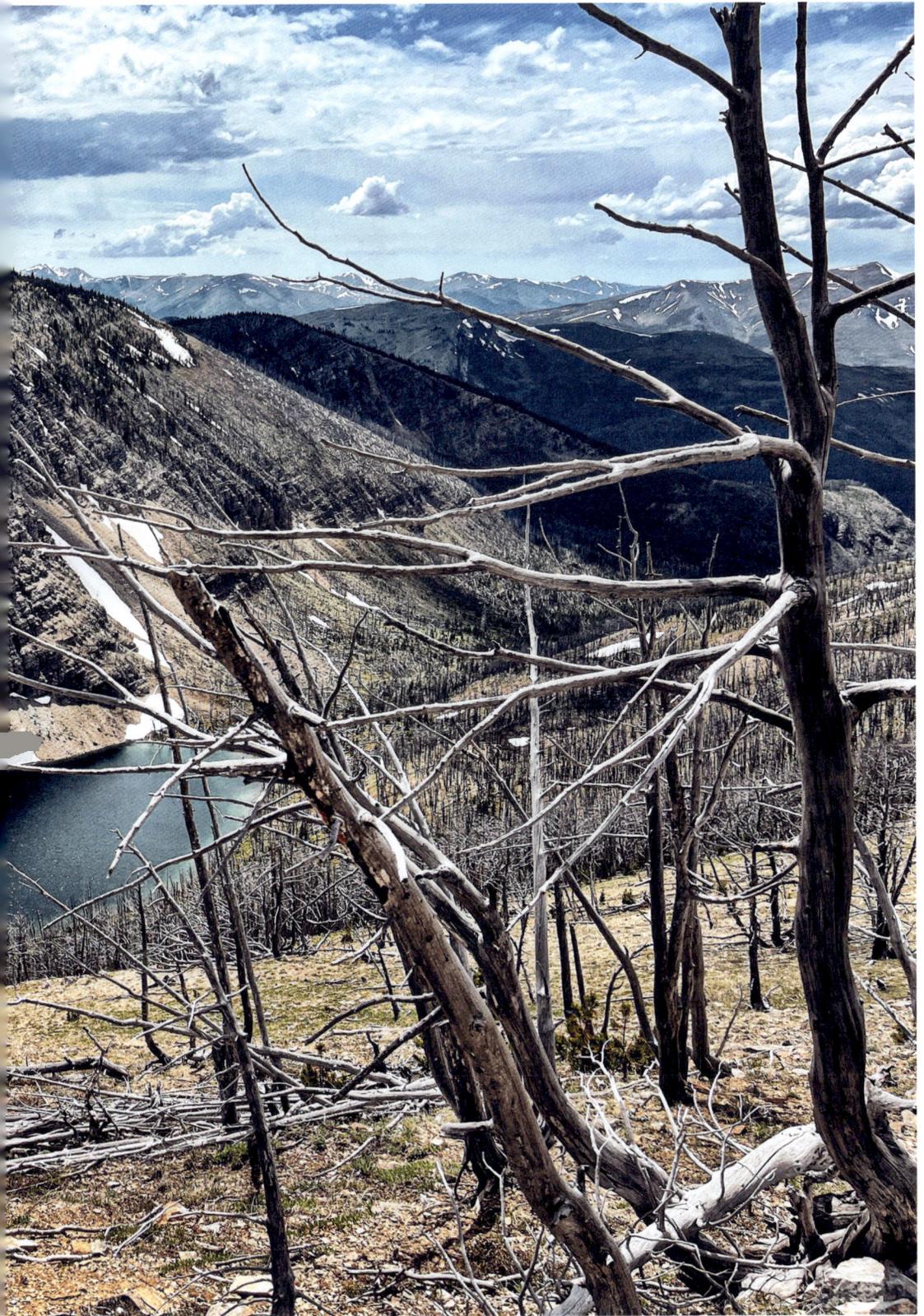

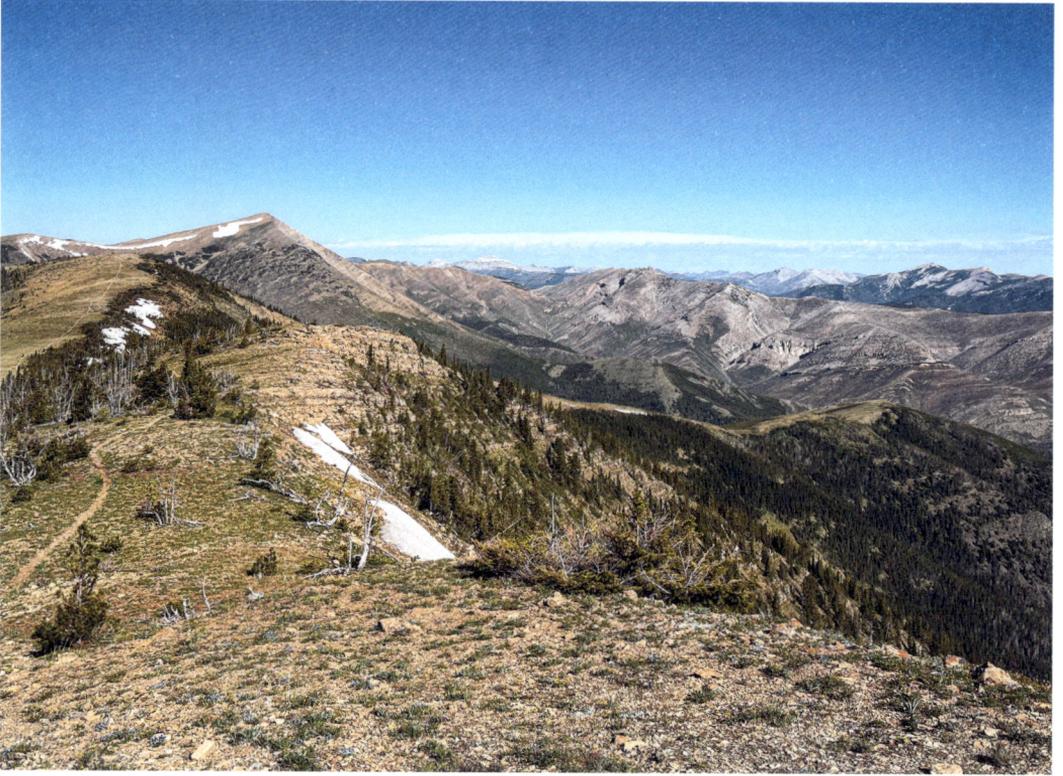

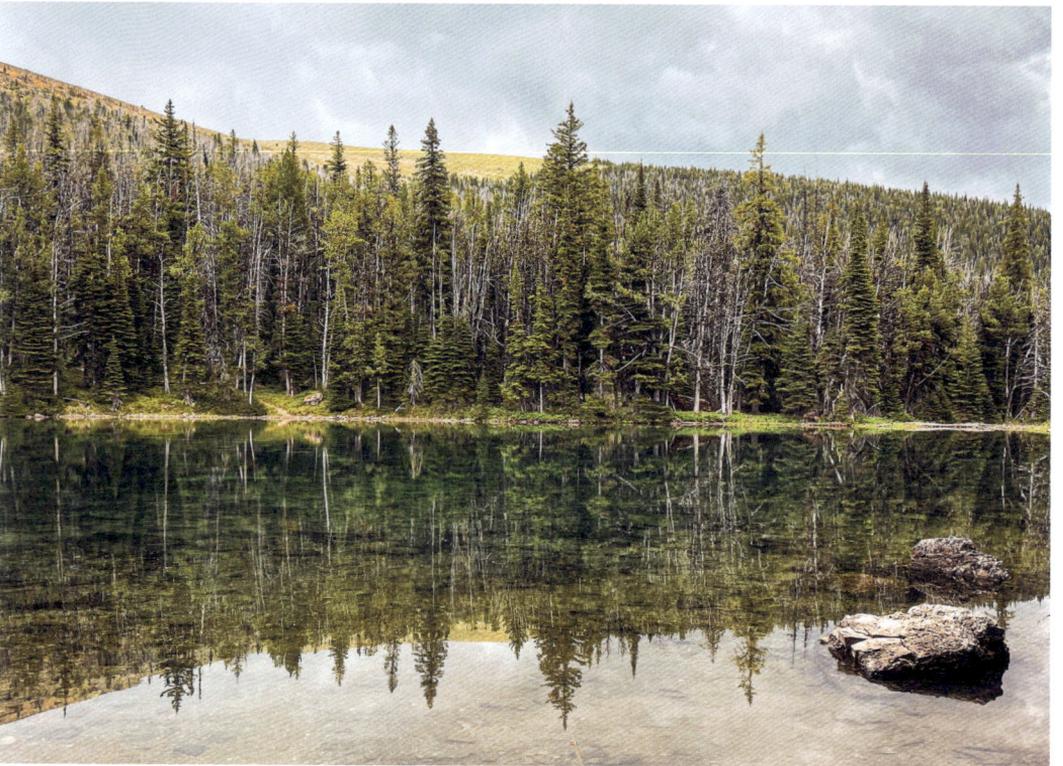

The trail takes us up and over mountains and down to the lakes in the valleys below.

"Thanks. Now I get why they call you Van Go," he said, glancing down at my trail name, which I had painted in a small signature underneath the painting of his cabin. He stroked his white beard for a few moments, looking at the two colors slowly drying on the paper in his hand. Without adding another word, he turned around and stuck four pins into each corner, tacking the painting right behind the counter. Right above his bed.

As the trail got steeper, it began to rain, and the history lessons were cut short as we focused on the forces of nature that hung above us.

It was another long section between Augusta and Helena, but fortunately, my ankle was holding up pretty well. The others were younger, with a slightly faster walking tempo, and the mileage we put in each day was averaging 25 miles (40 km). Not what I expected to be doing, but I couldn't complain. I was out here in the wilderness, wasn't I? I was walking with a big smile and loving it.

During those first weeks, I relied heavily on the crew, particularly Dom. It wasn't just his boundless energy, which often saw him darting ahead or making plans during the evening. He was a born leader: you could see it in the way he carried himself, even though at 24 years old, he was one of the youngest. One morning he gave us a masterclass in finance, and the group now knew everything about swaps and swaptions. But the one thing that he really loved was history. Dom was a walking encyclopedia on the Second World War, the Cold War, and many other eras. Each morning Rip and I would ask for another story, and Dom would oblige us with another entertaining masterclass. As we walked, we listened for hours, especially if the trail followed a gentle backcountry road. He took us back 3,000 years to the early Samurai Dynasties, and taught us how this period had strongly influenced the kamikaze philosophy of the Japanese military in the 1940s.

We were deep in one of our lessons when Chester interjected. "Your President just resigned." He was looking at Dom, having received the news of Boris Johnson's resignation through his satnav device.

"Dom for President, I say," I laughed, only half-joking.

"Prime Minister," Freddy corrected, gritting his teeth with a broad smile. "We don't have Presidents in England, and no, let's not go there. It's a terrible idea. Dom as PM, not a chance."

But I liked the idea and later suggested Dom think about it and perhaps sign up for local politics to learn the trade. He was leading the way out here, and it was easy to see how he'd be good at leadership wherever he was.

"Perhaps you should write your own manifesto for the future of Britain in your journal while you are out here," I suggested. "It would be interesting to get your vision down on paper now while you are full of pure idealism, undeterred by the obstacles and realities of everyday politics. You have all the time in the world right now. Out here, you are free to think whatever you want."

"Hmm, I kind of like that idea. The manifesto, not the PM bit." He threw me a shy glance.

"Dom for PM!" What were the odds? Probably higher than he imagined.

As the trail got steeper, it began to rain, and the history lessons were cut short as we focused on the forces of nature that hung above us. We were hit by heavy thunderstorms in the afternoon for three straight days. We'd been doing a lot of ridge walking over barren mountains above the tree line, which felt a little too exposed in these circumstances.

A bright flash of lightning struck a nearby hilltop, followed by thunder cracking and roaring above. A familiar fear gripped my throat as panic hit. "What am I doing here? If the next bolt hits me, I'm a goner," my fearful inner voice yelled

as I followed the others. "Stop! Turn around! Live another day!" the voice continued silently. But my feet continued all the same.

I knew these storms were coming, and I had tried to mentally prepare myself. Knowing I would have to face huge storms on the CDT was one of the reasons that this trail had always felt like a bridge too far for me to cross. The CDT is plagued by grizzly bears and storms, but that was just part of it.

It was five years ago, on the Te Araroa Trail in New Zealand, that I began to consider it. I'd met Coyote, an experienced female thru-hiker from California. Having completed the American Triple Crown—the Pacific Crest Trail, the Appalachian Trail, and the Continental Divide Trail—she convinced me that the CDT was within my reach.

To prepare for the CDT back home in Holland, I decided to set up a series of "fear experiments." My idea was, "Well, if you can't handle this, then you are definitely not ready for grizzlies."

"Dude, you're an experienced hiker; you can easily do the CDT. Plus, it's my favorite. It's definitely the most beautiful trail in the world," she said, frantically gesturing with her hands. "Believe me, the CDT is the best, and I don't want to brag, but I've been around. You simply have to do it, Van Go. I insist."

The seed had been planted. I don't know why Coyote gave me *the nudge*, as many people before had tried and failed to convince me to hike the CDT. But no one had made it feel achievable until that day in the middle of nowhere, high on a mountain somewhere in New Zealand, all those years ago.

Planting a seed is one thing, but this seed took quite some time to grow until it finally

bloomed into a real plan, a plane ticket, and an actual starting date. Years of doubts, fears, planning, saving, and, above all, mental preparation. First and foremost, was my anxiety about being alone in grizzly country, and secondly, being out for days alone in thunderstorms. Both fears were not something I could easily train for in my safe home country of the Netherlands. For bears, you had to go to the zoo. The most dangerous predator we have in the Netherlands is probably the fox or wild boar, and although we have our fair share of thunderstorms, there is always a safe roof to shelter beneath within a mile, wherever you go. So to prepare, I decided to set up a series of "fear experiments." My idea was, "Well, if you can't handle this, then you are definitely not ready for grizzlies."

In one such experiment, after driving home from a friend's wedding, I took a detour into our country's biggest protected forest, the Veluwe, and decided to sleep under the stars. It was already dark when I rolled out my sleeping bag, and strangely, it wasn't the wild boars that worried me most; it was the thought of being caught by the park rangers and the hefty fine they would give me for illegally camping in the park at night. Wild camping is strictly forbidden in Holland, and park rangers have thermal vision binoculars that can easily detect a warm body that has just spent the past three hours dancing at a wedding. Either way, it was exciting, and though I felt the tension in my body, I was lucky enough not to get caught and even saw deer and wild boar roam across the plain in front of me the following morning.

In another experiment, I confronted my fear of swans. Yes, swans. For several years now, I have swum for half an hour in a wetsuit in the cold canal in front of my house. However, the local swans aggressively protect their newborns each spring, and I always stop swimming for a month to avoid their wrath. But that spring, as part of my mental prep, I decided to face the swans and my fears. After all, if I couldn't handle swans, I definitely couldn't handle bears and

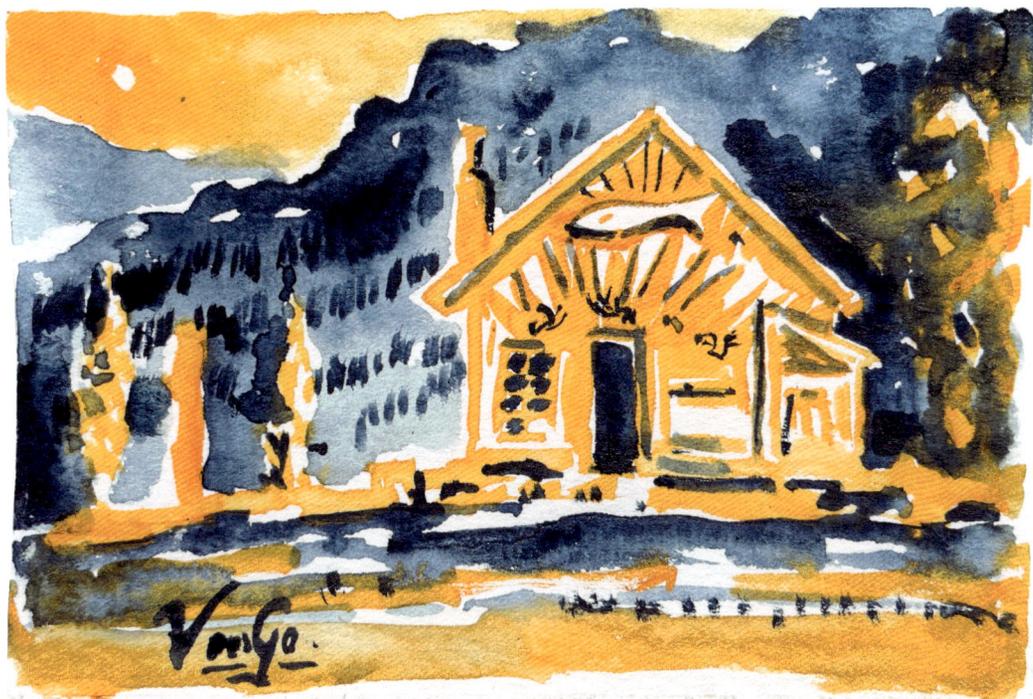

Only very rarely do we pass a lonesome
hunting or fishing lodge deep in the woods.

storms. The daily swim past the aggressive swans was terrifying at first, but as the days passed, the mother swan grew used to the intimidating breach of territory, and soon I was one fear poorer. I could swim with swans.

Time and time again, I would devise these silly challenges to test my mental strength and overcome small fears, each preparing me for living in bear country. After two years of these little experiences, something like a switch flipped, and I said, "What the heck! I'm going to do the CDT." Luckily I had the support of my wife and children. It was two years later that I finally boarded a plane to Chicago and then another to Kalispell to take the Amtrak up to East Glacier and touch the Canadian border before embarking on my trip down to Mexico.

Now, three weeks into the trail, I was facing one of my fears head-on, as the lightning strikes came ever closer. Dom and Freddy were way ahead, so I stuck behind Rip like glue. While I usually preferred hiking alone, I now asked if I could walk closely behind her. She didn't seem to fear the storm we were about to walk straight into; looking at her face, she was actually looking forward to it. Chester, who was a bit ahead of her, was also not that bothered as he increased his pace up through the last few trees before we hit the open, exposed ridge.

We were on the fifth day in the Scapegoat Wilderness and this thunderstorm was particularly gnarly. But what could we do? Sure, we usually waited out the worst of the lightning down in the valleys, but our food was also slowly running out; we couldn't wait around forever. I followed Rip up a steep mountain path along a high ridge for several miles and was happy to see that there were still a few trees around. Perhaps a false sense of comfort, but as they were still taller than us, I felt sure a lightning bolt would choose the

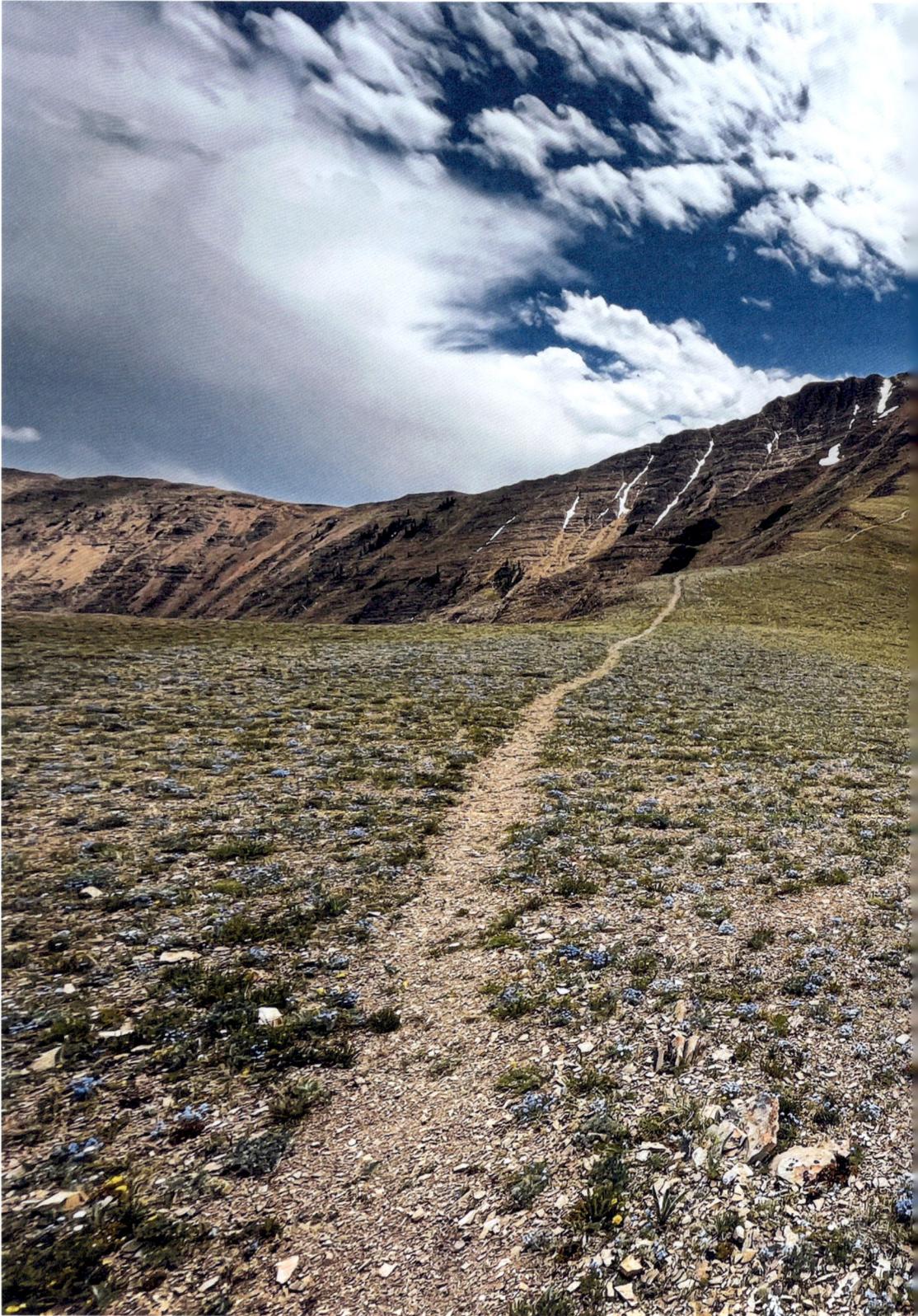

Countless spring flowers blossom along the
trail as it winds up and over the ridges.

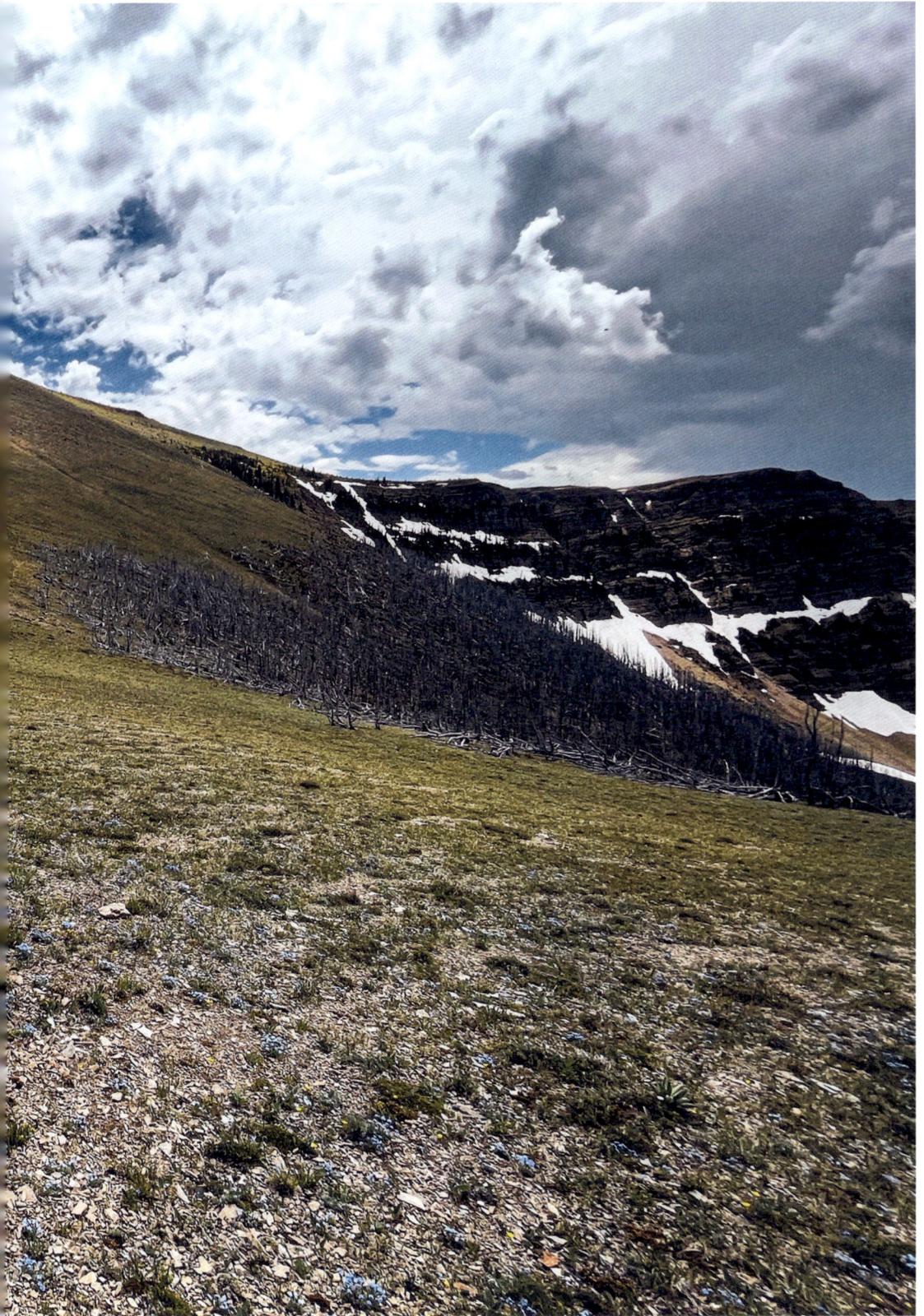

trees over us. But what did I know about these things? Shouldn't you keep away from trees in a storm? My mind raced but found few logical answers except to keep going.

We usually waited out the worst of the lightning down in the valleys, but our food was also slowly running out; we couldn't wait around forever.

But just as we were about to summit the mountain's crest, I felt a strange tingling sensation over my hands. All the hair on my arms was standing upright, and all the whiskers on my cheeks and chin too. I opened my phone camera to glance at my face and saw that I looked more like Santa Claus than myself.

"Wait up. Something's wrong." I called out. "Shall we go back? Or just stop for just a few minutes? Is that OK?" I was hesitating but hoped that Rip, who was a responsible ICU nurse back home, would listen. My voice was panicked, and my breath quickened.

No sooner had I spoken, and without a split second for Rip to even turn around and answer me, a sudden flash lit up everything around us. Chester yelled, "Hit the ground!" and dove face down into a snow patch, as a tremendous bang of thunder cracked right above us, shaking the ground on which we had stood. I saw Rip run down to find cover on the lower ground. My instinct was to block my ears and crouch down into a ball, sitting on the tips of my toes, as far away from any tall tree as possible. After the initial big bang, I ran down the hill to join Rip, away from the crest of the hill. I had no idea what method was best, and honestly, at that moment, it wouldn't have mattered. Lightning and nature don't have a calculated plan to attack you for your sins. Nature has no conscience or judgment. Nature happens, and when it does, it's merciless.

When the three of us felt that the coast was clear, we all stood up to assess the damage. Although my adrenaline was pumping high, I was surprised that I wasn't that scared. It really helped me to be close to friends I trusted. Rip had lost her cell phone while running down the hill, and I had lost one of my AirPods. We waited another 20 minutes in the pouring rain before the dark clouds moved into the valley behind us, and we felt confident enough to complete the 24-mile (39-km) day. I had come face to face with one of my biggest fears and was still alive. I couldn't quite believe it. What a day, what a day.

Walmart Virgin

Mile 357

The last 17 miles (27 km) into Helena, we took an easy alternate route along a dusty gravel road that connected the remote ranches to the distant highway. My feet hurt, and I could feel my toenail throb. But Dom was even worse off with open blisters on both feet. He had taken drastic measures and had switched to walking in his Crocs. It was funny to think that although I had just passed Dave's outfitter a few days ago, my mind was already creating a list of items I had to buy or do when I hit town again.

New gas canister. Ibuprofen. Repair my new gaiters, which had already ripped. Five days of re-supply food. Book an Airbnb. Lots of vegetables and fruit to make a huge salad. The list went on and on.

When we finally hit MacDonald Pass, we took turns trying to hitch a ride. It was usually Rip that clinched it, and then we would all pile in together.

Arriving in Helena turned out to be a warm bath of everything our bodies desperately needed. Rest, comfort, luxury, and healthy food. Rip had

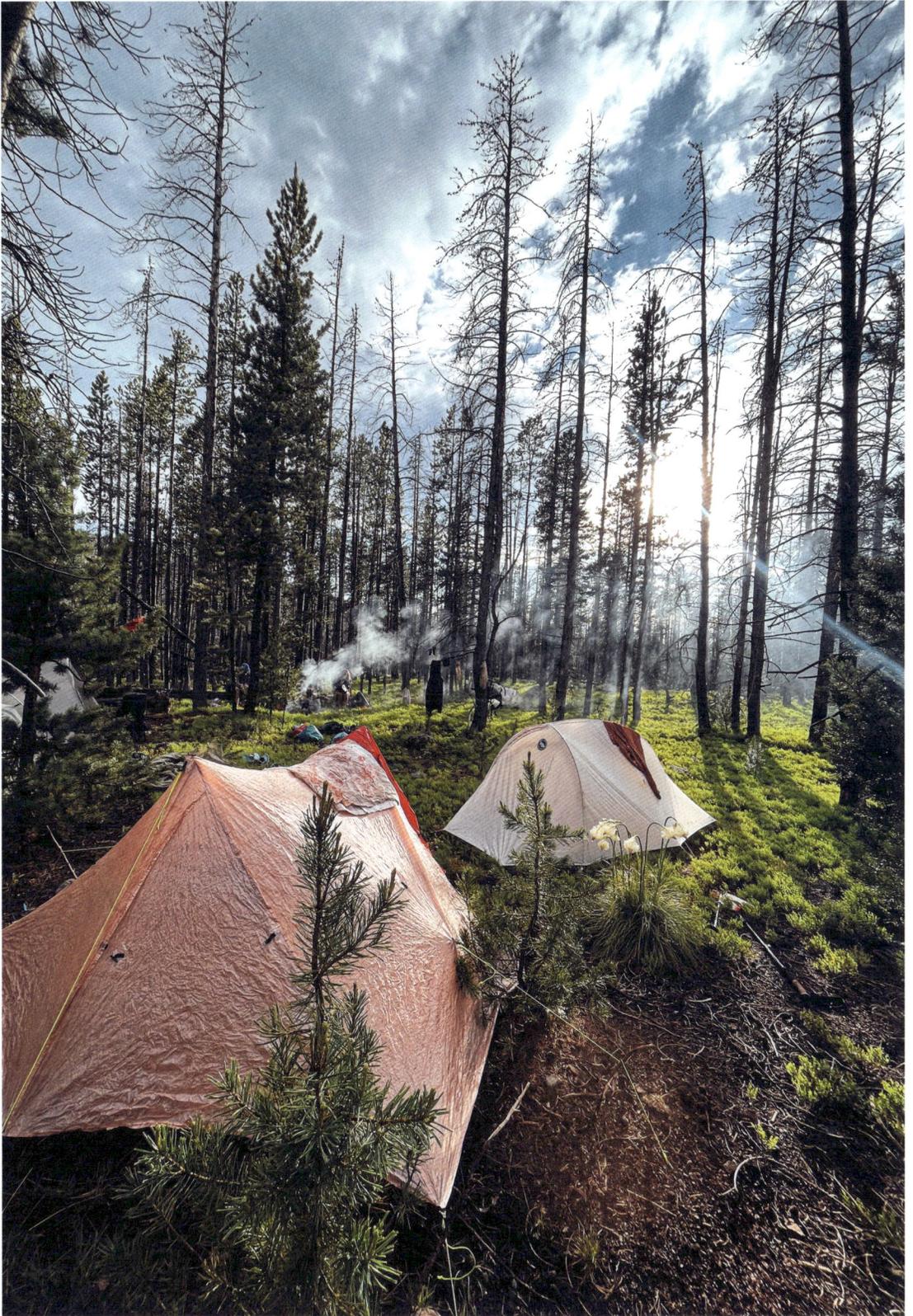

The five of us set up camp
between the trees for the night.

managed to book an entire house in the suburbs, which came complete with a gigantic TV in the basement with leather reclining easy chairs. But my highlight was the Epsom salt bath. I could hear each of my 10 toes scream for joy as I gently lowered my feet into the kitchen sink filled with hot water and salt.

"MgSO4 doing its magic," Freddy said with a wise guy twinkle in his eyes as he casually walked past me to get a second White Claw out of the fridge. Although he was a little quiet, he clearly knew a thing or two, and it didn't surprise me that he had been admitted to one of the UK's leading universities to do his PhD. A wealth of knowledge bubbled inside him, and I was keen to learn more but not now. Now all I wanted was to stay put, have another beer, and soak my feet.

"Yes, please," I said in Freddy's direction as he raised his eyebrows from the open fridge, silently asking if I wanted another beer. How had he guessed?

From my seat on the kitchen counter, I could hear the familiar one-liners of *Forrest Gump* as the others had collapsed in front of the TV in the living room. The doorbell rang, and two pizza deliverymen stood in the doorway.

"Sorry, we couldn't fit all your orders into one scooter delivery box," said one of the deliverymen. "I've never had such a big order before." He handed Chester a tall stack of warm pizza boxes.

"Thank you, buddy. We're hungry," he replied with a contented smile. "I love it when a plan comes together," he said through his smile, turning to us and placing the stack of boxes on the dining room table.

"Let's eat!" Freddy clapped his hands together. He could probably devour two to three pizzas by himself. My stomach, by contrast, always had a rough time transitioning from trail food to town food, and more often than not, I found myself running to the bathroom. But it didn't deter me from eating. I needed the calories.

"A healthy dinner for once! Just look at all those vegetables: tomato, artichoke hearts, bell pepper," Rip said with a sarcastic grin, picking up her first slice of pizza.

The room went quiet as we ate. We were too tired to go all the way to the grocery store, so we would have to take a cab to Walmart the following day to buy some real healthy food, all the salads I'd been dreaming of. But for now, these pizzas were healthy enough. Just perfect, to be honest.

The following day was slow and lazy, but something was bothering me: my beard. I had let it grow for the past two months, but now that I saw myself in the mirror, I was shocked at how old I looked. My beard had been brown in my thirties and grey in my forties, but now that I was approaching 50, it was rapidly turning white. I could hardly recognize myself: I looked old, and I wasn't ready to be old just yet.

Now all I wanted was to stay put, have another beer, and soak my feet.

Right then and there, I decided to shave it off. I was planning on not shaving for the length of the hike, but the long white whiskers were driving me mad. I fumbled to find my tiny Swiss Army knife from my repair kit and stared into the mirror. It had to go.

Timber

Mile 357

Walking from Helena to the next small mining town, Anaconda, only took us three days instead of the five I had expected. I had way too much food with me. After two days of rest in Helena, we continued to push big miles, averaging 24 miles (39 km) a day. The trail was finally well trodden, so it was easier to increase our tempo, although it was still up and over mountains each day.

After leaving Helena, humidity was high and the weather took a dramatic turn: we were suddenly walking in a downpour of torrential rain. Rain breaks the spirit of any hiker after a few hours, and the trail gradually transformed into a flowing stream. The mud made the going slippery and sketchy at times. So much for our newly washed clothes.

When the rain finally stopped, we decided to rest under some trees next to a fresh creek. It always felt good to have the first 12 miles (19 km) under our belt before lunch. As the creek's banks were still a little muddy, we all scrabbled up the far side and sat in a close group, quietly eating. Dom wanted to have some warm noodles, so he made his way back to the creek to get some extra water. Just as he was about to clamber back to his backpack, he looked up at a half-fallen tree suspended at a 30-degree angle over the muddy path. It hung precariously, ready to fall the rest of the distance to the ground at any moment.

"Do you think I'll make it?" He looked at the group with a big grin.

"No, wait, Dom," one voice said, sensing movement at the tree's crown.

"Run Dom, I dare you," Freddy provoked.

"No wait, wait!" Rip yelled and jumped up in alarm as the tree began to fall. It was as if it moved in slow motion.

"Holy shit," Chester whispered as the enormous pine tree crashed onto the trail right between Dom and the rest of us.

"Holy smokes," Rip echoed, equally quiet. "Holy smokes Dom," she repeated, looking out at him on the other side of the fallen tree. "You could have just died."

For a few moments, we were all somewhat in shock, frozen in time, unable to speak or eat.

But then Dom began to laugh as he climbed over the virgin blowdown. "You should have seen your faces!" He jumped down from the tree trunk back onto the wet trail and scrambled back up to us. "I knew it was going to fall, I just wanted to see your reactions."

A half-fallen tree suspended at a 30-degree angle over the muddy path. It hung precariously, ready to fall the rest of the distance to the ground at any moment.

"Dude, it only missed you by a few feet!" Chester said, not appreciating the funny side just yet. Chester generally kept to himself, but when it came to our safety, he was always very protective and caring. "That's what they call a widow-maker. The pine beetles are destroying all our forests."

"You pillock," Freddy grinned, relieved that his brother hadn't in fact run under the tree. After that, Dom rejoined us, poured the water into his cooking pan, and set about making his lunch as if nothing had even happened.

"I think we should name you 'Timber,'" I suggested. The two brothers still needed trail names. Chester's trail name was also his birth name, but he liked it that way. He already had a name and had no desire for a new one, although we did try to rechristen him as "Big Cheddar."

"How about 'Walking Dead?'" Rip suggested.

"If a tree falls in a forest and no one is around to hear it, does it make a sound?" Freddy offered.

"Well, we definitely heard it. It fell right in front of us!" I shook my head in disbelief.

"How about 'Lucky?'" I tried one last time. "You should be called Lucky, as you're probably the luckiest hiker out here today." By the look on Dom's face, we'd have to think a bit harder.

Tramily

Mile 432

It is strange to think that the four people I bumped into at the start of my journey, totally by chance, became my trusted trail family ("tramily") on the CDT. Rip, Dom, Freddy, Chester, and me, Van Go, in our twenties, thirties, forties, and fifties. We couldn't have been more different, yet we stuck together.

I began to ponder the question of chance. What were the odds that I would bump into these people, and not others with whom I would perhaps not have formed such a strong and safe tramily? Was it meant to be? Was it destiny or simply random chance?

I have never really dwelled on the why of meeting the people in my life. But during each of my previous thru-hikes, I met fascinating people who in a very short time, became close to my heart. And hiking alone, there was always more of an opportunity to meet new people. I've become friends with people of all ages—younger folks who still have a pure, idealistic, and ambitious outlook on the world—whose company has invigorated me, inspired me, and woken me up time and again. Their flexibility and adaptability have pushed against my tendency to be a bit of a grumpy old know-it-all. They've taught me to take more risks.

But despite being out in griz country, I still didn't consider myself to be a real risk-taker. With the others, I came to understand how comfort and discomfort, fear and fun, achievement and pain each lay very close to one another when you head out on an adventure.

Rip was the one and only woman in our trail family and played an essential role in the group dynamic. Her bright energy changed everything about the way we interacted as a group. If it had only been guys, the tone and mood might have been a lot darker. Admittedly, when I first met her hiking alone in the Bob Marshall Wilderness, my first impression was that Rip was a typical athletic cheerleader, that everything about her was very, very American. She spoke with a slight hint of a southern accent. She was always courteous, polite, and well groomed. But I couldn't have been more wrong: Rip had decided to conquer the length of America by herself. She had temporarily left her career as an ICU nurse behind, having spent the last two years helping those with Covid and other serious illnesses in intensive care. She had also temporarily waved goodbye to her husband to embark on this five-month walk alone. And while she was caring to us guys and also enjoyed organizing the next place to stay in town, she definitely didn't take on the role of "mother." She was just one of the guys pranking, teasing, farting, and walking across all these mountains with surprising ease. One night we discovered that she was doing 6,000 more steps each day than the rest of us, simply because of her height and gait. That is 810,000 more steps across the length of the entire trail. Rip showed me what badass was.

We all stopped at a creek to filter water, as we would be dry camping for the night with at least 20 miles (32 km) ahead of us before the next water source. As we headed on, a dirt road eased over the landscape, an alternate route that allowed us to avoid going over a big hill. I briefly stopped to take a pee and soon hurried after the group to catch up. Instinctively, I followed the dirt

track to my right, but after about a mile, I began to question whether I'd taken the correct turn. My eyes scanned the ground, searching for the familiar tread of my friends' shoes in the dust. When I couldn't see any tracks, I began to worry. The more I hurried to try and catch them up, the more I began to wonder whether I had taken the wrong turn. I checked my FarOut app and saw that the road I was on went in the opposite direction from the trail, but as we had taken an alternate route, we weren't following the CDT anyway. I had no idea where the rest of the gang was going. Something was off. I was lost.

With the others, I came to understand how comfort and discomfort, fear and fun, achievement and pain each lay very close to one another when you head out on an adventure.

I turned around to backtrack, hoping to catch my crew. Only there were now more than two miles between us. No one could hear my shouting or whistles in the wind. My mind began to worry and race, as I had no idea where we were going to camp for the night. I was well aware that I only had one meal left with me. My pace turned into a steady trot, and I was soon running in the direction of a huge white plume of smoke ahead of me. Chester had received word about a large forest fire. It was much closer than expected, and I was lost and running straight toward it.

"This is not the time to get lost!" I scolded myself, speaking out loud, and increasing my pace even more. I felt the strange sting of anxiety grip me by the throat. How could one simple, misguided turn suddenly have such a big impact? I had grown so dependent on the group when it came to navigating. I increasingly became angrier at myself.

An hour later, I finally saw four familiar figures in the distance. I hurried to catch up with them. As it turned out, they had waited for me for quite some time. I was over the moon to have caught them and was happy to put this uncomfortable chapter behind me. Together, we found a good spot to camp, and I was thrilled to set up my tent, eat, and fall asleep after another 24-mile (39-km) day with my trail family.

We rose at 5:00 to hit the trail early. The sun was yet to rise, but the sky slowly transformed with pale shades of pink and orange. The temperature was still pleasantly fresh, and there was a faint smell of smoke in the air. We made good miles, knowing town was not far away. With only 15 miles (24 km) ahead of us, we hoped to hit the outpost of Sula just after noon. The small settlement was no more than a gas station and an RV campsite along Highway 93 between Darby and Wisdom. But we hoped to resupply food for the upcoming section into Idaho, do some laundry, and take a zero (a day with "0" miles) with some much-needed food. As we walked into Sula, we had completed the first 550 miles (885 km) of the CDT, and I was slowly beginning to feel the pleasure of walking after a strenuous and challenging first month. We set up camp behind the gas station and settled down for some rest.

The next day, I had to attend to some business back home. Although I rarely got any emails, and my design team back at work handled the daily workload, I still had to sign off on things occasionally. And I had to send the monthly invoices. While we all began doing our laundry, I set up a makeshift desk perched on the dryer. I had only just begun to create a few new invoices on my smartphone when Chester crashed in.

"Dude, we gotta move," he said, handing me a raspberry White Claw. "The wildfire up ahead is getting out of control. If we don't get a move on, they may close the trail." He gave me a printout he had gotten from a Fire Service Ranger at the gas station.

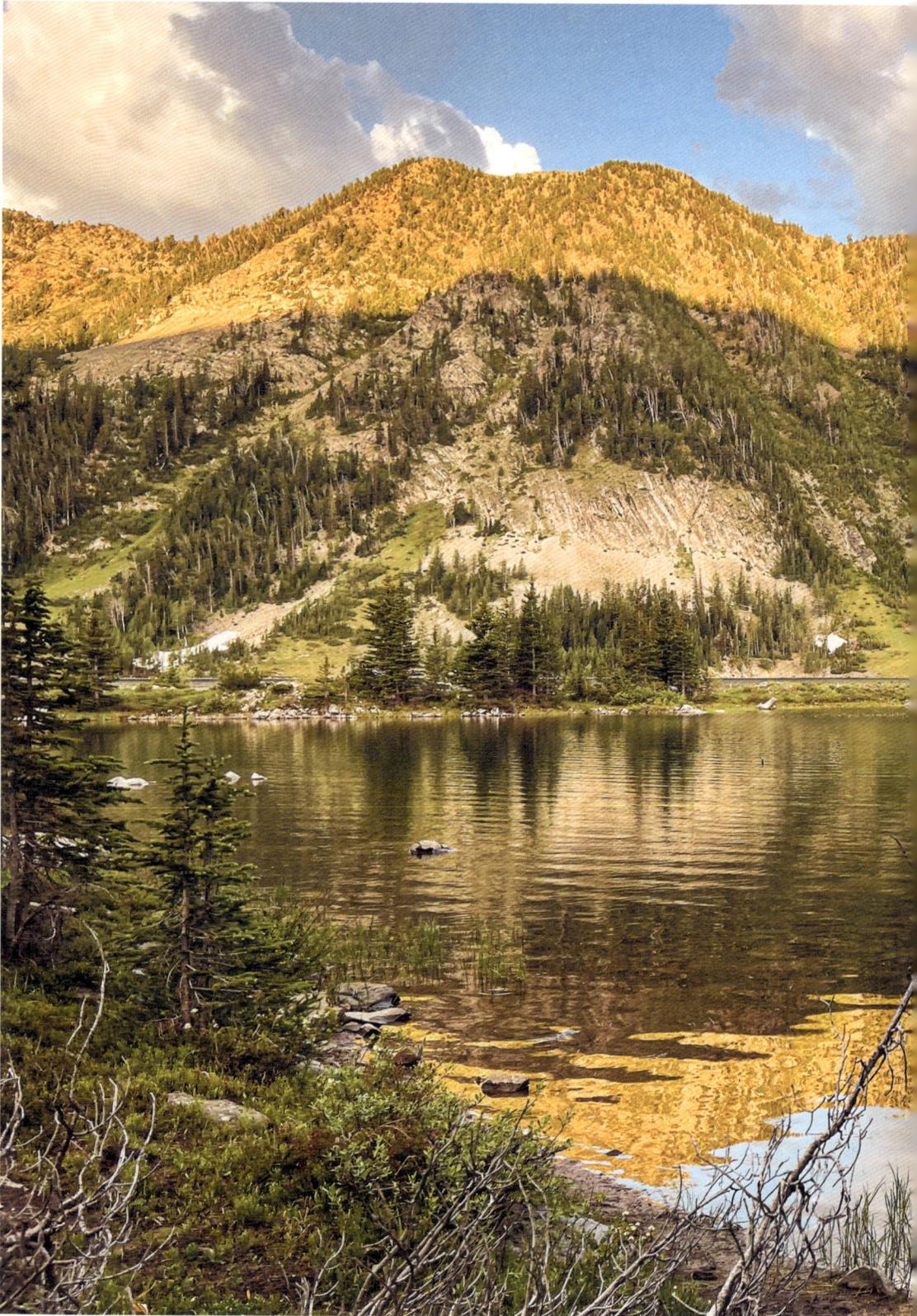

Camping next to a lake in Scapegoat Wilderness gave us fresh
water to drink and swim in after another long, hot day.

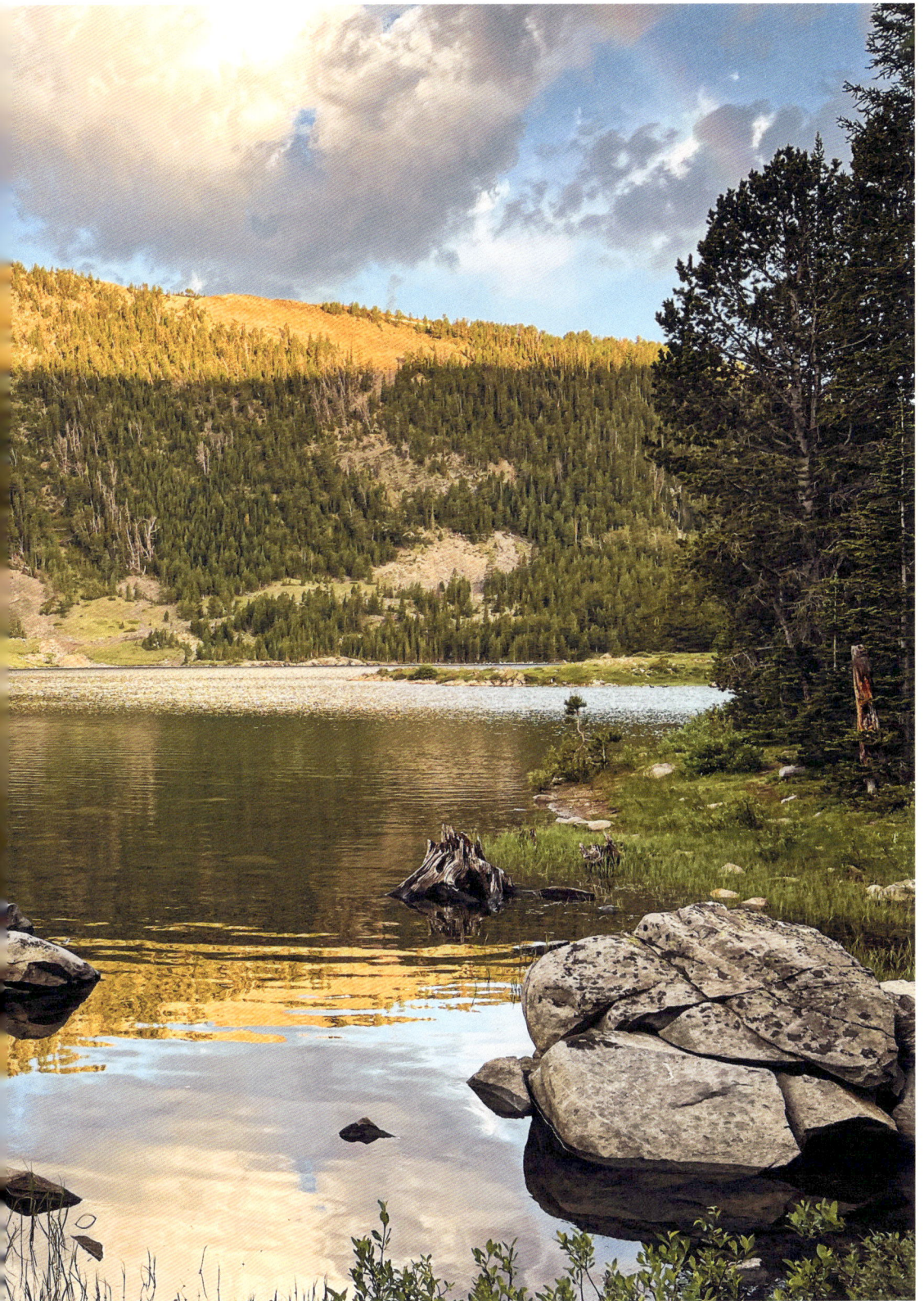

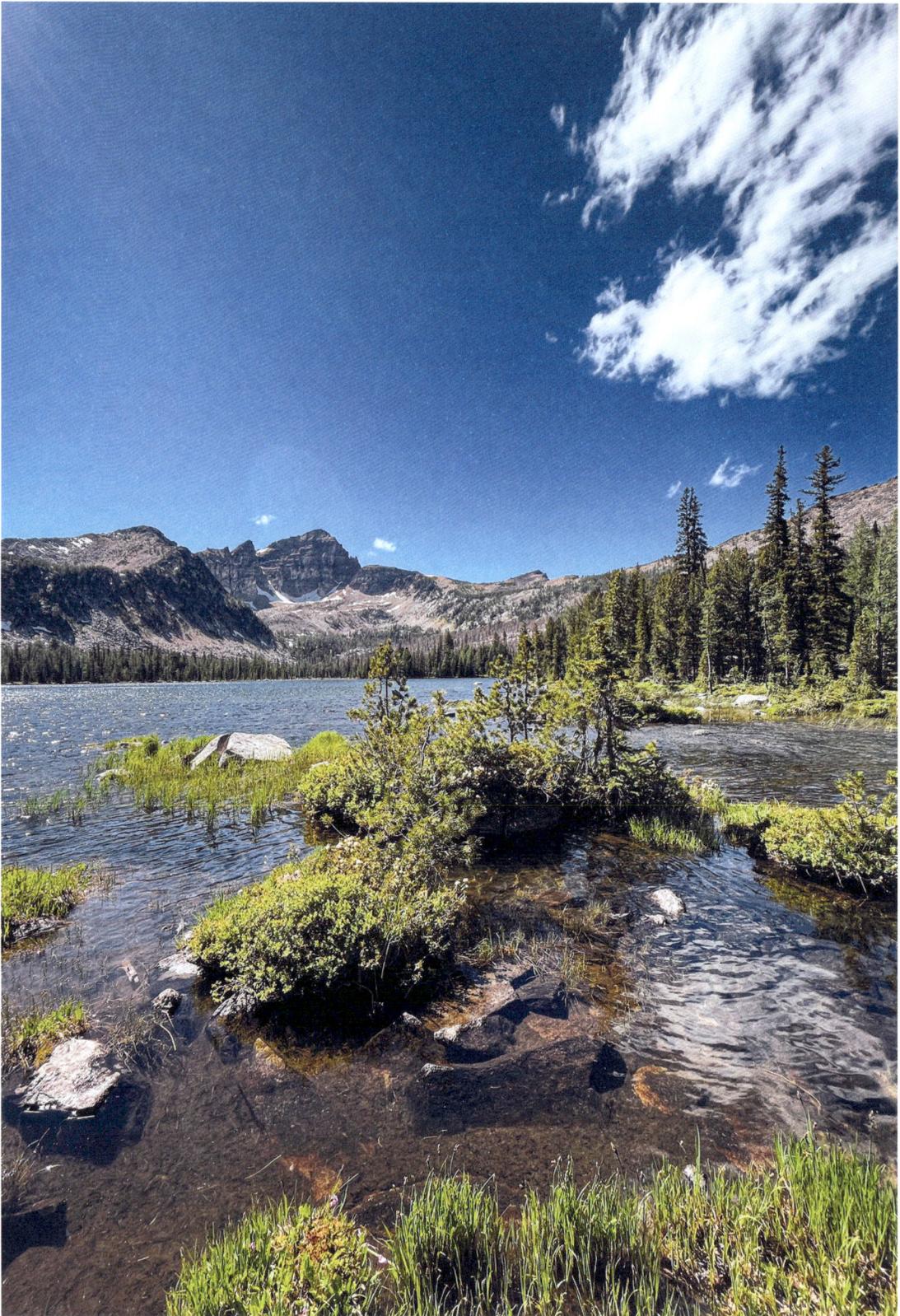

Always swim in the lakes of life.

"What, now?" I said, glancing down at my unfinished office work.

"Yup." With that, he hurried on back to his tent to get packed up. I wondered whether skipping this upcoming section was wiser.

"Chester, should we hitch around the fire?" I tried as I hurried on behind him, back to where all our tents were set up in the neatly mowed RV campsite.

"Be my guest Van Go, but we're headin' out. The wind is pushing the fire in the other direction. We should be fine if we push on." He spoke hurriedly as he collapsed his tent.

"But the wind could turn at anytime," I heard myself think as I, too, started packing up my tent. "What if the wind shifts, and we are stuck in the middle of it?" But once again, my desire to stay in the safety of the group won.

As I went to pay our bill for the campsite, I asked the attendant what she thought. "Excuse me, ma'am, do you have any new information about the fire? Did any of the firefighters stop by on their way past your store?" I hoped she would have more up-to-date information than the flyer Chester had shown me.

There had clearly been numerous wildfires around here in the past years. It seemed to be business as usual.

"Sorry, honey. I know as little as you do." She glanced down at the piece of paper in my hand. "But what I do know is that I would not go out there. My husband always hunts up in those hills, and he just called me to say he wouldn't risk heading out into that smoke. But it's your call, honey." She smiled gently. There had clearly been numerous wildfires around here in the past years, and although she warned me, she delivered her message without much of a fuss. It seemed to be business as usual. As if the entire United States

had been on fire these past years. Drought after drought, fire after fire.

I returned to the gang unsure we were making the right call. But they didn't see the danger as of yet. The fire was still at a safe distance from the trail, and if we pushed on, we could pass the worst of it within two days and be in the next town within a week.

"If the rangers haven't closed the trail, it's still safe," Rip declared. But she could see the worried look on my face as we headed back up the steep bank of the trail, leaving the safety of Sula behind us.

Stupid

Mile 615

What is the definition of stupid? How about this: You head into the wilderness, directly toward a 38,000-acre (15,378-hectare) wildfire, with seven days of food on your back—and you hope that the wind doesn't change direction.

I kept thinking about the worst as we trekked out of Sula: stupid, stupid, stupid. Just before we left, we had called the district fire service to get their latest advice, and although the winds were picking up, the lady we spoke to felt we could get through in time as long as we were fast. We headed back up into the mountains, already dry and bleak in the wake of past fires. Tall charred trees reached out for miles. On the not-so-distant horizon, billowing clouds of purple-gray smoke rose high into the sky. We'd reached the trailhead just before noon, so it was going to be a long, late hike into the night to get the first 24 miles (39 km) done and safely outrun the fire. More importantly, we had to outrun the smoke. Unpredictable winds could make breathing and hiking impossible.

Again a voice inside me whispered, "We could have hitched around the fire and skipped

this hundred-mile section altogether." But I wanted to stick with my trail family. "The most dangerous thing out there is you. Not the bears, not the snakes. You," I heard my inner voice once again.

We headed back up into the mountains, already dry and bleak in the wake of past fires. Tall charred trees reached out for miles.

As we walked, the sun vanished behind the tall column of smoke, and everything around us turned red. It was like walking on Mars, a monotone glow of red warmth around the whole forest. But even as the world around us transformed, the group carried on as usual.

"Qu'est ce qu'on mange?" I heard Freddy call out ahead of me. Although my French wasn't all that good, it struck me that he was learning about food as part of his course. It felt fitting: man, could Freddy eat. He was young and strong, I think he must have been eating at least twice as much as I was. I was losing weight at an alarming rate and was aware that if this continued, there wouldn't be much left of me within four months. But Freddy seemed to just channel all that extra food into energy and muscle, as he wasn't getting any thinner or fatter, for that matter. Hearing him talk about food, it suddenly came together in my mind.

"Nosh," I proclaimed with some grandeur when we stopped for lunch. "Why don't we call him Nosh?" Freddy still needed a trail name. I looked at the rest of the gang as they were quietly enjoying their lunch wraps and noodles.

"What does it mean?" asked Rip, a little lost in translation.

"It's a very English word, just as Freddy is very English," I explained. "It's a typical word for eating, and as he eats twice as much as the rest of us, it fits like a glove. Right?" I waited for

approval, looking in Freddy's direction to see if he liked his proposed new name.

"Nosh…" He pondered. "Let me think about it. I'll let you know in the morning." A trail name was often for life, and Freddy knew it had to feel right.

"Nosh. I like it." Rip allowed the word to marinate in her mouth. "Nosh," she repeated as we all packed up and headed out.

"You guys go on ahead," Chester said casually. "I want to hike alone from now on." He stretched out, making no motion to leave his lunch spot anytime soon. He didn't look up from his spot on the ground, and I was quite puzzled as to why he wanted to hike on alone and leave the group. After all, we were a family, weren't we?

A few minutes later, as we hiked on down into a valley leaving Chester behind at the pass, I caught up with Rip. "Is there something wrong? Did I miss anything?" I couldn't understand why someone would want to leave the group. Had something happened? Was he angry or sad? My mind spun in all directions as it searched for a feasible or logical answer.

"Nothing's wrong Van Go. He just prefers being alone," she said, as if it were the most normal thing in the world. "Introverts, remember?" she added, giving me a cheeky smile. And that was that. Even though we were only miles away from a forest fire and still walking through bear country, he felt more at ease by himself, at his own pace, hiking his own hike. From that day on, Chester went his own way, hiking alone, camping alone, enjoying the privacy of an entire motel room when in town. We bumped into him occasionally, and reconnecting and sharing stories was always a treat. I didn't get it then, but in time, I learned to appreciate and understand what drove him to strike out alone.

As I plodded on, keeping a beady eye on the smoke plume to my right, I noticed a definite shift in my body. I had been pain-free for the past few days, a novelty after the first six weeks. I no longer needed lots of ibuprofen during the day to lighten the pain in my feet and shoulders. It seemed as

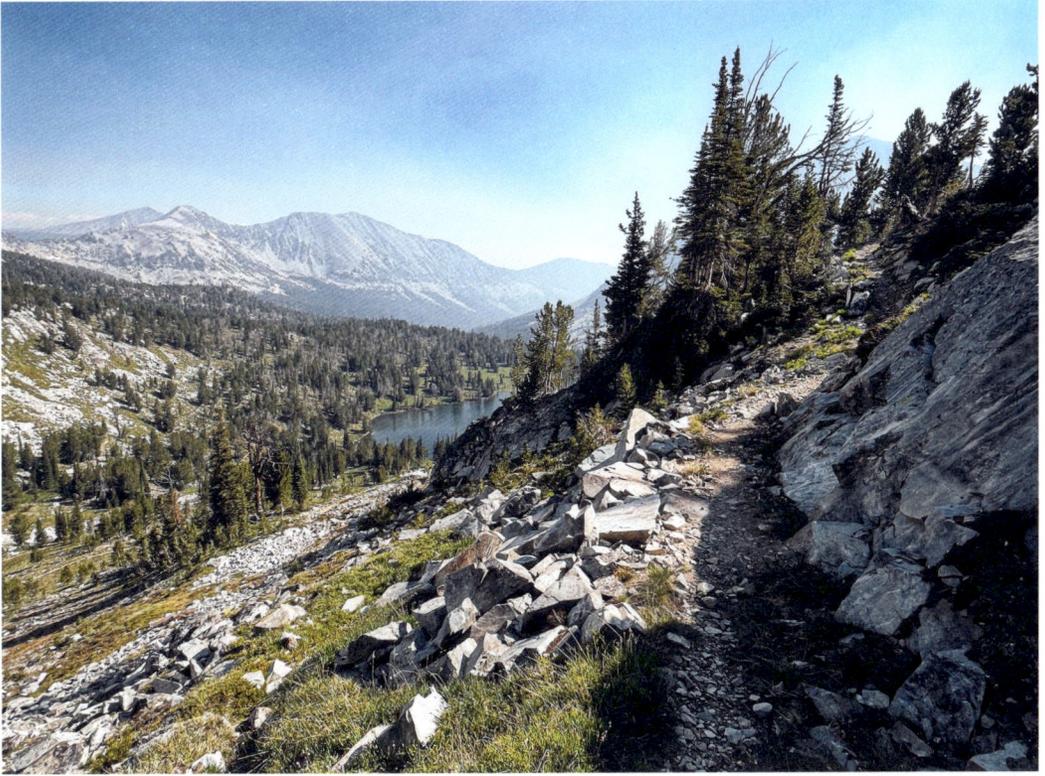

In 2022, there were more than 66,000 wildfires across the U.S.

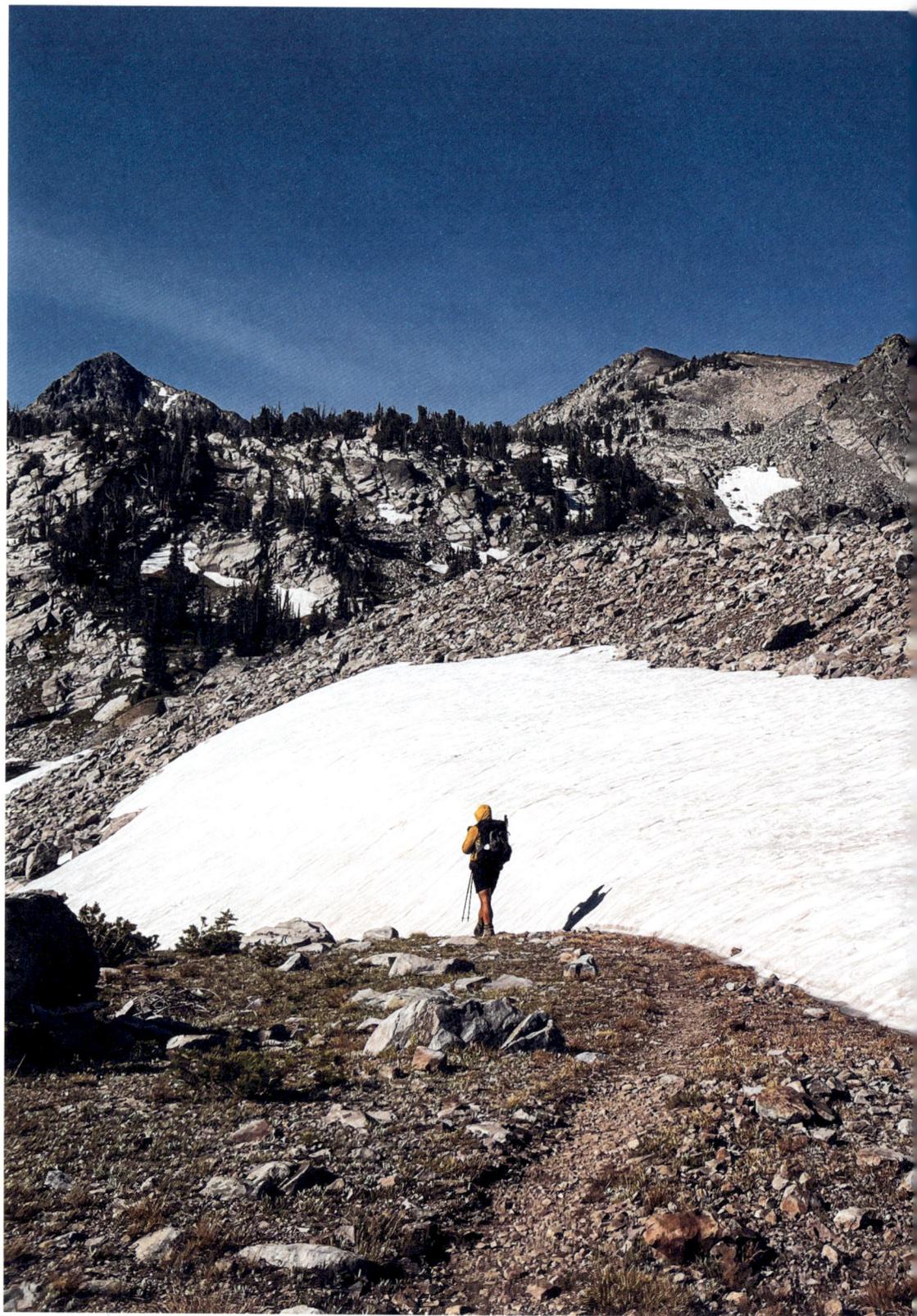

Chester hikes ahead, as the trail disappears under the snowfield.

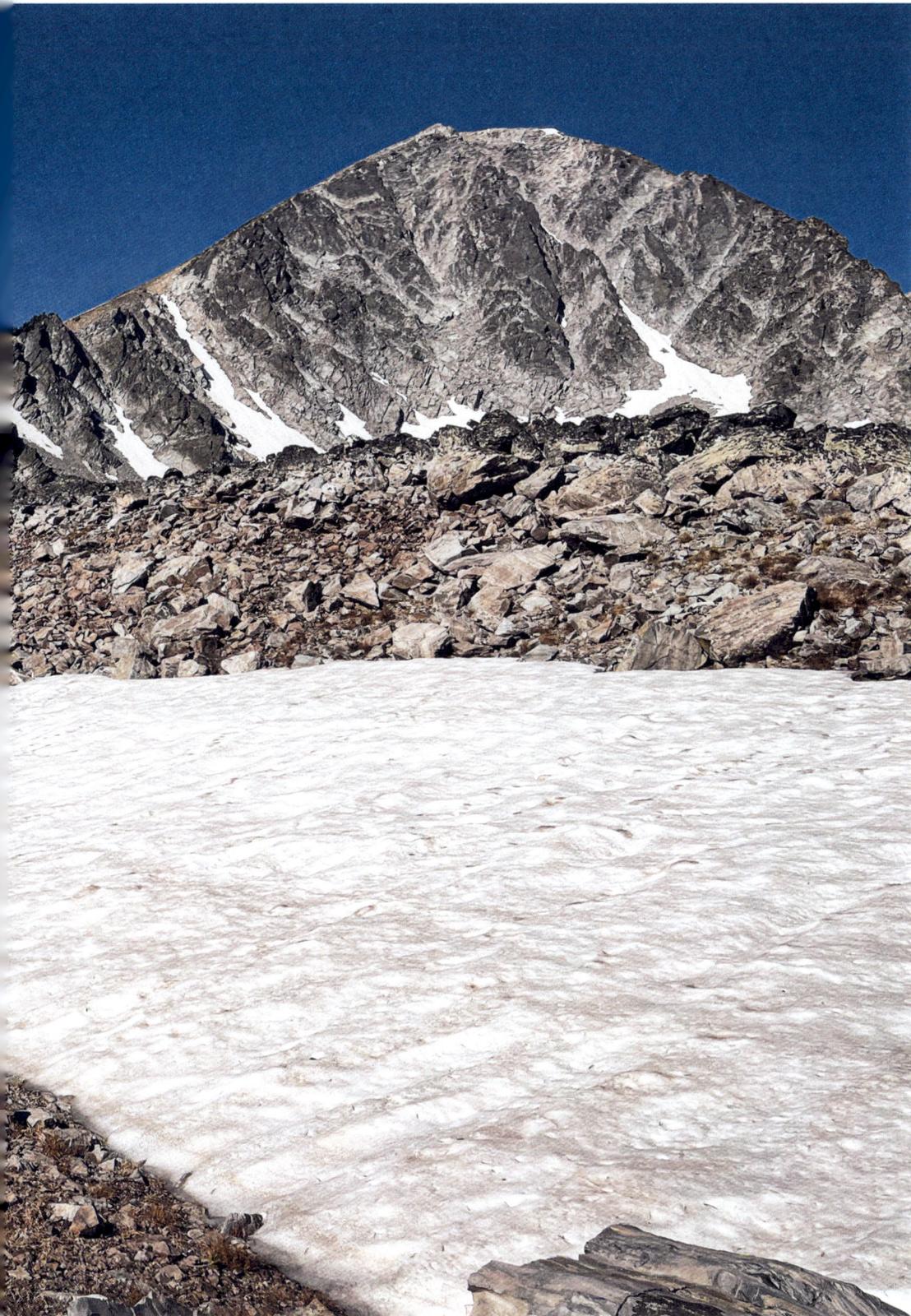

though my body had finally managed to heal it-
self. I couldn't quite believe my luck. My ankle had
regained its natural healthy color, only six weeks
on from being black and blue. I could walk, make
pace, and jump for joy from rock to rock. And I did!

On the third night, after having left Sula,
we hiked into camp very late. It was already dark,
and we could now see the orange glow of the forest
fire burning when we crossed a higher pass above
the tree line. This was the closest we had been to
the fire, and although the flames were still at a safe
distance, there was now no escaping the smoke,
and I had to keep my bandana wet and tied around
my face like a bandit to protect my lungs from the
fine dust. The burning glow reached down into
the neighboring valley, and it was distressing to
see the scale of the area that was alight. It was one
thing to read abstract numbers like 28,000 acres
(11,331 ha); it was another thing entirely to see a
valley smoldering in front of your eyes.

I woke up several times that night, find-
ing it harder to breathe with the smoke in the
air. When I woke at 4:00, the smoke hung heavy
over the lake where we were camped, and I felt
uneasy with every breath. When it was finally
light enough to leave my tent, I was swarmed
by a hoard of mosquitoes, clearly just hatched in
the marshland around the lake. And as I trudged
up another endless mountain slope, breathing
heavily, the amber-orange light of the sun barely
penetrated the haze.

Rest in Peace

Mile 738

Upon reaching the desert town of Leadore, we
were relieved to have left the wildfire behind us
but were also shocked and saddened to hear the
terrible news that two firefighters had lost their
lives in a helicopter accident. Their Chinook had
crashed into a lake while refilling their water
tank. At first, it was incomprehensible that two
men had died the previous day, while we had
been hiking the same hills, no more than ten
miles (16 km) away.

As soon as I connected to Wi-Fi in Leadore,
I searched the local news for what had happened.

*"Two pilots were killed Thursday, July 21,
when their Chinook helicopter crashed into the
Salmon River while working on the fire. They were
identified as Thomas Hayes, 41, of Post Falls, Idaho,
and Jared Bird, 36, of Anchorage, Alaska. The
Moose Fire near the Idaho-Montana border has
grown to more than 28,000 acres."*

I scrolled through the news story. Both pi-
lots had been experienced war veterans, having
flown in several tours of duty serving their country.

"What a sacrifice," I thought. First of all,
out in Iraq and Afghanistan, and now firefighting
to protect the country's forests and the people
who lived out here. It was far removed from the
work and world I knew. I read that there were
now 800 firefighters from all over the country
currently stationed here for the fire. "Moose Fire,"
as it had been dubbed, hung as thick smoke above
us here in Idaho and most of central Montana.

I spent quite some time thinking about
those two firefighters who would no longer return
home to their families. And the families of the hun-
dreds who were still out there fighting. I couldn't

One of the two paintings I make for the deceased firefighters.

imagine what such a physically demanding and life-threatening job would be like. And the very high price they could pay. I thought of my office job, sitting behind a computer screen, creating ad campaigns to sell more beer to people who already drink it. I felt a strong sense of gratitude for the work those men were doing to protect the very same forests that we were privileged enough to be walking through. I felt I should write something to their families back in Idaho and Alaska. But what do you write to someone you don't know, who has just lost their husband or father? Blue, I decided. Blue and yellow are what I can send them.

After having checked into a motel room for the night, I crossed the street and walked into the Leadore Ranger Station.

I pulled the wooden door open and walked up to the high counter covered in maps of the local forest.

"How can I help you sir?" A friendly middle-aged lady, Teeva according to her name-tag, welcomed me.

I felt a strong sense of gratitude for the work those men were doing to protect the forests we were walking through.

"I have a bit of a strange question," I started a little clumsily, searching for the appropriate words. "But do you have two envelopes by any chance?" She looked a little puzzled, but before she could ask why, I continued to explain. "You see, I would like to send a little something to the families of the two men who passed away yesterday."

"For Thomas and Jared," she said quickly. "I knew them both. I used to do a lot of the

coordination for the Fire Service. We're one big family, you see. It's so sad." I could see her eyes tear up ever so slightly. "They were such experienced pilots. Both vets, you know. They will be dearly missed, both here and back home." I didn't really know what to say. What do you say in these circumstances?

"Here." Teeva handed me two brown government envelopes. "You can use these. They will really appreciate you sending them something. That's real sweet of you." I was lost for words and thanked her quietly. In each envelope, I placed a small painting, both different depictions of the beautiful landscape we had just walked through. The very same landscape that was now on fire and had taken Thomas and Jared's lives. I licked the envelope flap, closed them, and handed them to Teeva.

"I'll personally deliver the letters to their respective units," she said. We were both in tears, and I could feel a lump in my throat.

"Rest In Peace," were the only words that flashed through my mind.

PUDs

Mile 738

It was 7:00 when the sun slowly rose over the endless sea of sage gently swaying in the flat valley ahead of us. We were back on trail. Due to the previous night's rainfall, the smell of sagebrush rose over everything; the silver-green shrubs made me think of lavender in the South of France. A few lonesome pine trees cast their long shadows over the open plain. Behind a curtain of haze, transparent blue mountains lined the horizon ahead of me, which meant only one thing: we would be climbing again soon.

We had left town the previous evening, saying goodbye to friendly Leadore behind us to head back into the hills. We were trying to reach Lima within four or five days. A hundred miles (161 km) of pristine, exposed ridgeline lay ahead. The weather forecasts had predicted it would be sunny the next two weeks, but by 15:00 on the first day, dark clouds rolled in, and a thunderstorm behind them. With limited food supplies, we marched on. But as the first raindrops began to fall, we were too exposed high up on the ridge, so we decided to take cover.

"One Mississippi, two Mississippi," I whispered between my gritted teeth, counting the gap between lightning and thunder. I was tense but no longer scared. I gained a lot of confidence from being with the group. Together, I felt we could take on the world. Foolish, perhaps, but my fear was gone. Luckily, the storm blew over within an hour, and although we were all wet and shivering, the steep climb uphill soon transformed our cold bodies into steaming hot machines. We trudged on up to our highest elevation yet, a whopping 10,000 feet (3,048 m). And there was a lot more of this to come.

I hoped some of the rain had fallen over the forest fire behind us. But judging by the smoke plumes, there was still little hope of it being contained anytime soon. The much-needed rain transformed the trail ahead of us into slippery mud. The trail had been a fine dust, but now it began to clog in thick slabs under my shoes. I saw large, fresh hoof prints trodden deep into the mud, telling me that there had been wildlife out earlier than us. We were crossing Elk Mountain. I scoured the horizon in search of any large elk. But in vain.

It was insanely hot. The sun sucked every ounce of energy out of me during the four days of ridge walking. Up on the ridge, there were no trees to offer shade. The occasional fresh breeze was the only (brief) relief, but the power and intensity of the sunlight were relentless. I stumbled forward, step-by-step, head down, with my bandana offering meager shade. Chester had previously given me a few packets of electrolytes, otherwise, I think I would've fainted.

And yet, we were walking through some of the most epic landscapes I had ever witnessed. A huge flat basin, perhaps 50 miles (80 km) long, with a mountain rim around it. I wondered why we hadn't just walked along the flat basin floor instead of going up and over these wretched hills. The red rock formations on either side of the basin felt like a scene from a 1950s Western. On the long stretch between Leadore and Lima, there were only a few sporadic springs and dirty pools to drink and wash my feet.

"Damn PUDs!" Rip cursed as we headed up yet another steep climb. Although she was relatively new to the game, she knew all the thru-hiker jargon and slang. "Pointless up and downs," she explained, as Freddy gave her a puzzled look.

PUDs or not, my eyes and camera lens couldn't get enough of the views: pale blue mountains layered in all directions. It was stunning. This is what I had come all this way to experience. This was the endless landscape I had so yearned for.

We briefly bumped into Chester a week or so after he had left the group, and to my surprise, he gave us all a parting gift: a small titanium whistle necklace in case we should ever find ourselves in an emergency. He explained that we should blow the whistle in three short, loud intervals to alert help. Such a kind and caring gift. I sat down and made him a quick painting of six different situations that we had shared together during the past month. The painting looked more like a comic, but by the look on his face, I could see he really liked it, and he gave me a big bear hug, whispering, "I never give hugs; I'm not a hug guy." It was hard to gauge what exactly went on inside his head, but that didn't matter; it had been a privilege to walk with the gentle giant.

We were walking through some of the most epic landscapes I had ever witnessed. It felt like a scene from a 1950s Western.

It was about two days later that we encountered another hiker, during a long thunderstorm. We had stopped and sheltered under some trees to keep out of the rain when we met him.

"Ten Gallon." The young man introduced himself with a broad open smile, wiping his long brown hair out of his eyes as the rain poured down. He had gotten his trail name on a previous thru-hike, as he always wore a large felt cowboy hat. But it wasn't his big hat that struck me; it was more the fact that he was hiking in sandals, exposing his bare feet to the rain. He explained that although he did have to keep his eyes on his feet most of the time, he had gotten used to occasionally stabbing his toes on the rocks. It wasn't for me, but I was intrigued by why someone would choose to hike this way.

Soon after, a quiet young guy named Ira joined our ranks. Ira was another hiker that we had often seen when we stopped in town. Although the 22-year-old American didn't say much, he turned out to be an incredibly gifted artist and quietly

We stop to rest and resupply at Leadore,
one of the many rural towns we pass.

A sea of sage stretches out in front of us
as we walk through the scorching hot basin.

drew in his sketchbook in his tent or at the diner's bar. I was amazed by the subtlety and detail he managed to create by only using a pencil and an eraser. Behind his courteous and polite demeanor, I slowly began to see his open and curious character. As we moved along, with Chester no longer with us and Ten Gallon and Ira having joined the group, the atmosphere began to shift.

It had been a long steep climb, and when I reached the summit, I stopped to catch my breath and enjoy the magnificent panoramic view over the flatlands below. I was not alone and joined an unfamiliar hiker for a quick snack.

"Hi, Snickers," he said, giving me a fist bump.

"Oh, thanks," I replied, a little surprised that a stranger was suddenly offering me his precious chocolate bar high up on the mountain. After all, we still had many days ahead of us, and people didn't generally share much food unless someone had run out.

"No, sorry, dude. Snickers, that's my name." He looked a little embarrassed for the confusion.

"I think your friends were looking for you down there at the spring," he added, pointing down the steep hill I had just spent the past hour and a half scrambling up.

"What spring?" I asked, still a little confused.

"Didn't you saddle up down there? There's a 20-mile (32-km) waterless stretch of ridgeline ahead of us. Do you have enough water with you?" Snickers held out his liter bottle of water, gesturing that I could have some. "You can have some of mine if you like."

I can be such an airhead at times, with my head in the clouds, thinking, dreaming. I had been so lost in thought that: I missed the junction to go off trail to the spring.

"Oh," was the only thing I could say, as I tried to process the situation. Not wanting to backtrack down the steep hill, but also not wanting to take any of his precious water, I collected myself enough to reply. "Oh, no thanks. That's very kind of you, Snickers, but I'll just pop back down to stock up. No worries. Really."

"OK." And with that, the skinny young hiker darted off, jumping from rock to rock as if he were a ballerina. Rarely have I seen someone glide over the trail with such ease and swiftness. I guessed I wouldn't be seeing Snickers anytime soon. "Happy trails!" he yelled back, waving his one and only trekking pole. I was surprised by the minute size of his backpack; he didn't even have a hip belt.

As I only had half a liter of water with me, I had no option but to turn around and walk all the way back down the steep mountainside. Just another day at the office.

The mountains were high and jagged, barren and dotted with snow. The valleys were teeming with life, full of insects, dotted with pine trees, and long, dry grass.

Hours later, when I had filtered and filled my 4-liter (135-oz) water bladders, I was surprised by a sudden and unfamiliar sound close to my ear. At first, it sounded more like an incoming helicopter than anything else, but it was far too close and intense to be anything mechanical. And then, in a flash, the source of the sound hovered straight in front of my face. A hummingbird, no more than two feet (30 cm) in front of my nose. Its beautiful head was motionless as it stared at me inquisitively, wondering if I was a flower full of nectar or perhaps something else. I stood motionless. As its amber-red beak moved ever so slightly from side to side, I followed the movement of its eyes in slow motion. And just as suddenly as the hummingbird had appeared, it vanished.

With the forest fire still ablaze and the wind now turning in our direction, I wondered whether we would be seeing even more wildlife as they instinctively ran for their lives.

Theoretically, the fire could push many species our way as they fled the heat, smoke, and flames. But as we were not seeing that many, I guessed we were still at a safe distance from the fire.

The section of trail ahead of us was breathtaking. The mountains were high and jagged, barren and dotted with snow. The valleys were teeming with life, full of insects, dotted with pine trees, and long, dry grass. The meandering rivers gently flowing down the valleys gave us sufficient water to drink and bathe in at the end of each day. In each of the seven-day pushes from one town to the next, we generally didn't come across another soul. It was only after Leadore, as we headed to Lima, that we started bumping into fellow CDT hikers heading the opposite direction. NOBOers.

"Howdy," a bewildered man in his forties said, briefly stopping for a quick chat as our paths crossed. His beard was notably longer than us SOBOers, all tangled, dry, and dirty. It was as if he had walked straight off the set of *Mad Max*, with his black outfit all shredded and faded. The man had a strange, distant look in his eyes.

"Want some weed?" he asked, offering me a drag of his pipe. "It's the only way I can get through these days anymore. I've totally had it with this trail. I just want it to be done." I shrugged and politely declined his offer. I wasn't a big fan of smoking while on trail, and I was surprised to hear he couldn't hike without it. He looked beat up, thin, and from another world. It made me wonder, "Will I look like that in four months' time?"

"Are you walking pain-free now?" I asked hopefully. After all, he had probably already covered more than 2,000 miles (3,218 km) since April. "Does the pain ever stop?" I had hoped his reply would bring some relief and perspective for my own journey ahead.

"Pain is like a ball; it moves around your body," he replied in a matter-of-fact tone. "You just have to manage it mentally; it never really goes away. There's always a shoulder, knee, or toe causing some discomfort."

Not the encouraging words I was hoping to hear.

"I'm doing back-to-back 30s now," he said, taking another deep drag from his pipe. "It's the only way I know." And with that, he was off, just as suddenly as the hummingbird, only the hummingbird had left a better impression. I sincerely hoped I would not be cynical and empty by the end of my adventure. But 30-mile days! It was clearly a mental game at the end of the trail. I imagined how I'd feel at the end: my body strong and flowing on autopilot perhaps. But I could tell from this encounter that, mentally, it was tough. As we headed farther south, back across the Idaho-Montana border, we kept bumping into more and more hikers headed north. They were a wild, feral bunch—a totally different species. With long and uncombed beards, tattered clothes, and eyes that sometimes looked straight through me.

I set out to do my first marathon a few days later. My first 26.2-mile (42-km) day on the CDT. The distance between springs was getting longer, forcing us to hike even later into the night. That night, I was the last to walk into camp at

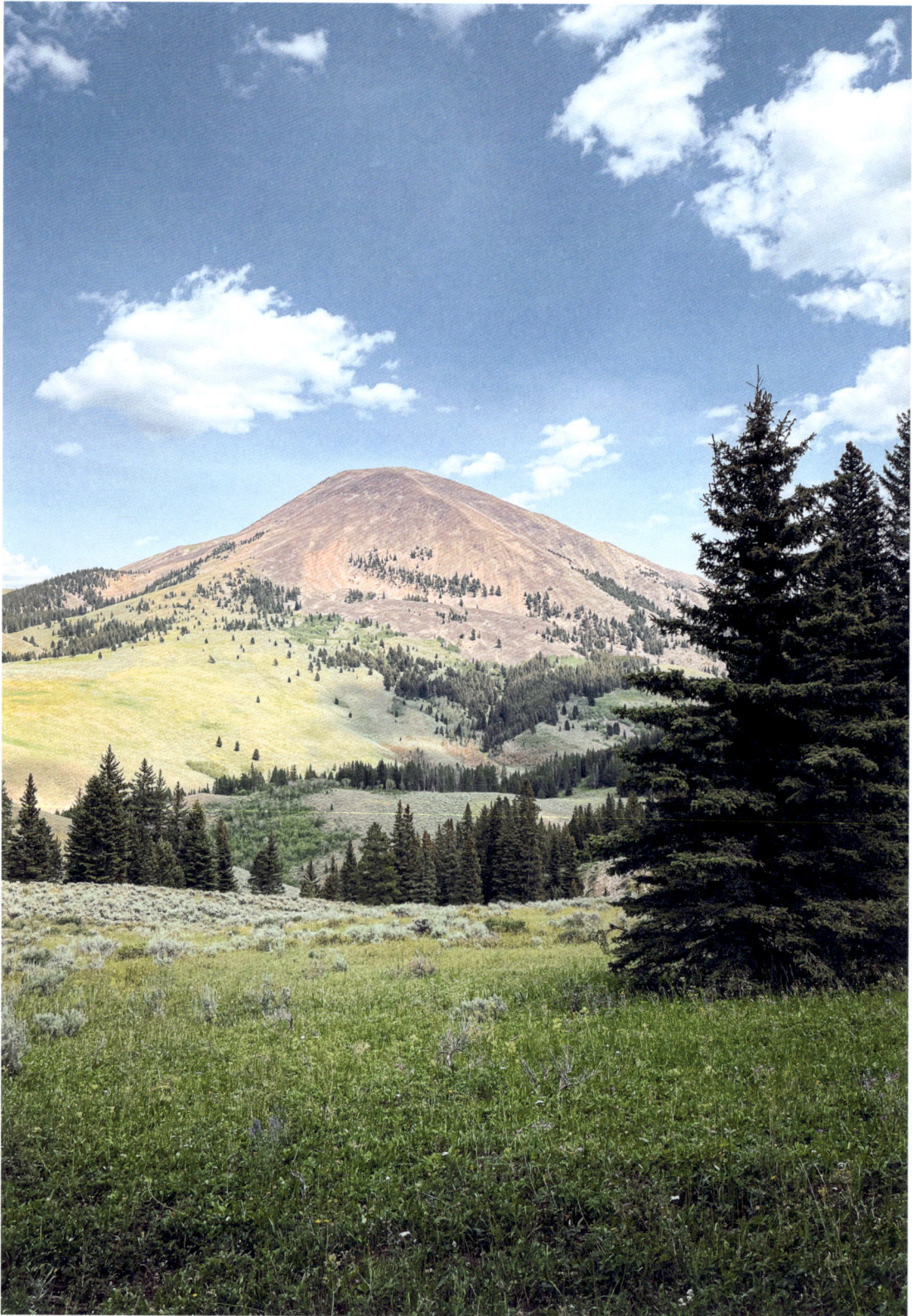

Another Pointless Up and Down (PUD)
in front of us as we head toward Lima.

21:00, after having walked 14 hours. The others had arrived a lot earlier: their tents were all set up, and they were already inside, having eaten before I arrived. I could feel both ankles throbbing, but overall I felt OK and happy with the day. When I finally settled down and looked at my phone, I was surprised to see I had done more than the marathon I'd planned. I'd hiked 32 miles (51 km). What a day, what a day.

As we headed farther south, back across the Idaho–Montana border, we kept bumping into more and more hikers headed north.

Most mornings, I spent in my ears: listening to audio that took me to different worlds, stories, and languages. After I completed my daily hour of Spanish lessons, I often switched to the inspiring interviews of Guy Raz. He spoke to all kinds of entrepreneurs on his podcast *How I Built This* on NPR. And one morning, I listened to his interview with Andy Puddicombe.

It wasn't the story of a typical entrepreneur—in his early twenties, Puddicombe gave away everything he owned to train as a Buddhist monk. But after 10 years, he decided he wanted to bring the benefits of his meditation techniques to more people. While running a meditation clinic in London, Andy met Rich Pierson, who had burned out from his job at a high-powered London ad agency. Together, they founded the Headspace meditation app in 2010.

As I listened, I wondered if perhaps I ought to try meditation myself. Puddicombe sounded conscious and deliberate in his quest to demystify meditation for those beyond spiritual inklings. This struck a chord with me. Meditation seemed all about simplifying things.

"Make it physical" is always my advice when people come to a crossroads. *Make it physical*, get out of your head, and start doing something.

Making, creating, whatever you do, just get your hands dirty. Even if you don't have a big plan or purpose. There is something important about not overthinking things.

I thought of my hikes, and the books I'd written about them: how much I wanted to make hiking seem more accessible to other people, to demystify thru-hiking the way Puddicombe had with meditation. I wanted to help give people that last little nudge. The final push. *Do the hike.* That vote of confidence that everything is going to be alright. That it's OK to be frightened, intimidated, and even scared shitless of the adventures in your mind. As long as you try. Life is shorter than we all may think, and we cannot be sure what's around the corner.

I am no doctor, but for most of the crossroad questions, I prescribe walking. It's the only pill I know.

Our stop in Lima was short but sweet. Rip had managed to book one of the last available rooms, so the six of us all piled in, Ten Gallon and Ira with us. Two people to the king-sized bed and the rest of us on air mattresses on the floor. And to top it all, new shoes were waiting for me at the reception of the motel. A stern elderly lady handed me my box, and after having thanked her for holding it for me, I sat down on the grass in front to unpack my box. New red shoes to replace the tattered, now-faded pair that had taken me across almost 1,000 miles (1,609 km). Rarely have my shoes been so beaten up. The blowdowns in the Bob Marshall, in part, had ripped them apart in the first week. I was overjoyed to throw my old pair in the trash and slip my tired feet into the new firm, bouncy trail shoes.

Wearing and appreciating colorful clothing when hiking was something I learned back in 2016 when I hiked the PCT. Instead of walking in all the sensible, technical outdoor gear, I discovered many folks on the trail just walked into a random thrift shop and left wearing a bright, slightly impractical but cool-as-hell Hawaiian shirt. At first, I found this very strange, coming

from Europe, where everything has a serious purpose when it comes to gear. But I realized that anything worn on trail is going to get trashed sooner or later. You might as well look and feel good out there. So in the desert town of Tehachapi, California, I traded my shredded, expensive merino wool shirt for a three dollar Hawaiian shirt. I have never looked back.

The shirt had become part of my CDT identity. The emotional connection to the threadbare linen grew stronger with each mile farther south.

Now, whether I hike above the Arctic Circle or through the wet rainforests, I never leave my Hawaiian shirt behind. Days before I left home to embark on this trip, a dear friend sent me a handmade shirt. She knew how much I loved bright colors. The shirt had orange flower patterns and fine black details of wildlife, making it the perfect gift for my CDT adventure. Crafted with handmade stamps, using permanent red and orange inks, there were so many little visual stories hidden in the shirt's pattern that I kept discovering new ones as the weeks on trail continued. But as the shirt was made of linen, the wear and tear was tough. Serious measures had to be taken to protect and repair it. I found a needle and some red thread at a drugstore and set about sewing the torn seams each time I was in town. Although it soon became a never-ending story of stitches and patches, I felt it was worth every effort. The shirt had become part of my CDT identity. The emotional connection to the threadbare linen grew stronger with each mile farther south.

After a well-deserved and much-needed hot shower, I hobbled across the street to Jan's Café. I'd read reviews online and had been dreaming of a burger—a proper American hamburger with all the fixings—and the café's pecan pie. When it arrived, I felt every cell in my body cry for joy. Although my stomach didn't handle strong coffee well, I couldn't resist and ordered one, which the lovely server kept returning to refill. Oh, endless refills! I felt I was living in luxury after so long on the trail.

When I was finished, just as I opened the door to leave the café, a bird flew straight into the glass. Damn, that was stupid of me! I flinched, feeling as though I should have seen it coming. The swallow lay at my feet. But just as I stooped to pick the creature up from the ground, it flew away of its own accord. The glass had probably stunned it, but its resilience was remarkable as it flew back into the sky. I was crossing the road back to the motel when the very same swallow dove from the telephone wire, swooping in front of my face. The bird came and went faster than I could fully process, but I clearly felt the dash of fresh air as its wings fluttered inches from my cheek.

"Cheeky!" I thought, spinning my head around to try and catch another glimpse of the playful, beautiful creature. But the magical bird was gone, southward bound, on to greener pastures.

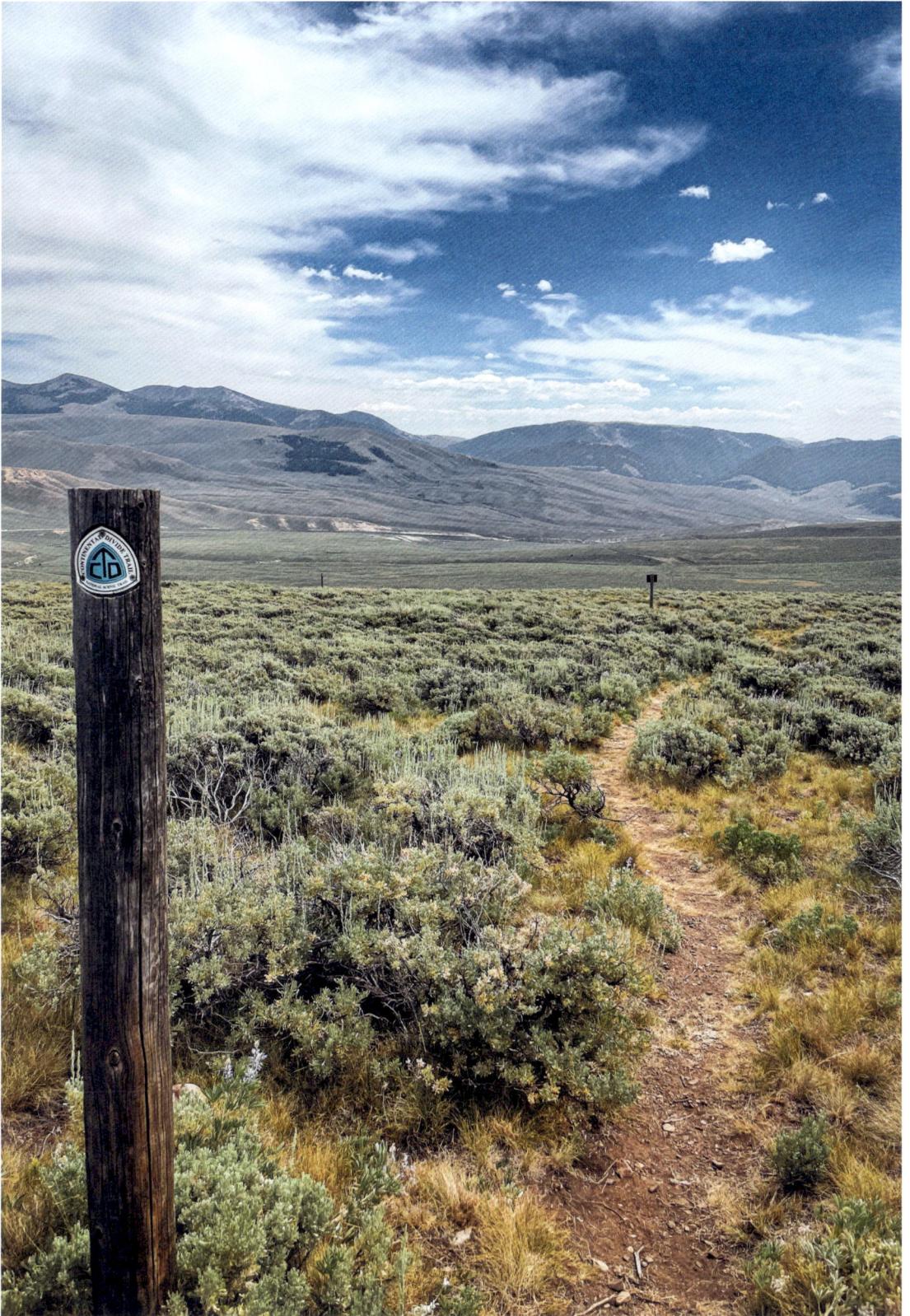

The trail has few markings, so it is particularly
comforting when we come across a CDT crest.

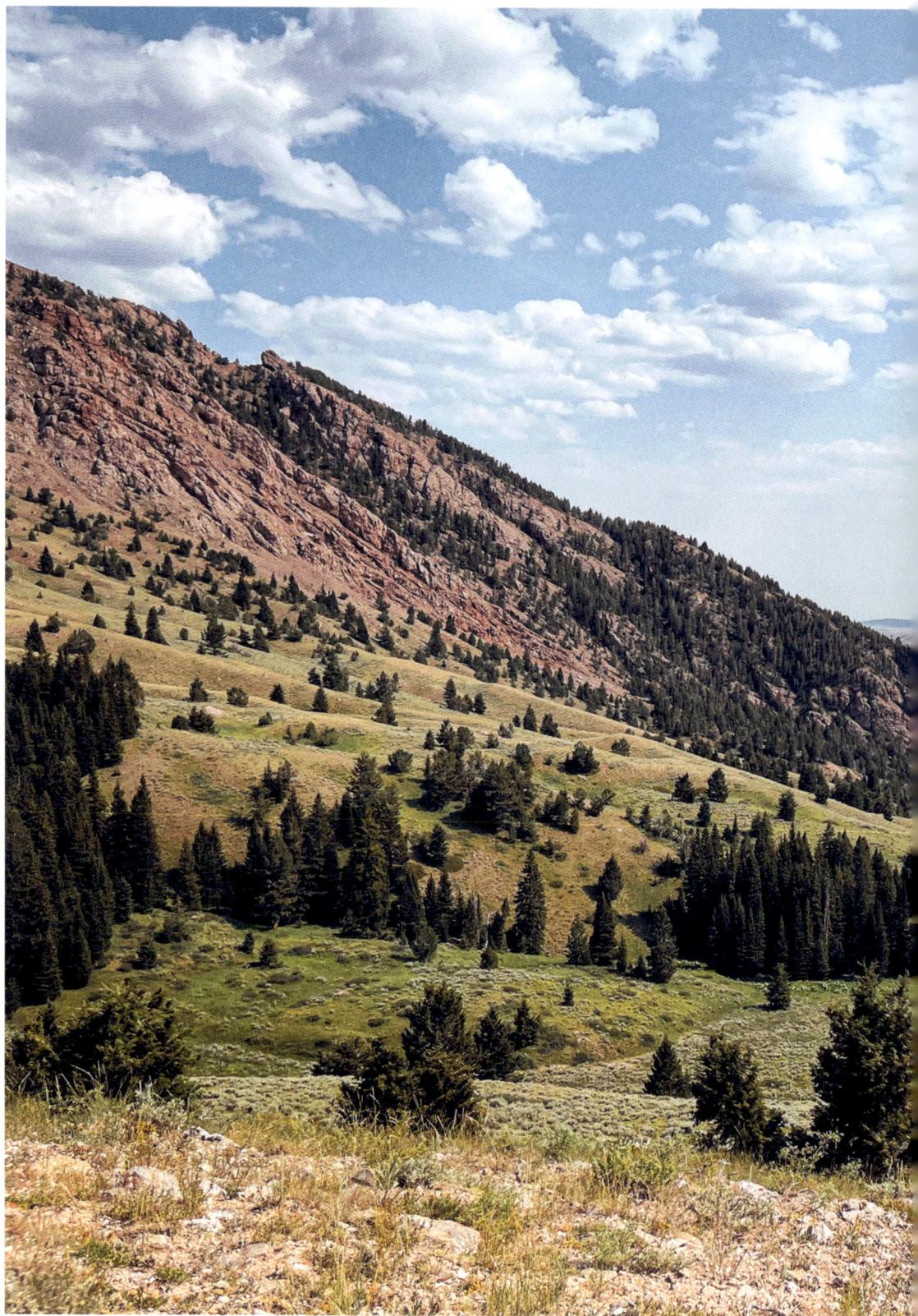

Yellowstone National Park lays far in the distance,
as the trail leads us down into the magical valley.

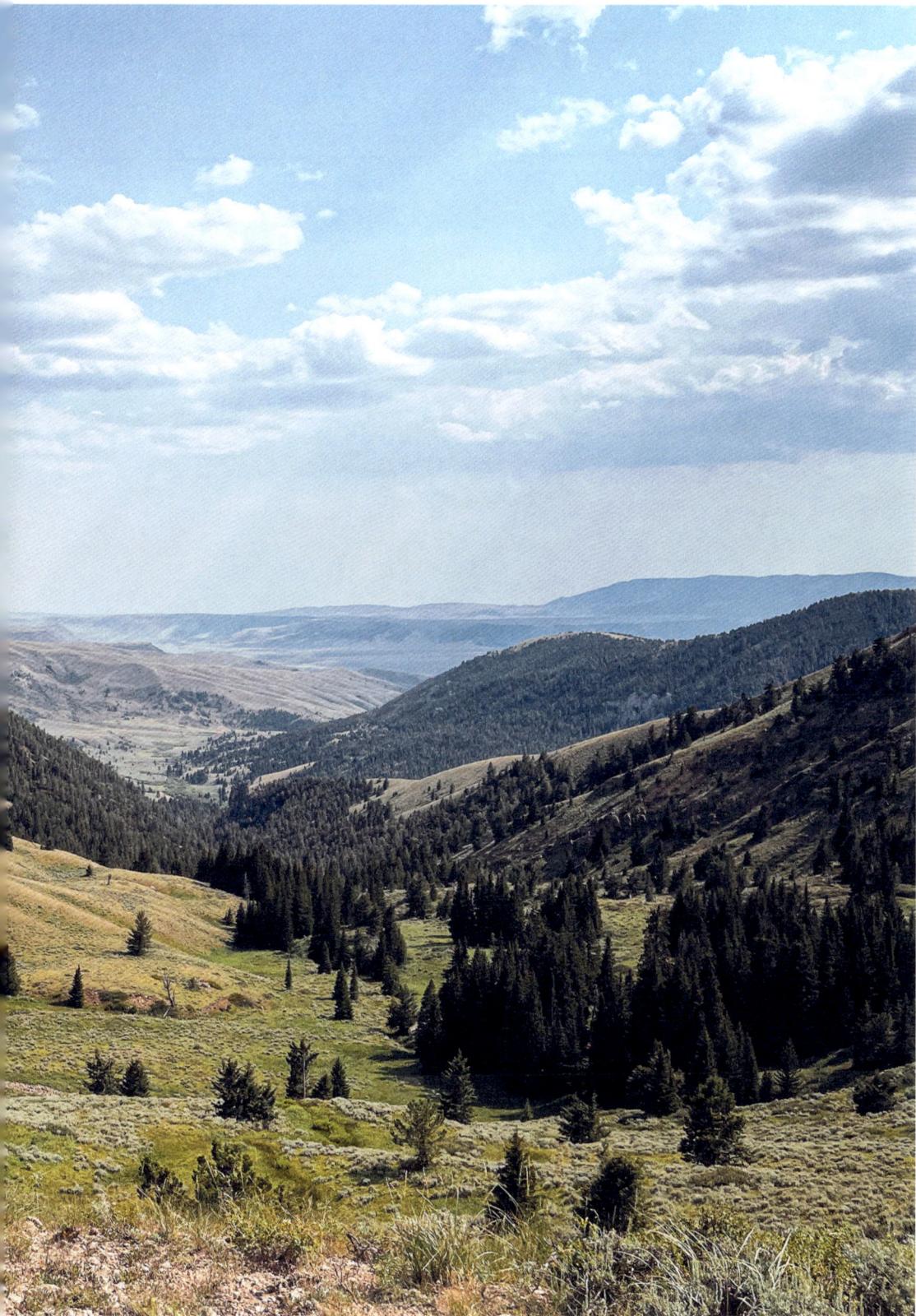

The Mental Journey

Mile 841 – 1,800

Every cell in my body needed rest.
What was I doing out here?
What was the purpose of all this hiking?

I Feel Like Crap

Mile 841

After leaving Lima, I felt like crap. Something was wrong. I had rested for 24 hours, yet I was still physically, mentally, and emotionally exhausted. I wondered if I'd picked up food poisoning in town, or perhaps giardia, because during the first night back on trail, everything inside me turned soft, and I had to go out to relieve my diarrhea. I hadn't been sleeping well the past six days, as there was always something keeping me awake. I was restless, and something in my body wasn't right.

We had taken the Trail Angel shuttle out of Lima to rejoin the CDT and walked 6 miles (10 km) back up into the hills, passing a few remote cattle ranches. Although we were with a large group, I kept to myself, and even when we set up camp under a few broad trees, I remained silent. I couldn't put my finger on it, but I was in no mood to talk or be social. When I'd set up my tent, I retreated away from the group to eat the chicken wrap I'd bought in Lima's gas station along with 4 days' of resupply. I hadn't had much food all day, but thought getting some calories in was important, as there were some serious miles ahead.

A breathtaking sunset fell in the distant valley, and a large group of cows gathered on the other side of the barbed wire, regurgitating the grass they had eaten that day. Hundreds of eyes stared at me, peaceful vacant looks, while I did my best to work away at my wrap.

So much for extra calories: twice that night I had to crawl out of my tent to relieve myself. Sudden cramps gripped my stomach as my body worked to remove everything from within it.

Something was off, and clearly, everything had to come out.

When I woke early, there was no thought of breakfast, only a quick dash to find a bush I hadn't visited to go to the toilet again. After sitting around watching the others enjoying their breakfasts, and quietly listening to their high spirits, I soon followed them over the fence into the cow field to retrieve water. Only no sooner had I started down the hill than I cramped up, buckled over, and violently vomited all over the cows' green pasture.

"Yo! You okay, Van Go?" Rip asked, taking an extra quick step aside to avoid any splashes.

"Yeah, I'll be fine," I said, wiping slime from my mouth with one sleeve and tears from my eyes with the other. While the others filled their water supplies, I slowly came to my senses as my breathing slowed. I did feel a lot better. I pushed to standing and slowly made my way downhill.

"I'm not sure it's a good idea you continue on today. Looks like you're not keeping any calories or energy inside." Rip looked concerned. The others had clearly discussed my situation on the way down, out of my earshot.

"I'll be alright, I think." I was still in denial. "I'll try the first ten miles and see how I feel. I can always turn back then." I was trying to buy some time before having to make a decision.

"I was dehydrated with diarrhea out on the John Muir Trail for several days. Believe me, it's really miserable," Nosh advised me.

The others had clearly discussed my situation on the way down, out of my earshot.

I wasn't strong enough to argue, and it was at that moment that I accepted the reality of my situation. I was not well and definitely not strong enough to hike into the mountains and do four consecutive marathon days.

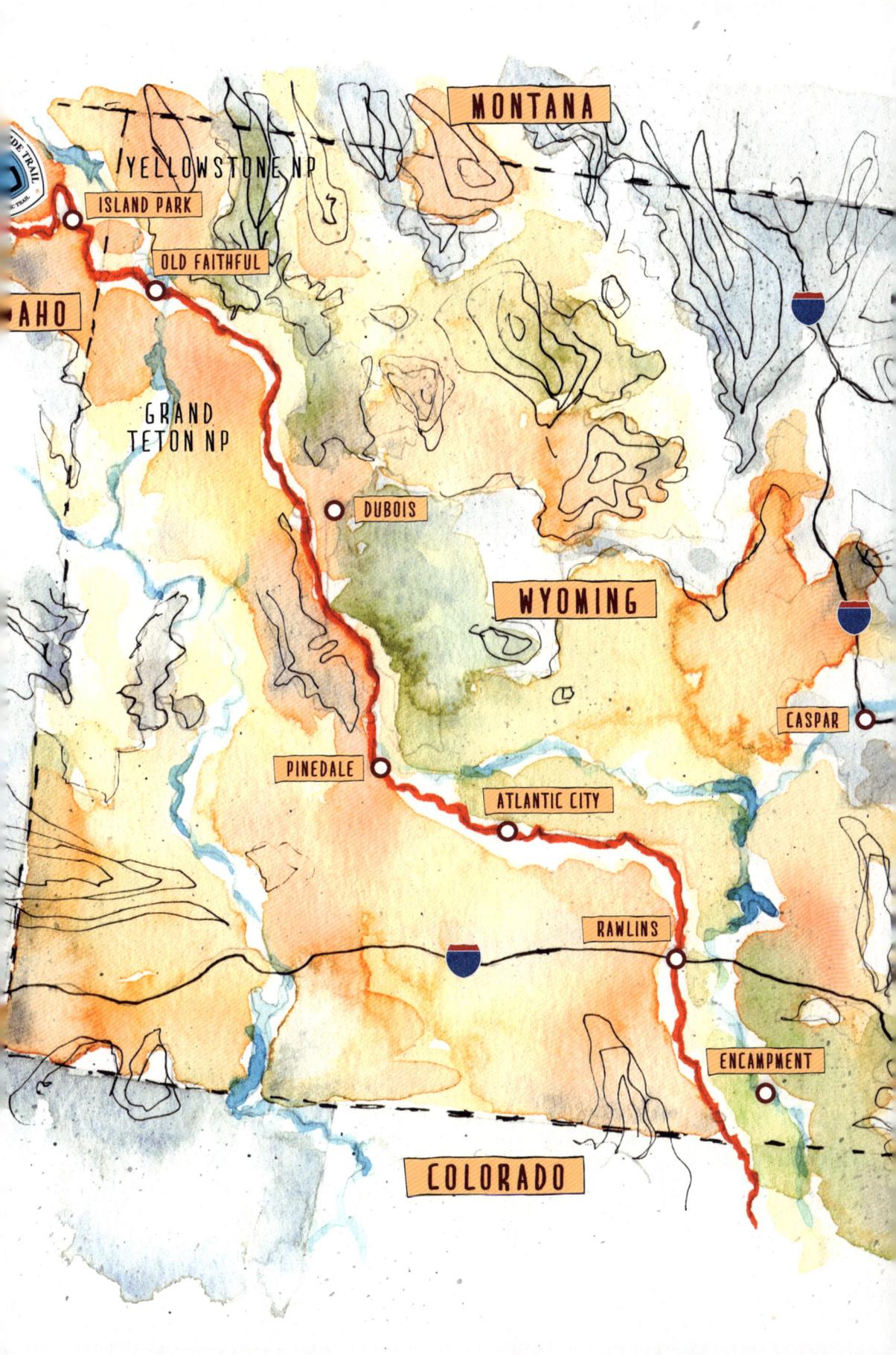

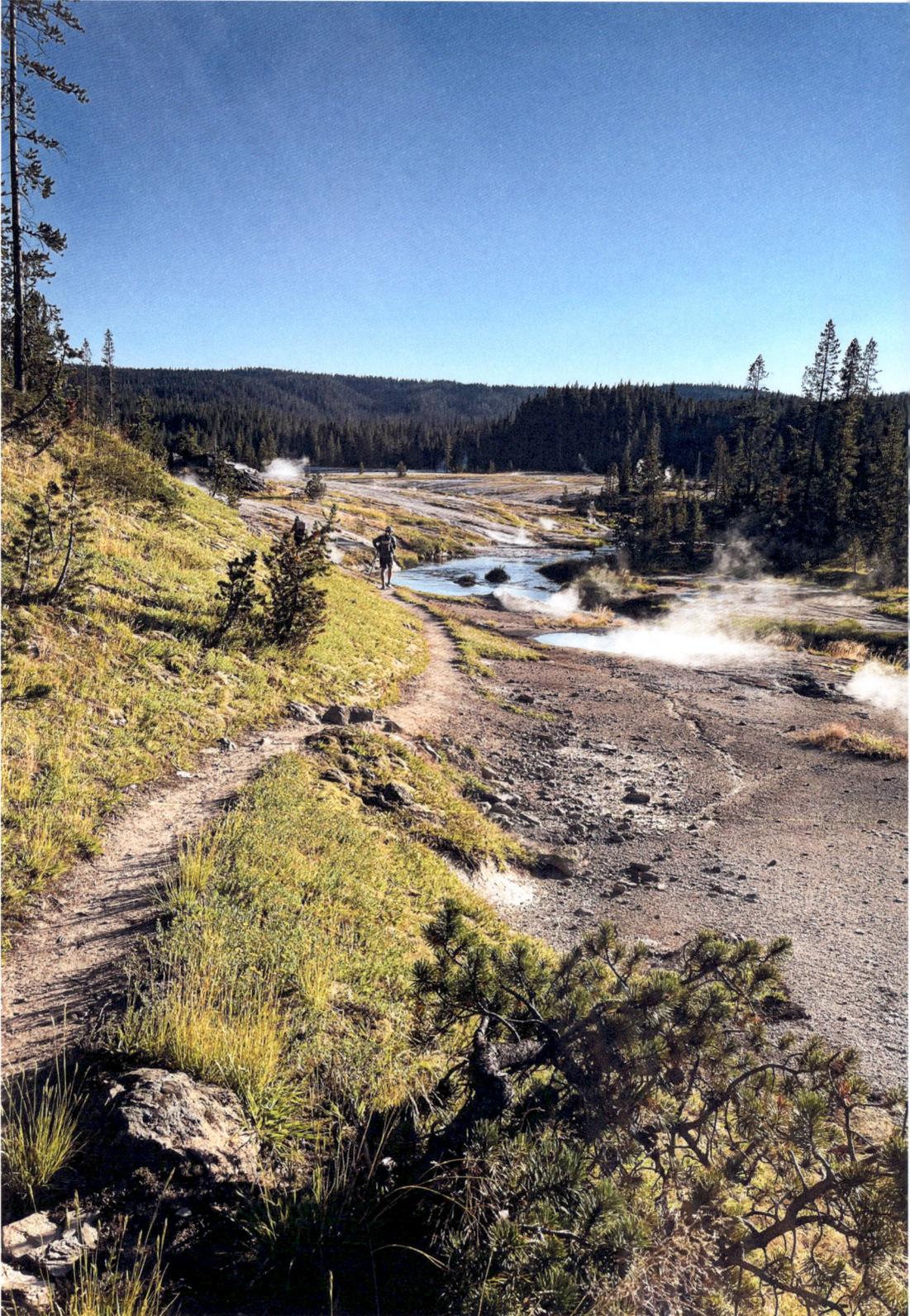

Leaving the tourists behind, the trail lead
us past countless geysers and hot pools.

"You're right. Sorry. Thank you," I stumbled over my words, seeing that my friends only meant well and were giving sound advice.

"If you turn around and head back now, you may be able to catch the first shuttle back down to Lima and get yourself a bed at the motel," Rip said, glancing at her watch. It was still only 7:00, and the next shuttle would be down at the trailhead 6 miles (10 km) away at 9:00.

"Yes. You're right. I'll see you guys in the next town." With that, I swung my heavy backpack back on and waved a feeble goodbye as I hobbled back down the hill while the others continued on.

"You again?" The lady at the motel's reception looked surprised. "Thought you had checked out and headed off?"

"Yes. Do you happen to have a room for one available?" I asked, as all I longed for was a dark, private room to close the curtains and fall into a deep sleep.

"You're lucky: I have one room, but only for one night. The rest of the week, we are fully booked." She glanced through all the bookings in her register. "If you don't mind me saying, I had noticed that you looked a little gaunt."

"Great, I'll take the room. Thank you so much." I answered with great relief.

That day and night, I slept and slept and slept, only waking up to eat a banana in the hope that my body wouldn't reject it. I would've stayed in bed the next day too, but I had to leave for the cleaning lady. Begrudgingly, I gathered all my possessions, checked out, and sat on a wooden bench in front of my motel room. The shuttle guy also happened to be resting, smoking a cigarette during his break between shifts.

"Sir, would you be willing to drive me to the next town?" I asked. It was the only chance I had of getting out of there. There was no public transport in these hills, and taxis were nowhere to be found either.

"What town?" the man asked, taking another drag of smoke, inhaling deeply.

"Island Park," I said. "Could you take me to a B&B there?" I figured it would take my tramily about four nights to get to Island Park, in which time I could rest and hopefully heal from this bug inside me.

"Sure, why not," the man replied and threw his cigarette into the gravel. "Let's go, it's a three-hour round trip, and the road is terrible, so we better get cracking." He climbed back into his immense pickup. I was a little thrown by the sudden pace of events but was more than delighted that I'd managed to get a ride so fast. I hastily threw my backpack into the back of his truck and once again, joined him in the passenger seat for the third time in as many days.

"Buckle up, buddy, it's a bumpy ride." I braced my stomach with two hands, hoping I would make it to Island Park without vomiting in his truck. We drove over a badly maintained gravel road through a vast, grassy plain dotted with pronghorns.

When he kindly dropped me off at the B&B in Island Park, I found my dorm room empty, at least for now. Fortunately, it stayed that way for the next three days, as the other guests hurried away early in their cars to go sightseeing in Yellowstone National Park, which wasn't too far away. By car, that is.

It was good to be alone. To be alone in silence all day. To sit in the bathtub in the morning and bathe again in the afternoon. To lie in bed all day with my feet up. To drink water. To eat bananas, apples, oranges, and eggs all day. Somehow the trail and its trail community felt very far away.

What was I doing out here? What was the purpose of all this hiking? I missed home, my children, and my family. I was a mess. I don't know what had gotten to me, but I suppose my whole being was in a state of shock. Shocked by the intense sun, shaken by continuous days of marathons up and over the mountains, and shattered by the lack of healthy food, which was so hard to find in these tiny towns we drifted through.

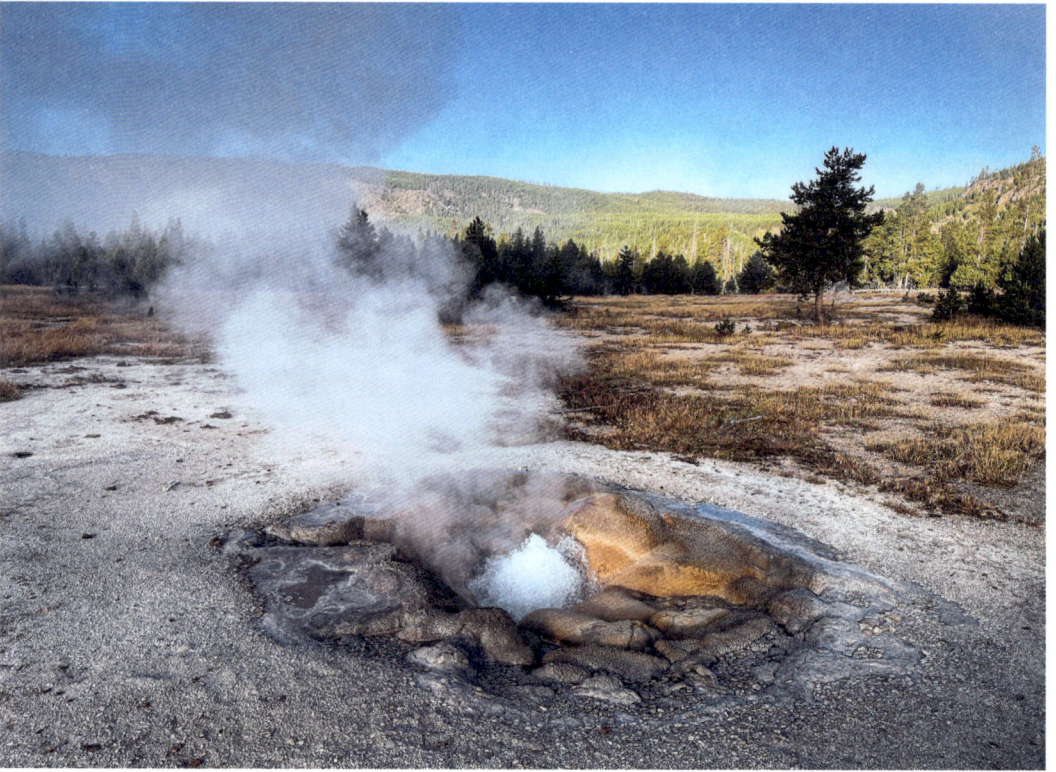

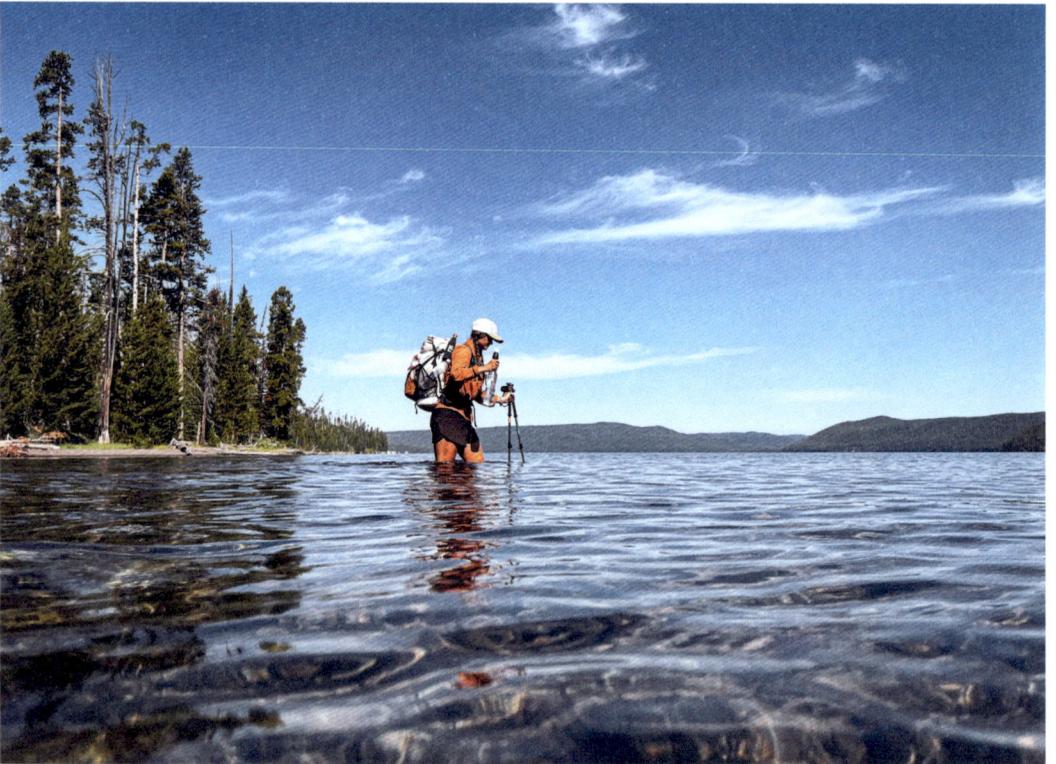

Yellowstone National Park takes us past
hot geysers and through wide rivers.

I knew it was probably some kind of bug. But whatever it was, it didn't really matter; I needed rest. Every cell in my body needed rest. It was time to follow the advice I always give my kids: "Sleep a lot and drink lots of water." Well, that was just what I was going to do. Nothing more, nothing less.

It was good to be alone. To be alone in silence all day. Somehow the trail and its trail community felt very far away.

My stay at the cabin in the middle of nowhere was actually rather quiet and peaceful. As the nearest store was more than twenty minutes away, I stayed in and ate their complimentary breakfast—for breakfast, lunch, and dinner. Slowly my stomach began to accept little bits of nutrition, and my vitality slowly returned. Although it was only bananas, cornflakes, and milk, it was just perfect for now.

Having spent four nights in a real bed, I felt I was slowly getting a little better, but I was far from back to my old self. I couldn't stay in Island Park too long, as my friends were on the move, and as they say in the Tour de France, the caravan doesn't stop for anyone. Plus I was excited to get back on trail to see how my body would react to some walking in the sun. Montana lay behind me, and with just a few more miles through Idaho, I would soon be reaching Wyoming. And if I believed the stories of the NOBOers, I had quite a treat in store for me ahead. Most of them said that Wyoming was their favorite state on the CDT. I thought about it and decided anything would be better than Montana and the Bob Marshall. Although Montana's scenery had been wild and breathtaking, it had also taken more out of me than I had bargained for. I feared I would be scarred for life by the small trauma of the endless blowdowns, utter remoteness, and bear encounters. Adventure

comes in all shapes and sizes, though you can never pick and choose, as Mother Nature does that for you. But I was looking forward to less challenging terrain.

I knew next to nothing about Wyoming, and it was difficult to believe it had been so many hikers' favorite section of the trail, as I'd heard great stories about Colorado. I supposed Yellowstone captured the minds of so many people, so I was excited to see what Wyoming had in store.

Having rejoined my tramily, we headed toward Yellowstone, and the terrain finally leveled out. The difference was clearly noticeable as the grading became gradual, and a pleasant track led me gently through the valleys.

As I crossed paths with more and more NOBOers, my impressions of them changed. I sometimes passed 20 of them in all shapes and sizes on a single day. But compared to the first 20 I passed in Montana, the folks I was passing on my way toward Wyoming were a much more cheerful and friendly bunch. No longer was it the middle-aged veterans; there were many more young people, with more than a third of them women. Compared to our SOBO bubble, with only about 10 percent women, I was pleasantly surprised.

"Have you seen any grizzlies?" one of the NOBOers asked Rip.

"Don't listen to her; SOBOers are all liars," another NOBOer jumped in, laughing. The banter and teasing between the two groups as we sat around a campfire was a tonic. We had just entered the boundaries of Yellowstone National Park.

As we sat joking, I noticed a familiar face join us around the fire. "SwissChris?" I said in utter surprise as the man joined me on a log.

"Van Go! What are you doing here?" SwissChris and I had met four years earlier hiking the Te Araroa, on the South Island in New Zealand.

"Doing the CDT," I answered with a cheeky grin.

"Same." He smiled and gave me a fist bump, a common custom among thru-hikers, to avoid transferring any germs, bacteria, or illnesses to

one another out on trail. We were terribly filthy after all, and there was no restrooms to wash your hands along the way. SwissChris and I talked on into the night, exchanging tales of our recent CDT experiences. It was good to speak to a friend, but my headache and stomach cramps had returned. Something was still rumbling down there.

The following morning, I rose at 4:00 and walked through the darkness with a headlamp in my hand. It was the first night hiking I had done on this trip, but I felt fine as I was not alone. Mentally, that is, because physically I was feeling like crap again. During the night, my stomach turned once more, and it was still cramping and causing me trouble as we hiked. This was not good, especially as we had gotten up so early to make it in time for the infamous breakfast buffet at Old Faithful Lodge in Yellowstone National Park Village. The others were so excited about everything they were going to eat that morning, but I was more excited about visiting a real toilet.

There was much to distract me, though. As the group moved ahead, I walked down into the steaming valley of Yellowstone alone, past countless geysers and deep blue, bubbling hot pools. The famous geysers were erupting left and right of the trail. The tourists hadn't arrived yet because it was still before 7:00 in the morning. I had the magic all to myself. The rising steam in the cold morning air. The scent of sulfur as I walked over an active volcano crater that stretched out for hundreds of miles. I marveled at how close to each of the boiling pools I could get. And the landscape seemed to go on and on as the sun rose over the mountains. When I finally reached the Old Faithful Lodge and joined the gang at the breakfast table, I looked in despair at their bulging plates of fruit, sausages, bacon, buns, butter, and cheese. There was even a large salad bar with numerous vegetables to choose from. My eyes cried and my mouth watered, but my stomach summoned me to the bathroom. Pronto! I did my best to eat what I could, as I knew my body was dehydrating once again. I needed nourishment to continue walking.

But all I could handle was tiny bites of toast, and this too soon ended up in the toilet.

I walked down into the steaming valley of Yellowstone, past countless geysers and deep blue, bubbling hot pools. The famous geysers were erupting left and right of the trail.

Not only was my body out of sync, but I noticed a shift in our group dynamic. It was strange; although the new faces in our group were all fun and interesting people, I felt a slight disconnect. This was probably mostly because of me, as I wasn't the most fun in my current situation, but I sensed that the whole dynamic was changing. I've always found it hard to adapt to sudden shifts in group dynamics. Although I couldn't quite say why, I felt we were slowly drifting apart, ever so gradually.

Yellowstone turned out to be one big dilemma. I wasn't well yet, and the past three days of hiking had proven more challenging than I had hoped. My four nights of rest had not fully done the trick of restoring my energy, and although I found it hard to admit it to myself, I was still ill. Yellowstone felt like a crossroads.

Every option ran through my mind: Should I stay and rest for another few days? Should I leave the group and continue at my own pace? Should I take a side trail to the Tetons? Or should I grit my teeth and stay with my group? I knew that if I stayed behind for too long, I would never catch up to my buddies again.

But there wasn't much time to fuss. It was either stop or continue on. I could flip a coin, but the urge to stay with my group was stronger, and after everyone had charged their phones and bought some food, we headed out for Knapsack Col. I stayed with the group, but soon found myself lagging behind.

Of course, I don't want to be overly dramatic about these dilemmas; after all, these were textbook First World problems. I was getting to do something I'd dreamed of and was extraordinarily privileged to have that opportunity. But in the moment of having to choose between the familiar routine of my group and setting out alone, I felt my mind stretched too far. A wider perspective and the world's real problems seemed very far away.

Two days after leaving the touristy hustle and bustle of Yellowstone and the Old Faithful Geyser behind us, we were once again lost in the wilderness. The ibuprofen was doing its job, and I was keeping up with the gang. It would take us approximately five days to walk through the lower section of Yellowstone National Park. Along the way, every few hours, we were treated to another spectacular blue or orange hole in the ground, bubbling and steaming right next to the trail. Staring into the deep pools, it somehow felt as if I was looking straight into the eyes of Mother Earth.

It was common for the trail to cross one or two rivers each day, but Yellowstone had a surprise in store for us. We came to a river and discovered that it was hot, not too hot, but enough to be steaming. The clear creek flowed gently down through the Yellowstone Valley with bubbling geysers on either side. It was a scene straight out of a fairytale or apocalyptic sci-fi movie. I couldn't quite comprehend that this entire river was so hot.

It called for one thing only: a swim. I stripped off my clothes and cautiously dipped my foot in to gauge the temperature. It was like a hot bathtub, so hot your body takes a while to adjust. I lowered myself down slowly, resting my hands on two boulders, and finally submerged myself completely into the liquid.

It was just what my body needed. Not long after, Rip, Nosh, and Dom joined me. And as if the paradisial scene could get any better, Dom pulled out a four-pack of IPAs! He had gotten them from some day hikers who had been carrying their cooler back to their car after a day out. Cold beer in a hot river! My heart jumped for joy.

"Paradise!" We all raised our cans to the moment. No other words were needed.

> Every few hours, we were treated to another spectacular blue or orange hole in the ground, bubbling and steaming right next to the trail. Staring into the deep pools, it somehow felt as if I was looking straight into the eyes of Mother Earth.

In the week after leaving Yellowstone, I started leaving about an hour earlier than the crew each morning, walking through the darkness into the morning dawn. It was the only way to keep up, to be honest. My face would break the cobweb-booby-traps that spiders had spun across the trail during the night. One dawn, it was light enough for me to see a small, two-foot snake slither across the trail in front of me. Nothing harmful, simply beautiful to behold. To my delight, I found that by starting earlier and being the first out there, there was so much more wildlife to be seen. Deer quietly grazing and drinking along the rivers, marmots motionlessly resting on their hind legs, and squirrels and chipmunks going about their morning rituals.

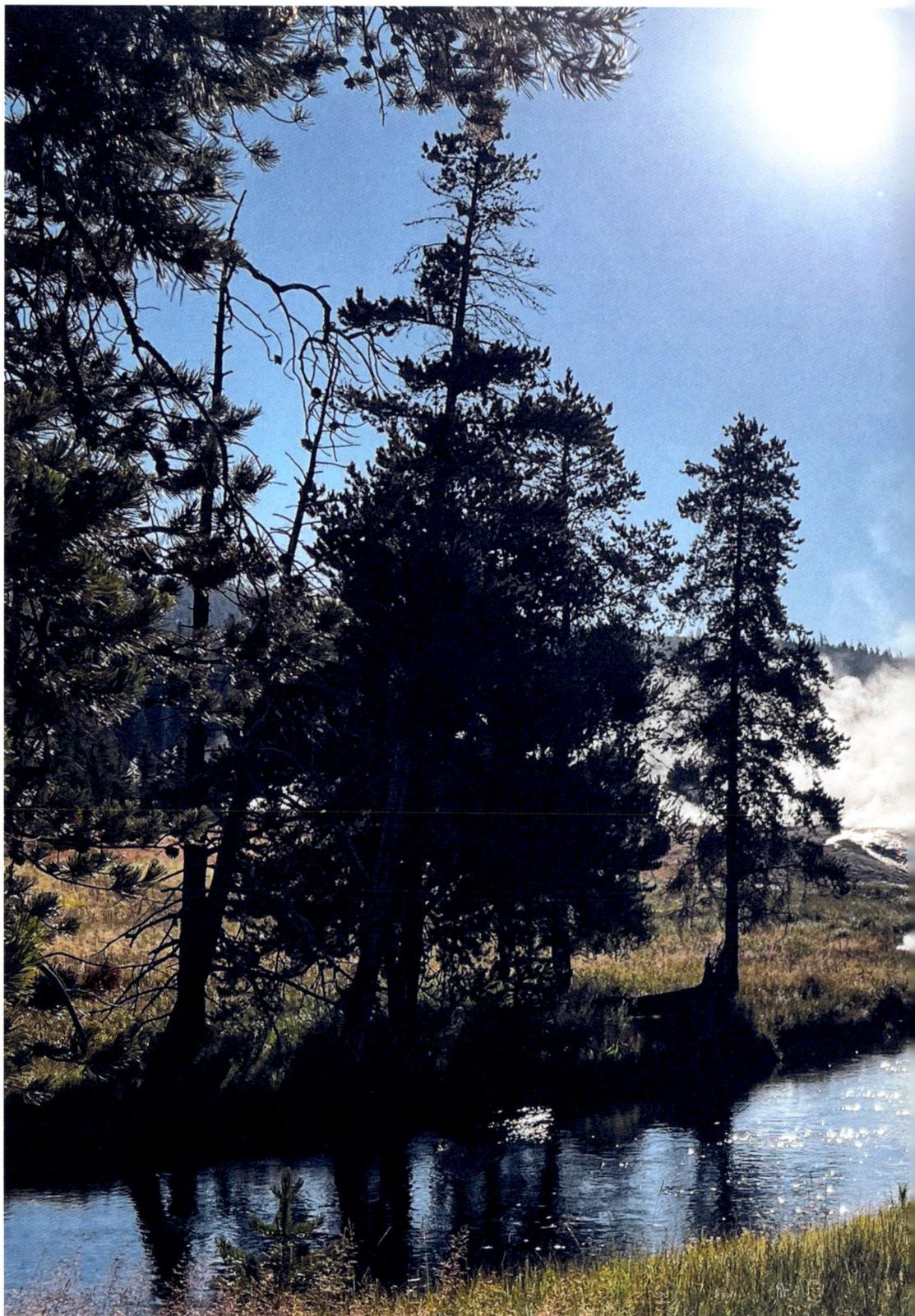

Steam rises from the valley floor as we approach
Old Faithful in Yellowstone National Park.

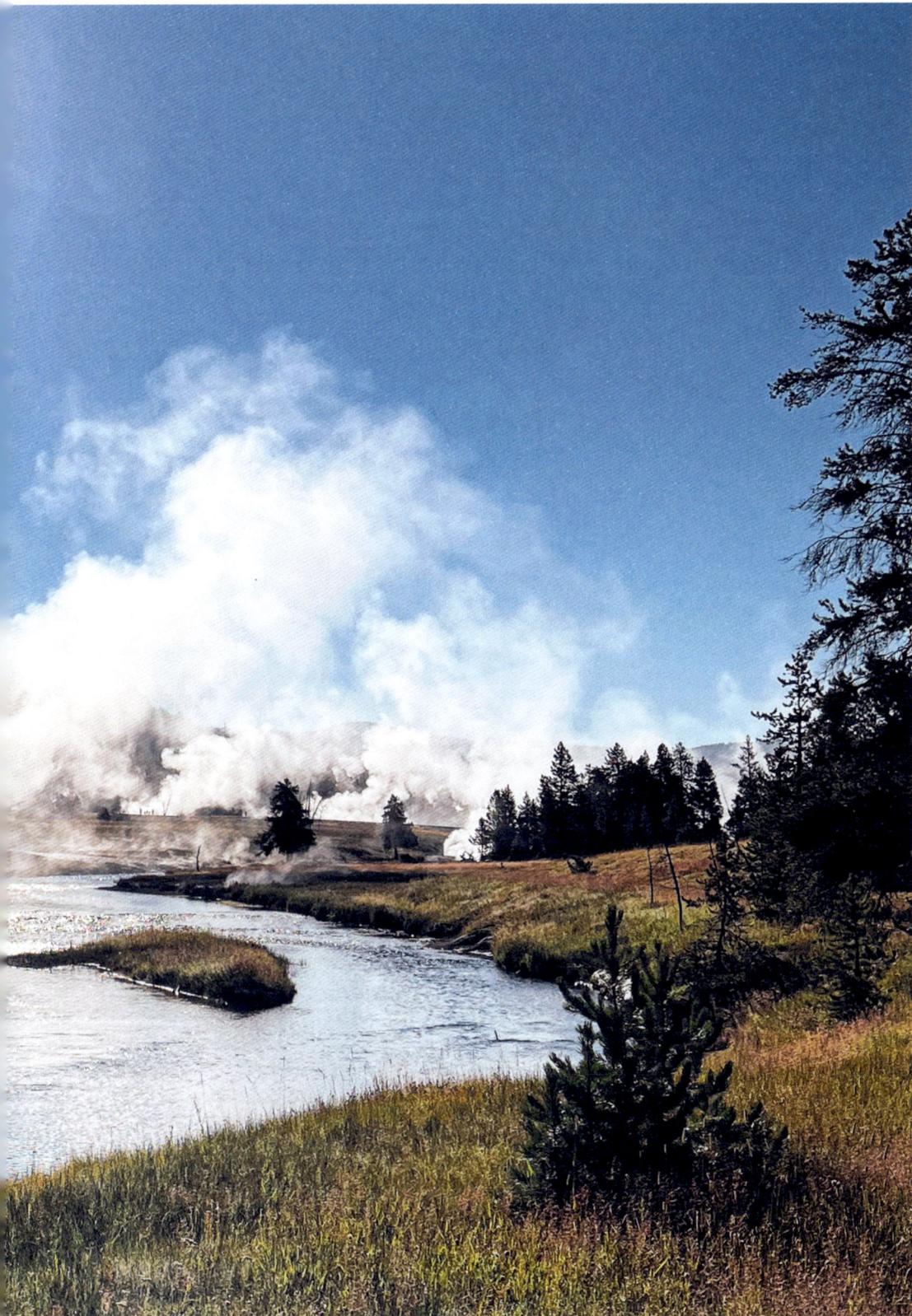

It is said that we swallow an average of 10 insects a day. Well, during these mornings, I believe I was swallowing 10 an hour as I gasped for breath on my first steps uphill. The mosquitos, flies, and ants were also out in force. Nosh had seen a sizable black bear only three days earlier, quietly minding his own business, and today I bumped into a NOBO hiker who warned me he had just seen a grizzly a mile back. That definitely woke me up, and though I didn't see one, I was on full alert, shouting "Heyyyyy bear" every few minutes after he had shared this news with me.

Everything was continuously in motion around me, forever changing. Ever so slowly. Although my eyes could not perceive the transitions, I felt and saw the change of the seasons in the landscape around me. Days were becoming noticeably hotter, and I saw at least three snakes a day now. The grass slowly turned golden, with dry orange flowers, and the occasional tree glinted gold. Fall and winter still felt far away, but I could feel the season slowly moving.

I saw the change of the seasons in the landscape around me. Days were becoming noticeably hotter, and I saw at least three snakes a day now.

The snakes also got thicker and thicker as we walked farther south. The first snakes I had seen back in Montana were no thicker than my pinky, but most snakes I came across now were as thick as my thumb. They meant no harm, and I found that if we all kept to our own business and treated each other with peace and respect, no one would get hurt. Respecting wildlife was key: there was no guarantee of safety, and I knew not to get complacent or cocky. Animals, weather, and nature in general can be quite unpredictable at times.

One day, I bumped into a family of seven heading northbound. They were hiking the whole CDT, and the youngest was only one year old. Sure, I bumped into all kinds of packs, herds, and flocks of hikers, but this family was something else. I met them where the trail disappeared into a wide, shallow river. The father waded to and fro, carrying one child at a time across the river.

"Need a hand?" I asked him, as a few small kids still waited on the other side.

"No, I'm good, but thanks anyway," he said humbly and returned to collect the next of his kin. I put my pack down, got out a snack, and watched as he ferried his children, one by one, across the water. I was reminded of the story of Saint Christopher, who devoted his life to carrying the weak and poor across a river. One night, while carrying a child, he felt his burden grow heavier with each step. When questioned, the child declared that he was Christ and that Christopher was thus bearing the world's weight.

On the final crossing, the father assisted his wife across the river, who held their baby in a carrier on her back.

I stretched out my arm to help pull her onto the dry bank and asked about their journey.

"They call us *The Family*," she said with a smile that was both proud and a bit shy.

"Wow. Going all the way to Canada?" I asked.

"Yup," she said simply. I was clearly not the first to quiz her on their family field trip.

"And what's your name?" one of the children asked.

"Van Go."

"We all have trail names, too. Wanna hear them?" Another of the kids beamed.

"Of course, I want to hear your names!"

"Mom's Queen Bee (age confidential), Dad is Spreadsheet (43), Blaze (13), Boomerang (11), Angel Wings (9), The Beast (7), and that is Dead Weight (1)." The Beast was echoed by his sister Angel Wings, who added the family's ages after he named them. There was a musical rhythm

to how they did it—they'd clearly done it before.

After stopping to take a photograph and wishing them happy trails, I found myself thinking of what their journey must've been like. They each carried light packs, presumably only carrying their own clothes and some food and water for the day. The mother must've carried the baby on her back for five months with two more still to go, so it all came down to the dad to carry most of the gear. Just imagine: a huge tent, seven sleeping pads, seven sleeping bags, the list in my head went on and on. But no one seemed to be bothered or complaining. The Family's whole attitude and energy was cheerful, happy, and hardworking.

"Imagine taking your very first steps on the CDT," I thought as I waded through the same river southbound. That one-year-old girl would soon be doing exactly that. Her very first strides on Earth, here, on trail.

My own family was far, far away, and I had my own issues to worry about for the moment. My head and stomach were still bothering me. It's hard to explain what the state of my mind was then. Blank or empty would seem appropriate. I simply felt as though I existed. I walked, I ate, I slept. I had few thoughts about the future and even fewer about the past. My 25-mile (40-km) days dictated the rhythm.

Perhaps the best way to describe my state of being was that of a "pleasant void." I felt as if I was in between the past and the future. Comfortably numb and without a plan. Without ambition, goals, or responsibilities, beyond continuing to hike. A weird state of being, perhaps only to be compared to the mind of an infant. Perhaps it was a form of escapism, as the realities of society were far away. But I could also describe this temporary state of being as a time to recharge and heal—and accept whatever nature and fate threw at me.

The trail seamlessly transitioned from Idaho into Wyoming. Other than a handwritten sign, nothing in the natural world around me suggested I was about to enter another state. Nature doesn't do borders. That came from humans—and here, it came from settlers and colonizers.

It was a warm morning, and everything around me was wet due to the heavy rainfall that had fallen during the night. Wyoming was very picturesque; I felt like I was walking through countless postcards from the Old West. But my mind was focused on town. I was exhausted.

I felt as if I was in between the past and the future. Comfortably numb and without a plan.

"Hi, I'm Snow," a tall, well-built young hiker introduced himself to me. Snow had recently joined the gang. I had seen him around but had never really spoken with him at length.

Snow had long red hair, a few feathers in his ponytail, and a laid-back demeanor. After lunch, we hiked out together, and he asked me about the books I had written. More specifically, he told me he was interested in the writing process, and as it turned out, he too dreamed of writing a book one day.

"What's it going to be about?" I asked.

"About us walking through occupied country. About my Nevada Tribe and about the Navy Seals," he answered without looking back. It was quite a list of topics, and I couldn't quite wrap my head around what connected them. "It's about my life, I guess." That explained it a bit, but still, I was curious to learn more. In that respect, Snow had a gripping base from which to write a fascinating book.

Snow was from the Northern Paiute "Agai Dicutta" tribe in Nevada, and had spent every childhood summer on the Walker River Reservation. Although only 30 years old, he was already playing with the question of how he could best give back to his community, with whom he had lost touch during the past 15 years. This long hike had given him time to reflect,

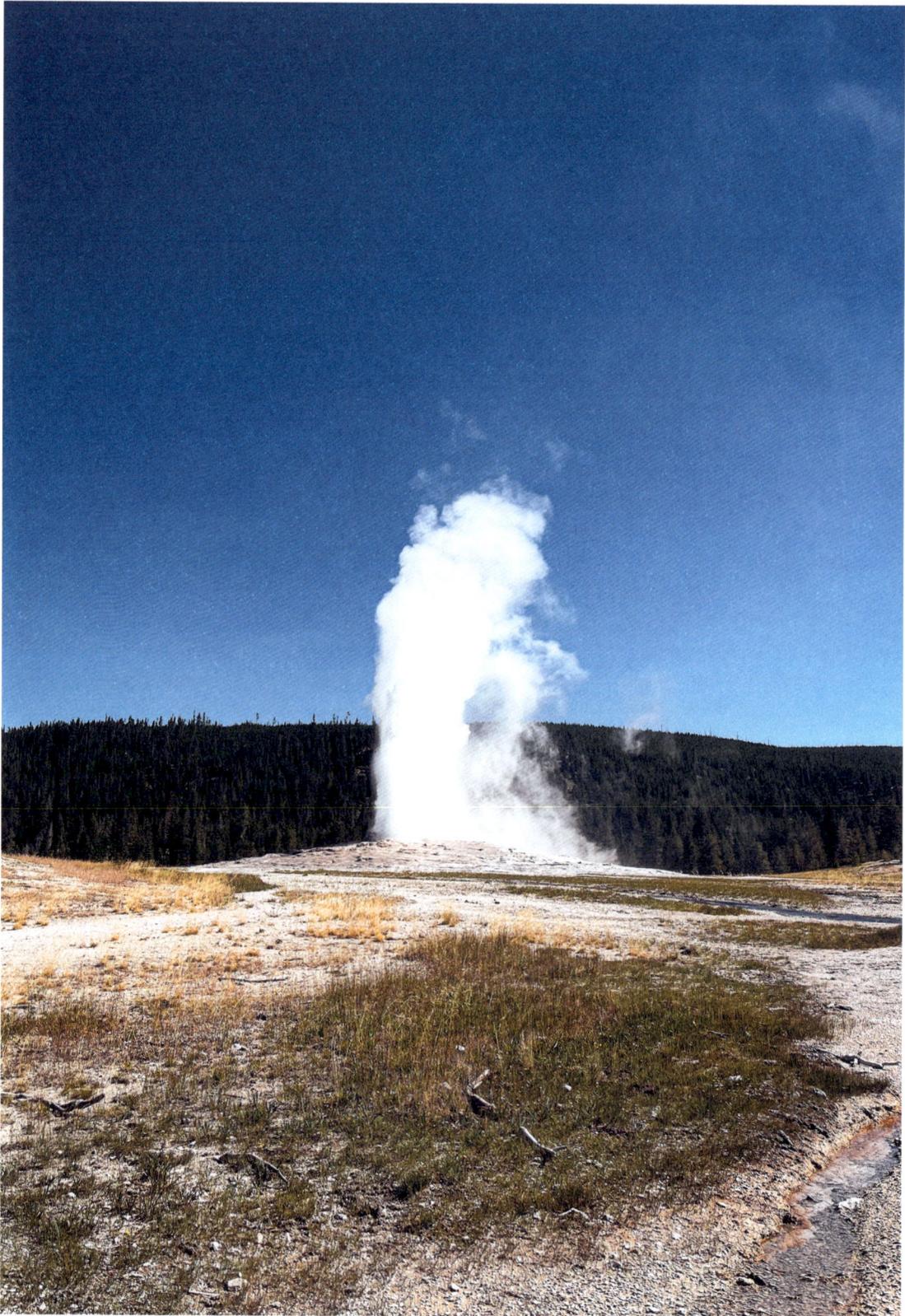

We watch the Old Faithful cone geyser in Yellowstone National Park together with all the other tourists.

and he felt it was time to reconnect with his ancestors. He thought he had something to offer the young teenagers living on the Reservation. At 18, he'd left his small town and enrolled with the Navy Seals. He was later stationed on the USS Nimitz aircraft carrier and deployed on several missions around the world. However, as the years passed, having served in several tours of duty, he grew a little older and a little wiser and started asking questions. Actively questioning the purpose of war. The missions he was told to participate in and, of course, himself. "We are currently walking through occupied land," Snow said, stopping in his tracks before me, gesturing to the horizon around us. I looked out at the flat plains stretching ahead of us as we walked and talked.

But instead of being angry and frustrated, he told me he felt he could channel his energy and ideas into something more positive. Perhaps by writing a book, he could inspire other young Native Americans to rediscover their land and reconnect with the elements, animals, and plant life. To connect with their rightful home, as their ancestors had done for thousands of years before the occupiers arrived.

Walking Dead

Mile 1,087

The motel in Dubois happened to have a scale, and we took turns seeing what we had lost. Between the four of us, Rip, Nosh, Dom, and I had lost 50 pounds (22.5 kg) in body weight within the first two months on trail.

"Dude!" Rip gasped in astonishment as she stared down at the digital scales. "We still have three months to go!" she added. I was well over 15 pounds (7 kg) lighter myself and still didn't look all that healthy.

Fortunately, Dubois did have pizza, and after a peaceful zero resting in town, we soon headed back into the woods.

Fully packed with eight days of provisions, we started hitchhiking in front of the general store. Soon after, a petite lady in an oversized pickup stopped to offer us a ride.

"Hi, I'm Pat! Want a ride? I'm headed that way anyways." Her truck's side door had a big sticker on it saying "Pat for Mayor of Dubois."

"Thanks," we said in chorus and all clambered inside. I took my usual spot in the passenger seat up front next to Pat.

"Excuse me. But are you the mayor?" Rip asked from the backseat as the truck's big wheels left the gravel curb and sped off on the asphalt. We were the only ones on the road, and it was a beautiful morning.

"I'll find out next week. Too bad y'all can't vote here," she added with a friendly smile as she glanced back at Rip. Pat continued to tell us that she was a proud local woman who loved her horses. Although she hadn't lived in the town all her life, she felt she had a lot to offer the community, and judging by her cheerful and welcoming energy, I believed she would make a fine mayor.

"But it's gonna be a tight race," Pat said, glancing over at me. "Another guy is doing a lot of campaigning. But I don't want to get into those dirty campaign tricks. It's just me, Pat. We will see, we will see."

"Oh guys, Felicity is back!" She changed the subject and pointed at a digital sign along the road warning motorists to watch out for bears in the area.

"Felicity?" I asked, a little puzzled. What did that have to do with the bears?

"Oh, that's our local momma bear. She's just had cubs and is back in these hills. Y'all be careful out there." Her tone became serious. "She's been here for years and hasn't harmed anyone, but you never can tell with those female grizzlies." We all absorbed this new information, preparing for the hike ahead. I felt grateful to have met

Pat—and we later found out that she had won the vote and is now Dubois's proud mayor.

"Bear Country. Dangerous. Avoid confrontation." The same poster was at every trailhead. It had a large bear claw on it and was pinned to the noticeboard where the trail led us back into the mountains. Well, we had been warned. Not once, not twice, but three times. Felicity was out there with her cubs, and we needed to stick together.

The strange thing about all the warning signs was that they no longer intimidated us. Not to a state of fear anyway. Strangely, I was kind of hoping to glimpse Felicity. After all, we had seen plenty of black bears, but I was kind of getting curious about grizzlies. A few days earlier, another hiker had come across her about five miles into the trail and had to use his bear spray to scare her off. But I felt good heading out into the mountains with Rip and Dom. Nosh had taken an alternate route and would reconnect with us next week in Pinedale.

We soon came across some bear scat, and things really changed when we saw fresh prints in the mud. The paw prints, with deep sharp claws, were in front of us, and we were on full alert, scouring the horizon for any movement. Fortunately, the trail soon forked into two directions, and the paw prints veered off right as we continued straight on up the mountain track.

As the day continued, we saw no further sign of Felicity, and my attention switched to my other pet fear: thunder. A dark thunderstorm began to rumble in the distance. The clouds rolled in, and inevitably, it started to rain. The heavy load of food on my back made my left shoulder ache, so I popped some ibuprofen to ease the strain. Having had far too little food with me during the previous five days, I had subsequently bought much

too much food in Dubois. The first day back on the trail was horrific, with big jars of peanut butter, mayonnaise, and Nutella weighing me down.

On the second morning, we got up early and were treated to a surprise moose encounter. I had never seen a moose in real life. The year before, I had hoped to see one when I hiked up above the Arctic Circle on the Kungsleden Trail in Swedish Lapland. However, nature can't be scripted, and unfortunately, I didn't see a single moose during my three-week hike. But now, in the early morning, there was one right in front of me, taking its time having its breakfast drink from a pond. The majestic creature waded gracefully through the boggy water, with tall green grass reaching up to its belly. The three of us stopped, took pictures, and let everything sink in. What a sight, what a sight! A creature like no other, larger than a horse, with its long brown nose and a strange goatee dangling under its chin. What struck me most was how silently and gracefully it moved, trotting off a little and then stopping to give us a second glance.

On the second morning, we got up early and were treated to a surprise moose encounter.

Judging our close proximity, the animal decided to move on to more private pastures and trotted off into the thicket. And just like that, he was gone. We stared at one another with wide eyes and broad, contented smiles. We had finally seen a fully grown male moose. No words were said, and we hiked on.

As we walked on, we realized that we had finally seen the so-called *big five*: Rip had seen a pack of 12 wolves up in Glacier and also caught a glimpse of a mountain lion up there. We had seen plenty of black bears and one of us had seen a grizzly in the distance. Elk sightings were becoming more and more frequent, and now

finally we had bumped into a moose. Wildlife really was in abundance along the CDT, as we also encountered longhorn antelope, and the countless deer were beginning to lose their novelty. Rodents frequently poked their noses up at us, and we often saw beavers swimming in lakes, making their dams of logs. The chipmunks and squirrels frequently jumped from branch to branch, and the reptiles became ever more frequent the farther south we trekked. There were numerous kinds of ants, big and small, busying across the trail as we stopped for lunch, hoping to catch a crumb or two. A plethora of birdsong filled the morning air, and we were soon also graced by the sight of a bald eagle as it dove down into a lake to catch a fish.

It's strange to think that less than half a year ago, the thought of walking among all this wildlife really intimidated me. To be totally honest, it scared the shit out of me. But reality is often much less frightening than imagination. The thought of living with bears worried me so much that I nearly cancelled this trip altogether. And to think how totally different my mindset was out here in the wilderness itself. Time and time again, I am baffled by how adaptable and flexible our human mind is in adjusting to new circumstances.

Olympic athletes average a pace up to eight miles (13 km) an hour, over twice as fast as I was walking, and I already felt as though I was flying.

Walking with this young, energetic crew, I found that my pace had increased considerably. Perhaps a little too much, but I was still managing to keep up. We were hiking three miles (5 km) an hour for days and days. As I looked down at my feet in continuous motion, it struck me how abnormal this pace was when compared to the normal tempo of walking with my family in the woods. There are all kinds of words for this sort of pace: speed walking, race walking, and even power walking or flying. Olympic athletes average a pace up to eight miles (13 km) an hour, over twice as fast as I was walking, and I already felt as though I was flying. But I guess the continuous elevation gains and descents, as well as the 10-hour stints we did each day, compensated for that difference.

The wide, flat plains of Wyoming offered the perfect circumstances to get some faster miles done.

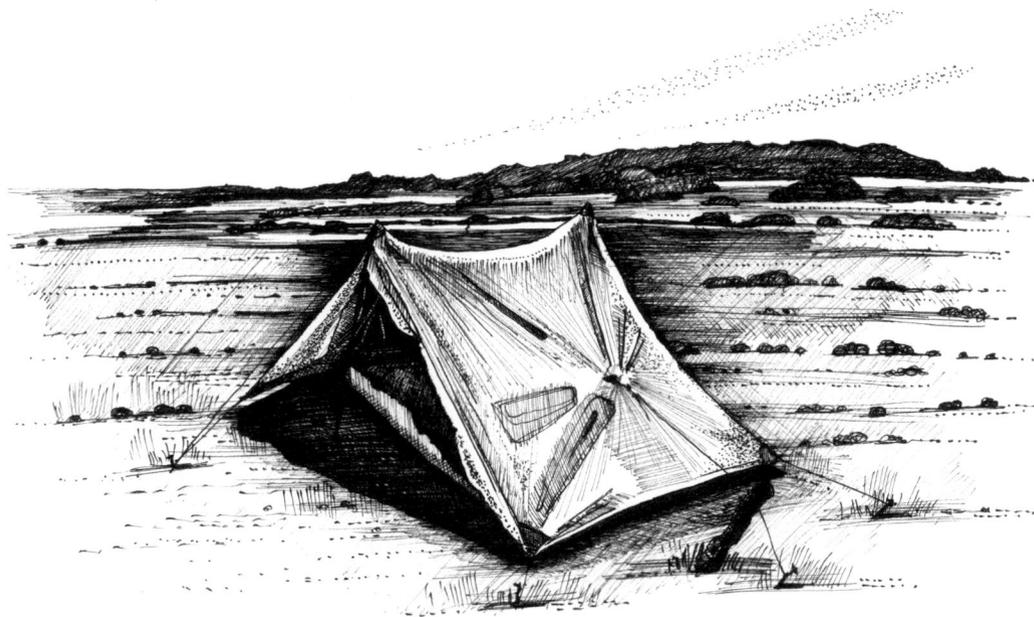

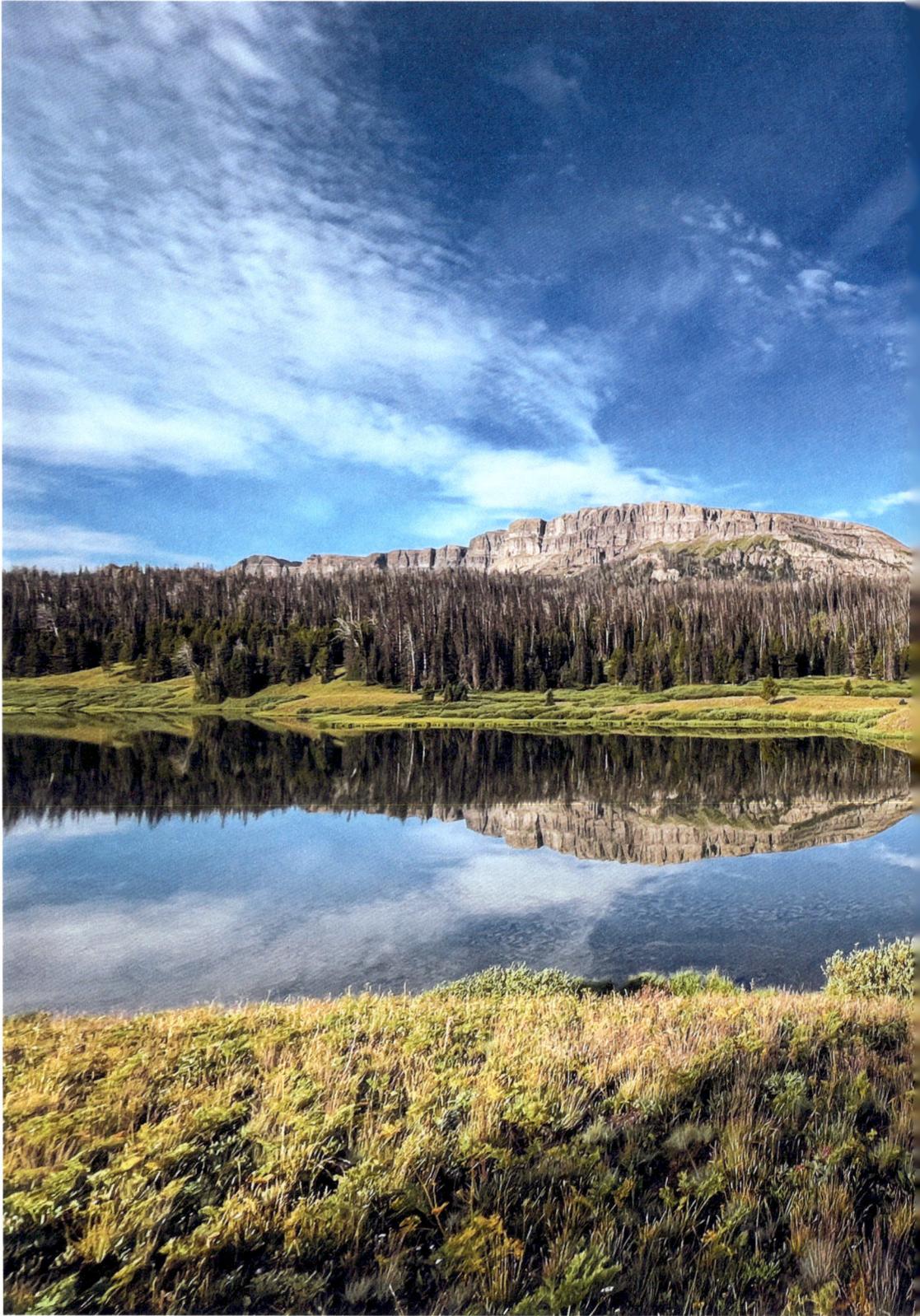

The trail meanders past countless magical lakes in Wyoming.

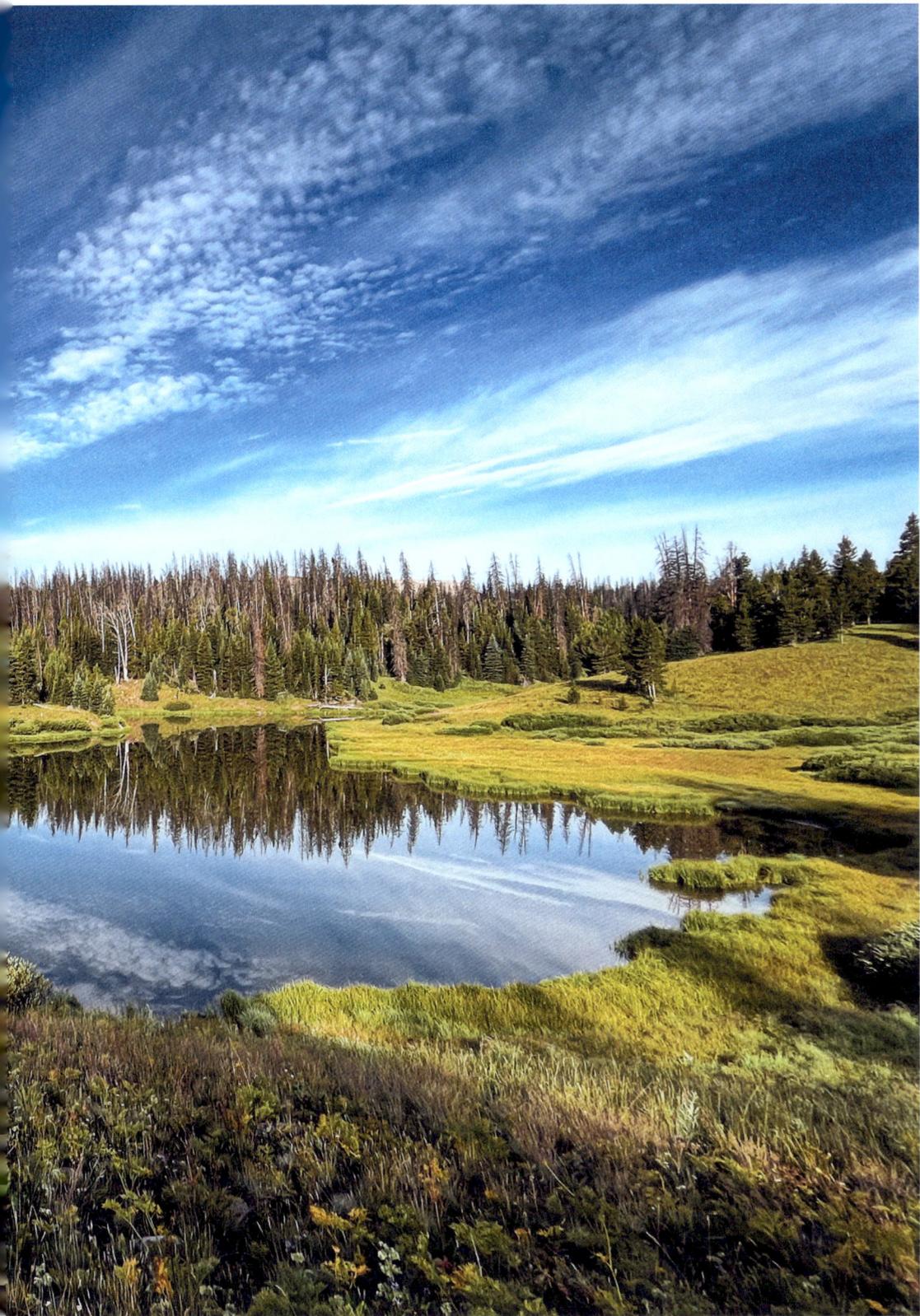

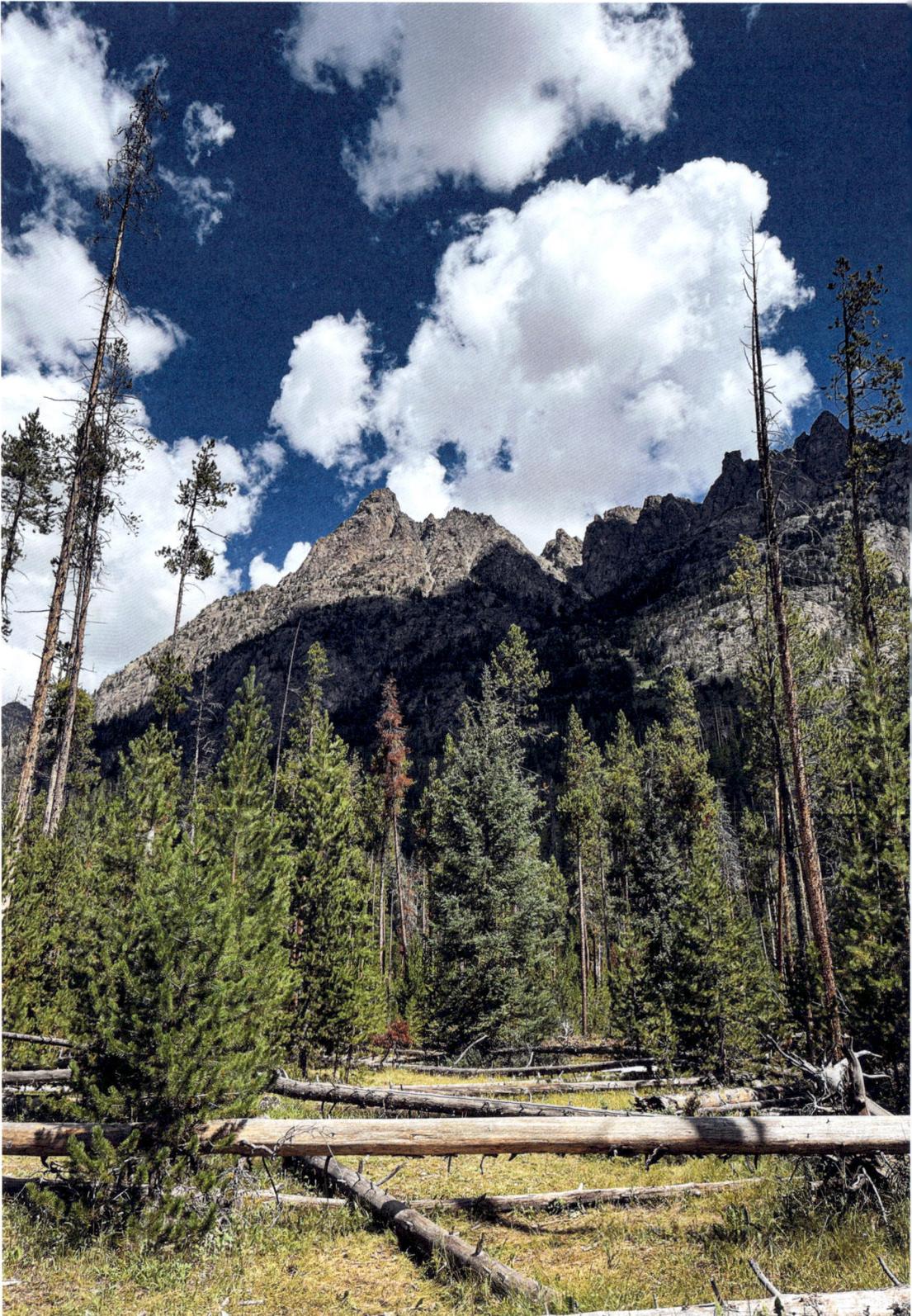

Blowdowns are common on the CDT and
can make trail navigation tricky.

Rip was a great planner and according to her, we were bang on track. The CDT has quite a narrow time window, as we had to get up and over the San Juan Mountains in Colorado before the fall snow came. Having spent a zero in Dubois, we headed back toward the Wind River Range, an area that most NOBO hikers referred to as their favorite section of the entire trail.

The CDT has quite a narrow time window, as we had to get up and over the San Juan Mountains in Colorado before the fall snow came.

The scorched, pale ocher grasslands were occasionally dotted with emerald green oases of wet marshlands. Hundreds of Black Angus cattle grazed the rolling plains. This was a wide-open, wild country with a cinematic beauty.

All of a sudden, the peace and tranquility of my daydreams were interrupted when a lone cowboy galloped toward me. In his wake, a dust cloud rose. This wasn't the movies; it was happening right before my eyes. There was a real working cowboy with two dogs at his horse's heels, checking on the well-being of his livestock. The man wasn't checking on me but was doing his rounds to look in on his cattle.

"Just another day at the office," I thought. These cows really did have wide-open space to roam, and it was strange to think that they would soon all end up as hamburgers. Strange, but I supposed they had a pretty decent life out here. The cowboy rode his horse in a wide circle around the herd of grazing cattle and disappeared into the distance, followed by a fresh cloud of dust.

As he disappeared into the horizon, an even bigger herd of pronghorn antelope ran across the plain with their white tails in the air. The cowboy must have startled them, as they flew across the land at an impressive speed.

Somehow seeing the combination of all these animals together gave the scene a magical, timeless feeling. I was pretty damn lucky to witness this cinematic dance of nature.

But the walking was more challenging than in the movies, and although the scenery was often breathtaking, the reality of the endless miles was tough. On those long, hot days with a heavy backpack filled with food and two or three liters of water, I sometimes had doubts.

When things were rough, I only had to think back to my time in Holland, when I dreamt of walking from Canada to Mexico. Back then, it was so much more than a dream; it was a desperate desire, an unexplainable yearning for adventure. Although there is nothing I dislike about my everyday life, breaking the cycle of repetition, and having distance from all that I know and love has allowed me to see life from a clearer and fresher perspective. To see what has grown in my life and the people around me. To see what has passed. And to think and dream about what may be in front of me one day.

I stopped in my tracks and leaned down to pick up a pair of sunglasses on the trail. They were Dom's, if I wasn't mistaken. Just as Hansel did while walking through the woods with Gretel, Dom left a continuous trace of things behind him. He was notorious for forgetting and losing his belongings, be it his sit pad, his trekking poles, or even his smartphone one time. We had been trying to give Dom a suitable trail name for more than a month, but he didn't like any of them and nothing really seemed to stick. So when I caught up with the others to take a lunch break and handed Dom his sunglasses with a cheeky smile, Rip decided.

"Misplace! That's your name, Misplace. You're always misplacing your stuff. That's gotta be your name." She pointed her finger at him as though he had been a bad boy for losing yet another piece of his gear.

Dom smiled and graciously accepted his new identity. "OK. Misplace it is."

On the third day, we finally reached the Wind River Range. A towering, flat monolith rose above a turquoise, opaque river. Squaretop Mountain was a vast, squat mountain with vertical faces on each side. Hard granite surrounded by soft volcanic rock in the valley. The mountain rose 11,695 feet (3,565 m) from sea level.

I had to stop and take it all in every once in a while. The chances of me ever returning were quite slim.

The trail wound through a meandering bed of blue-mauve sage. Late summer had dried out all the flowers. The sweet smell of sage in the morning never disappointed, and with every step, I became increasingly closer to the mountain rising in front of me. As the path followed the valley and river, we embarked on yet another climb up out of a valley.

Although the four of us camped together each night, we stretched out to hike individually during the day. Everyone had found their own rhythm, and the order we hiked in had even crystallized into a fixed pattern. We walked in an order based on our age. 22-year-old Nosh was always way out front and would probably have loved to do 30- to 35-mile (48- to 56-km) days every day. He was followed by the long strides of his 24-year-old brother, Misplace. Rip's somewhat shorter legs carried her surprisingly quickly, as she was never far behind the brothers. I often forgot that I was twice their age, but fortunately, my skinny legs were still up to the challenge. I usually started the day a bit earlier than the rest, but inevitably always found myself trailing far behind at the end of each day. Of course, it didn't help that I also kept stopping to take pictures, which broke my rhythm quite a bit, but it was a price I was willing to pay. I had to stop and take it all in every once in a while. The chances of me ever returning were quite slim.

Leaving Squaretop Mountain behind us, we decided to take the Knapsack Col alternate. This route would take us up and over the 12,280-foot (3,744-m) Knapsack Col. It took us most of the day to climb, but as darkness fell, and the rocky terrain became a little sketchy, we called it a day at 10,000 feet (3,048 m) and camped near a high mountain lake. It was a splendid spot to camp, quite like no other, as it was high above the tree line. The steep granite mountains towering around us cast long shadows over the lake as the sun dropped behind the summit.

After dinner, I suggested we do a photoshoot. Rip and Misplace agreed to take part, although they had no idea what they were getting themselves into. I had had enough of all the standard mountain and hiker photos and thought that with all these mighty mountains in the background, we could spice things up a little and travel back in time to prehistoric times—I wanted to get creative with the gear we had.

"Take your tents back down; we'll be needing those," I said enthusiastically, rallying the troops.

Misplace looked confused. "But I just put it up."

"I'm not taking mine down either Van Go," Rip responded.

"No worries, we'll just use mine." I pulled the six guy pins out of the soft grass in one pull and swung my Dyneema tent over my shoulder. They looked at me in confusion, wondering what it was I had planned.

I draped the pale orange fabric around Rip's head and shoulders, letting her hair fall straight along her eyes. The contrast of her dark hair with the light tent fabric made a great base for a picture. The tent magically transformed into a cloak as the wind blew it in all directions. I crouched low with my camera and started taking a few shots with the looming mountain rising up behind her.

"You look great! Look into the distance, just behind my shoulder," I shouted, giving her

directions as if we were in a professional photo studio. "Now look left, now look straight down at me!"

"How long is this going to take, Van Go?" Rip burst out laughing.

"No smiling!" I commanded. With a stern, stoic expression, Rip instantly appeared timeless.

"Now it's your turn," she yelled to me through the wind. I suppose it was only fair they got their share of laughs, turning the camera lens back onto me for a photoshoot of their own. As darkness fell, we returned to camp smiling and I set up my tent for the second time that evening.

The following day we skirted a lake before heading ever higher to scramble up to Knapsack Col. But this sounded easier than it was, and for the first time on the CDT, we had to do some serious rock climbing. I stowed my trekking poles in my backpack as we used our hands to grip the boulders up the steep mountain face. The trail was nowhere to be seen, and the remains of a small glacier to our right created eerie sounds deep beneath the rocks. I could hear water gushing deep below me. We moved painstakingly slowly, and I had to stop to gasp for air every hundred feet (30 m). The high altitude was getting to me more than the others.

"Turn around!" Misplace shouted down to us, waving his arms to indicate that we should stop. It had evidently become too dangerous to go any farther on our route. I sighed with relief and was very happy to turn around again.

"We probably took the wrong route. Let's try left over there," Misplace said once we gathered again, pointing to another field of impregnable boulders. I was happy he was taking the lead again, as my fear of heights always got to me in the high mountains. We followed Misplace and tried the other route on the far left, where we were happy to see a few sporadic cairns, suggesting other hikers had been before us. We slowly made our way up to the pass, careful not to kick any loose rocks that might tumble down the hillside and hit one of the others.

The whole morning's endeavor took us more than three hours. When we finally reached the top of the pass, we were surrounded by snowfields, remnants of what had once been large glaciers. We found a warm rock out of the wind and had our lunch. Much-needed calories after all the energy we had lost in two attempts to scale the mountain.

We slowly made our way up to the pass, careful not to kick any loose rocks that might tumble down the hillside and hit one of the others.

Resting and looking down into the next valley, I felt as if I was back in the Alps, with the tall, pointed mountains of the Wind River Range rising before us. Gazing into the picturesque valley, I understood why we had gone through all this trouble to get here, and why so many NOBOers held this section of the trail in such high regard.

The view was breathtaking, and I sat in silence, taking it all in. But what comes up must go down, and the descent was a lot more challenging than the previous climb. The steep slope downhill was nothing more than loose scree, which required some technical expertise. I was surprised to find myself at the front of the group, as I usually trailed behind. I shuffled down the slope slowly, with small steps. I made a conscious effort not to look down the steep drop-off to my left and managed to keep my composure. At one point, maneuvering around a tricky boulder, I glanced down and saw that the drop beneath was practically vertical, and one misstep could have been fatal. My stomach turned. This was usually the point where I froze. But strangely, this time, I kept my cool. I asked the person behind me to give me a few seconds while I worked out how best to tackle the obstacle in front of me. I took a deep breath to lower my heart rate, placed my left foot carefully on the ledge in front of the overhanging boulder, and balanced my way around the

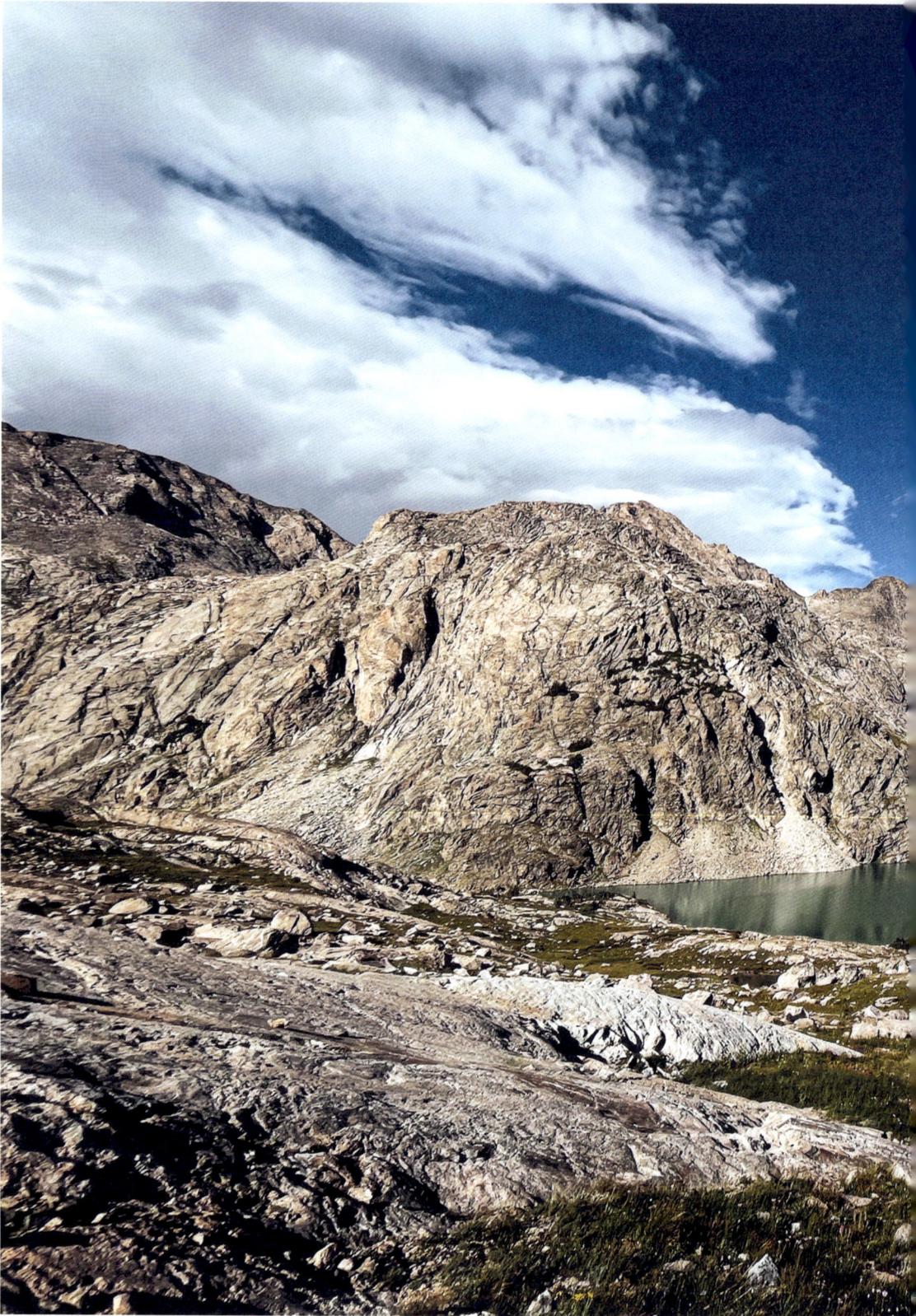

We find the perfect spot to camp high in the Wind River Range.

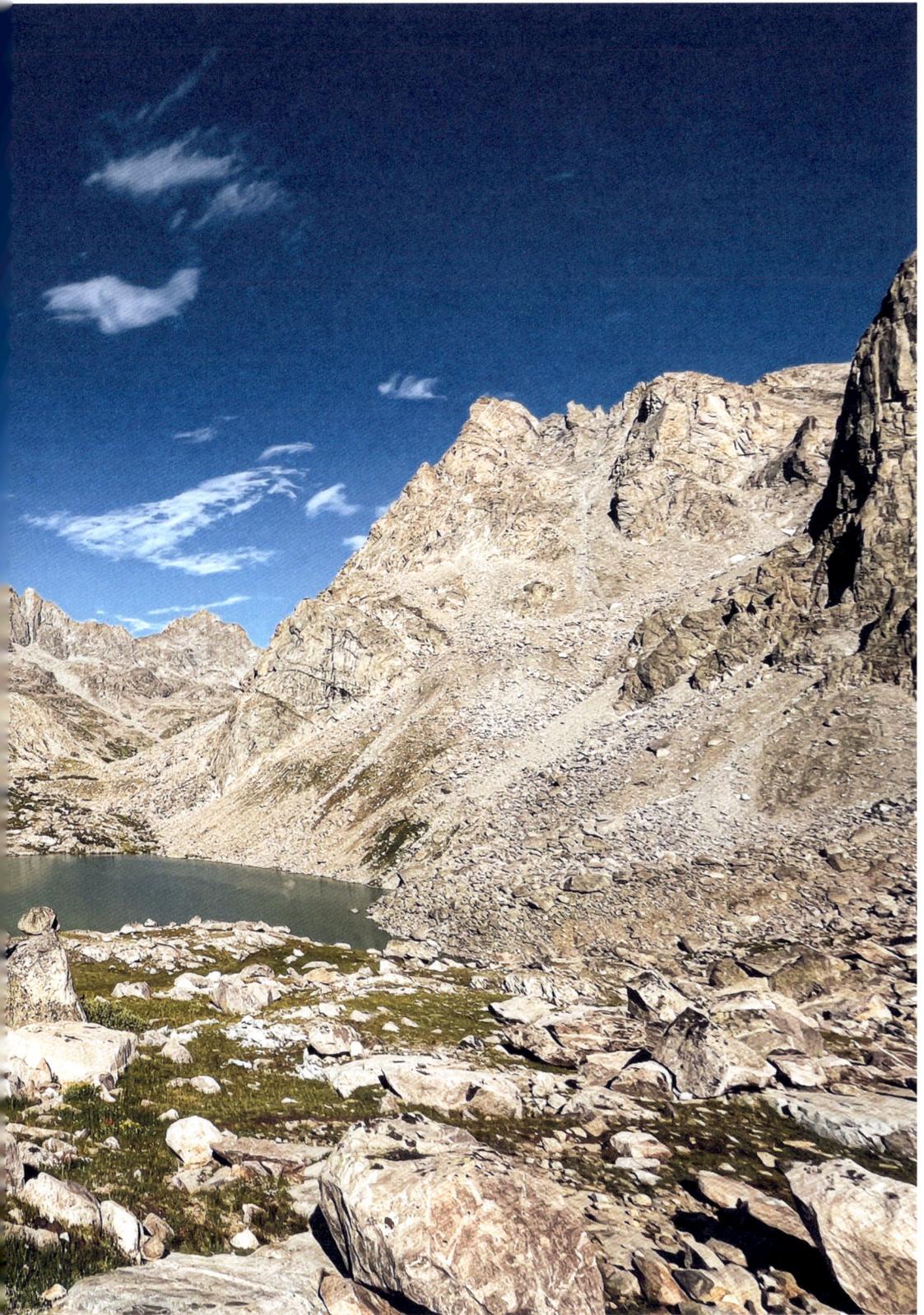

rock, gripping it for dear life. I slowly continued down the hill as if I were walking on a tightrope.

Having passed the steep, sketchy section, the trail eased, and by glancing back at the others, I could tell I wasn't the only one who had been terrified. When the trail hit a large snowfield, we all sat back and slid down the remaining part of the mountain. It was great fun, like being a kid again, sliding 100 feet (30 m) down the steep slope.

The mountains and milky lakes stretched out before us, with a perfect trail meandering through an alpine meadow dotted with flowers of all colors. We had quite literally reached the Garden of Eden: The Wind River Range in all its splendor.

Rock 'n' Roll

Mile 1,089

I was relieved at last to see a message from my friend Necktie, who I expected would be a few days behind me. I was surprised that my youthful English friend still hadn't caught up with me. But when we spoke, it soon became clear why. Necktie had taken the Big Sky alternate through Montana; we were hundreds of miles apart. And he had some bad news. He had picked up a back injury and had been off-trail for the past two weeks. But Necktie always seemed to walk into a new adventure wherever he went.

"The trail provides," he said in his soft-spoken British accent. He told me that by chance, the person who had stopped to give him a ride from the trail also happened to be a chiropractor who offered to put him up while his back healed.

"What are the odds?" he added, still in disbelief at how his misfortune had brought him so much good fortune. "But dude, I can hardly walk."

It was quite a setback for a hiker. I could hardly imagine what he must have been going through. He told me that he had decided to change his plan and had borrowed a bicycle from friends down in Colorado, with which he now planned to cycle through Wyoming, from Yellowstone down to Colorado. Cycling was a lot better for his back, apparently. He sent me a picture looking all happy and excited next to his lightweight bike, with tiny saddlebags hooked to the front forks.

I was aware that there was a long gravel road following the Continental Divide but didn't know so many people took this route each year just to cycle from Canada to Mexico. The Great Divide Mountain Bike Route, as it is called, attracts lots of cyclists from around the world each year and has been developed and mapped since 1997. I had bumped into the bikers occasionally in town or when our paths crossed, but for the most part, our communities didn't mingle or mix much. As they were doing 100 miles (160 km) a day, we never saw them more than a night, and the whole lifestyle and mindset seemed worlds apart. So Necktie had decided to turn his adventure into a biathlon, using only human energy to power him all the way down to Mexico. He intended to rejoin the hike in Colorado, so who could say, perhaps we would reconnect a few weeks down the road.

After speaking to Necktie, I realized I needed to be honest with myself: I had potentially been carrying giardia with me for the past 10 days. I walked into the medical clinic in the small town of Pinedale.

The Great Divide Mountain Bike Route attracts lots of cyclists, and I had bumped into the bikers occasionally in town or when our paths crossed.

My health was not good, and I was tired of walking on empty. The bug— whatever it was— was still eating away at my energy, and it was time

to nuke it. As several other hikers were also down with similar symptoms, I figured it must be giardia.

A friendly nurse took me into a sterile cubicle and filled out a form, running through a few general questions before taking my blood pressure.

"The doctor will be with you in a few minutes," she said with a smile that was brighter than the white walls, and I was surprised at the speed of their service. I had heard terrible stories about health insurance and the medical system in the U.S., so this could mean only one thing. I was going to get a mighty high bill for this great service. But I had little choice, and I was grateful to be getting medical attention at last. The bug had to be stopped; I was losing all sense of joy in my hiking.

"You could be right; it could be giardia. Do you want us to send a specimen to the lab?" the doctor asked after having briefly examined me.

"No, just give me the drugs," I said, trying to hide my desperation, giving him a polite smile.

He handed me a prescription and pointed me toward the pharmacy. I signed a bunch of papers at the reception and didn't ask what it would cost. I simply hoped my health insurance would cover it.

Half an hour later, I picked up my antibiotics at the local pharmacy. I couldn't have dreamed of better service and efficiency. I was delighted to finally have the antibiotics, as I was heading back onto the trail again the following day. There were three other hikers in bed with giardia and three more who had quit the trail altogether, unable to shake the beast. I hoped the meds would kick in soon.

Rip had booked us a room at the Pinedale Jackalope Motor Lodge, and we all bundled into the dated room, taking turns for warm showers. We had frequently bumped into other groups of hikers in previous towns, but although many of their faces were familiar, I hadn't spent much time speaking with them yet. It was a large gang, comprising several smaller groups of friends. But together they were called "The Horde."

The energy was high—a few natural highs and a few drug induced. They were falling over one another to make obnoxious jokes, with

New Zealand's Corncob winning the most laughs. Everyone seemed to have bought some new loud, colorful outfit at the thrift shop in town, and some of the girls were painting everyone's finger and toenails with glittery green polish.

There must have been 20 of us in the backyard, squeezed around the picnic table laden with cheap beer and plenty of mushrooms.

"Is that your pack?" a guy asked, gesturing to my bag. He was shirtless, clad in only his dark chest hair and brightly colored shorts. "Can you do one of those drawings on my pack?"

"Sure," I said, "What do you have in mind?"

"Not sure, really," he replied, handing me his black backpack. "What do you think? I'm Sweetness, by the way." The young guy gave me a fist bump and handed me a beer.

"What are two words that are important to you?" I asked.

"Saving and People," he said quickly. I was a little puzzled as to what lay behind the combination of the two words.

"Sweetness used to be a helicopter pilot," someone else explained.

"Six years in the Navy. You wouldn't think so, though. With my hiker trash beard now, an' all." Sweetness kept it at that. But it explained enough for me to know what to draw. As there was free Wi-Fi at the Jackalope Motor Lodge, I quickly Google Translated "Saving People" into Latin.

"Salvis Hominibus." This would work better for the design I had in mind. As Sweetness's backpack was black, I used my silver Sharpie, as it had worked well on Nosh's backpack a few weeks earlier when I had drawn him an eagle.

As Sweetness had been a pilot in the Navy, I decided on the classic Navy tattoo: the swallow. I have always loved swallows and swallow tattoos in particular. Swallows have several meanings. Each swallow represents 5,000 nautical miles in a sailor's career. The Earth's circumference is 21,639 nautical miles—about 4.16 swallows. Swallows are known for their migratory patterns, where they travel long distances from home and back again. So a swallow could also mean that a sailor would always find their way home safely.

Each swallow represents 5,000 nautical miles in a sailor's career. The Earth's circumference is about 4.16 swallows.

So the swallow felt fitting for Sweetness's pack. Sharpie in hand, I set to work, my fingers feeling for the familiar shape of the bird. I've drawn so many swallows that I could draw them by heart, diving into my mind's eye. There is something iconic and timeless about its shape. Its circular head and body contrasted by its long, V-shaped wings.

"Love it," Sweetness said when I was finished. "I love it, man. Thank you so much." He leaned forward over the picnic table to hug me. There was even a tear welling up in one eye; the words and the bird clearly meant a lot to him. I can only imagine what he had been through as a young pilot in combat. Experiences like that must scar you for life.

The Horde was temporarily homeless by choice, all dressed in worn-out rags, hairy, and showering once a week. Yet everyone—myself included—felt totally at home in this Wild West environment and within this group of strangers. Privileged hobos who chose to save up, create time, and go on a walk across a big country. Each had their own reason for walking, some running away from something and others searching for something or themselves. But each was a dreamer living their dream.

The Horde was rowdy and loud and had a totally different vibe about them. Some had previously hiked the PCT and AT and were now completing their Triple Crown together. During their past trails, their backpacks had shrunk considerably to ultralight setups, often not much heavier than 11 pounds (5 kg). That included all their

belongings, from tent to sleeping mat, sleeping bag, and clothes. Forty-liter packs seemed to be the norm these days, with some as small as 39 or even 35. Quite compact compared to my 55 liters.

The more I hung out with these guys, the more it felt like I had traveled back in time, witnessing a rock 'n' roll band's tour in the 1970s. Hanging out with this crowd, I didn't totally feel as though I belonged, but rather like an accidental observer. Like in *Almost Famous*. Of course, as with any self-respecting band, there was a considerable amount of substance use and some good old free love among them. Boundless youthful energy, filled with raw confidence, unbridled optimism, and uncompromised idealism. They were primarily American guys between 20 and 35, but also several women. One was a tall 26-year-old Danish woman named Wrecking Ball. I'd seen her before back at Luna's, but it was only now that I kept bumping into her more and more. Her colorful personality was reflected in the bright neon outfit she had picked up in one of the local thrift shops. She wore rainbow-colored cycling shorts and a glittering red blouse, perhaps not made of the most ideal hiking materials, but you had to sweat to look good out here. She had found a pair of flashy silver Pit Viper shades and wore them religiously over her blond curls.

The more I hung out with these guys, the more it felt like I had traveled back in time, witnessing a rock 'n' roll band's tour in the 1970s.

Wrecking Ball and I got along well, as we both liked obnoxious colors. We gave each other a much-needed long hug every time we met. Her bubbly personality was infectious and influenced the mood of the entire gang. Everyone around her seemed to be friendly and upbeat.

There were suddenly a lot of extroverts around the table, and I enjoyed the long conversations we had during the long day in the sun. Although Wrecking Ball was Queen Bee in this group, there wasn't a real leader. But the group did have a lead singer: Treeboy, a gifted young musician. He carried a battered old Martin Backpacker guitar wherever he went. It had been his companion during the AT, PCT, and here on his CDT—and it showed.

The sing-along covers began and we all joined in. Nothing quite like a campfire evening with live music. All eyes were on Treeboy as he plucked away at his five strings. The sixth had broken. He pushed his straw hat back, which had a whole collection of feathers, and the light from the flames caught the purple crystal earrings dangling from his ears. With his fashionable blond mustache and straight long hair, he looked right out of a 70s band. There was something mystical about him, as he generally didn't speak much when he wasn't singing. As with most singer-songwriters, a cloud of mystery hung around him; you could never quite catch the full scope of his personality.

While everyone listened, I returned to the picnic table to tattoo the gear of more hikers. I did a mountain for Race Horse, a marmot for Marmot, a Japanese wave for Easy, and an Eagle for Corncob. There were so many new faces, and meeting so many new hikers felt great. And their trail names never ceased to entertain me: Doc, Chuckles, JT, Recharge, Lotus, Fastcash, King Wallabee, Mango, Mousetrap, Princess Ann, Wander Woman, Cheepers, Piper, Wanderer, Nice Lady, and Lacoppa.

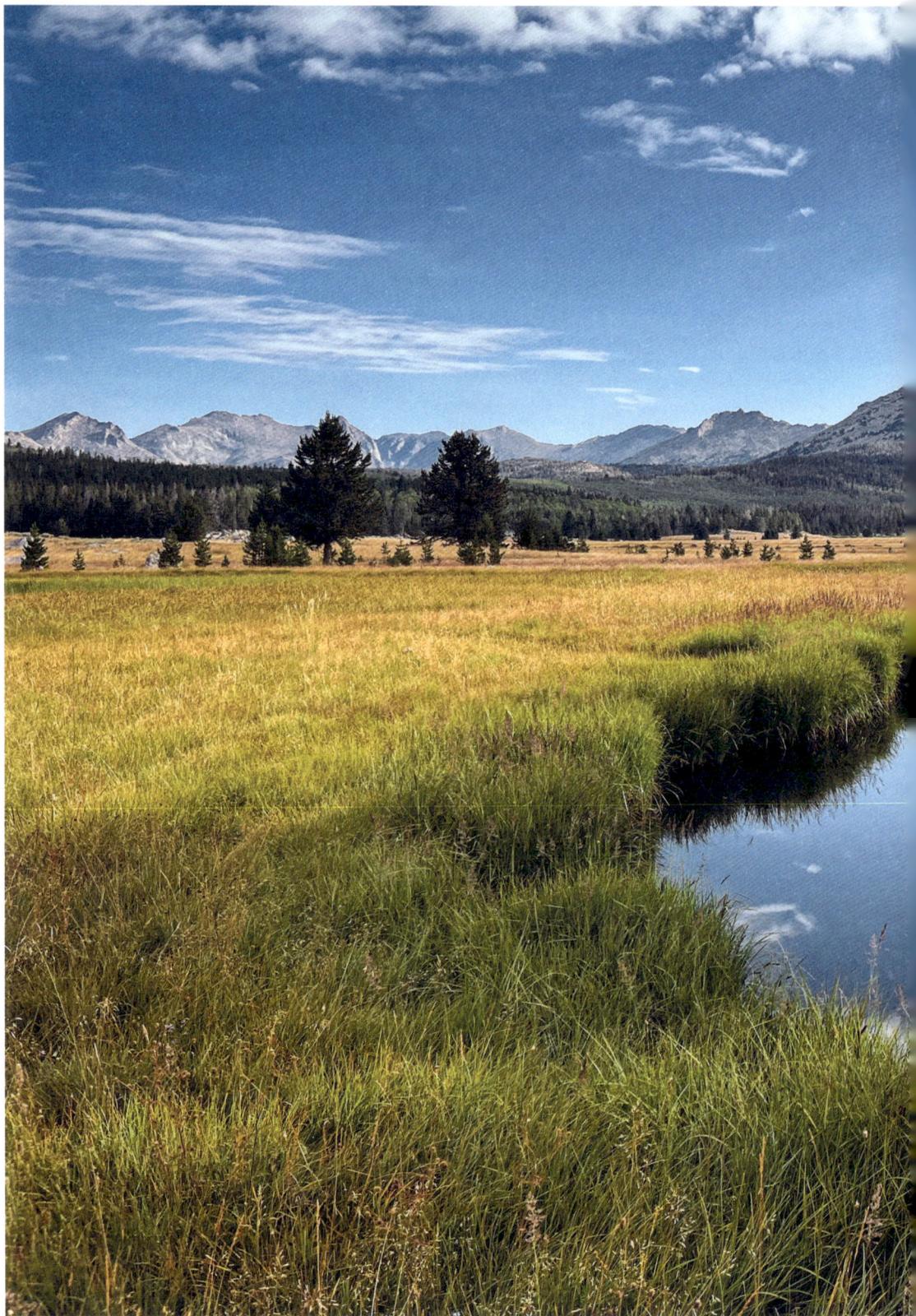

We stop for a quick swim during another stunning day in the Wind River Range.

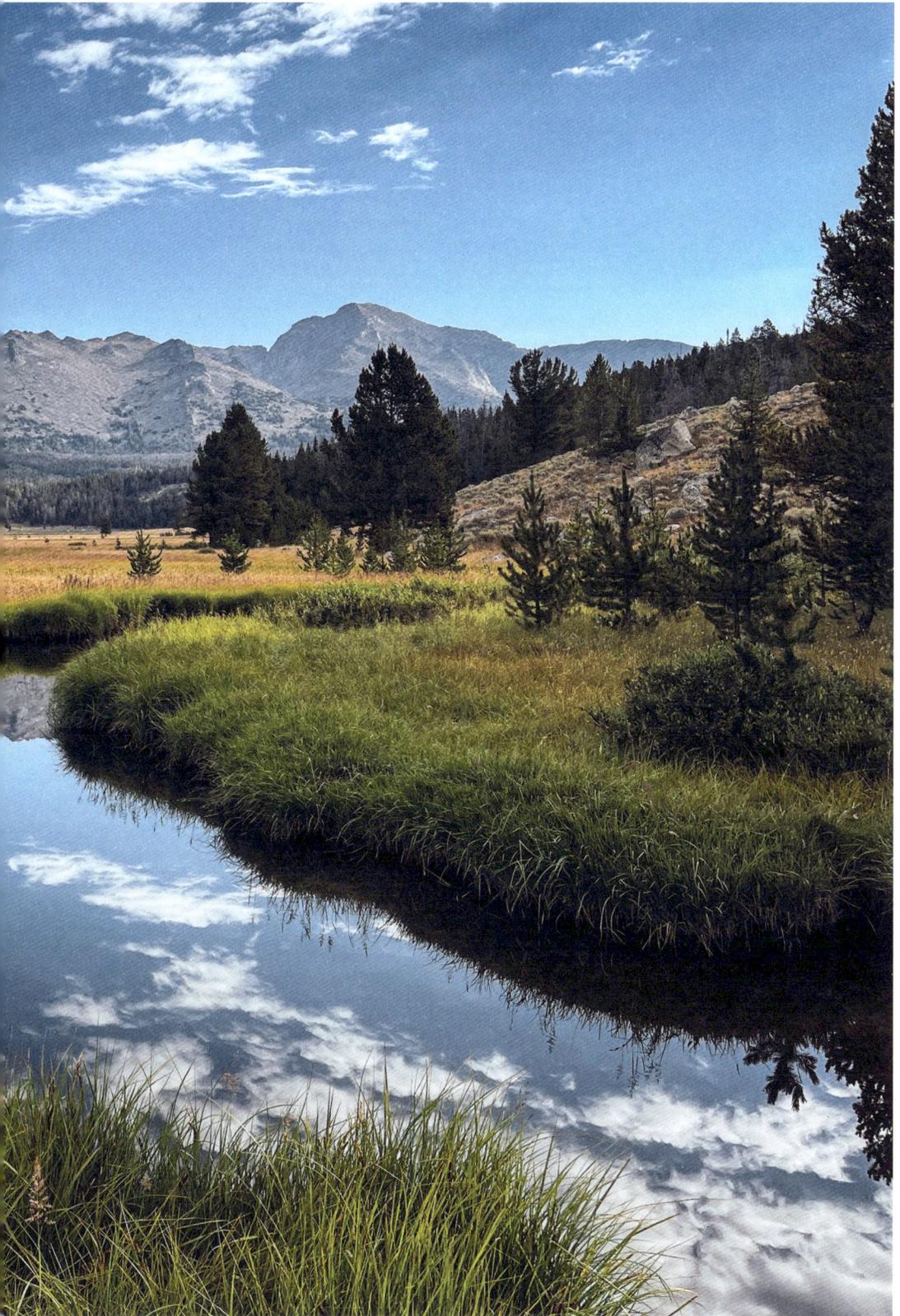

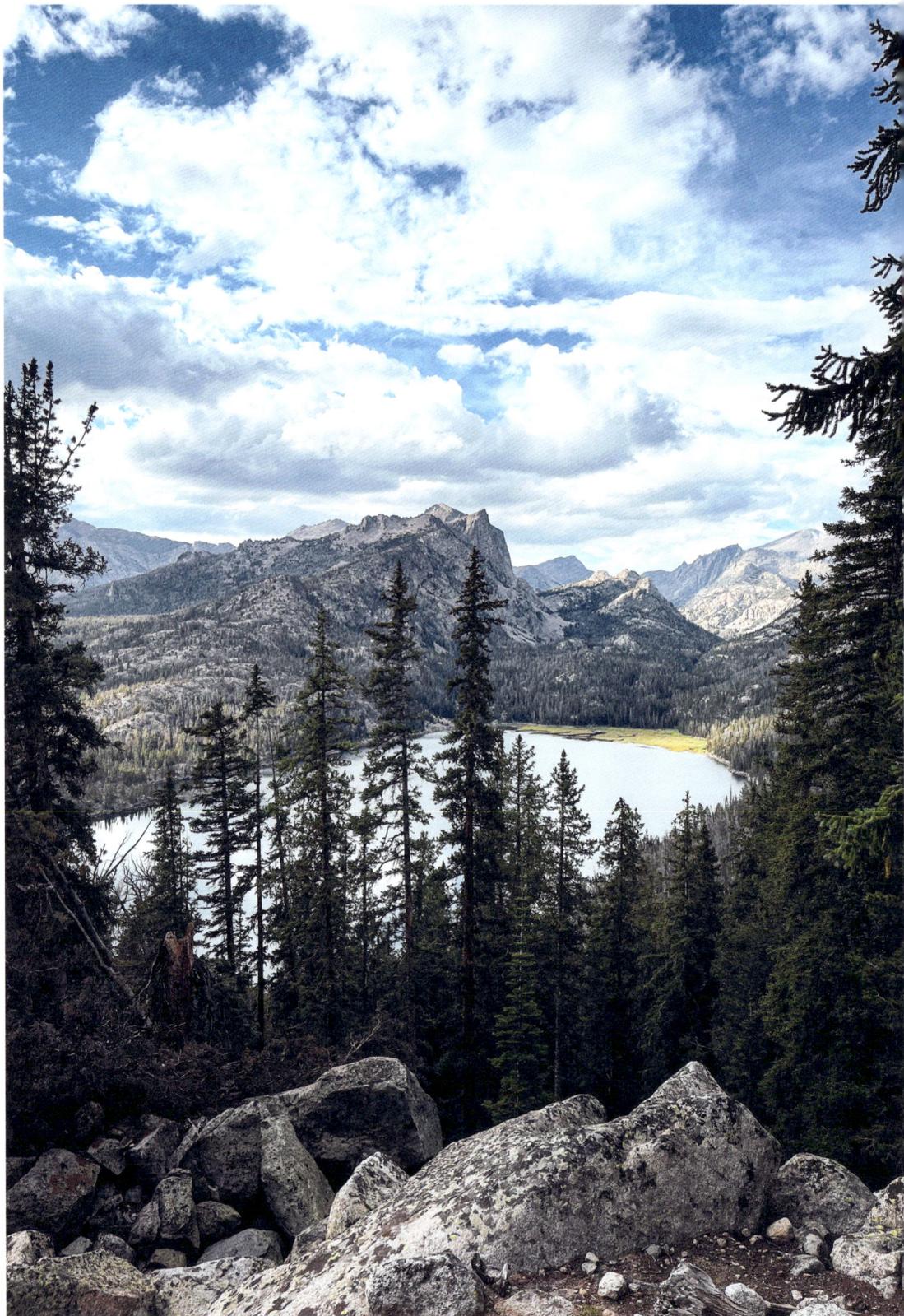

What comes up must go down, and I am looking
forward to another refreshing swim.

Alone

Mile 1,161

Having left Pinedale, our hitch dropped Rip, Nosh, and me off at the trailhead. Misplace had gone on ahead earlier that morning. Everyone needed some peace and quiet, and I felt the time had come to let the group go. Their pace was a little too fast, the days were a tad too long, and I needed some time alone.

So I said goodbye to my trail family, feeling both sad and relieved. Relieved to slow down and finally let my body heal with the meds. And honestly, I was excited to be heading on totally alone.

I had to look out for myself now. All the decisions in dangerous situations would be on me. All the fun and entertainment, well, I would have to create that for myself now. There was no hiding anymore. For weeks the group had given me a strong sense of security, structure, and joy. I was grateful for my time with them but was equally looking forward to striking out alone.

> I felt the time had come to let the group go. I had to look out for myself now. All the decisions in dangerous situations would be on me.

My timing to go on alone couldn't have been worse, but as with so many things in life, these things can't be predicted. Soon after I said goodbye to my friends, an enormous thunderbolt ripped through the sky, followed by cracking thunder. Just my luck. But although I was alone for the first time in a storm, I didn't freak out. I'd been through enough storms with the group.

As it was Sunday, there were lots of day hikers hastily running back to their cars at the trailhead, as most of them hadn't expected the heavy rain. Wet T-shirts clung to their cold bodies as they hurried back. I had bought a new silver sun umbrella a few weeks back and hadn't used it much yet, but this was a great opportunity to use it as protection from the worst of the hail and rain. It took about an hour and a half to blow over, and then I simply pulled my pack back on my shoulders and headed farther up into the Winds.

I followed the trail back to the CDT, and after 10 miles (16 km), I took a right turn and left all the day hikers behind me to finally be alone. It felt good to be walking at my own pace, and I was kind of excited to see what unexpected twists and turns the CDT had in store for me. I definitely had to pay more attention at each trail junction to avoid getting lost, and had to ensure that I had enough water with me until I reached the next spring or river. And although I did take a wrong turn now and then, I generally did okay that first day.

By evening, I was ready to set camp. As I didn't want to be joined by anyone for the night, I walked a good distance from the trail, finding a small lake with a nice flat spot where no one could see me. As it was getting cold, I quickly set up my tent, put all my clothes on to keep warm, and boiled some water for pasta. I was too tired to feel worried or anxious about sleeping in bear territory, as I had already spent nearly 70 nights out in the woods with them. This was my home for now, and I felt comfortable. Grateful that I was finally keeping my food down, I tried to eat as much as possible, aware that I still needed a lot of calories. Although I was pretty tired, I couldn't fall asleep immediately and lay on my back, reflecting on my first day alone and how much I had enjoyed it. On my own, I realized, I only had to listen to my body.

The following days passed in something of a daze. I slowed my pace, took many more breaks, and did far fewer miles than in previous

weeks. I simply didn't want to push too hard, as the meds and my red blood cells still battled the bacteria in my stomach. I uttered no more than two words in a day, greeting what must have been one of the last NOBO hikers that crossed my path. It felt good to turn off my verbal side for a while.

Several days later, after having spent a while alone on trail, my voice had to refind itself when I greeted a familiar face.

"Good to see you, young man," a familiar Lancashire voice greeted me. He always had a kind and entertaining way with words.

"Hi there," I replied in a rasp. "WoW, right?"

"Yes! Van Go, right?"

I was delighted to see WoW again. After meeting at Luna's, we'd bumped into one another quite frequently during the past two months but never really had the opportunity to have a decent chat. There was always something else to do when we met in town. WoW's loud, raw, typical North West English accent disguised the fact that he had lived in Tasmania for most of his life. His thin, strong body was no more than muscles and bones. As I soon discovered, he, too, was low on energy.

"It's just the old age and lack of calories; it's as simple as that," he said with a generous dose of modesty.

WoW had recently turned 67 and would complete his Triple Crown when he reached the New Mexican town of Grant. He had already walked up from the Mexican border for a month in spring but had to flip-flop up to Canada, as there had been a fire closure in New Mexico. He was an entertainer with a radiant, loud laugh, always at the ready with a funny story. Only right now, there wasn't much to laugh about. We were both quite fragile and hungry.

"Fancy a burger?" WoW said, giving me a cheeky glance as he walked on ahead of me.

"You what?" I said, totally puzzled, as there were two days both ahead of us and behind us before we would hit any town.

"There's a café just a few miles off trail. Want to join me for a burger?" he explained. "It's

a bit of a detour, with quite a few extra miles; I figure it's worth it, right?" His grin had grown, as he fantasized about what to order alongside his burger. "I'm starving."

"Of course. Yes. Sounds like a plan," I said enthusiastically. I couldn't believe my ears and my luck, as I was already pretty bored with all my pasta, and my stomach was holding up pretty well the past few nights.

"But we will have to skip the Cirque of the Towers if we choose the burgers," he added, not slowing his pace one bit. "I just don't have the energy to walk up there. I need food."

It would be a pity to miss out on the stunning views and photogenic mountain pass, but I was in no mood to test the weather gods right now. We took a right, leaving the trail in our quest to find sustenance.

"I'll never forget that poor chap who came in after having been struck by lightning one day. His heart was all out of rhythm. It had basically withered with the power of the lightning bolt." WoW was telling me about his lifetime spent working in emergency wards of hospitals in and around Australia.

We followed the trail through a grassy yellow valley, skirting the high mountains. Our navigation app led us to the small mountain lodge, a few miles off trail, and we both looked at the comments in the app that stated that the lodge had *The Best Burger in the World*. "That sounds familiar," I thought, recalling the Paradise Café along the PCT, which also claimed to make *The Best Burger in the World*.

As we talked and walked, I could see that WoW's energy was so low that he was simply falling forward as his feet pushed him onward. Unfortunately, there was no one to give us a hitch to the lodge when we reached the road, so we had to walk another few miles. When we finally reached it and opened the wooden log cabin door, a kind waitress walked toward us, welcomed us, and handed us a menu with all their burgers displayed on it.

"Sorry, we're out of practically everything today," she said simply.

"I'll have *The Best Burger in the World*," I replied, hoping they still had them.

"Sure, we will never run out of those!" She smiled. WoW ordered the same—twice. He clearly must have been hungry.

Life is simple out in the woods. Very simple. If there is an obstacle in front of you, you simply have to work it out right there and then before you can continue and do anything else. The trail forces you to focus. The obstacle may be a river, mountain, storm, moose, or bear with its cubs. Although the puzzles I faced each day were often less dramatic, thank goodness. But if things got too serious and dangerous, there was always the option to turn around and go back.

Life is simple out in the woods. If there is an obstacle in front of you, you simply have to work it out right there.

What makes life so simple on trail is that you often have very few choices. You can choose to go through the dangerous river, or you can choose to wait and camp on its banks, hoping the water will be lower the following day. That day we chose what we needed: we left the trail. And the burgers were very good.

A few days later, having lost sight of WoW, I woke up to the sound of an unfamiliar voice calling out.

"Moose!" The voice came from a tent nearby. It was 6:00 in the morning, and I quickly poked my head out of my tent to see what was going on. To my astonishment, a large male moose with its heavy antlers was looking straight at me. No more than 8 feet (2.5 m) away from my tent. It seemed life went in slow motion for this majestic animal, who chewed its grassy breakfast ever so slowly. It grunted and sniffed from its nostrils

repeatedly, but made no advances toward our tents. Someone had pitched his tent next to mine sometime in the night, and we both watched the moose in happy disbelief. We had clearly camped right in the middle of his breakfast buffet, and he had no intention of leaving anytime soon.

"Honeybum," whispered the young hiker later, stretching out to give me a fist bump. As we sat having breakfast together, he told me that he'd had the fright of his life when he had gone out for a pee in the middle of the night. His headlamp had met two reflective eyes low to the ground, right by his tent. The two eyes had moved up, towering far above him like some kind of alien giant taking off. He had no idea what it was in the dark, and shot back into his tent after relieving only half of his bladder. The following morning, when the twilight returned, he saw that a moose had slept right next to him all night. Although we were nearly out of bear country, the wildlife was still all around.

After that, the hot mornings swiftly transformed into rainy thunderstorms for seven straight days. That day was no exception. While I used my silver umbrella in the morning to protect myself from the bright sun, I was under my umbrella again by afternoon to protect myself from the rain. After days out on trail, my food was nearly diminished, and I was walking on empty again. Luckily my spirit and morale were still high and untouched, though my energy was flat. The climbs especially were taking their toll, and I could feel the life drip out of me with every drop of sweat. I was very much looking forward to town, bed, and some rest in Lander.

After two days of sleeping like a starfish on a king-sized bed in a dark motel room, my energy returned. The meds had at last done their magic, as my stomach cramps and bad wind were finally gone. I packed up and hitched back up to the mountain, where a trail stretched out into the desert. The flat landscape, interrupted only by a few plateaus, looked like something from my dreams. It would be nearly 125 miles (200 km) of relatively flat trail, but without a single tree

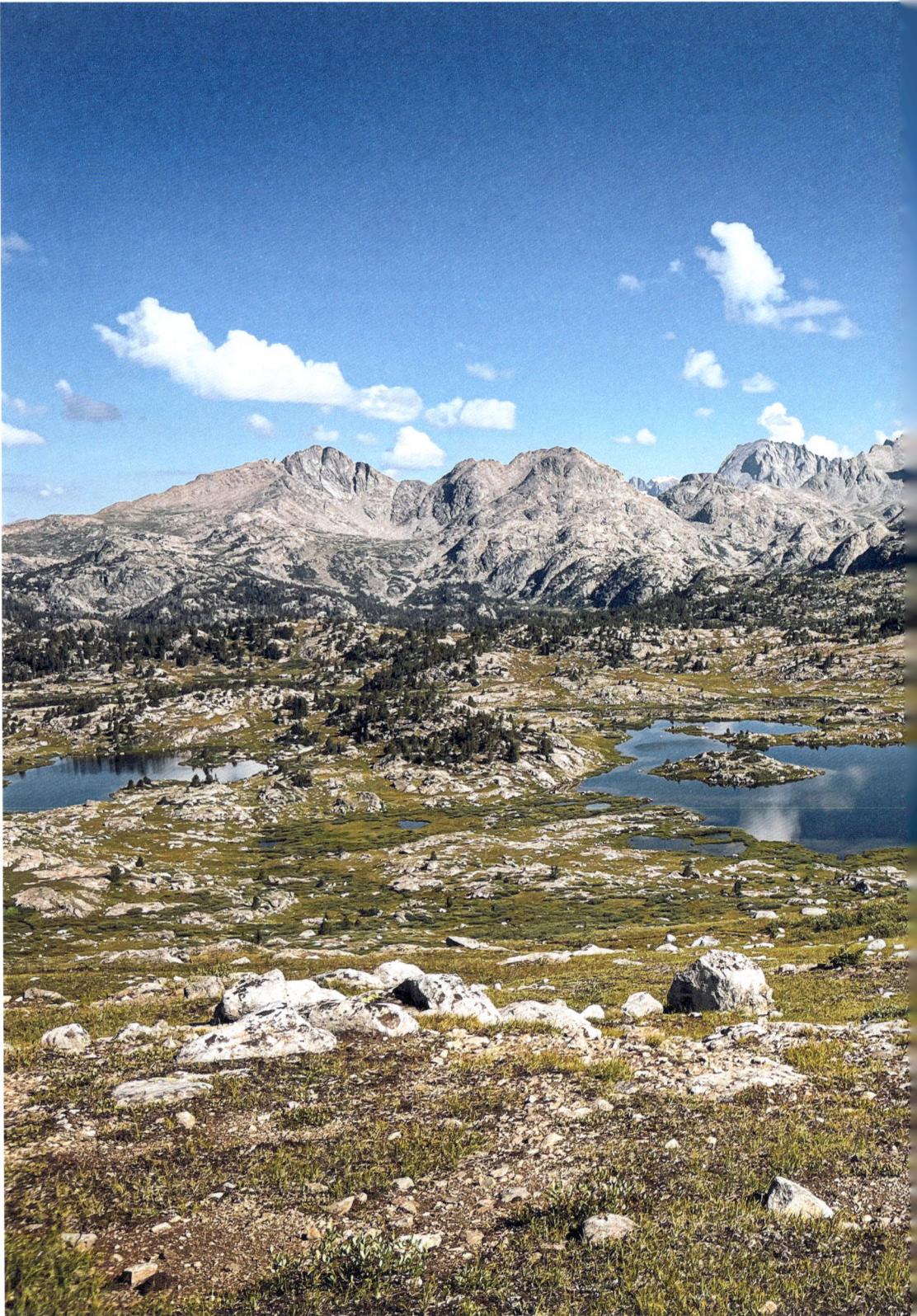

I leave the Wind River Range behind me
and head down into the desert basin.

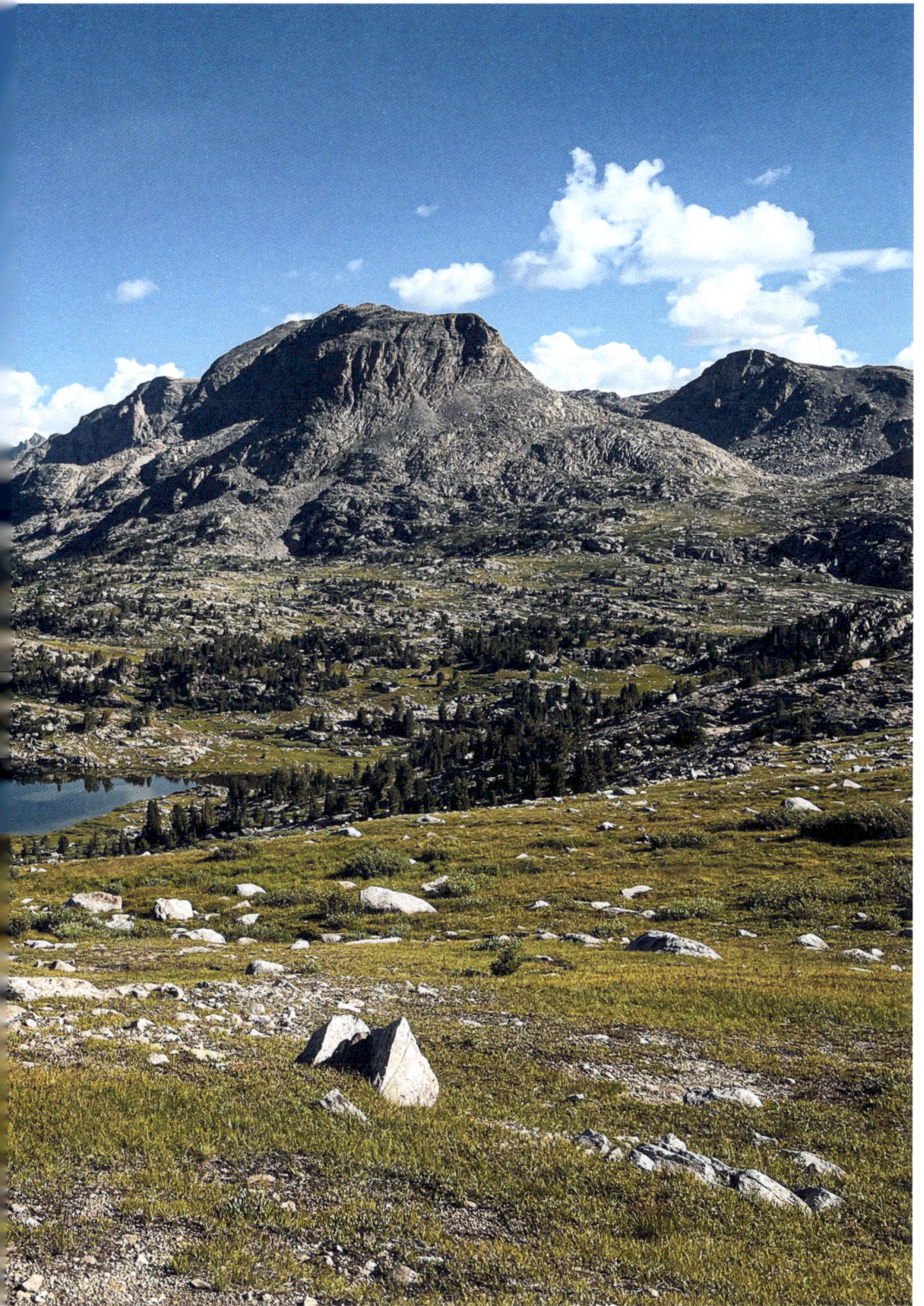

to hide under. The dry, sandy earth was covered with sage—and only sage—for hundreds of miles in every direction. I put on one of Schubert's piano sonatas and the landscape suddenly came alive. Hundreds of migrating antelope were like dolphins, occasionally leaping up from the grassy ocean. There was nowhere to hide out here. Nowhere to hide from my thoughts or the obstacles that lay ahead.

The first day in the desert, I lost my water filter and broke my stove. I don't know how I lost it, but when I got to the one and only river for days, I discovered to my horror that I no longer had a filter with me. This was pretty bad timing, as I still had 120 miles of desert in front of me. Plus, the water sources were all relatively poor in the desert, as we would be sharing them with the local cows, deer, and antelope.

After pitching my tent next to a river, I sat down to boil some water for dinner and ponder my options. I couldn't go on without a filter, and I didn't feel like walking 40 miles (64 km) back to town either.

But I was in luck. I soon heard voices behind some nearby bushes and discovered four other people were camping on the banks of the river too. I walked over to introduce myself and discovered that the men were from Belgium and cycling the Great Divide Bicycle Trail. We could speak Dutch together! What were the odds?

When I told them how stupid I had been to have lost my filter, one gentleman kindly offered to give me a small bottle of chlorine, which, with five drops, should kill everything in a liter of water. I was very grateful and thanked the man more than twice.

"Join us," one of the men said, gesturing for me to join them for dinner. "Want some ravioli?" He lifted the lid of a warm pan. They were not into the whole ultralight thing and had taken plenty of canned food and wine with them. I was interested to hear how their bike trip was going. Their entire trip, from Canada to Mexico, would take them around two months, compared to my four

or five. As we ate, they told me they had seen a bear earlier that morning on the outskirts of a small town, which made me raise my eyebrows as I had just left my bear spray back at the hotel's hiker box. I figured there wouldn't be anymore bears in the desert. I guess I was wrong. After exchanging a few stories with the friendly cyclists, I soon retired to my tent, as I would need all the sleep I could get for the coming days.

"Van Go. You down there?" A voice yelled down from the bridge over the river. I poked my head out of my tent and saw a familiar face. It was Lotus, a friendly fellow hiker I bumped into from time to time, waving a water filter in her hand. "Is this yours?"

"Yes, oh, thank you, thank you!" I scrambled up the banks to meet her on the bridge, relieved. She had found my filter some ten miles back.

The following morning I was walking before six. The sky was still dark, and there was no sign of the sun, only a faint glow in the distance behind the horizon. I saddled up and filtered four liters of water to get me to the next water source more than 20 miles (32 km) ahead. As I walked, I could hear a pack of coyotes howling to herald a new day. As the sun finally rose, I could see I was passing an area with buffalo and a small herd of antelope on a hill.

The following morning I was walking before six. The sky was still dark, and there was no sign of the sun, only a faint glow in the distance behind the horizon.

I was quite chuffed to see I'd walked more than 10 miles (16 km) before 10:00. 10-by-10 is another one of those silly thru-hike challenges. As the day continued, the winds picked up ferociously, but as luck would have it, they were at my back. Pushing me forward as the sun shone on my face.

Turning 50

Mile 1,373

I was turning 50 years old on trail. 50! Out here on my own, I decided to do 50 miles as a gift to myself. I had recently heard about the 24-Hour Challenge, which means you hike nonstop for 24 hours, or at least see how far your legs can take you in 24 hours. Ever since I had heard of it, the idea had captured my imagination. Such a ludicrous, pointless challenge, and yet such simplicity, just like walking from border to border. The only question was, was my body ready?

The day before my fiftieth birthday, I decided to do a test hike by walking 30 miles (48 km) and was relieved to discover that my body and the meds had finally shaken off the giardia. My mind was up to it. So I began to make preparations for the 24.

Before the big day, I went to bed early and set my alarm clock for 23:30, enabling me to start hiking at exactly midnight, just as I would be turning 50. Something also attracted me to the idea of spending my entire birthday alone, sleeping alone in the wilderness, hiking alone through the desert, and then sleeping alone again once the 24 was over. I couldn't say precisely why I liked the idea so much, but there was some purity to this notion of being utterly alone on such a day that would typically be spent surrounded by people. I'm not a big birthday person, and I only give a big bash every 10 years or so. The more I thought about it, the more I looked forward to it. To find some peace and quiet for my short night's sleep, I left the trail and found a narrow gorge between two hills a few hundred yards away from the trail. There was hardly enough space to set up my tent, but the ditch made a sufficient shelter from the wind.

At midnight I was all packed up and ready to set off, with more than four liters of water to get me through the first 20 miles (32 km) in the dark desert. I had recently picked up a free headlamp from one of the hiker boxes and tied it around my head with a piece of elastic ripcord to keep it in place. There was no telling how long the batteries would last me, but I hoped they would get me through until the sun rose. There was no sign of the moon that night, but 50 million twinkling stars lit up the sky. It was genuinely dark, and without my headlamp, I wouldn't have been able to walk a single mile. A surprisingly mild breeze blew gently at my back as I started my challenge with a five-hour climb up and over a desert mountain.

> I went to bed early and set my alarm clock for 23:30, enabling me to start hiking at exactly midnight, just as I would be turning 50.

The darkness around me was occasionally lit up by sporadic green lights; cattle apparently don't close their eyes when they sleep at night. My headlamp caught the eyes of a small desert fox, and countless nocturnal butterflies flew into the light and my face. As I climbed farther up the mountain, I saw three lights on the horizon evenly stacked on top of one another. I figured it must have been some kind of communication tower on top of the mountain, but a quarter of

24 HOUR CHALLENGE

TEAM VAN GO

24 HOURS ON MY 50TH BIRTHDAY. LETS GO GO.

an hour later, the reality revealed itself to me. It was my beloved constellation Orion, which slowly rose over the mountains ahead, with its belt in a perfect vertical line.

The sky was studded with 50 sparkling birthday candles, some of which appropriately fell from the sky before me. The warm pink glow slowly rose above the horizon, heralding the new day. As dawn swelled, I called my family back in Europe, hoping to catch them with the eight-hour time difference. When I got through to them, it was possible to do a quick video call, as my high altitude gave me just enough internet connection from a town far below in the valley.

"Happy birthday to you! Happy birthday to you! Happy birthday dear Tim-VanGo-Pap-Flip. Happy birthday to you!" I heard an echo as the children sang to me through the poor connection. I could just about make out my son yelling "We can't see you!" so I took my headlamp off and shone it onto my face to illuminate my features in the darkness.

"There you are," I heard my mother say with relief. "Happy birthday, son."

"50! Happy Birth… How does it …?" My wife's voice broke through the connection. My wife, children, parents, and sister had gathered for tea and cake to celebrate my birthday, even though I was all the way across the Atlantic.

"So good to—" I tried to reply but the connection was weak. And with that, they were gone;

I was thrown back into the lonely darkness. And for a few minutes, it did feel lonely. An unpleasant loneliness. I would have loved to speak to everyone a little longer, but I also felt blessed to have briefly seen their happy faces. Knowing that everything was going well with my family and aging parents gave me peace, and I suddenly became grateful.

I couldn't ask for more. The freedom to roam the world and the knowledge that all was well back home. There's no better birthday present that I could have wished for.

By noon I had passed 30 miles (48 km), but as the day wore on, the weather shifted considerably. I became very exposed, in every sense of the word. Exposed to the sun that mercilessly shone down on me. To a fierce headwind, which picked up to near-gale force as the sun crept higher in the sky. Exposed in the flat desert landscape, with dust in my eyes.

As the hours slid by, I prodded on, bent forward, head down, into the dusty wind. I may have made the decision to do this 24-hour thing, but the desert was letting me know who was boss.

I had intended to reflect on the past 50 years of my life, but unfortunately, the wind blew every sane thought straight out of my head, and I had to focus all my attention on each and every step. I made five-minute stops every eight miles (13 km) by curling up into a ball in a dusty ditch. The shallow ditches were the only places

I could find some shade to rest my legs before heading on. My body yearned for more rest, but I worried that if I stopped too long, my muscles would get stiff, making it harder to continue. The only thing my mind could focus on was the recurring question, "What the hell am I doing?" But I quickly shut down the thought, gritted my teeth, and put one foot in front of the other.

Having stopped to eat dinner at 18:00, the sun slowly began to set behind me. What a day! It just kept giving. There were six more hours to enjoy—or endure. The sky once again transformed, with glowing orange-pink clouds that stretched from north to south as darkness fell. The mountain range in the distance turned bright purple in the evening glow, and once again, I felt lucky.

After a quick meal, I packed up and headed on, turning my headlamp back on again to complete the final stretch. Having had some brief internet connection on a mountain pass, I saw some birthday wishes on my phone and looked forward to reading them later. For now, I had to focus. Although I had only spoken a few words to a hiker I had passed that day, I had thoroughly enjoyed my day of birth, and it really did feel like a celebration. I was healthy, I was happy, and looking forward to whatever may be in store for me. I had been born prematurely in a hospital back in 1972 when my parents had left their apartment in a rush. Ever since, it's as if I've always been in a rush. Rushing to take the next step in life, rushing from one project to another, rushing, rushing, rushing. It is as if I feel I have little time to live. It's not necessarily something I am all that proud of, but it's me all the same. I've learned to accept and embrace it for what it is. But out here, putting one foot in front of the other, it all felt right. "I rush, therefore I get places." That would be my lame contribution to the wise quotes of this world.

That night, the moon was absent again. As I passed the 20-hour mark, everything began to hurt. After 128,244 steps and 4,760 kcal burned, my hip joints weren't happy, my ankle was playing up, and the soles of my feet were bruised and battered.

"It's done, it's done!" I shouted ecstatically into the empty desert blackness. A new day had started, and the 24 hours were over. I had gotten my 50 miles in and even done a few extra. By the time the clock struck midnight, I had walked just over 58 miles (93 km) in 24 hours. I was overjoyed, as well as broken.

That night, the desert was cold. I was too tired to set up my tent, so I crawled into my sleeping bag with all my rain gear on over my clothes and stared up at the Milky Way. A band of countless stars stretched from horizon to horizon above me. The desert really was magical, both by night and day. I had no idea where I was camping exactly, but it didn't matter. My heavy eyes closed, and I sank into a deep sleep.

Some six hours later, I woke to dust and sage as far as the eye could see. Lost in nothingness, exactly where I wanted to be. The early morning sun filled the sky with the most beautiful colors. Life in motion. It was no longer my birthday. It was only 15 miles (24 km) to the town of Rawlins, where I was looking forward to tending to my feet and drinking a few birthday beers.

But most importantly, I wanted to call home and thank everyone for the wonderful video messages I had received from friends around the world. When I finally got online, I saw that my family had made a touching video compilation with more than 60 friends. People from all different phases of my 50 years had taken the time to send me a video message. And that made me cry.

My 24-Hour Challenge:

00 miles (00 km) by 00:00
10 miles (16 km) by 03:00
20 miles (32 km) by 08:00
30 miles (48 km) by 12:00
40 miles (64 km) by 16:00
50 miles (80 km) by 21:00
58 miles (93 km) by 24:00

Colorado

Mile 1,521

For weeks, a mysterious figure had been hiking a few days ahead of me. Someone named Lilian had been leaving a wealth of comments in the FarOut navigation app, offering invaluable intel on the condition of the water sources, tent sites, and alternate routes. As the state of water was important, Lilian had reached legendary status among the hiking community following behind.

At first, little was known about her, and we hikers came up with the wildest ideas as to how we might thank her at the end of the trail. Sending a bottle of champagne or a cake to the end terminus at the Mexican border, perhaps, to thank her for all the tips she'd left behind. Lilian had helped us find the right path as we headed down south through what was sometimes quite a difficult route to follow. When the rumor trickled down the trail grapevine that Lilian was, in fact, not a she but a he, and a very experienced hiker from Hong Kong, I was quite surprised. I had a picture in my head for weeks—and I couldn't have been more wrong. Lilian was a guy!

After having trailed behind Lilian for what felt like months, I finally caught up with him at a hamburger café in Riverside. When I joined him for lunch, he sat quietly slumped over a plate of food that he could hardly get down. His thousand-mile stare into his food said enough. He was clearly not feeling well. I asked how he was, and he told me his stomach had painful cramps. Although this was the first time I had met Lilian in person, I could see he was ill and recognized many of my recent symptoms in how he looked. I told him my story and recommended he go and see a doctor now that we were in town, as I felt he was perhaps also in denial about having giardia. He stared at me blankly, and I changed my tone.

"I think you are ill. You need help. You must go see a doctor," I said slowly and sternly. I turned the burger menu around and broke down what he should do in three simple steps.

The tears rolled down his cheeks as he sat silently absorbing all I'd said. I could see he was finally accepting his fate of actually being ill, and against his will, would have to stop and take some rest. I knew exactly what he was feeling, but I assured him he would feel so much better within a week and that he would feel happy and excited to continue walking soon. The bugs in his stomach were messing with his head, as he was even playing with the idea of quitting altogether. Being ill on trail is horrible, as I guess it is anywhere in life. It sucks all the energy out of you and plays games with your mind. The value of good health becomes ever more apparent.

When Lilian gestured to the bartender that he would like to pay for his meal, she replied simply that some other hiker had already taken care of the bill.

> Being ill on trail is horrible. It sucks all the energy out of you and plays games with your mind. The value of good health becomes ever more apparent.

"So kind. Thank you," he gestured to a guy sitting at the bar in a loud Hawaiian shirt, who tipped his baseball cap to say thank you. A small, fragile smile crossed his lips as he whispered to me that he hadn't been able to pay for a meal in weeks, as so many fellow hikers wanted to show their appreciation for his invaluable comments by paying for his dinners. The trail provides.

Just as in life, not everyone on the trail was amazing, friendly, and inspiring. A few days later, I bumped into a few new characters.

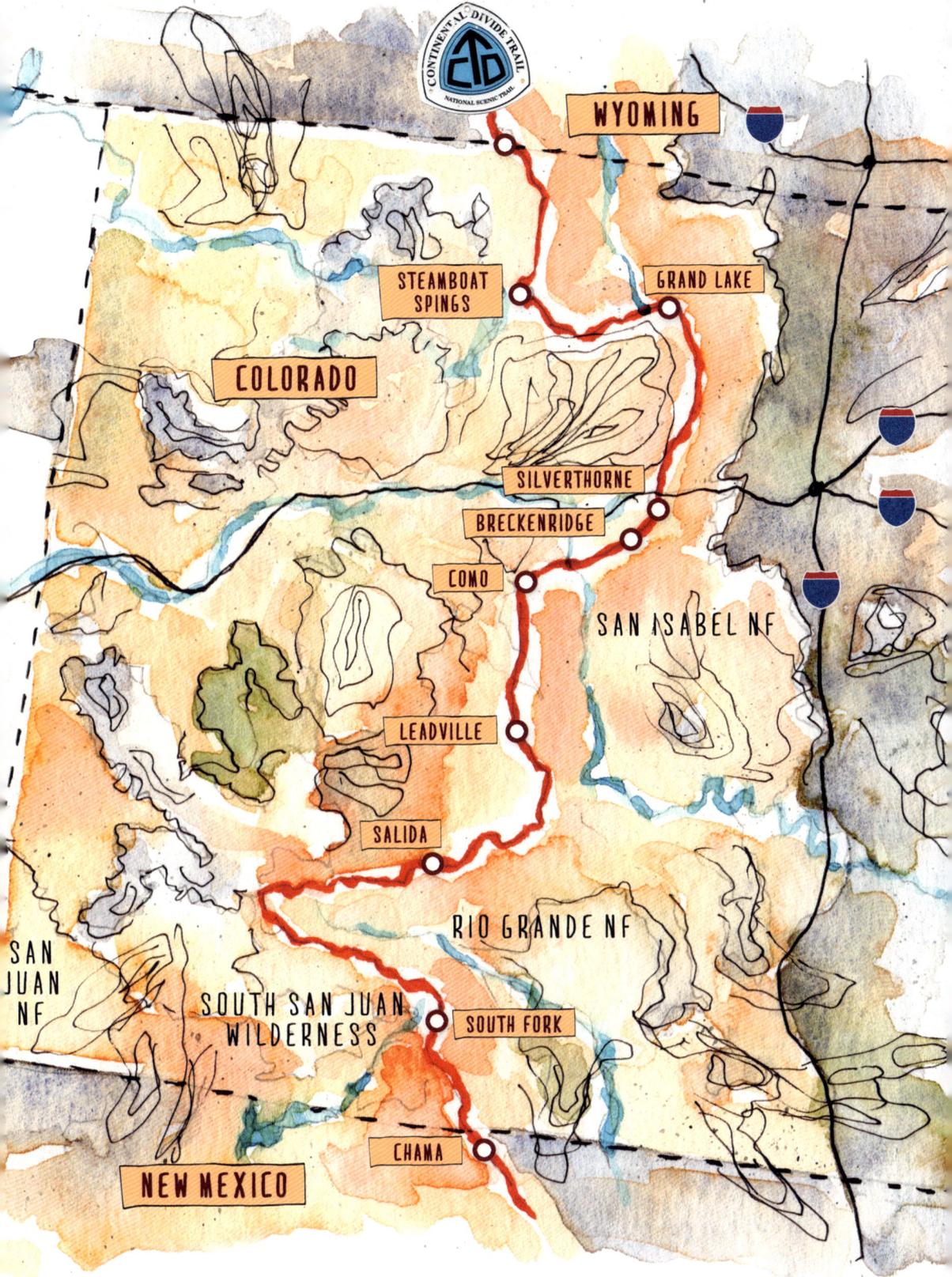

CONTINENTAL DIVIDE TRAIL
NATIONAL SCENIC TRAIL

WYOMING

COLORADO

STEAMBOAT SPINGS

GRAND LAKE

SILVERTHORNE

BRECKENRIDGE

COMO

SAN ISABEL NF

LEADVILLE

SALIDA

RIO GRANDE NF

SAN JUAN NF

SOUTH SAN JUAN WILDERNESS

SOUTH FORK

CHAMA

NEW MEXICO

Colorado's high elevation soon takes me up past the tree line.

Strangely, I had never met them before, probably because they did insanely long and fast days.

"Do you mind if I camp next to you?" I asked the strangers, as it had been a long day, with very few suitable flat spots to pitch my tent.

"Sure, why not? It's a free country, isn't it?" answered a tall man in his fifties with a smirk. He didn't seem too happy that I would have to camp so close to his tent, as there wasn't much space really. He made no eye contact and continued eating with a spoon from a Ziploc bag. The other hiker was a girl in her thirties who I had seen in town before. I waved as she set up her tent nearby and then introduced myself to the man.

"Hi, what's your name? I'm Van Go," I said, stretching out my hand.

"Mi chiamo Luigi," he replied in Italian and added that he was from Rome. "I don't need a trail name; my mother gave me a perfectly good name."

I got out my stove and joined them to eat some mashed potatoes and tuna.

"Oh, the food is so bad here in America, don't you think? They are all addicted to sugar here; that's why they are all so fat," Luigi said bluntly. "I don't get these Americano hikers. They carry much too much."

Looking at Luigi's backpack, there seemed to be enough space for lots of food, as he appeared to be enjoying a three-course dinner.

"You can only buy shit here." He spoke in a heavy Italian accent about how the quality of the food in America was so bad that it was making everyone sick.

He was a strong athlete and boasted that he had done several Iron Mans and thought the CDT was a lot easier than people had made it out to be. When he started talking about all the day's data that he got from his smartwatch, I had had enough. If there is one thing that really gets to me, it is data on trail. Who gives a shit about how fast you can hike? It's not a race, I thought irritably.

Luigi made it very clear that he was a purist and that he always stuck to the official CDT red line route, and he pointed out that he was one of the very few doing the real CDT, as practically everyone else was taking alternates, or skipping short sections with a hitch. It didn't really bother me that he was a purist, as I had been one myself in the past, but on this CDT, I definitely was not.

The other hiker and I hadn't said more than a few words, but Luigi was on fire and just didn't stop talking about everything that he had experienced during the day, comparing everything to his Italian Alps back home.

A while later, I was enjoying my Snickers dessert alone on a rock overlooking the mountain valley, appreciating the peace and quiet some distance from the tents when I suddenly heard what sounded like a helicopter. Before I knew it, there was a drone hovering in front of me. Not long after, Luigi popped out of the woods behind me and waved as he maneuvered his drone along the cliff.

"For my followers on Instagram," he explained. Who was this guy? Fifty years old and still obsessed with his Instagram followers.

I was enjoying quite some peace and quiet, when I suddenly heard what sounded like a helicopter. Before I knew it, there was a drone hovering in front of me.

Boy, was he annoying, I thought as I retired to my tent. It surprised me that I was so irritated, and I asked myself why. Perhaps this was more about me than it was about him, as he had no ill intention. I just didn't like the guy.

But I realized this guy was simply a culmination of all the irritating people I met on trail throughout the past years. And what really got to me was the fact that his behavior also brought to light some of my own less positive characteristics. Perhaps he was the mirror I didn't want to look into? After all, I'm also pretty annoying at times too. Am I not also a 50-year-old smug extrovert

European who likes to talk a lot, with my own Insta stories, books, and all? Well, whoever this Luigi was, I wasn't planning on spending too much more time with him, but he certainly made me reflect. Food for thought. Food for thought.

Two days before reaching Steamboat Springs, I crossed the Wyoming-Colorado border, and it felt exciting to be in a new state. I had covered the 550 Wyoming miles (885 km) in a flash. I couldn't quite believe it; what a difference to the obstacle course that Montana had been. Colorado wouldn't be easy, with its high Rocky Mountains. When the trail crossed a dirt road, my eyes fell upon a handwritten sign on a piece of cardboard in the dirt, inviting hikers for some Trail Magic. This was one of the perks of thru-hiking: unexpected acts of kindness and surprises along the trail. I had encountered practically zero Trail Magic in

the past two months, so was delighted to follow the arrow on the sign. It pointed to a recreational campground nearby where I finally found a guy called Happy waiting for me. Although I was the first to arrive, soon after, more and more hikers seemed to appear. Some had hitched around, some were SOBOers, and there were even a few NOBOers as the evening wore on. I had never met Happy before, but he was an avid thru-hiker and had hiked the PCT the previous year. He had driven all the way down from Utah to surprise some of his old trail family. From the moment I met him until I left the following morning, Happy lived up to his name, with the most sparkling smile you could ever come across. He was so excited to be back among hikers again. I helped him unload his car, which was full of goodness, in the form of countless XL pizzas, drinks, fruit, and weed, but he insisted that I sit

down in one of his comfy chairs and enjoy a cold beer from the ice cooler.

It felt great to roll the cold can across my forehead and take a few chugs, practically downing it in one.

When the trail crossed a dirt road, my eyes fell upon a handwritten sign on a piece of cardboard in the dirt, inviting hikers for some Trail Magic.

"There's more. Please," Happy gestured to the beers. And when he walked over to the picnic table with five giant pizza boxes, I couldn't have been happier with Happy. Margherita, my favorite, with a thick greasy crust. I enjoyed every crumb. Slowly the campsite filled up with more and more hikers, and by sunset, there must've been about 15 of us enjoying soda, beer, and pizza. When I had finished my fair share of two slices, I sat down to make a sign for "Happy's Bar," and he looked even more joyous when I handed it over. The blue and yellow paint I had used on the cardboard beer box was still dripping when he proudly stuck it under his windshield wipers for all to see.

After the beer and pizza were devoured, complimentary bowls and spliffs followed. Trail Magic to the max. Usually, I politely decline when offered a drag of a spliff out here on trail, but this time at Happy's Bar I decided, what the hell, and took a few long deep puffs of smoke. I soon felt the campsite spin in wild circles around me, so I quickly left the group, headed to my tent, and fell asleep in my clothes on top of my sleeping bag.

Colorado had its very own welcoming party, and no beers, weed, or pizza were involved. No sooner had I crossed the Colorado state border than the trail went straight up—practically vertically up and over two enormous 11,000-foot (3,350-m) mountains. That was something Wyoming didn't do to us. These were big beasts.

The second mountain took me more than seven hours to climb.

When I finally reached the summit in the afternoon, I bumped into a gentle elderly man who seemed to come from another era. Although I didn't always stop to talk to the NOBOers, this time, I just had to stop for a chat. "They call me Tinker," he said in a friendly, soft-spoken voice.

"Forgive me, but may I ask you your age?" I asked, somewhat impertinently. His long white beard swayed gently in the wind, and he was wearing a warm puffy coat, a contrast to my Hawaiian shirt. I guessed it was harder to keep warm at an older age. "I'll be 77 soon. I'd hoped to finish the whole CDT this year, but I guess I should be happy with the first two states. I'll return next year to complete Wyoming and Montana," he added with a twinkle in his eyes. He had probably been asked it a million times before. He looked like a wizard, with his thin white beard blowing gently over his shoulder. His long arms and fingers hung motionless to his side as he walked without the aid of trekking poles—or a magical staff. Tinker told me with a grin that he would be the last NOBO hiker I encountered. Unfortunately, he wouldn't reach the Canadian border this year, which would've marked his proud Triple Crown before turning 77. Yes, this man had walked all the way from the Mexican border over the past four months. Tinker was inspiration in motion. Only his wrinkled, dry hands gave him away. I was happy to have started my thru-hiking adventures 26 years sooner and just as happy to have bumped into Tinker.

I hadn't seen Rip, Nosh, or Misplace for a while and had naturally transitioned into another bubble of people, The Horde from back in Pinedale.

Although I left Rawlins alone, I soon caught up with Treeboy, Doc, Recharge, and Chuckles, and for once, we didn't have to use our headlamps but could walk in the moonlight.

Everyone was upbeat, and I enjoyed a long conversation with Doc, getting to know the 43-year-old a little better. He was an extremely fast, fit hiker with a tiny 35-liter backpack without a hip belt.

I sometimes choose to take the lower gravel
roads to avoid unnecessary climbs.

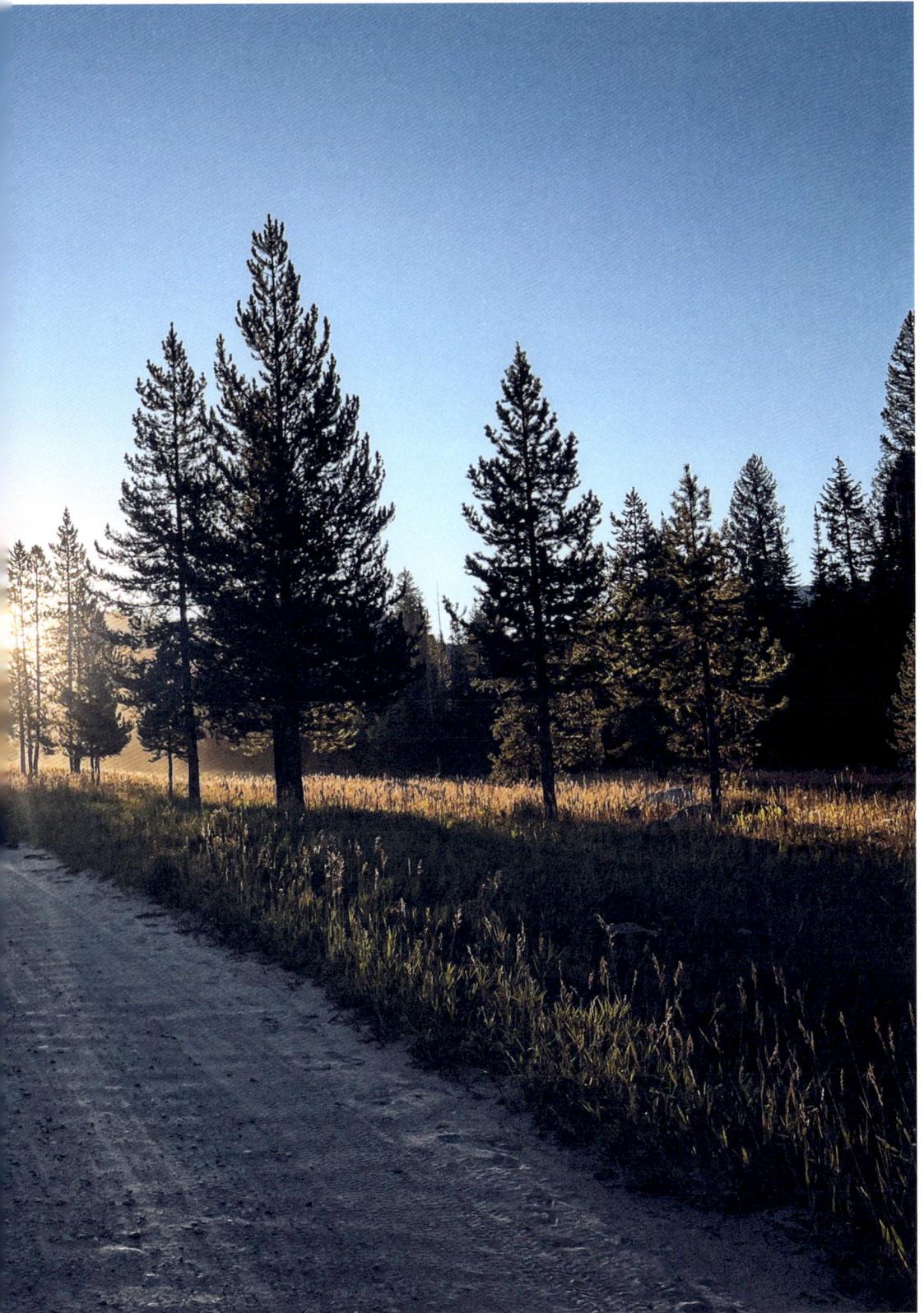

He ate meals when in town and mostly ate bars and snacks while on trail. He had fascinating stories about working at an Ayahuasca retreat center in Central America.

"You were hiking with Rip, right?" he asked in the middle of a sentence.

"Yeah, a while back. Why?"

"She broke her wrist," he told me. "Back in Wyoming. She's alright now, but still hiking in a sling, I heard."

I was surprised. Rip was so strong and athletic, but I guess we can all slip and injure ourselves occasionally. I hoped she was doing OK, but I was sure she would be in good hands, as she always attracted good folks.

Wake up!

Mile 1,600

Colorado was giving me very little space to think. The continual up and down of high mountains demanded all my energy and concentration. But Colorado did not disappoint. The Rocky Mountains, of which I summited about two passes a day, were impressive. I sometimes had to scramble up the 13,000-foot (3,962-m) peaks on loose scree to reach the top of yet another exposed, barren mountain. But the upside was that I was often treated to hours of high-altitude ridge walking. The trail gradually wound down the spine of the ridge, with steep drops on either side, hundreds of feet into the clouds below.

The most impressive aspect of the mountains was often the colors. Ridges draped in warm sandstone hues, from white to yellow, ocher to orange, red to black. It was as if I was walking across a postcard of Mars. I often had to stop for a moment to catch my breath, and looking around, I could see the pale blue mountains on the horizon as the smoke of distant forest fires still

hung in the valleys. In the evening, these pastel shades gradually transformed into pink-violet mountains, with the sun's orange glow piercing through all the particles of smoke.

Ridges draped in warm sandstone hues, from white to yellow, ocher to orange, red to black. It was as if I was walking across a postcard of Mars.

There were often long stretches of walking without water up on the ridges, as this was arid country. Thousands of charred trees, remnants of a recent forest fire, were a testament to these lengthy droughts. We SOBOers had been fortunate in that respect, with only one forest fire that had threatened to close the trail for a while. But many places in the States were on fire; I could only hope and pray for the safety of the firefighters and residents in the affected areas.

The burned sections that we sometimes walked through stretched for tens of miles and weren't the most suitable place to set up your tent and camp for the night. You never could tell whether the wind would pick up at night and blow one of the dead trees right on top of you in your sleep. These trees we called widow-makers.

I collected four liters of water from a beautifully cold spring and trudged another few miles in search of a safer patch of woods to pitch my tent. But as the burned remains seemed never-ending, I eventually settled for a tiny, flat spot in a narrow gorge, which had just about enough space for me to pitch my tent.

It had been a long day with steep climbs, and I was tired and hungry. I got out my stove to cook myself some dinner, but as I had enough water, I first treated myself to some miso soup. In the process, I accidentally knocked over the stove, and the hot water spilled all over my dry shoes. But worse yet, the butane flame also got knocked

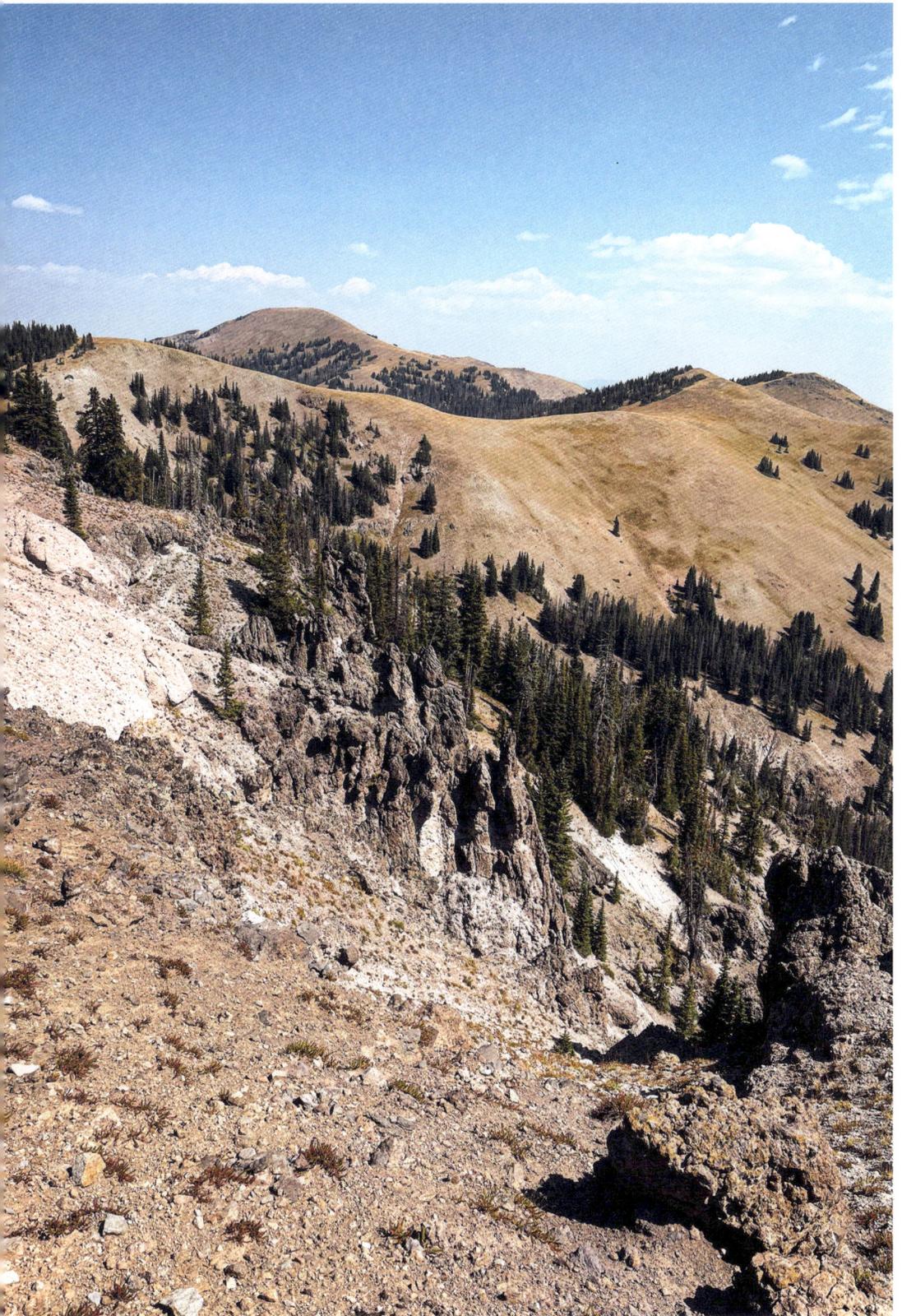

The trail includes some magestic ridge walking
across Colorado's Rocky Mountains.

Colorado's Rocky Mountains stretch out
in front of me as far as the eye can see.

over, setting fire to a bit of the grass around me. When I tried to turn the gas off, I unintentionally turned the gas higher, creating an even bigger flame. Only after I had managed to turn the gas and flame off, could I pat down the fire on my clothes and the grass around me with my flat hands. All while still seated. Fortunately, it was a nightmare that ended just as fast as it had started. I was shocked and relieved—but could see how quickly it could have gotten out of hand.

This scenario was probably one of my biggest fears. People who accidentally or deliberately set alight wildfires cause unimaginable damage to nature and property and are often sent to jail for many years.

"Wake up!" I spoke out loud this time, commanding myself to be more careful in the future.

Down in the valleys, as I walked through the dry, dead trees, the trail was littered with moose droppings from young calves and old bulls. I bumped into families of moose far more frequently than I had expected. Chuckles, a fellow hiker from Florida, had even seen two bulls locking horns, fighting for their turf on the trail not too far away.

Having reached the wealthy ski town of Steamboat Springs, I sat down for my seventh shakedown. I had to lose some more weight from my pack, as I was a little intimidated by the climbs ahead of me in Colorado. I decided to ditch my umbrella, as I really wasn't using it much here in the mountains. I also ditched my Ursack, which was supposed to protect my food from bears and mice at night. It had to go; it was all simply too heavy. I also trashed my bug net, as it wouldn't

be necessary anymore now that the nights were getting too cold for mosquitoes. And I finally ditched the DIY camp shoes I had made from an old pair of insoles, foam, and duct tape. I'm not sure how much weight I put into the hiker box that day, but at least it would decrease the bulk and space in my backpack. Every little ounce counted. Colorado meant business; the less I had on my back, the more I could enjoy it.

Steamboat was pretty, quaint, and hip, but it could also become an expensive vortex. Once I'd had a good night's rest, enjoyed the local food, and resupplied at the insanely expensive organic supermarket, I headed back up into the mountains toward Grand Lake.

Collective Consciousness

Mile 1,632

September 1st was the start of hunting season. This region was known for its hunting and fishing, which was managed under strict regulations by the Fish and Wildlife Service. During the first few weeks of hunting season, one could only shoot antelope and elk with a crossbow. But as the weeks wore on, other rifles and game were added to the list. I bumped into quite a few hunters as I hiked, many preferring to hunt early in the morning when the game was feeding at the ponds and rivers.

"They can smell us," one hunter told me. We had gotten to talking about hunting, and how so many of the animals seemed aware that hunting season had begun. "Even the difference between you hikers and us here with guns, they can distinguish the danger. Animals are so smart."

I showed one of the hunters my collection of shit pics. I had accumulated quite a few

in the past months, and was eager to understand them. I was surprised to hear the hunter distinguish grizzly scat from that of a black bear, or that moose droppings are very different in the winter compared to the summer months. I was especially eager to know what creature lurked behind the large furry poop I had occasionally encountered high in the mountains along the trail. "That's a cougar or mountain lion, as some call it," he said. "Gotta watch your back; they'll jump on you from behind as they lie in waiting in the trees above the trail. But it's usually the mountain bikers that they jump on. And as legend has it, they seem to stalk women mostly, but I don't believe that crap."

Meeting these hunters led me to wonder: Do animals have collective consciousness? Do people? Or is collective consciousness simply a romantic myth? How, for example, is it that so many elk and moose seem to warn each other and flee to the safety of the designated Wildlife Refuges throughout Colorado to escape the threat of the hunters just before the season starts? As I learned, thousands of wildlife flock to these so-called safe zones during the hunting season each year. The data doesn't lie.

Scat List:

1. *Pellets*
Ungulates
Moose
Deer
Elk

2. *Plops*
Bear
Cow
Buffalo
Horse

3. *Tubular (large)*
Coyote
Fox
Wolf
Mountain Lion
Bobcat

4. *Tubular (small)*
Mouse
Rat
Chipmunk
Squirrel

Although Colorado was tough going, there was an upside, as there seemed to be a small ski town every three days to ease the suffering. From Steamboat Springs, I continued to Winter Park, after which I headed farther toward Silverthorne.

A few hours after leaving Winter Park, I bumped into an older man sitting on a side trail high up the mountain. I soon found myself sitting next to the gentleman as he stared across the valley toward a mountain that looked no different than any other to me. It obviously had significant symbolic value to the man; I later learned his brother had tragically died on its slopes. I expressed my condolences, and we exchanged some stories about our lives. He introduced himself as Tom, and it turned out he was a 60-year-old physician who looked pretty fit and healthy for his age. I had no idea where he was in life, but something in me felt like a long walk from Mexico to Canada would perhaps do him a world of good. As we spoke, I tried to lay the seeds of inspiration.

I must confess to being an awfully annoying hiking evangelist. I am a strong believer and recruiter for the cause. I love bringing people into the fold of long-distance hiking. And while I do admit that hiking is certainly not for everyone, for practically every able-bodied person between the age of five and 85, I see no reason why they wouldn't benefit from the goodness of some regular or long-distance walking in nature. It could be regular short walks, long-distance hikes, religious pilgrimages, tramping, promenading, jaunting, rambling, putting one foot in front of the other, strolling, Nordic walking, stretching your legs, or simply getting some fresh air. Putting one foot in front of the other is free, keeps you fit, gets your blood flowing, allows your mind to wander, rests your nerves and stress, and allows

you to step out and see the world. Hiking may not solve all your problems, but I guarantee you'll return home with a few new insights and a lot less weight on your shoulders.

While the man and I spoke, I got out my painting gear and made a quick impression of the mountain before us. I could sense that it was so symbolic for Tom and his family, so when I was done, I gave it to him. Tom thanked me, and we exchanged contact information in case he needed any tips and advice should he decide to embark on a ridiculously long walk. When we waved goodbye, I could just about imagine the great adventures he would perhaps be having sometime soon, together with all the youngsters in Hawaiian shirts out on trail next year. Time will tell. Time will tell.

I had gotten to that predictable stage when I didn't really give a damn about how I looked or smelt. A hobo at large. My beautifully homemade Hawaiian shirt had turned to rags, my shorts had turned pale, and when I dipped in and out of a town after a few days in the mountains, I sometimes just couldn't be bothered to do laundry. The only thing I did was wash my underwear and socks in the restroom basin with some soap and hot water. After leaving the restroom, I hung my wet washing to dry on the back of my backpack with a safety pin as I headed back out onto the trail. The comforts of town were great, but in Colorado, everything was very expensive. Plus, the dollar was worth around the same as the euro, making this a costly trail in general for me. Hotels and motels were great, but I generally slept a lot better in my tent out in the woods. My sensitive ears could no longer handle the soft noise of a mini fridge. The thought of a shower no longer crossed my mind, as my daily dip in mountain lakes had become much more favorable. Although I had only been living outdoors for at least three months or so, I could clearly feel that things had shifted inside me. I had grown accustomed to sleeping alone, and after the initial discomfort, I now found it more enjoyable than sharing a campsite with others. I was becoming a hermit, enjoying my own company more than constant social interaction.

Colorado was steep. My steps were often incredibly slow, and I could feel the impact of the high elevation on my breathing. I was gasping for more oxygen as I reached a 13,590-foot (4,142-m) pass. Each evening I would go to bed with a light headache, reminding me of where I came from, six feet (1.8 m) below sea level. But I was satisfied with how my body had adapted to the new circumstances. I had thought it would be worse.

Hotels and motels were great, but the thought of a shower no longer crossed my mind, as my daily dip in mountain lakes had become much more favorable.

The nights were getting chilly, and as I set my camp up high on a mountain ridge, it marked the first frost on my tent. That night the water inside my water bottle even turned solid. Luckily, I remembered to put my new Sawyer water filter inside my sleeping bag, as the filter would break if it were to freeze. As the hours in the night progressed, I put on more and more layers, until eventually I was wearing everything I had. My long johns and rain pants, my merino shirt, my Hawaiian shirt, my windbreaker, my down jacket, and my rain jacket. Only my nose and mouth poked out of my sleeping bag, and I had quite a good night's sleep.

The following morning, the plants around my tent were covered in beautiful frost crystals, and I rubbed my hands to find warmth in their friction. But in vain; I would have to wait for a few hours until the sun rose above the mountains. In front of me was a long stretch, a lengthy climb that would take me until about lunchtime. When the sun finally did rise over the pass, I stopped to rest and slowly peeled off one layer of clothing after the other. Within minutes of being under

Passing a hunter's cabin, we are invited to stop for hot dogs and beer.

The sun sets on the Rocky Mountains
as I push on for another few hours.

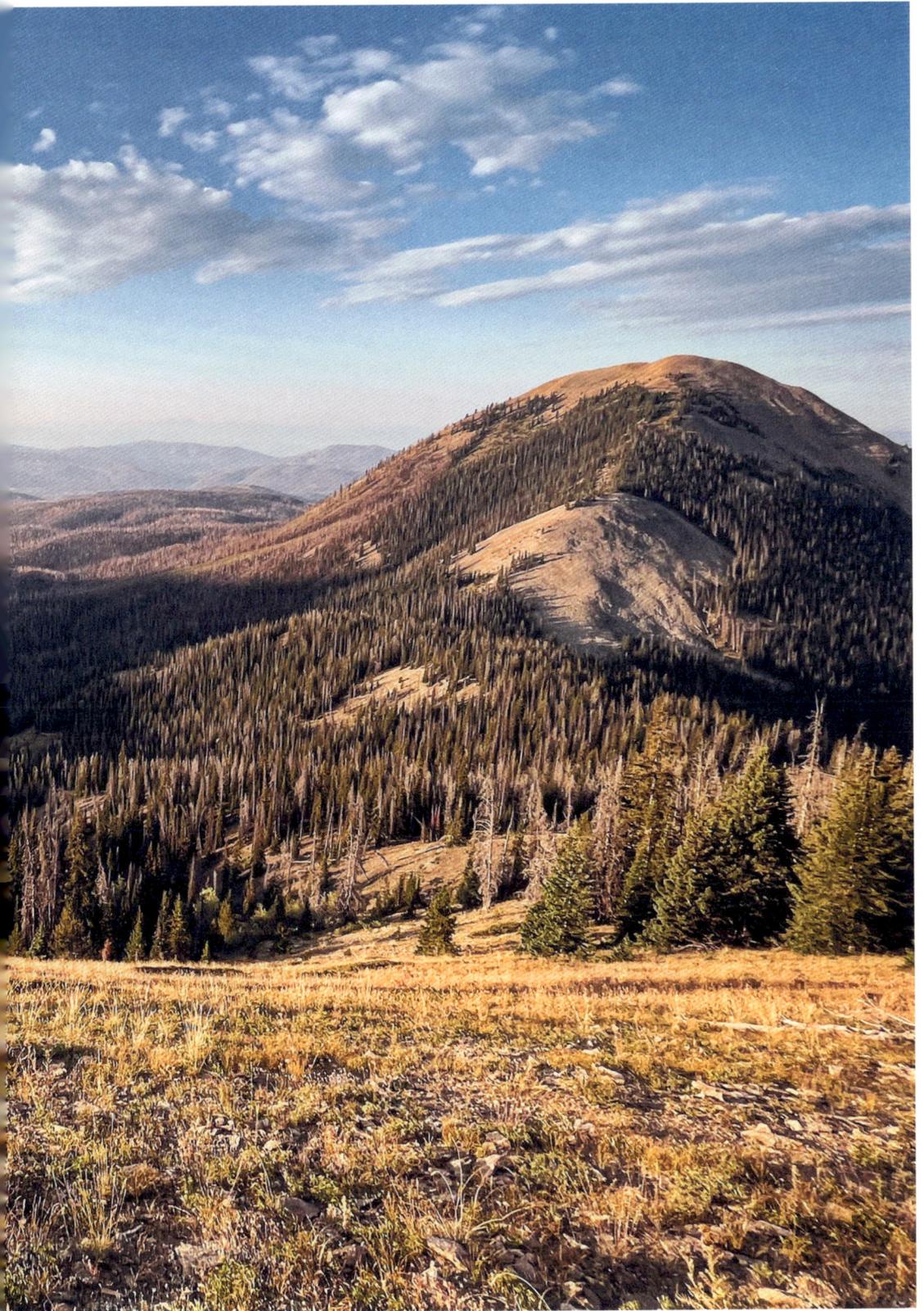

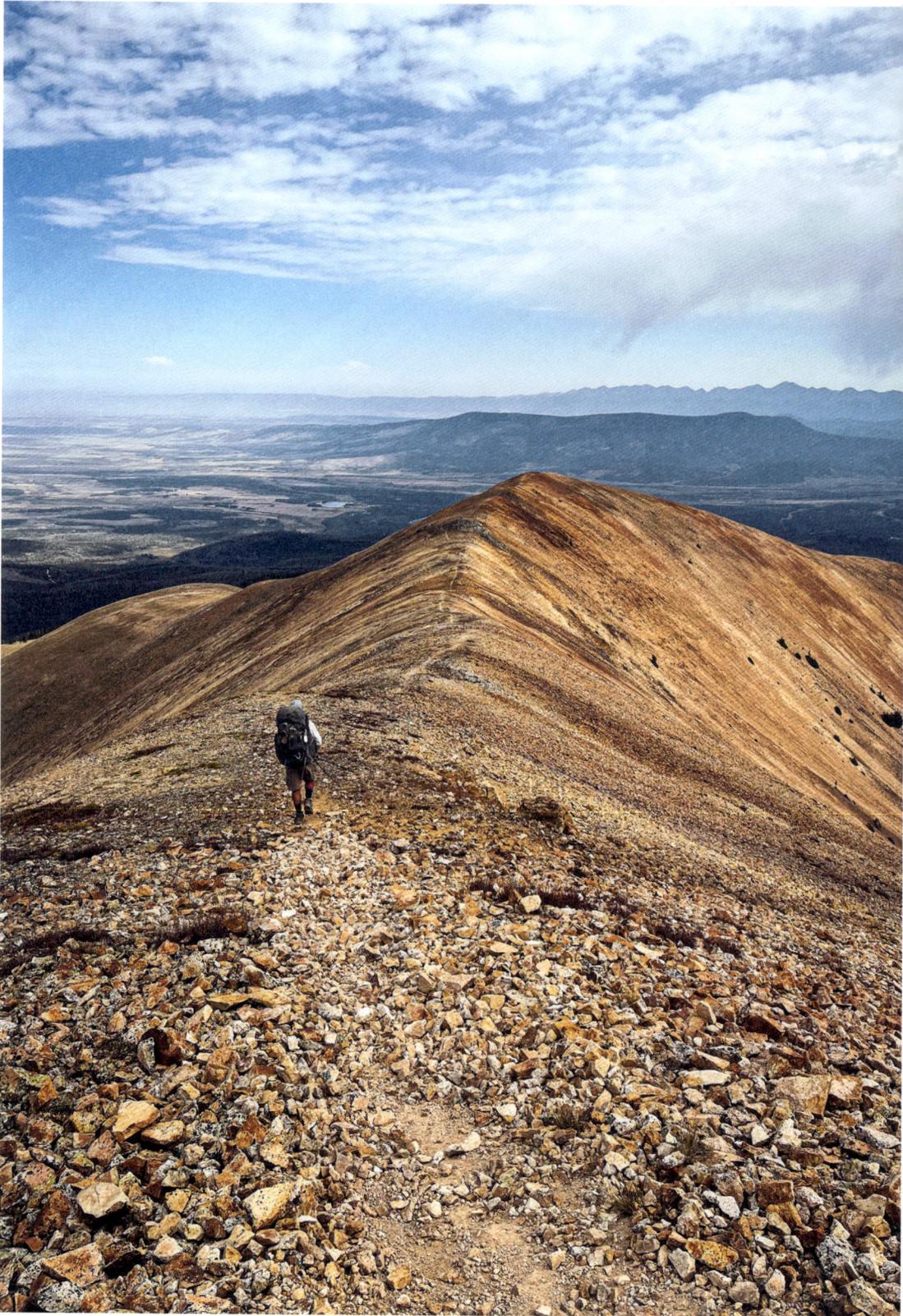

Irish Canuck heads down the mountain on another stunning ridge walk.

the sun's rays, I warmed and became my old human self.

When I finally reached the top of the mountain that day, the trail followed the high ridgeline for miles, and it was a joy to see the Rocky Mountains stretch out in a panorama around me. There wasn't a cloud in the sky, only shades of blue. Colorado was majestic, and it became ever more apparent why so many people choose to move and live here.

The trail followed the high ridgeline for miles, and it was a joy to see the Rocky Mountains stretch out in a panorama around me.

I always made an effort to only have about 10 miles (16 km) to do in the morning before reaching a town so that there was plenty of time left to enjoy all the food and comfort town had to offer. So when I arrived at 11:00 that morning, I had time to do some laundry, read the news, and find out that, sadly, Queen Elizabeth II had passed away. I drank to her honor and ordered a big pizza, half of which I would pack out and eat high on the mountain pass that same evening, doing another seven miles into the night.

I decided to take an alternate route after Winter Park, as it would be fun to catch up with WoW, who was apparently one or two days ahead of me. Plus, this alternate would dip in and out of towns more frequently. This way, I could carry less food, which was one way to reduce weight. Most of the other hikers in the bubble around me took the official red route to summit Grays Peak, so I soon found myself totally alone for a few days. There was usually always at least one person a day that I bumped into at a water source or camp at night, but now I didn't meet a soul for days. Learning that my mind had adapted to solitude and could handle it without worrying about

anything was encouraging. Only four months earlier, I had still been quite anxious about sleeping alone in bear country, whereas now I felt quite at home getting in my tent all alone in a deserted valley between two mountains. I felt happy making dinner for myself and crawling into my sleeping bag at 20:00. I was pleased we had left the grizzly bears behind us, though the black bears were apparently still all around.

Living and sleeping alone in the woods had become the most normal thing in the world. But being alone in the high mountains, I had to keep my wits about me because no one would hear me should I fall. As the days grew colder, I kept on my windshell and raincoat all day as the cold wind blew down from Canada, heralding the beginning of winter. I protected myself from the occasional light snow and hail with rubber dish gloves over my fleece gloves. The warm fall sun cast long shadows over the nearby hills. I loved the fact that I was walking through continual panoramic views and that, because I was practically always above the tree line, I could see and anticipate the upcoming challenges ahead. On the other hand, being up so high, I also felt vulnerable to the unpredictable, rapid changes of the elements. My heavy breathing tried to suffuse my lungs with blood, and my body with sufficient oxygen as I climbed from cairn to cairn. With all that heavy breathing, my mouth was always open, which resulted in my lips drying up and blistering in the sun. And putting sunscreen inside my mouth wasn't really an option.

The air became ever thinner as the trail took me up and above 13,000 feet (3,962 m). Finally, after hours of early ridge walking one morning, the trail dove down into a valley. I breathed a deep sigh of relief. When I reached the cover and safety of the tree line and was no longer exposed to the cold wind, I felt every cell in my body begin to relax at the lower altitude.

I hadn't known I needed it that much. I sat beside a stream to filter some water and ate a bar. I no longer took long breaks, as my body was

The evening glow on the mountains in the distance
as I set up my tent early for the night.

finally up to walking all day. Though I had been ill for over a month, I could finally say I was back. My ankles could handle the rocks and unevenness of the trail. It felt great to feel fit at last.

I still had several mountains to cross in Colorado, but it had started to snow. Never a dull moment on the CDT. I guess Colorado was living up to its very own trail name, *Killerado*.

My Melly

Mile 1,800

I was happy to see WoW at the breakfast buffet in the Silverthorne hotel the following morning. Tom, the 60-year-old physician, had bumped into WoW and asked him to pass on a message to me. The man I met on the hillside some time ago wanted to thank me for our conversation and painting, and said he was seriously considering doing the PCT next spring. I was overjoyed as I knew the wonderful adventures that lay before him.

A few other hikers were scattered in motels around Silverthorne and Dillon, and we planned to see each other for dinner that night in the local brewery. But beforehand, I used my time wisely to take advantage of all the worldly things the Dillon shopping mall had to offer. There was even an REI! The only really big outfitter on trail, come to think of it. Aside from Dave's ad hoc outdoor store in the middle of the Montana forest.

The rain fell all that day in town, but the surrounding mountains were getting a thick layer of fresh snow. So after stocking up and unwinding with my friends, I decided to book another night in the hotel. I lay in bed and turned on *Forrest Gump*—again.

It was still drizzling when I pulled my backpack over my clean shirt and walked across the Dillon Reservoir Dam. To my left, a large flight of swallows swooped low in magical formations across the lake. When swallows fly high, the weather will be dry. Are birds really any good at forecasting the weather? Whatever the truth, it was a spectacle to see, and it felt comforting to know they hadn't all left for the South just yet.

But when the drizzle transitioned into heavy rain, the swallows soon disappeared. At times like this, I was sorry that I had ditched my umbrella back in Steamboat Springs. It rained, and I got wet. But what can you do?

A few days later, in the woods, it was still raining—pinecones! Everywhere around me as I walked through the dense pine forest of the valley, pinecones were being hurled right and left. There were shrieks and scatters of laughter coming from high in the crowns of the trees. A few gray squirrels scampered, busy foraging for the winter.

> A large flight of swallows swooped low in magical formations across the lake. When swallows fly high, the weather will be dry.

When I reached Leadville, it was great to see so many familiar faces, but although they were throwing a party in a rented Airbnb, I decided to have an early night and head out early the following day. And just as I was leaving, I encountered a strange ritual. After having breakfast in a diner, I saw four of my fellow hikers all waiting outside what looked like a thrift shop. Strange, I thought, as they were all red-eyed and hungover from the night before. Why were they up so early? As the store doors opened, I joined them to see what the fuss was all about. Inside, it still looked like a thrift shop, but with a big rack of brightly colored fleece hoodies that looked like they'd been picked up from a stolen shipping container. The man at the reception asked if I had a reservation, and I answered that I didn't, somewhat

puzzled. But when I mentioned that I was a CDT hiker, he gestured that I could browse the exclusive selection of hoodies. Behind the counter was a large space with about 20 sewing machines, indicating that this was a small factory producing weird-colored clothes. Most of the people working behind the sewing machines had long beards, were young, and looked surprisingly similar to all the hikers in the store with me that day. I asked Lotus, one of my fellow hikers, what was happening.

"They're Mellys," she told me. Melanzana shirts were very hard to get your hands on and had become an exclusive, sought-after brand. By making these ultralight, well-designed fleece hoodies so rare, the store created a must-have item for every outdoor lover. This was the only store in the world where you could actually buy them, and you couldn't buy them online. And you had to make a reservation to pick one up. The waiting list was up to six months before you could come at the designated time slot to pick up your fleece. There were five special time slots for CDT hikers every day, and I was one of the lucky early birds that day.

> By making these ultralight, well-designed fleece hoodies so rare, the store created a must-have item for every outdoor lover. You had to make a reservation to pick one up.

When I walked out of the store wearing a bright orange fleece, I felt as if I had just purchased a Hermès Birkin bag or an exclusive pair of Gucci shoes. I was in *My Melly*, as they're called in Colorado. It's a thing, I learned that day. I was happy to have stumbled across this modern American folk legend by accident.

Having dipped in and out of Leadville quickly, I left the bubble of hikers sleeping off their hangovers and headed out alone along the Colorado Trail toward Twin Lakes. The tiny town, as the name predicted, lay next to two big lakes. I got into town by 19:45, having done a fast 20 miles (32 km). I hadn't booked a room, as I never do in advance, but unfortunately, the only hotel in town was fully booked, as was the only restaurant. Sorely disappointing, as it was one of the first places I'd come across with a decent healthy menu.

I walked around the 10 village houses, aimlessly wondering what I would do, as there was no place to sleep or eat. I thought I'd try the restaurant by asking the waiter if I could at least enjoy a beer in the lobby. And yes, I got an IPA. They even allowed me to use their Wi-Fi. As I enjoyed my beer, several guests slowly began to leave, as it was already dark outside. So I too headed out into the night as the barman closed the restaurant. The street was silent, and a few signs along the road showed a tent with a red diagonal cross through it, indicating that I was not welcome to pitch my tent right in their village. So, I walked a few hundred yards along the road back up to where the trail started and pitched my tent in a ditch some six yards (5.4 m) away from the road, under some trees, hoping it would be camouflaged and out of sight. I ate four tablespoons of peanut butter for dinner, blew up my sleeping pad, and crawled into my sleeping bag, wearing my new Melly, which was indeed soft, comfortable, and very warm.

By keeping a steady pace of 20+ miles (32+ km) a day, I was beginning to meet up with a few new groups a few days ahead of The Horde. I was always trying to keep close to WoW, as there was so much positive energy radiating from him. Wise lessons to learn. I also often bumped into a retired couple from Australia who were keeping a steady pace. I guess the younger bunch hiked a lot faster but spent a lot more time having fun in town. Irish Canuck was another colorful fellow I bumped into increasingly often. The 59-year-old from Virginia had hiked the AT back when he was 30. It looked as if he hadn't

bought himself a new backpack since he was still carrying a large, battered 110-liter pack. Although he carried the heaviest load of us all, he never moaned about the weight as he slowly marched on and over all the mountains I was struggling over. His family came from Ireland but had immigrated to Québec, and Irish Canuck was a good old character full of stories and anecdotes from the past. Although not a military man, his look was similar to that of Vietnam veterans in movies, with his white goatee, long gray hair, and faded green shirt. He had served his country in all ways, including being a forest firefighter, getting dropped into fire zones across the country to protect the land and the people from raging flames.

But though I was meeting so many new faces, the brutality of the trail was catching up with all of us, and it was sad to see numerous people going off trail or having to quit altogether due to an array of different injuries. Hernias, slipped discs, norovirus, and giardia seemed to be the biggest culprits, but the high altitude also affected a few people. The total gain in elevation for a southbound hiker, I learned, is roughly 457,000 feet (139,293 m), and the total elevation loss is almost identical. We were summiting the equivalent of Everest many times over.

I felt a new sense of urgency as the days and nights grew ever colder. Nature's alarm bells were all around; the change was in the air. The aspen trees had all turned golden yellow and frost covered the ground at night. Animals were collecting food before winter fell, and elk bugled during the rutting season. Nights were becoming uncomfortably chilly, and there were forecasts for a lot of rain and snow coming soon.

But there were still plenty of ridges to master before I hit the desert as I followed the thin line cutting diagonally through the mountain face that was my trail. The thinner the air got, the slower it made me go. However, I got into a rhythm of taking several quick breaks. Walking 11 hours a day, I managed to do a marathon every day.

On the third night after leaving Twin Lakes, I walked on into the night wearing my headlamp. I wanted to get one last pass under my belt to reach the next town of Salida the following day. The days were getting shorter, and it was dark when I found a suitable spot to camp. Alone high in the mountains, without a soul in earshot for miles. The jagged mountains framed a moonless sky with millions of stars as my canopy. I got out my new stove, boiled some water, and quickly made some pasta while I ate some seaweed and wine gums. When I finally crawled into my tent, I couldn't sleep. I kept forgetting to avoid setting up camp high on the ridge, as the high altitude badly affected my sleep. It also didn't help that it was considerably colder up in the bitter wind blowing down from the pass. I put on all my layers and crawled into a ball, hoping the hours would pass faster rather than slower. I managed to get a few hours of sleep but at 5:00 in the morning, decided I might as well get up and hike before sunrise. Gossip along the trail had reached me, and the weather reports predicted rain and thunderstorms for the coming three days. I wanted to reach town before the heavens opened.

I was more than ready for New Mexico.

I leave the last remnants of Colorado's Rocky Mountains behind me.

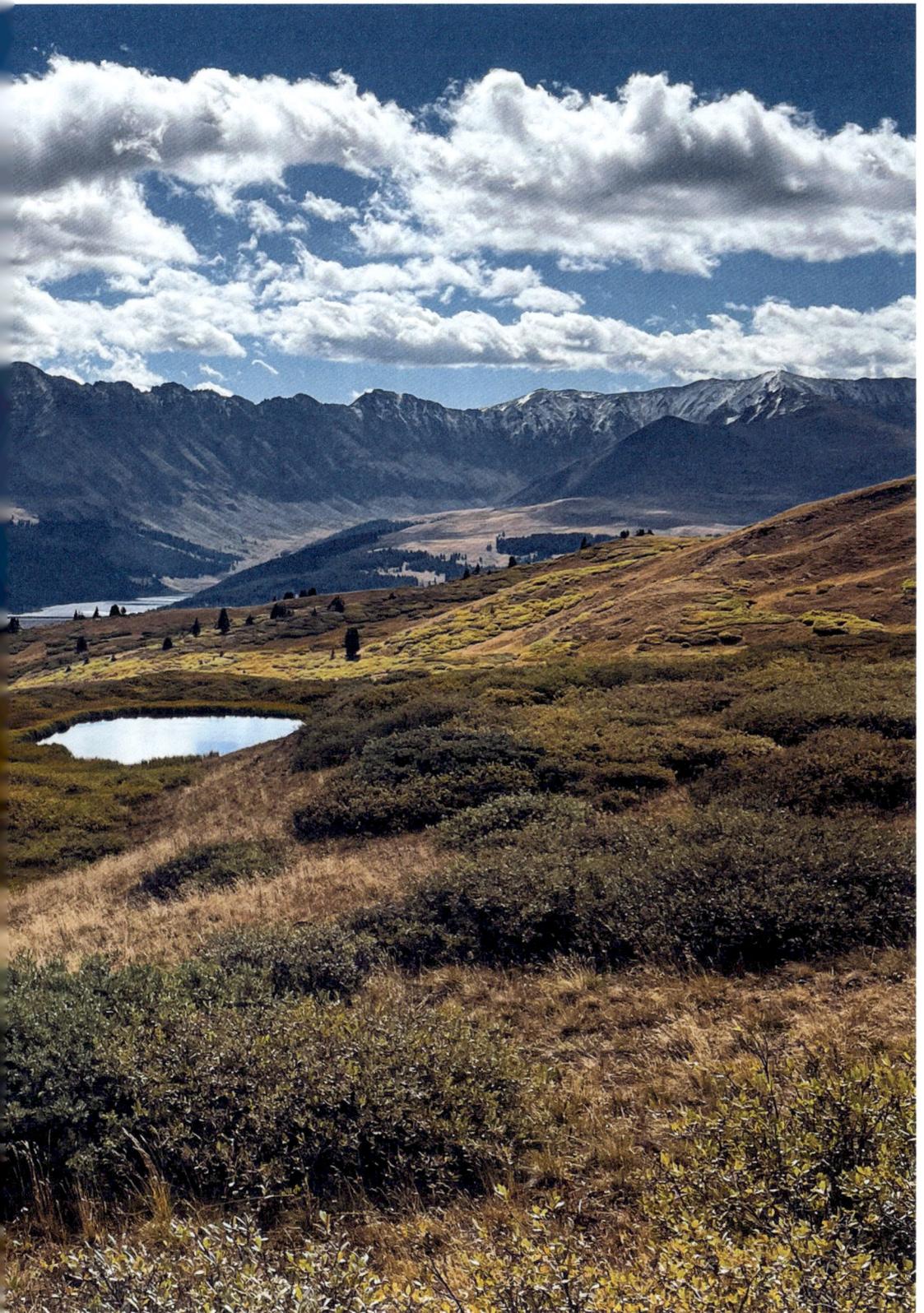

The Spiritual Journey

Mile 1,912 – 2,975

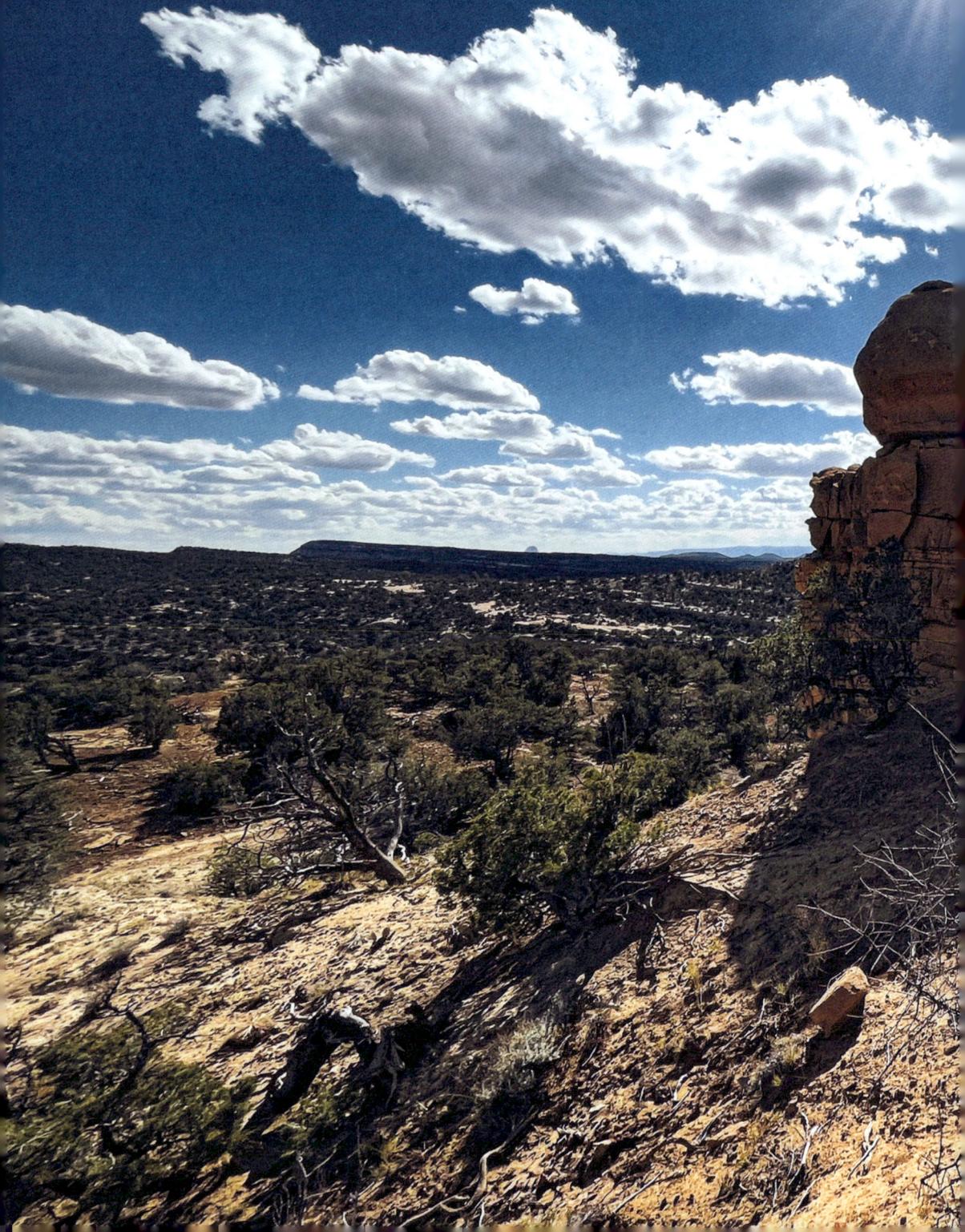

You can get lost out here, both physically and inwardly. Lost in thought, lost in reflection, and lost in the moment.

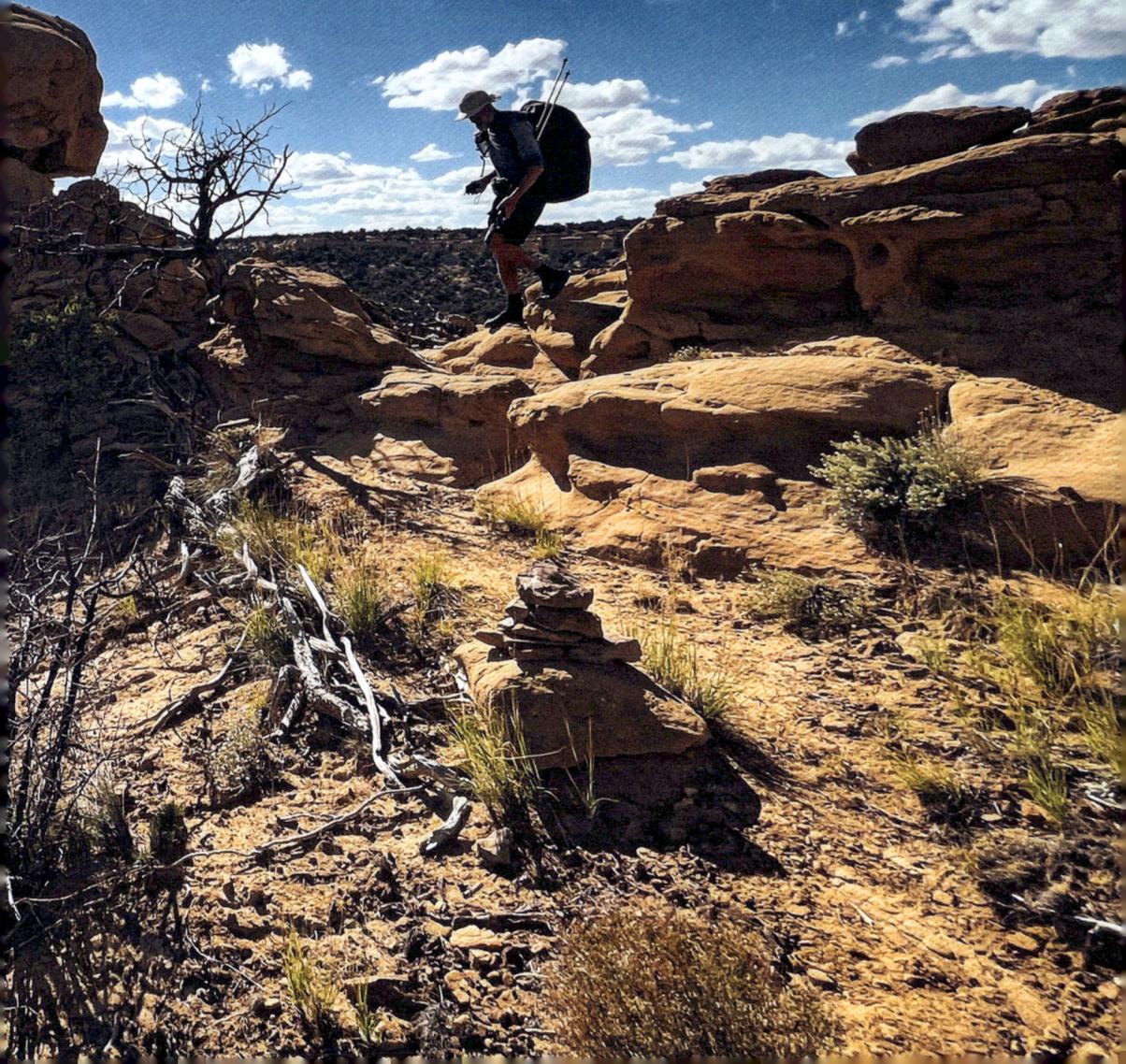

we were heading straight toward a large dark storm cloud hovering over the trail. I didn't say much and let WoW go ahead with me behind. Sensing my nerves, he started bellowing one song after the other.

Wild Rover

Mile 1,912

Having left Salida in a hurry, I had been living in total survival mode for two days. Due to the perpetual cold rain, I even forgot the heavy weight on my back, including five days of food and water for the upcoming section toward Creede, Colorado. I could have stayed in Salida for a few more days to sit out the bad weather in the comfort and safety of a motel room, but instead, I chose to head out into the mountains to face the predicted days of nonstop rain and storms. Why? After all, I was in no real rush. Doing some laundry would have been quite a sensible idea, as it hadn't been done for more than nine days. Instead, I chose to dip in and out of Salida, enjoying a pizza—half of which I packed up—a beer, and some breakfast, made a quick dash to Walmart to resupply, and hitched back up to the Monarch Pass where I had left the trail 12 hours earlier.

The reason for all this madness was WoW. I managed to catch up with my 67-year-young friend, and we hit it off well in Salida. The vibe and positive energy he radiated were exactly what I needed, and it seemed apparent that he, in turn, was happy to see me again too. These things can't be explained, but some people connect better than others. As WoW was on a tight schedule to complete his CDT soon, and the rain and storms didn't bother him, he was in no mind to hang around in Salida for more than 12 hours.

By the time we were having breakfast, I had decided to join him, and we headed back out on trail. No sooner had a hitch dropped us off at Monarch Pass than the rain began to fall, and not lightly either. To my dismay, I saw that

"I've been a wild rover for many's the year
And I've spent all me money on whiskey and beer
But now I'm returning with gold in great store
And I never will play the wild rover no more
And it's no, nay, never
No, nay, never no more
Will I play the wild rover
No, never no more ..."

Keeping my eyes on the threatening clouds, I couldn't help but smile, and soon I joined him for the second and third verses of the old folk song.

Many Scottish and Gaelic songs followed, although we didn't know all the words. However, I noticed that my throat was tightly gripped, and the music's flow was frequently broken by heavy panting and gasps of oxygen. Probably a combination of light anxiety and the thin air up at 11,000 feet (3,352 m).

The rain got stronger and stronger and occasionally alternated with hail as we walked across the exposed, grassy ridge high above the tree line. I couldn't have been more pleased with my recent purchase of a new umbrella. It was too cold to stop and eat, so we chewed some bars along the way while our feet did the work. By 18:00, we had had enough and found something resembling a camping spot, although the ground could have been flatter.

We hastily set up our tents in the rain and crawled inside to eat dinner. I quickly worked away two slices of cold pizza and sat about organizing the interior of my bedroom. Unbeknownst to us, we had set up camp right next to a cliff on a mountain called Windy Peak. We soon found out how the mountain had gotten its name. As darkness fell, the cold wind picked up and blew violent gusts against my fragile tent, and when the

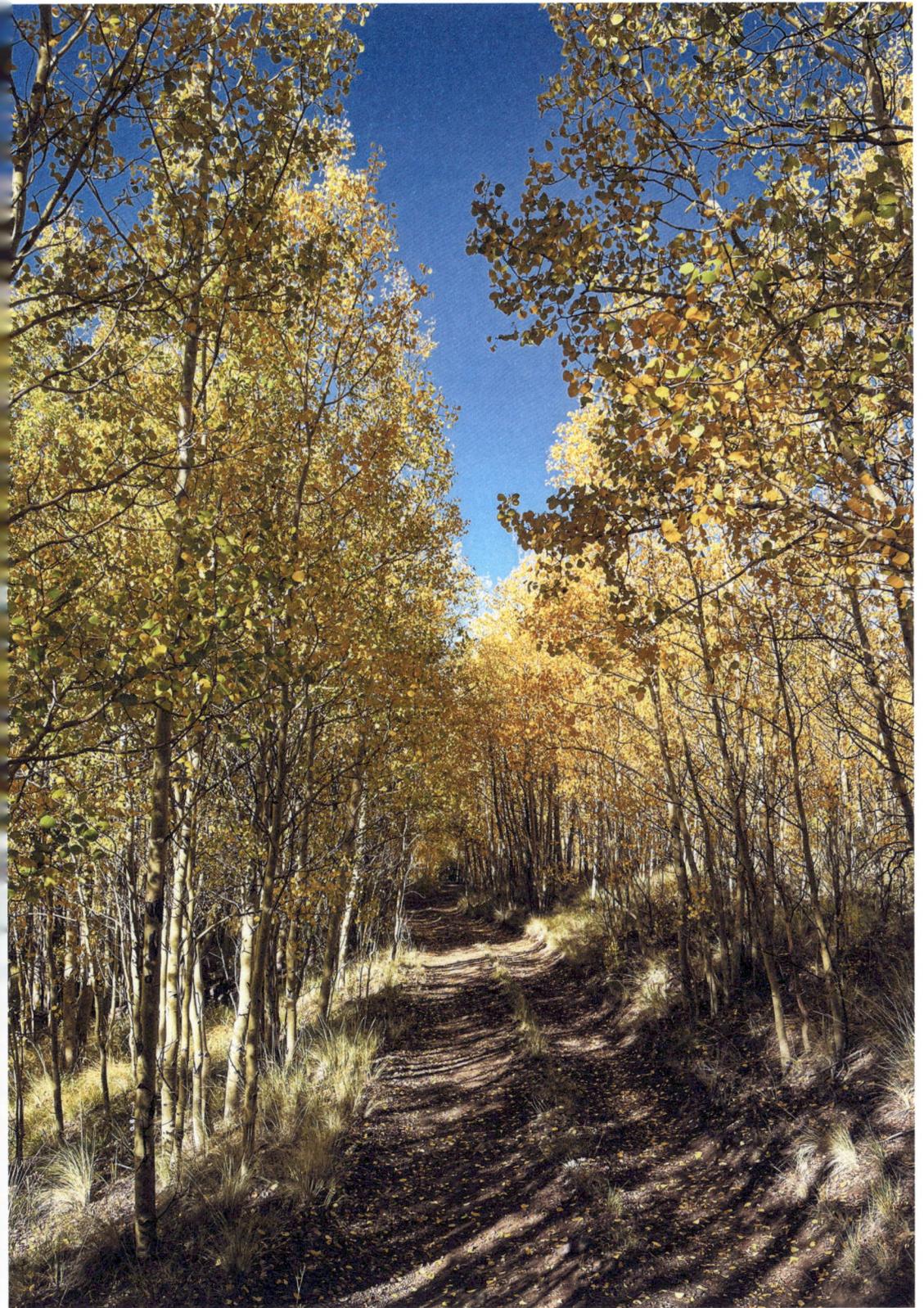

Walking through Colorado's glorious golden aspens.

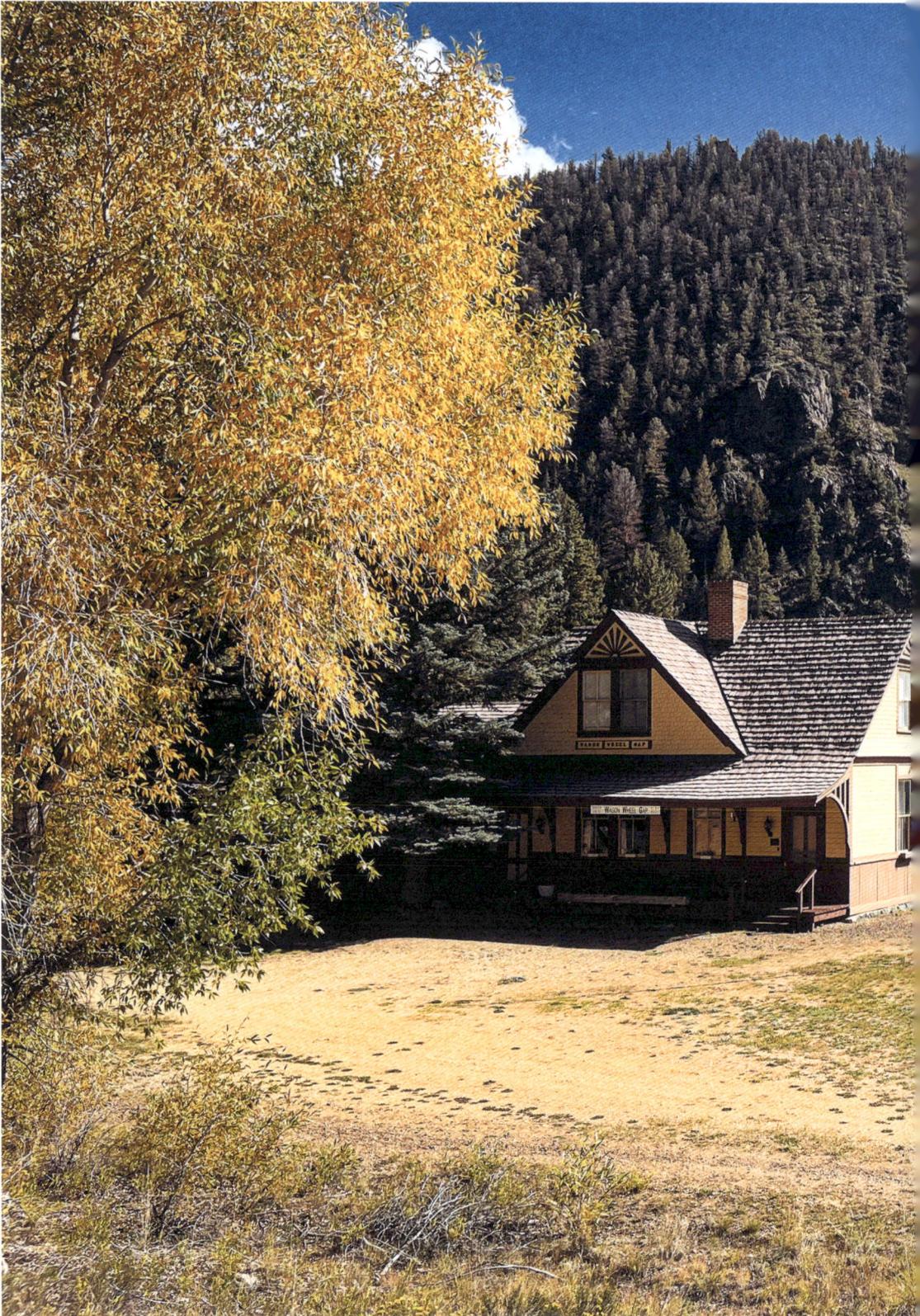

We follow an abandoned railroad track
dotted with golden yellow aspens.

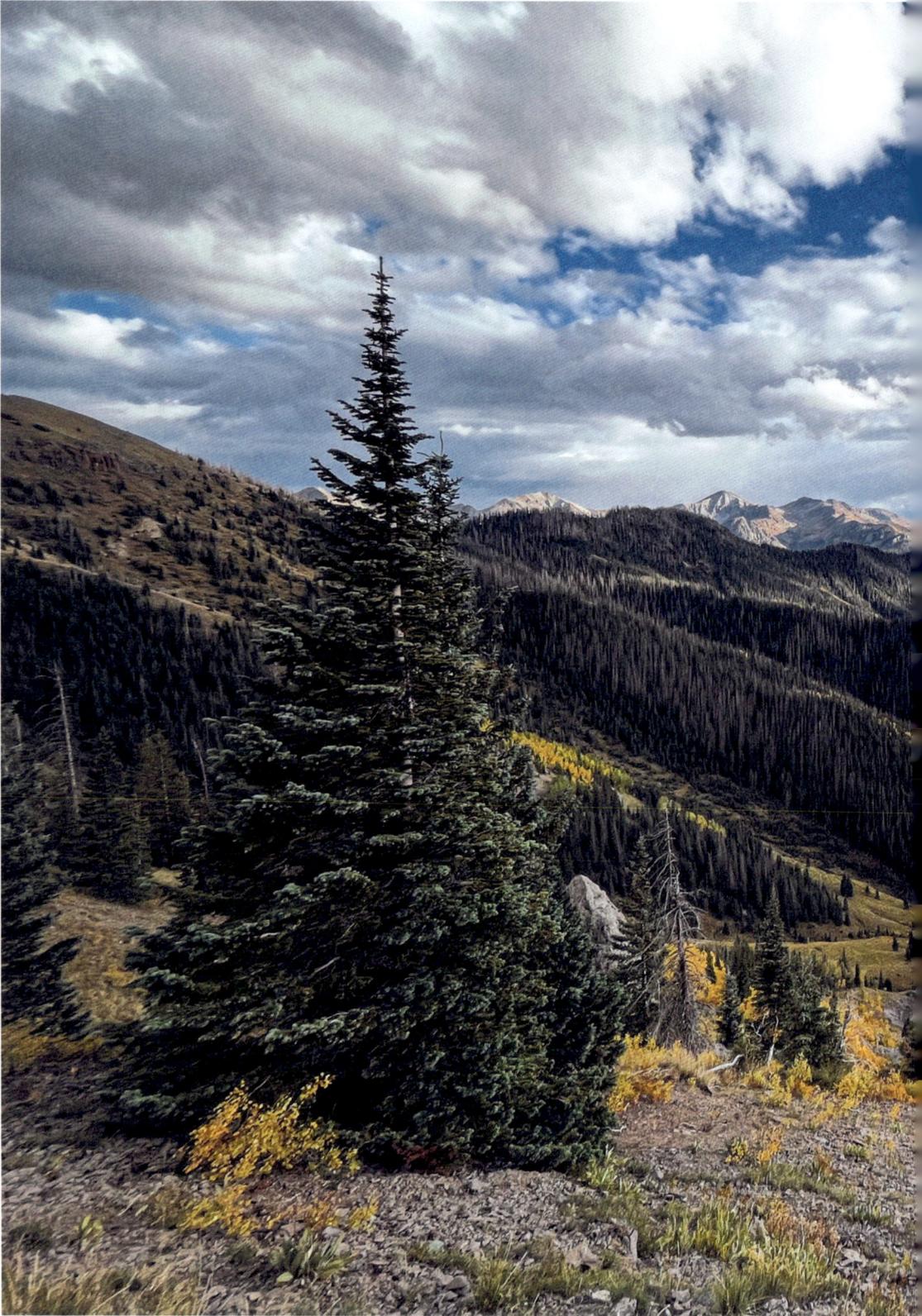

With fall in the air, we eat berries along the trail,
while the aspen trees shed their golden leaves.

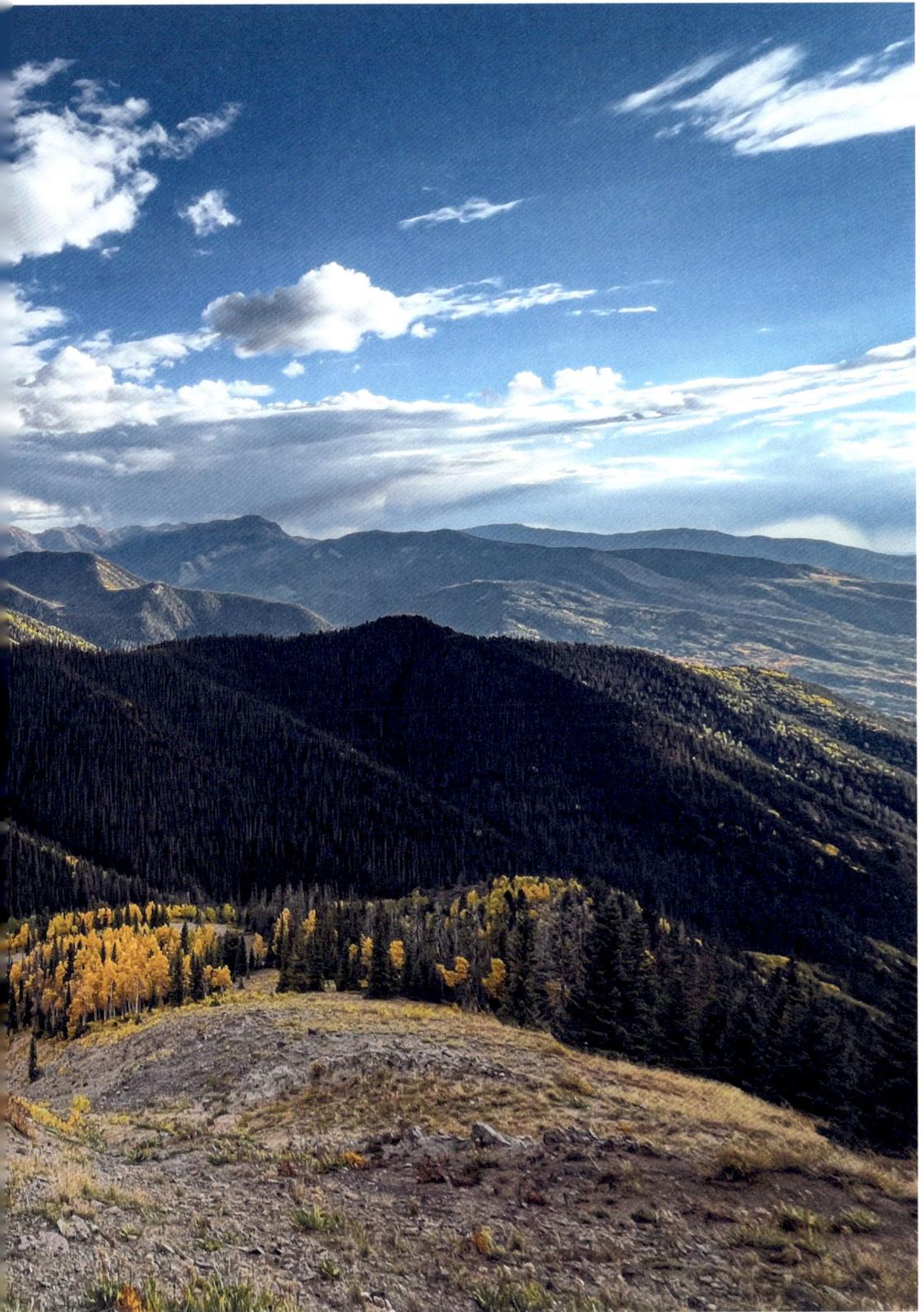

rain intensified, I found that not just the outside but also the inside of my tent was getting wetter and wetter. When I later put my headlamp on to go for a pee, I discovered that the bottom half of my inner groundsheet was flooded.

We had set up camp right next to a cliff on a mountain called Windy Peak. We soon found out how the mountain had gotten its name.

Luckily my thick air mattress saved my sleeping bag from getting drenched in the process, but my foot box was soaked. I used my shoes to create an irrigation system to aid the water flow out of my tent. I glanced at the time, disappointed that it was only midnight. Fortunately, I did fall asleep again but woke multiple times to scoop water out of my tent.

When I finally heard the rustle of plastic coming from WoW's direction close by, I knew it was time to get up and get moving. The rain was still pouring down. By this point, the bottom of my sleeping bag was soaked, as was practically everything else around me. An inch-deep puddle stared right back at me when I shone my light on it. As dawn came, I quickly packed everything up and trudged on into the rain in the hope of catching WoW, who had left shortly before me. The only good things about the long climb ahead of me were that it helped warm me up a little and that my cold, wet socks and underwear slowly became lukewarm. The weather predictions had promised us another full day of rain, something we had knowingly walked straight into.

"The miles aren't going to walk themselves," WoW said as I followed his big black backpack up another long climb. As the raindrops continued to fall, my whole being again slipped into survival mode. I put my head down and new umbrella up and trudged up the trail at a painstakingly

slow rate. As the trail stayed relatively high for a while, we followed a long ridge line for many miles. The next water source would only be eight miles (13 km) farther, and as I didn't have any water left, I knelt down and filled up my dirty bottle with water flowing down the trail itself; my filter would clean it for me. Water is water, and I was grateful for it, whatever color it came in. At around 15:00 in the afternoon, I suddenly saw a tiny patch of blue sky ahead of us, and my heart sang. "Could it be? No, really?" I sighed.

We were in luck! We had a short window where the sun shone down on us, and within minutes we had stopped and unpacked everything into what is called a *garage sale*. Everything I owned was wet, and I couldn't believe my luck as a gentle breeze and some sunshine slowly dried our belongings. I stripped down to my underwear to dry my clothes and hurried around, flipping each item like a pancake to dry. Although not everything had dried fully by the time the next misty cloud rolled over, it still felt so good to have semidry clothes on again as I headed down the trail with a very satisfied smile. Another side effect of this weather was that we had the entire trail to ourselves, having left some 30 hikers back in Salida. A situation that suited me just fine.

Some days later, WoW mentioned that he had seen a brown rabbit with fluffy white feet. He told me that the mountain rabbits slowly transformed from brown into white as they prepared for winter.

"They what?" I said in astonishment.

He explained how color changes are an evolutionary survival mechanism born of a rabbit's status as a prey animal. Rabbits molt several times a year. Their fur initially molts and then grows back a different shade, camouflaging them to fit the season, and protecting them from potential predators.

Paradoxically, arctic foxes do the same, only they are the animals of prey.

I couldn't believe my ears: how smart, how adaptive these creatures had become through hundreds of thousands of years of evolution.

White fluffy chameleons high in the mountains, camouflaging themselves from their prey.

One could argue that I, too, was adapting well to the upcoming winter around me; my hair was turning white. But these foxes and rabbits would return to full color in the spring. My hair would still be white.

But I have always considered myself somewhat of a chameleon, adapting to different social groups. There's something that I like about the fluidity of different groups, different attires, different rituals, different codes, different expectations, and different roles, while at the same time staying true to myself with all my qualities and flaws.

The trail passed through endless berry fields. But strangely, I hadn't seen any blueberries or huckleberries along the trail these past three months. The bears had gotten there before us. But in southern Colorado, we were treated with wild raspberries. The red, juicy wild raspberries were ripe for picking along the trail, and we were loving it. As I bent down to pick, my hands slowly turned pink, as did my lips and mouth. My body desperately needed vitamins and fiber, and I could feel my cells rejoicing with every berry I swallowed. WoW soon joined the pick-your-own party, and without saying a word, we feasted as we made slow progress down the trail.

"Good morning, young man," WoW said as he walked into a freezing sunrise.

"Good morning, young man," I replied. It was becoming somewhat of a ritual each morning. On that day, we rose early to walk the 11 miles (18 km) downhill into Creede, Colorado. Once in town, I suffered another restless night; I couldn't sleep well above 10,000 feet (3,048 m). I tossed and turned all night, tried to watch a movie, did some writing, and edited some photos, but nothing really seemed to help me sleep.

In southern Colorado, we were treated with wild raspberries. The red, juicy wild raspberries were ripe for picking along the trail, and we were loving it.

When morning finally broke, I was happy to return to the trail. Things were good, and my spirits were high, but I still could have used some rest. There was a general fatigue hanging over me, and although my legs were strong and my body was healthy, I couldn't eat enough calories compared to what I burned during the day. My body was slowly eating away at itself, and the

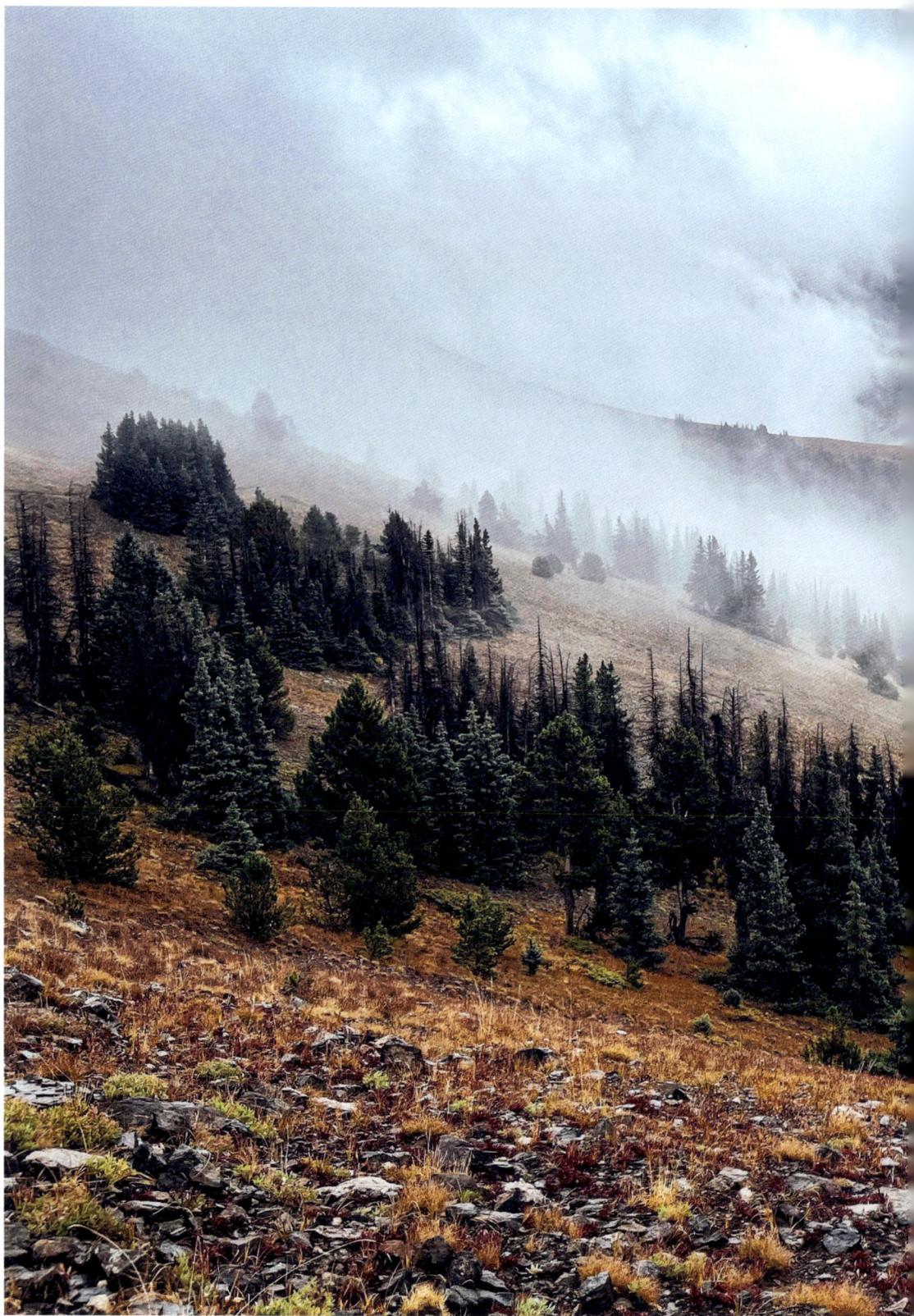

The weather takes a turn in the South San Juan Wilderness.

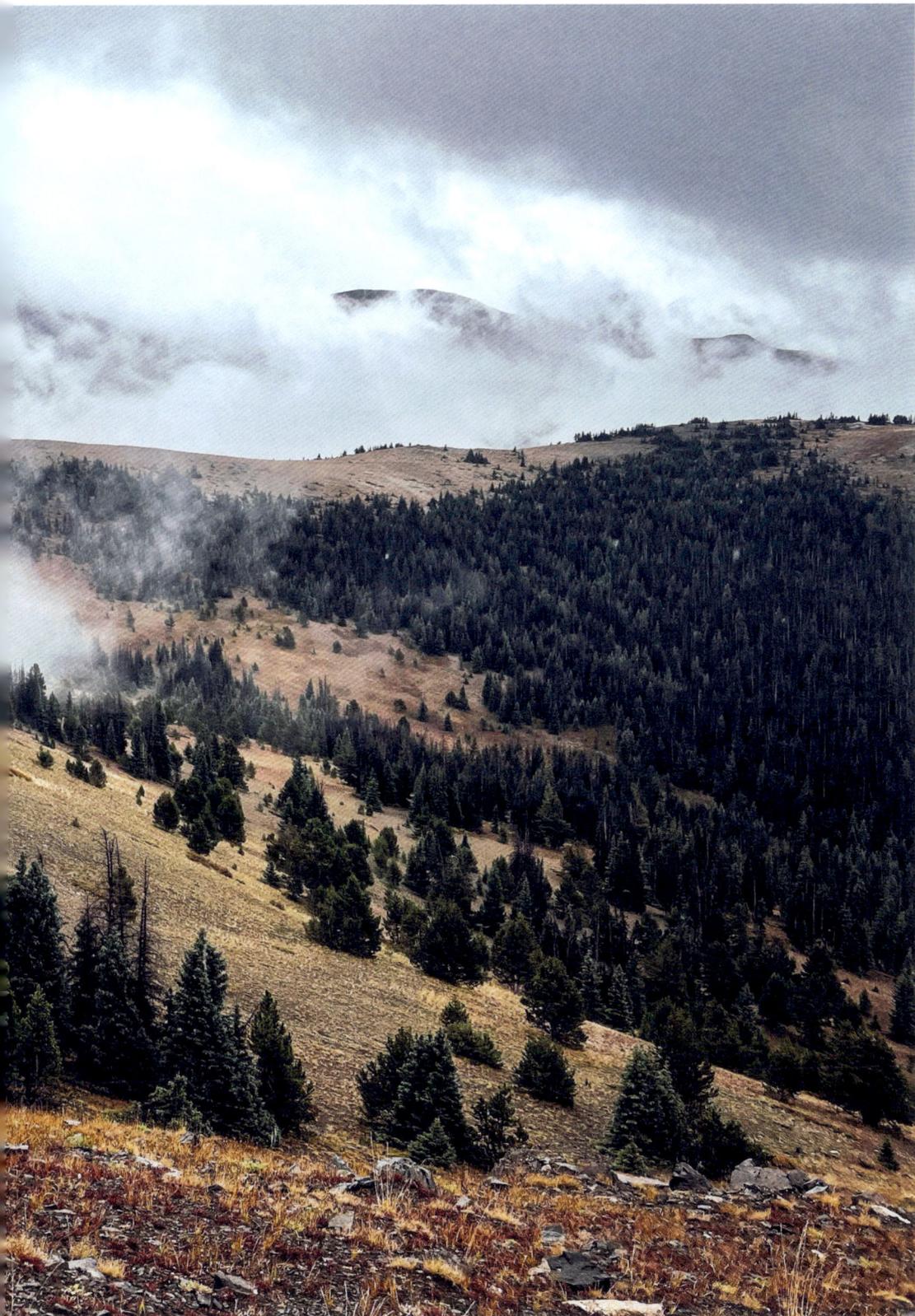

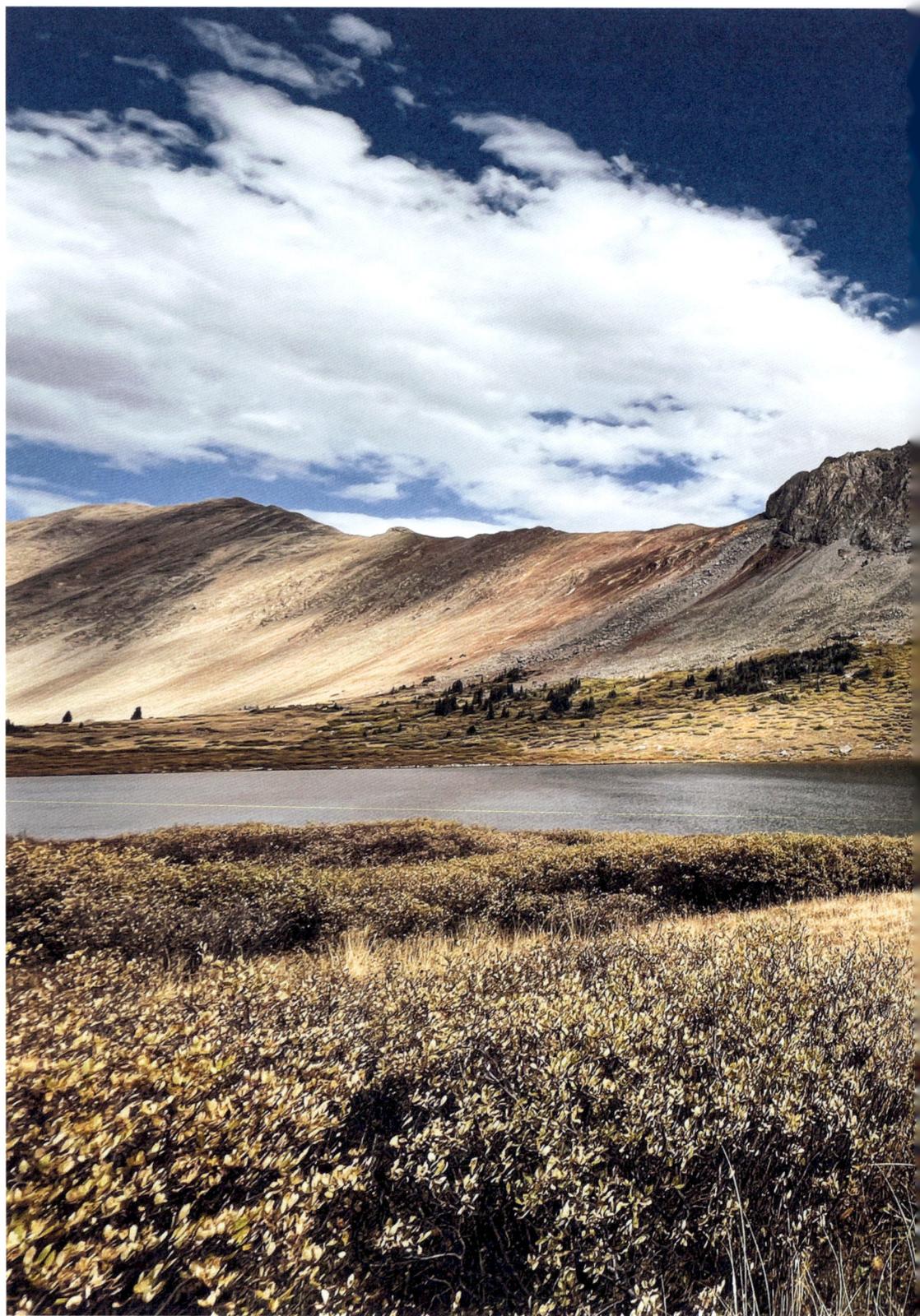

It is cold in the South San Juan Wilderness, as winter is coming.

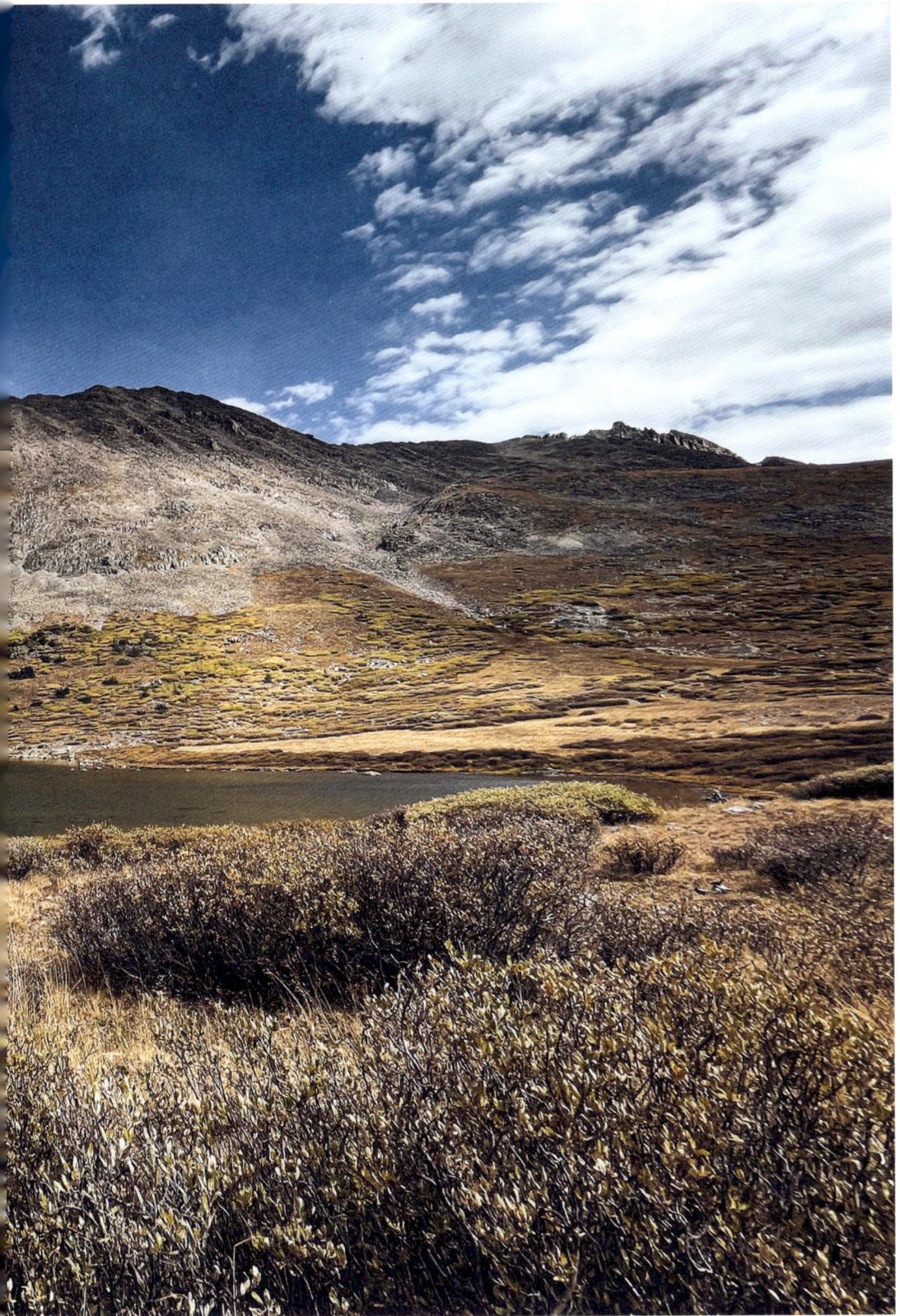

high altitude and endless climbs were taking their toll. It was time for a good old zero.

As summer came to a close, the grass that fringed the trail had grown tall, reaching above the height of my nose. Pale golden strands with beads of seeds that would give new life next spring waved gently in the fresh mountain breeze. Stretching out both arms, I felt like a swallow flying over a field. We, just like the swallows, were migrating south, searching for warmer weather and greener pastures, following an instinct to move on. Migrating, walking, trekking, following the swarm. Following an inner compass toward something that no one can explain.

Pale golden strands waved gently in the fresh mountain breeze. Stretching out both arms, I felt like a swallow flying over a field. We, just like the swallows, were migrating south.

As for swallows themselves, we still don't fully understand how their migratory process works, but numerous researchers have shed light on the subject. It has been found that when migrating, they use visual landmarks to remember when to turn. Swallows can migrate vast distances, sometimes traveling a staggering 6,800 miles (10,943 km) in one go, seemingly through instinct and memory alone. I love swallows. Their shape, symbolism, and movement. I feel there is still so much we can learn from them.

Hawaiian Shirt

Mile 2,037

It was getting pretty crowded inside my sleeping bag. I now had to sleep with my water filter, external battery pack, and telephone inside my sleeping bag to ensure they didn't die in the freezing temperatures at night. But with the seven layers I wore, I was always comfortably snug and warm.

"Are you aware that you whistle all day?" WoW said behind me as we stopped to look out over a new valley, having reached yet another high pass.

"Is that right?" I answered, racking my brain about whether I whistled that much.

"Yes, you practically whistle and hum all day!" WoW answered, laughing and shaking his head in disbelief that I was unaware of my chirping.

As I thought about it, I realized there was always a song in my head, either a childhood nursery rhyme or one of the songs I enjoy singing with my boy band, a group of eight middle-aged boomers with whom I've sung and performed close harmony songs for 25 years. People who whistle are generally cheerful, happy, and content, I thought. I felt good in WoW's company and thoroughly enjoyed every step of the trail. I was in the flow. My creative flow had really taken off, too, and new ideas had been flowing, whether for new books, short trips with my family and children, plans to build cabins in the woods, business, new keynote talks, or reunions to reconnect with long-lost friends. My spirit was on fire.

After the initial physical discomfort and pain of the first two months and the mental instability and illness of the third month, I had finally reached a state where I felt physically and mentally at peace. I had space for more creative

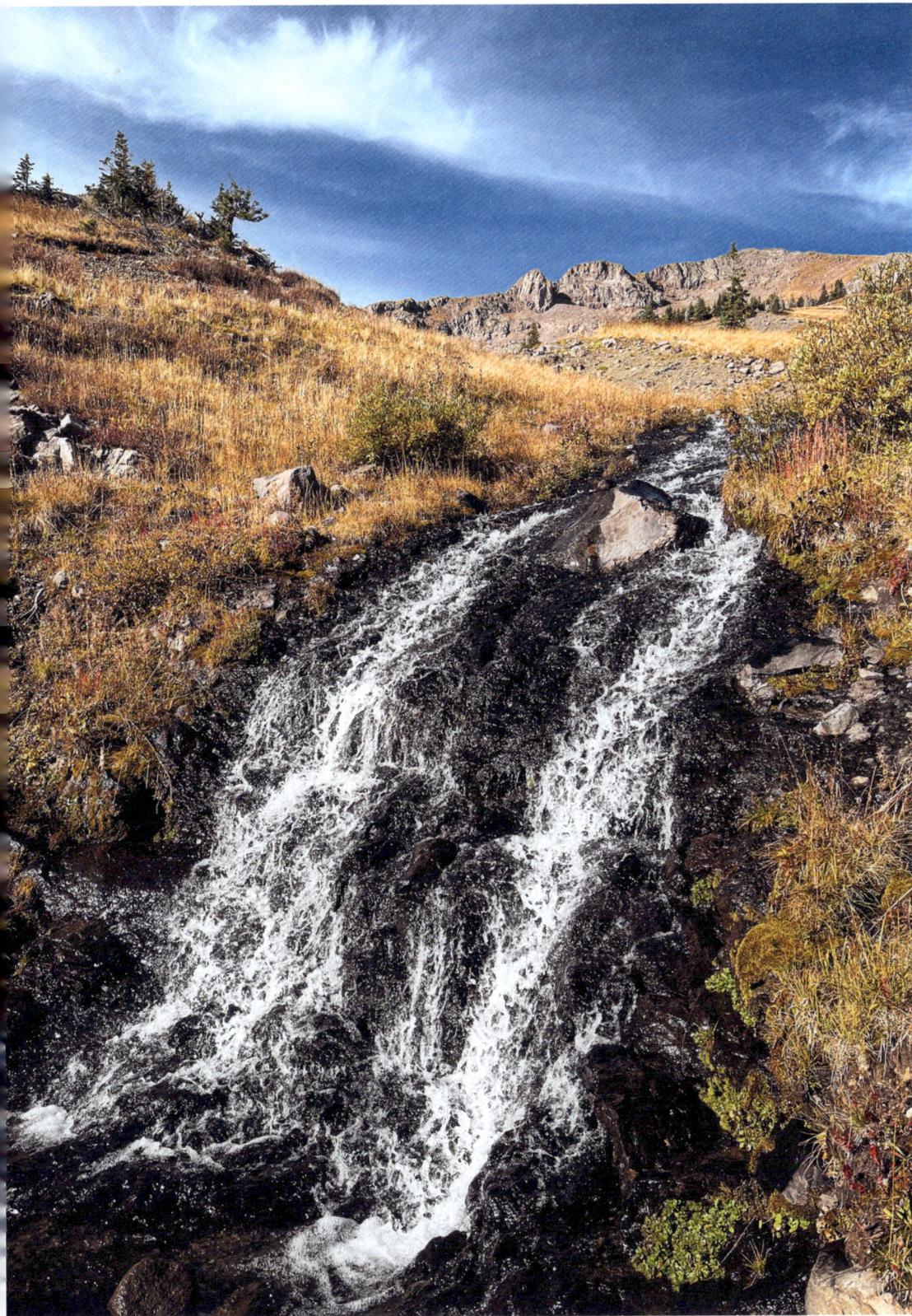

The heavy rainfall means there is ample drinking water along the trail.

The trail community is what creates the magic of the long walk.

and spiritual questions. It was always fun to have long philosophical discussions about faith and purpose with WoW, and I felt so grateful to have found a hiking partner to reflect with.

To my surprise, WoW was a very spiritual person and had devoted his entire adult life to his faith. Quite contrary to his Catholic upbringing, he had discovered Sufism in his early twenties. It had inspired him, given him direction and purpose. Sufism—which may be best described as Islamic mysticism or asceticism—through belief and practice helps its followers attain nearness to what WoW called *The Source* via the direct personal experience of God. And although WoW was a strong believer in *experiencing* one's faith, he also spent a lot of his life learning, meditating, and sharing with others, as well as serving those in the community who entered his emergency ward at the hospital each day. The more we talked, the more I realized this kind of spiritual reflection was something I had been missing during the past months.

We left a trail to rest in the nondescript highway town of South Fork to take a well-deserved zero. When our hitch dropped us off in town, we first booked a motel room, bought a 12-pack of IPA, and did the laundry. Afterward, we rested and ate. There was a lovely little Mexican restaurant, Ramon's, which we frequented on four occasions for breakfast and dinner as we did our best to compensate for the calories that we'd lost in the mountains. There seemed to be no end to our hunger.

I ordered a spicy chicken soup, followed by a surf and turf plate with an immense amount of juicy protein. For sides, I ordered a guacamole salad with tomato, onions, jalapeños, and bell peppers, and a serving of fries. The main course was followed by a dessert made of fluffy cake laced with cinnamon sugar and covered in honey. As it was our zero and I was feeling rather festive, I ordered a piña colada and a large Coke. I could feel the sugars, fats, and salts gushing through my body and becoming one with my cells. I slowly began to feel human again with this much-needed pit stop.

There was one crucial thing that I had to do in South Fork, namely, repair my Hawaiian shirt once again. Only this time, it called for serious measures. The entire back of the shirt was shredded. I headed to the general store and bought a large shirt to act as a donor. When I returned to the motel room, WoW gave me a funny look as I spread out on the floor to cut up a perfectly good shirt and replace the back of my old shirt with the new fabric. The hand sewing took me the good part of two hours, while WoW enjoyed an old Western. When I was done, I got out my black Sharpie and drew a large image of a swallow on the back of my shirt, adding a long thin ribbon in its beak. The ribbon bore the words "CONTINENTAL DIVIDE TRAIL." I was happy to have the swallow at my back.

With 30 hours of rest in South Fork, I had nearly forgotten how terribly cold it could be in the mountains at 12,000 feet (3,657 m). Although the days were predominantly bright and sunny, we were frequently hit by hail showers and looming dark clouds. I was pretty pumped about my new purchase of insulated neoprene fishing gloves, which kept my hands warm and dry. Again for days, we didn't see or meet another soul, and as

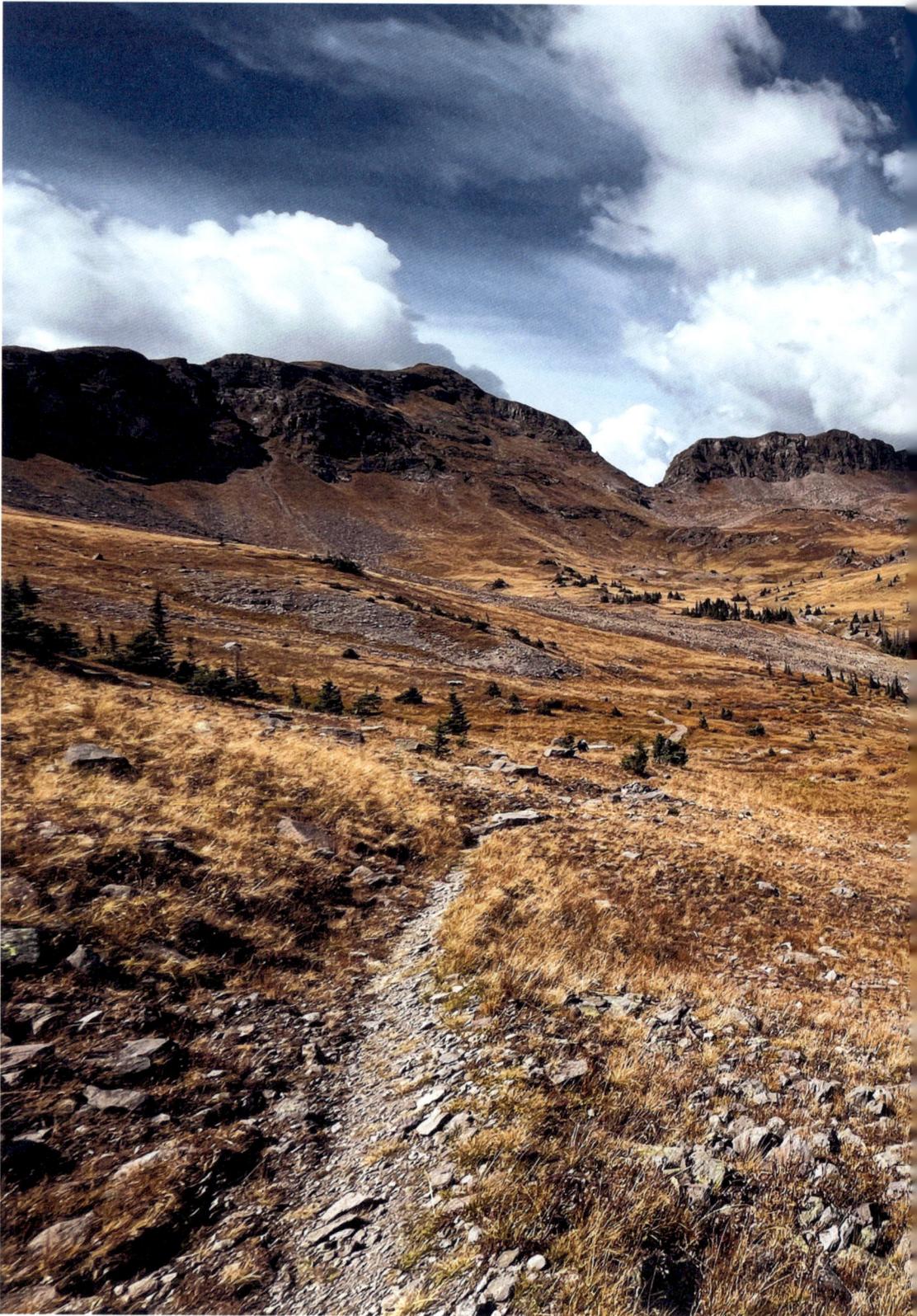

Parched yellow grass blankets the landscape high
above tree line in the South San Juan Wilderness.

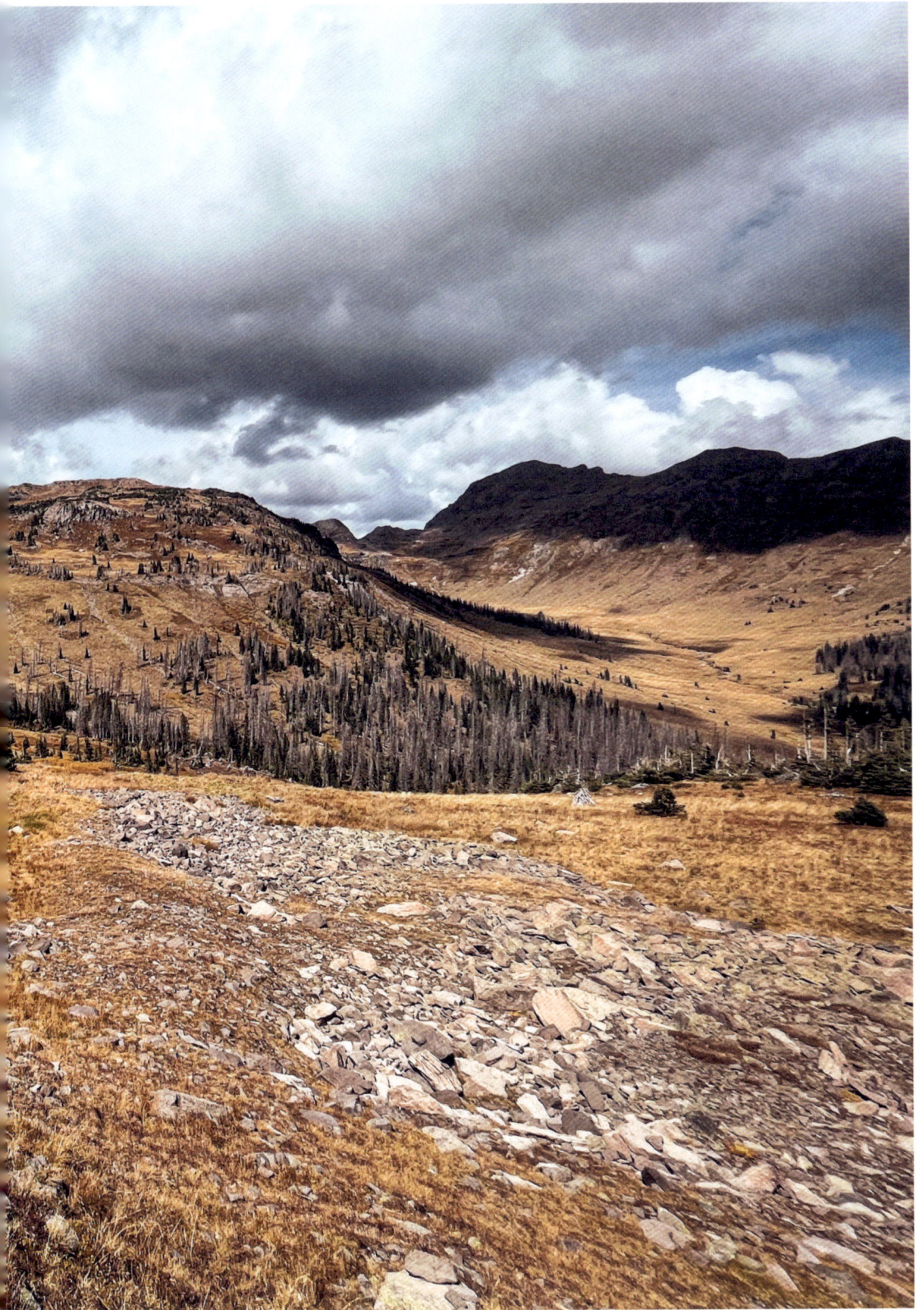

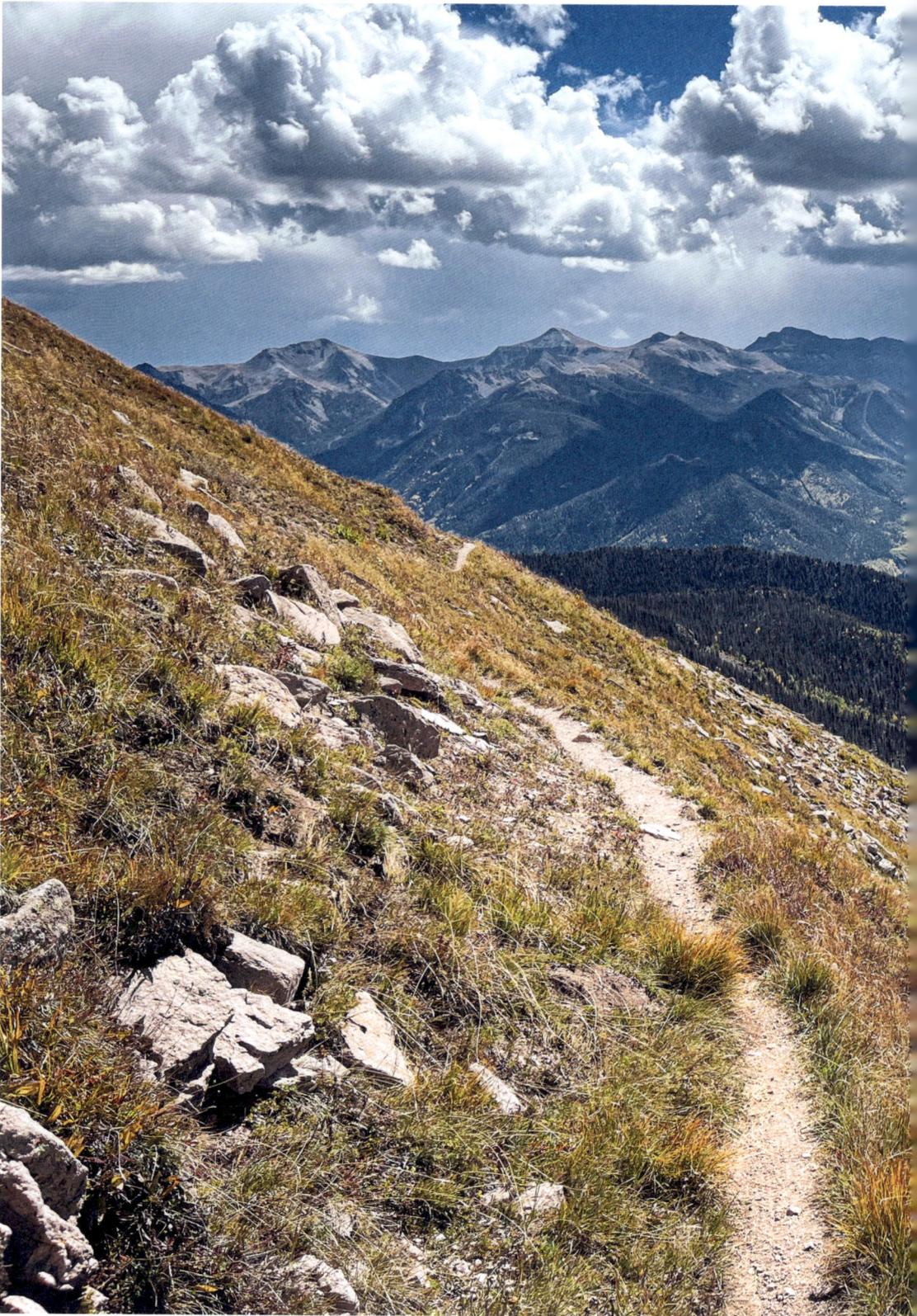

Sometimes the trails winds around the
mountain instead of climbing up and over.

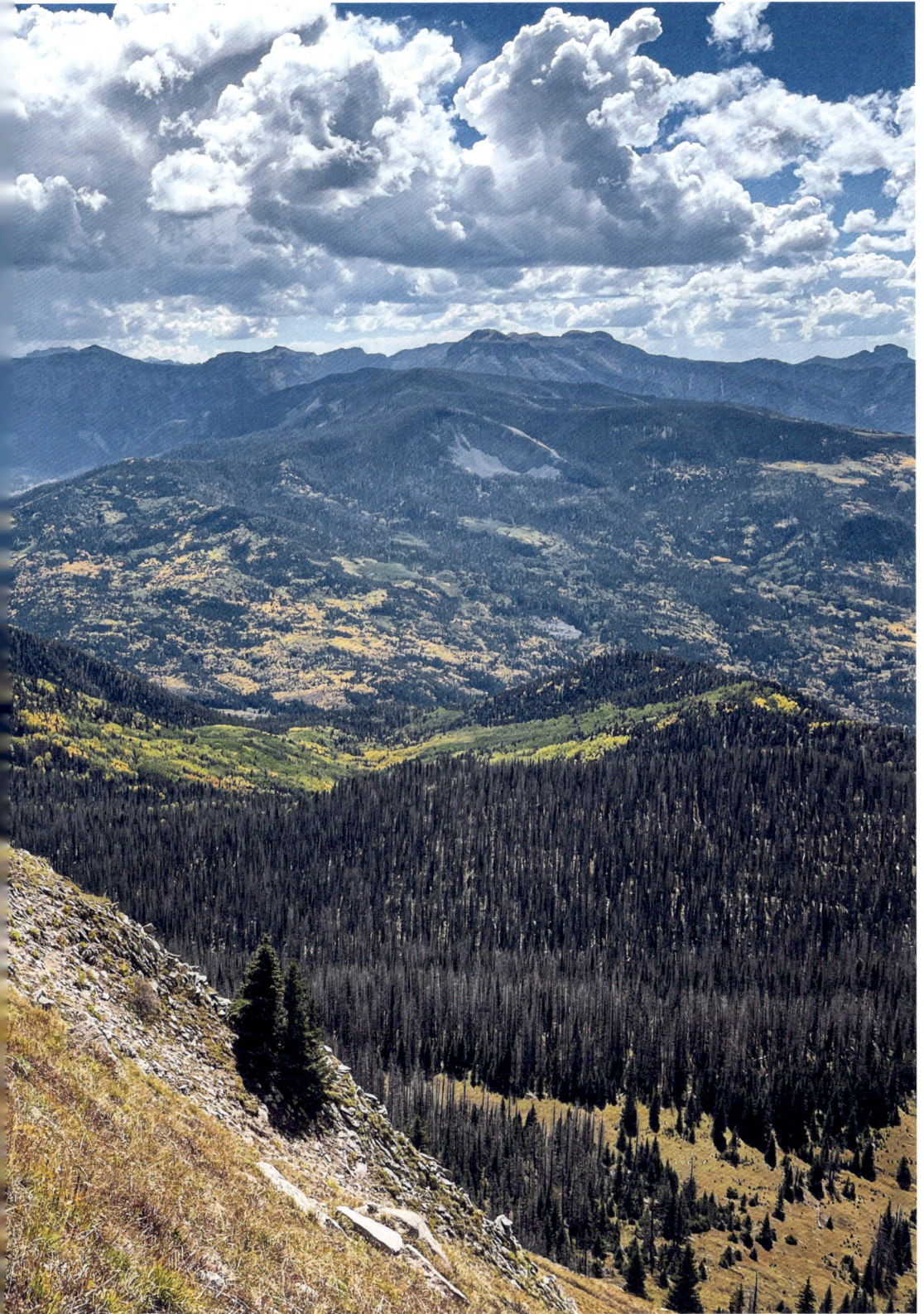

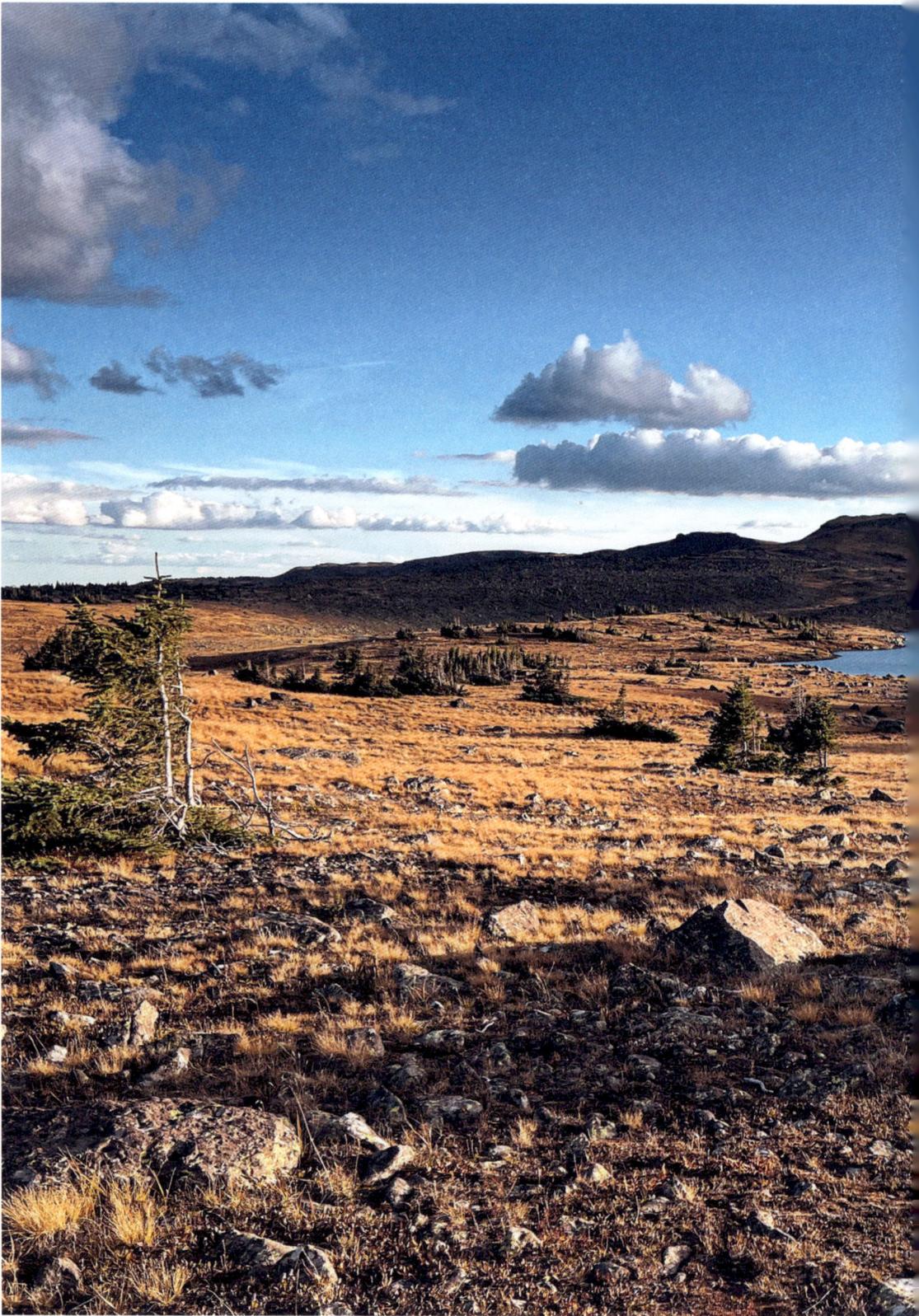

The evening sun casts long shadows over the high,
cold landscape. What better place to set up camp?

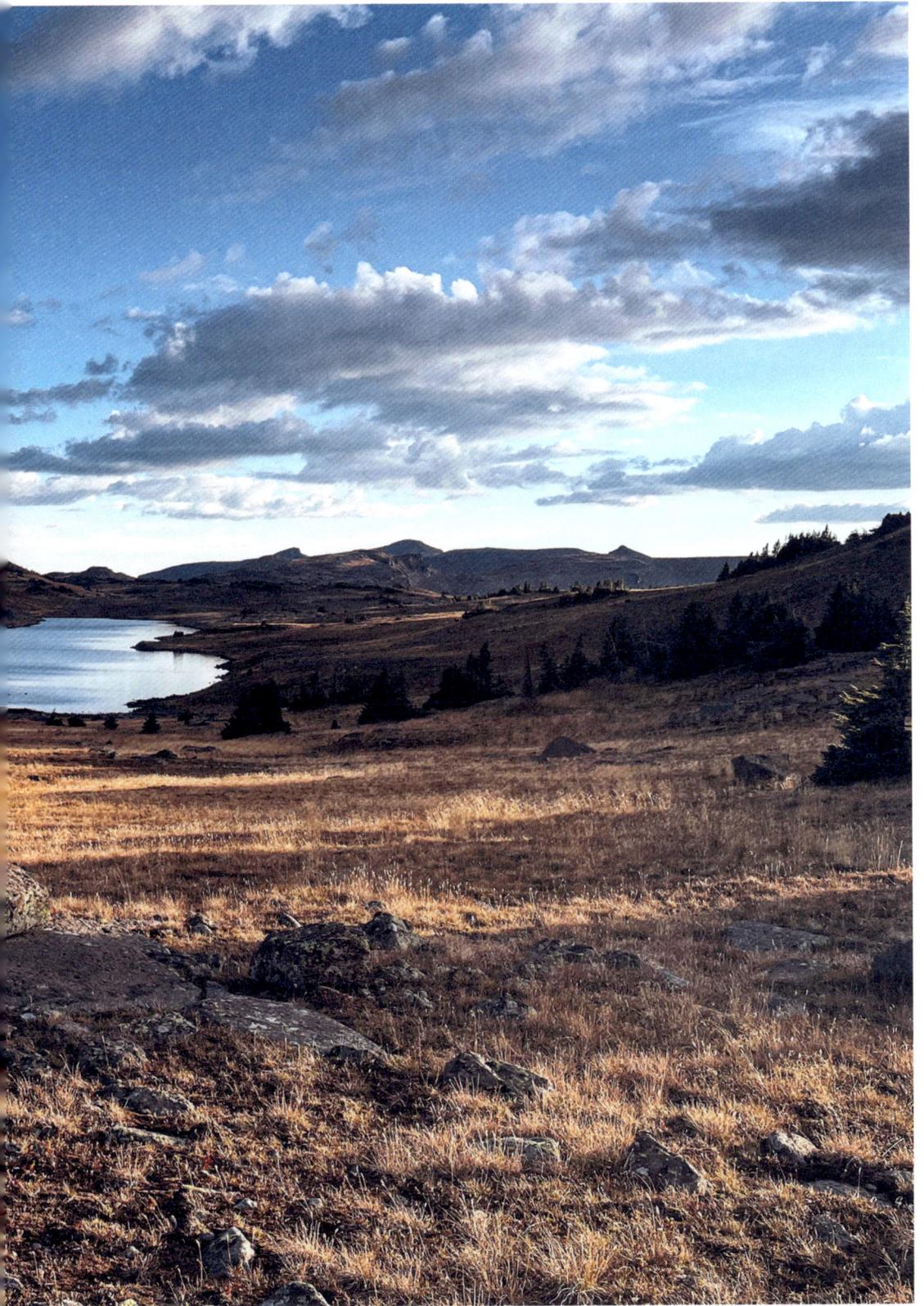

we walked about half a mile apart, I often fell into a trance of thought, undisturbed, as I placed one foot in front of the other. The San Juan Mountains were quite famous within our hiker community, and we soon discovered exactly why. Although we had taken the lower alternate around the first section of the San Juans to avoid the snow, we did get a good feel for their beauty in the southern section. High above the tree line, a soft quilt of endless shades of yellow stretched over the vast range. Grass swaying in pale warm yellows, faded green yellows, warm fall yellows, and rusty yellows. There were more shades than I could possibly try to describe. It was a beautiful blend of color, stretching out as far as the eye could see, filling my heart with joy throughout the day. Due to the remoteness, there were no roads, no day hikers, no hunters, no internet, no cell reception, no ski lifts, no pizzas, no cappuccinos, no nothing. This was the wild open expanse I had longed for the past four years. The only sign of civilization was the thin trail that cut through the hillside, guiding us farther south. The American wilderness is unique in so many ways, without light or noise pollution from nearby towns. You can get lost out here, both physically and inwardly. Lost in thought, lost in reflection, and lost in the moment.

> The only sign of civilization was the thin trail that cut through the hillside, guiding us farther south. The American wilderness is unique in so many ways, without light or noise pollution from nearby towns.

I breathed a sigh of relief. After more than a month of Colorado's Rocky Mountains, without a single flat moment, the trail finally evened out the day before we hit New Mexico. Colorado had been brutal. Beautiful but brutal. I had forgotten what it felt like to be able to walk three miles an hour. To walk at an even pace with long strides, to put my head up and dream of new endeavors. If this was a sign of what was to come, I was really looking forward to New Mexico; that, and the lower elevation, sounded like music to my ears, feet, and lungs. I couldn't imagine a better place to be.

Self-Pity

Mile 2,170

I woke up in a yellow cloud. We had camped high on a ridge with mist surrounding us, and although it wasn't raining, you could feel the moisture in the air. The sun must have risen just above the horizon and had colored the clouds in a golden glow. But the rest of the day did not have a golden, or even silver, lining. Shortly after I started walking, the heavens opened once again, and it rained all day. Although the climbs were not as high and hard as previously, I found the day to be quite heavy. The rain pulled me down, weighing down my backpack and mind. There was no point complaining, but I couldn't wait for it to end. Hopefully, the next day would bring sunshine.

In total, it had been raining for seven days now, but it felt more like seven years. My daily routine was turning into that of a zombie, putting on cold, wet socks and shoes and dressing in wet layers. It wasn't easy to raise my inner temperature, and only by hiking fast could I warm up my core. My hands hurt, and I couldn't feel my feet anymore. I kept slipping and sliding or having to clamber over the fallen trees. But I put my head down and trudged on. Stopping to break for food wasn't really in the cards in those circumstances, as my core temperature dropped if I didn't keep moving. We could only move forward.

SOUTH SAN JUAN
WILDERNESS

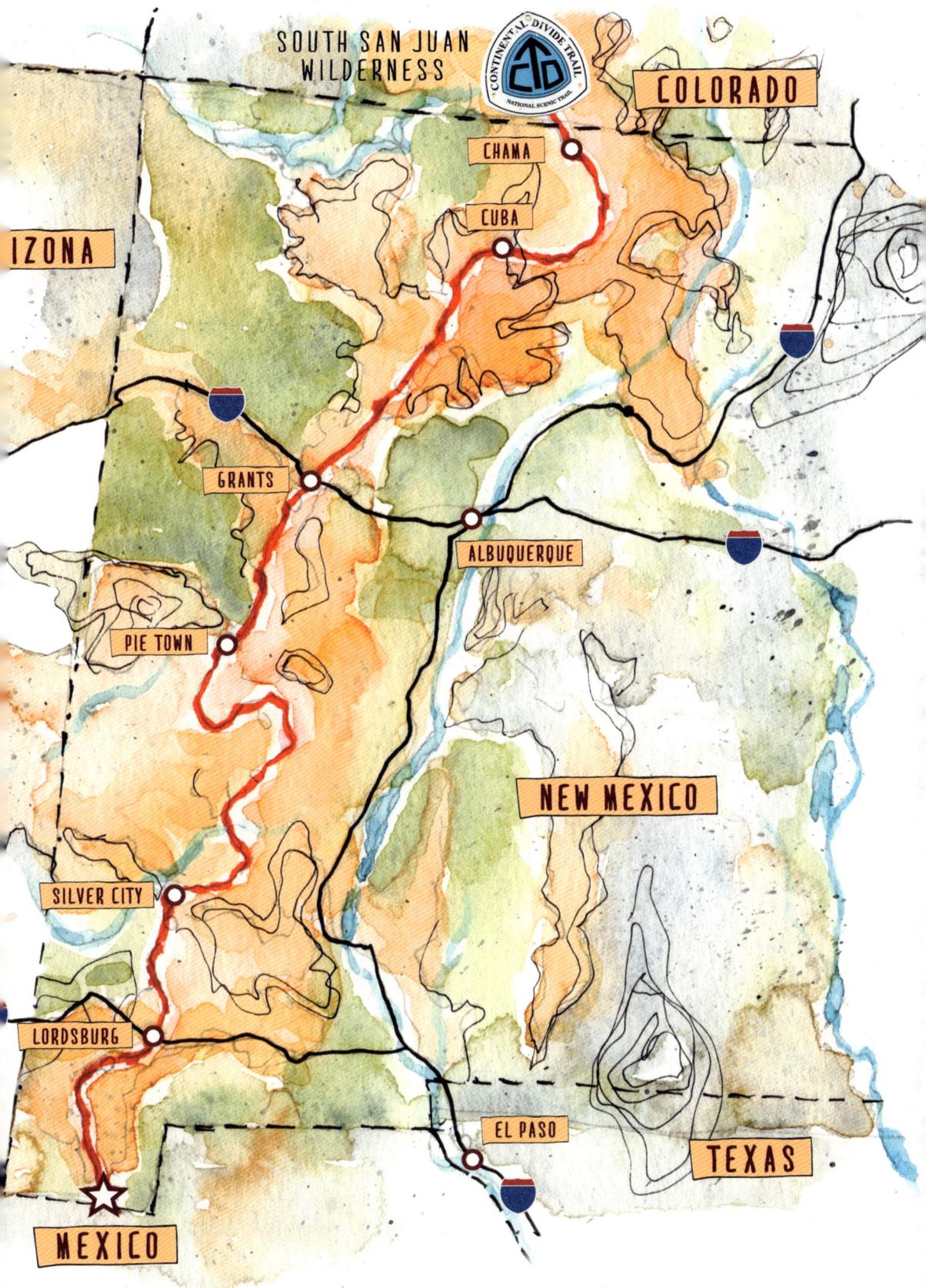

CONTINENTAL DIVIDE TRAIL
NATIONAL SCENIC TRAIL

COLORADO

CHAMA

CUBA

IZONA

GRANTS

ALBUQUERQUE

PIE TOWN

NEW MEXICO

SILVER CITY

LORDSBURG

EL PASO

TEXAS

MEXICO

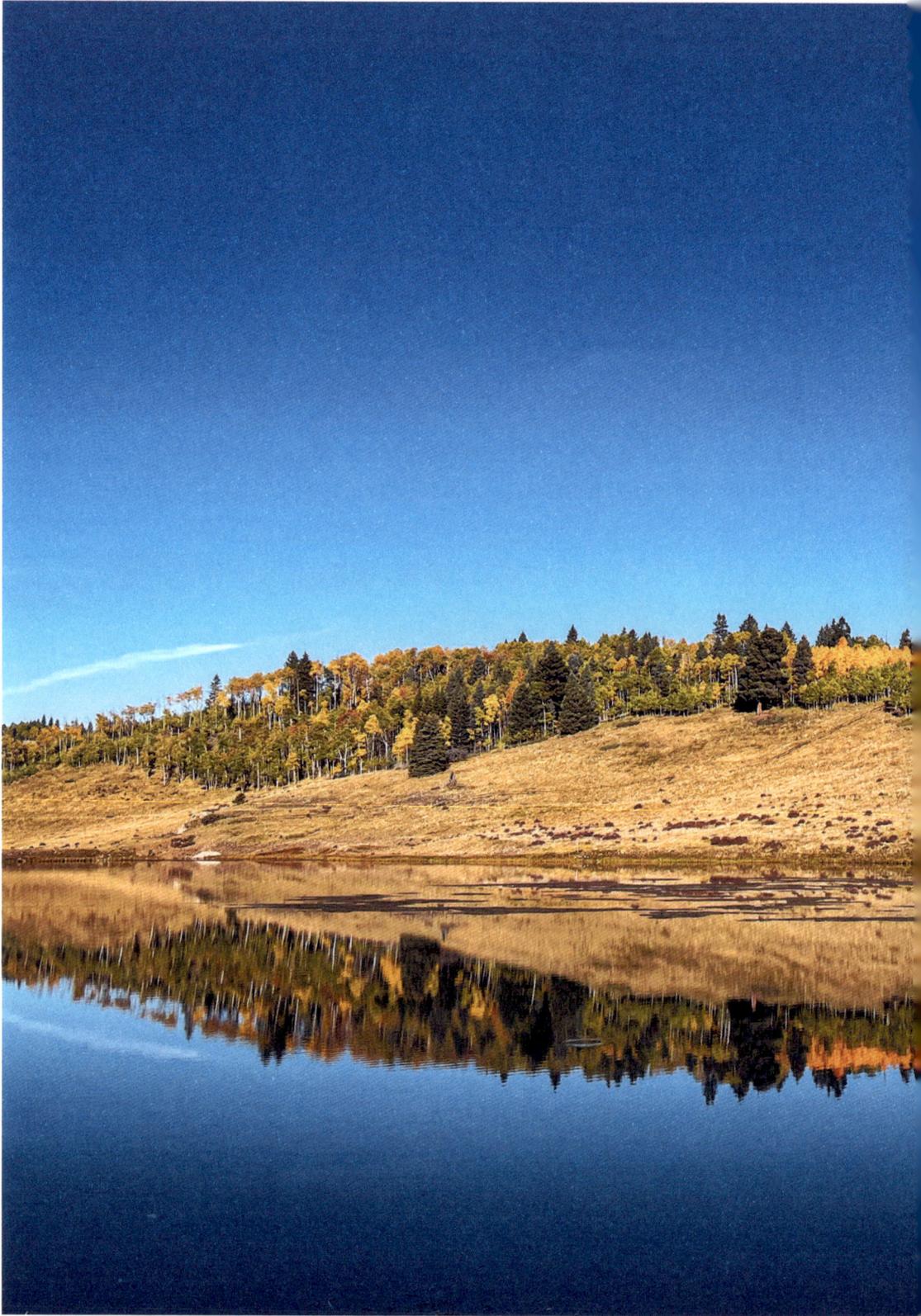

Golden aspens and evergreens are mirrored
in a motionless lake in Southern Colorado.

The trail takes me through endless aspen forests in Southern Colorado.

We walked from one cloud to another, and only when there was a small break in the cover could we see a new type of landscape around us. It had become more hilly than mountainous, covered in coarse grasslands that reminded me of Scotland. Only here there were no pubs to shelter in. No jacket potatoes or good pints of stout. Not only that, but this land wasn't used to this kind of intense rainfall, and the otherwise dry, arid plains had now become totally saturated with water. And the water didn't know where to go. East and west of the Continental Divide, the soil turned into a marshland. Everything was wet, and the trail itself turned into an endless muddy river. It was pointless trying to avoid wet feet.

I was no stranger to a little complaining or the occasional bout of self-pity, but I found myself in the company of someone who truly never complained. WoW made it into an art form, always focusing on the positive in any given situation. He told me that it had become a very natural subconscious process.

"There are always two choices in any given situation," he said, pointing to the example of a loud drunkard we had seen in the bar a few days earlier. "You can focus on the annoying drunk man in the bar and get irritated and express your complaints, or you can choose to focus on all the beauty and positive things in the bar and let these things determine your mood. You can ignore the loud drunk man." Based on this mindset, WoW had yet to complain about the rain. Not once, even after seven days of being drenched.

"It's a choice as to what you focus on. The good or the bad." WoW's words rang through my mind as we trudged on in the mud. My parents rarely complained, and I have never heard them swear. In that respect, I was brought up not to complain about anything either, rather focusing on the things in life for which to be grateful. It was an important Calvinist principle that they had passed on to me in my youth. Living by such high standards can be hard, and I must admit to losing my composure more often than not.

Complaining about the weather, the cold, my heavy backpack, and the pain in my left shoulder—well, there simply was no point. Especially out here, where there was no one to hear my complaints. Besides, it's what I signed up for.

After all, wasn't it a privilege to be on trail for so long, living in the wilderness for months? Rain may be tough and cold, but it, too, would pass.

One morning I passed two hikers going northbound in the pouring rain. The first didn't utter a word and just sped on behind me. The second man, older and with a short white beard, passed me a few minutes later.

"Having fun yet?" he roared with a mischievous grin on his cold, wet face.

"Yup," I answered, smiled, put my head down into the rain, and marched on. I guess it's all about perspective.

I discovered that WoW took this concept even further, as it was one of the main reasons why he was doing this trail in the first place. He wanted to discover whether his inner conviction, his *understanding* as he called it, would continue to hold up and not waver, even under the harshest physical and mental pressures. He was putting his 67-year-old body through hell, walking on empty, tired, exhausted, wet, cold, and often mentally drained. He was practically broken, yet he was so happy to discover that his inner beliefs stood stronger than ever.

"I'm walking home to my heart," he said simply.

Just as we were leaving the high mountains behind us, and the sun was back creating some beautiful light and contrast, I thought it was another perfect opportunity to do a prehistoric photoshoot. After all, we had two ancient white-bearded wizards, epic mountains in the background, and some wind to add drama to the shoot. What could possibly go wrong? "Stop!" I shouted and waved down at WoW. First of all, he had taken the wrong route down into the wrong valley, and secondly, I needed him for the photoshoot.

"Get your tent out; we're going back in time!" I yelled into the wind as he headed back.

At first, WoW didn't quite understand what I was up to, but when I added, "It's for art," he no longer hesitated and pulled his tent from the bottom of his backpack. WoW had enjoyed the paintings I had done for strangers along our path. He saw the effect these small pieces of art had on them and was excited and curious to see what I had come up with this time.

He stood tall as I wrapped the thin fabric around his shoulders and draped the tent over his bald head to make him resemble a wizard from *The Hobbit*. His long white beard and beady eyes poked out from under the fabric as he looked into the distance with a stern stare. This took him back centuries, and as the wind swept the tent up behind him, the picture practically created itself. All I had to do was crouch down to take the shot. When I switched the photo to black and white, the image rewound eons of time. After taking a few of WoW, I wrapped my tent around my head and shoulders and joined him as we looked south, away from the lens, into nothingness. Hilariously heroic. Pointless, as with so many other things in life—yet fun.

On the seventh day, we finally descended into New Mexico and its sage fields and cacti. We were welcomed to the desert state by a tarantula scampering across the trail in front of me. When the spider detected the vibrations of my heavy steps, it stopped and reared its hairy legs, ready to defend itself. All of a sudden, there were so many new desert plants around us, all totally foreign to me. An abundance of tiny desert flowers, orange, yellow, purple, and blue, were scattered around my feet. The recent rain had brought the buds to life now and the sun was finally out again. I picked a few leaves of the new shrubs along the trail and rubbed them between my fingers to extract their oils and smell their scents. The red, sandy canyon walls on either side of the path felt like a gateway into a promised land. Finally, I was in the desert, and I could feel the end of the trail nearing. There were still four weeks ahead of me until I could touch the Mexican border, but I felt I would enjoy this last stretch. Far below me, a lone settlement, Ghost Ranch, lay waiting for me. The only place for miles.

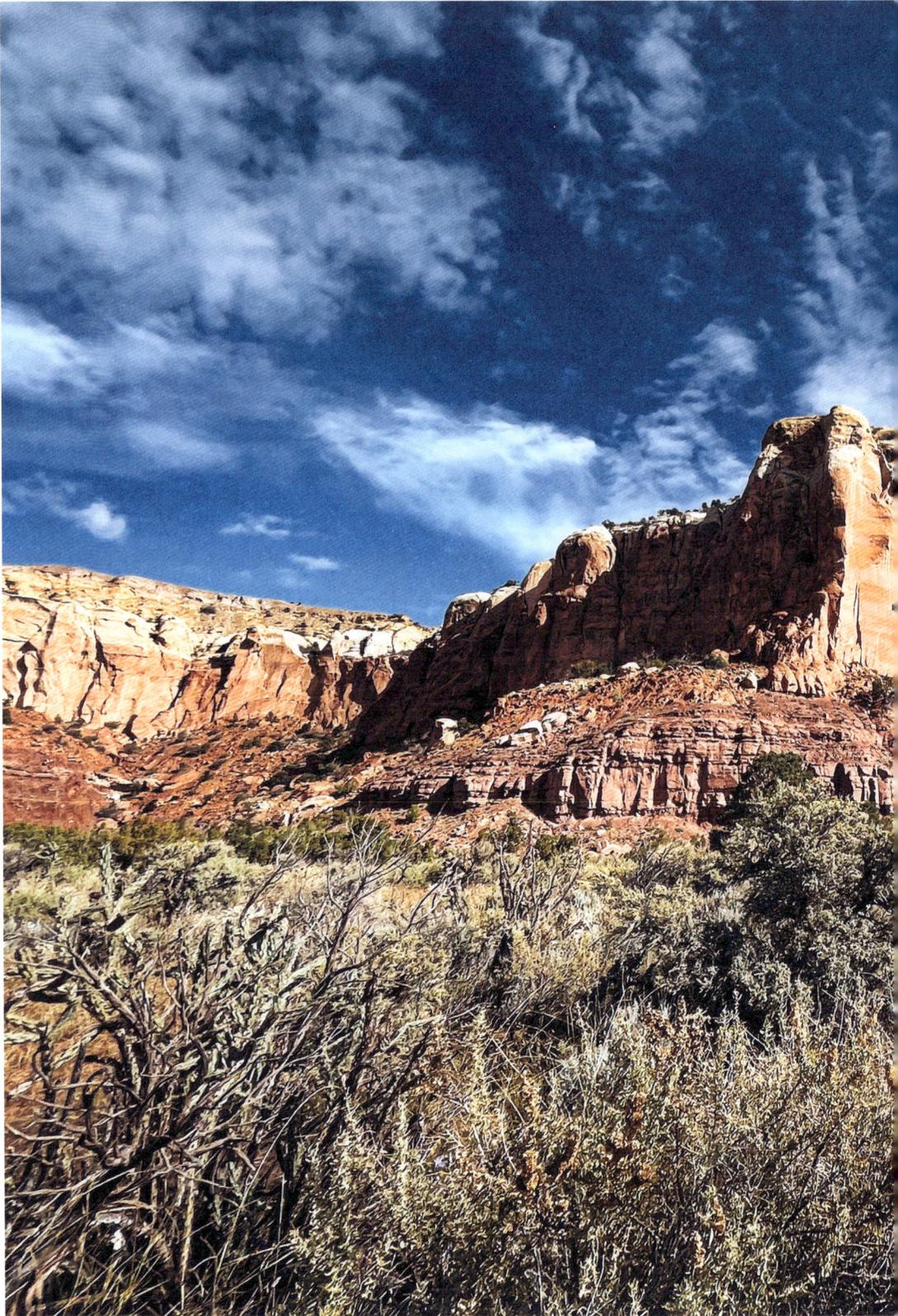

The brick-red Chinle Group at the base of the cliff is overlaid with red, white, and yellow-banded Jurassic Entrada sandstone.

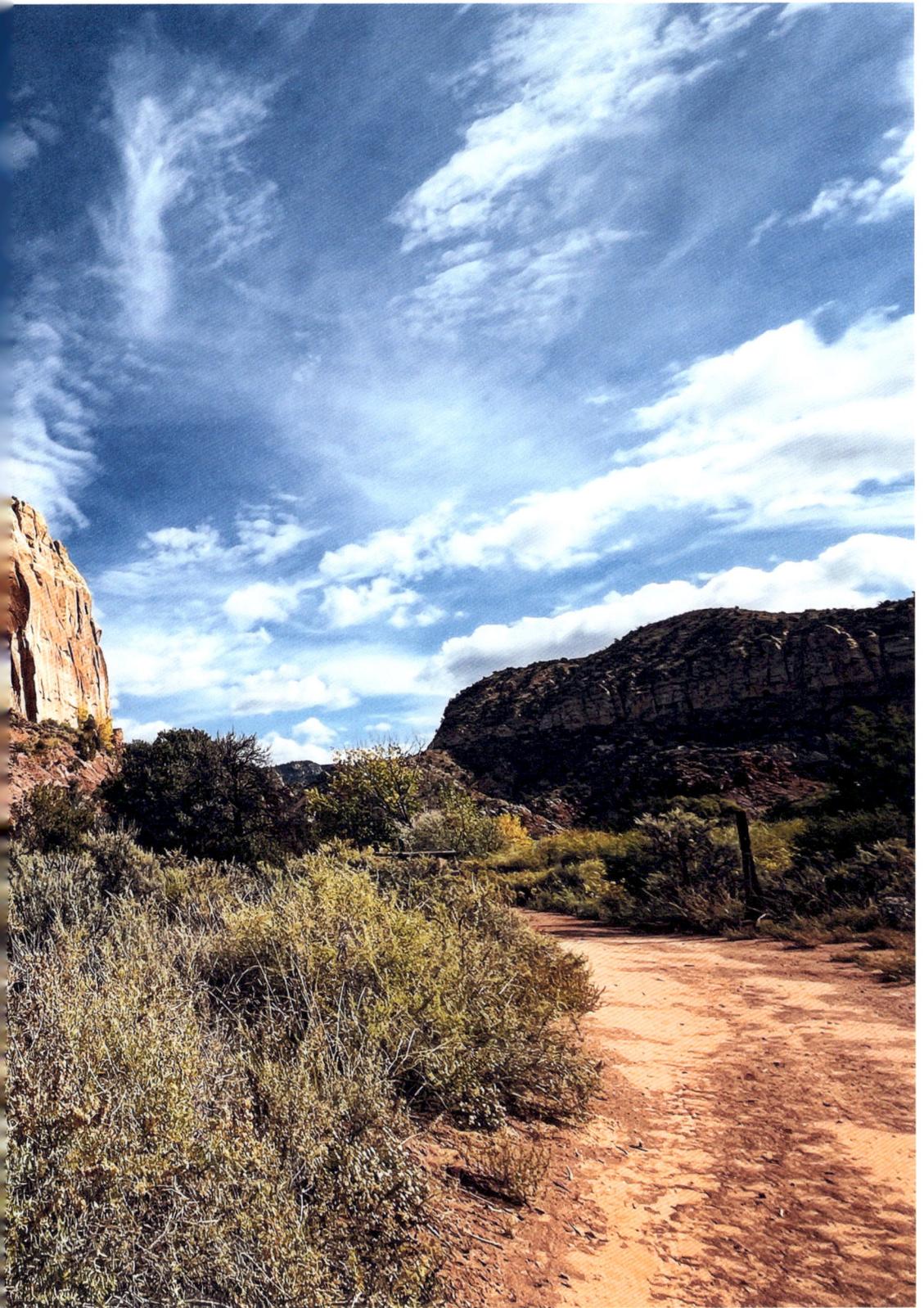

Ghost Ranch

Mile 2,289

WoW asked me a question one morning on a remote hillside: What were my understandings of *beauty* and *love*? He quickly added not to give him an answer immediately but rather to think about it and tell him later. I was somewhat overwhelmed by the sheer simplicity of the question but also excited to dive into it. WoW definitely knew how to press my buttons.

I spent days and days lost in silence, pondering his question. Finally, this was the understanding I came to: I often hear myself saying, "Oh, this is so beautiful" when standing on top of a mountain, looking out over a spectacular view. But is it? Is it really beautiful? I came to the conclusion that beauty and love in themselves don't exist. While I was walking through this raw, untouched stretch of nature, I had time to think, to observe, and to question what I had been taught to believe. But also to look around and think of how this landscape may have looked before humans existed.

There is a very high likelihood that all these mountains, valleys, and rivers looked and behaved relatively similarly to how I was experiencing them. Although nature is in constant transition, things had not changed dramatically in the landscape I was walking through in the past million years or so.

Of course, I love and appreciate all the beauty around me. Beauty in nature and beauty in people. But I tried to address the question of beauty from another angle. I asked myself: Do animals see beauty? Do trees and plants appreciate beauty? What if no people were living on Earth, would there be beauty at all?

Without people around, nature and the world would still look as it does today. Perhaps *beauty* is simply a concept, and a very subjective concept at that, or perhaps it is more of an emotion or human judgment. Without people, nature simply *is.*

But what about love? Does love exist without people? Does love grow, flourish, and die for the rest of the world as it does within us humans? Is there love between animals? Animals, just like people, can form lifelong partnerships and show care and affection for one another. But what about plants and trees? Can trees feel and express their love for one another? We know that trees and plants are connected and can communicate through an intricate web of fungi underground, sharing knowledge and supporting one another if one of the neighboring trees within the network falls ill. They share the resources of light, rain, and minerals. But do they actively *love* one another? This perhaps is harder to imagine. Some believe there was love long before life on Earth itself. But is love simply a concept, an emotion, a chemical reaction from one thing to another, sparking a feeling? Is it highly subjective and volatile? As I walked, I thought about WoW's faith as I considered beauty and love. They are all powerful drivers, giving solace, purpose, and happiness to our lives. Never underestimate the power and potential of the human imagination.

> While I was walking through this raw, untouched stretch of nature, I had time to think, to observe, and to look around and think of how this landscape may have looked before humans existed.

When the clouds finally lifted and the rain subsided, a long orange-red cliff opened before me. It was hard to find and follow the trail when it suddenly dropped into a narrow gorge,

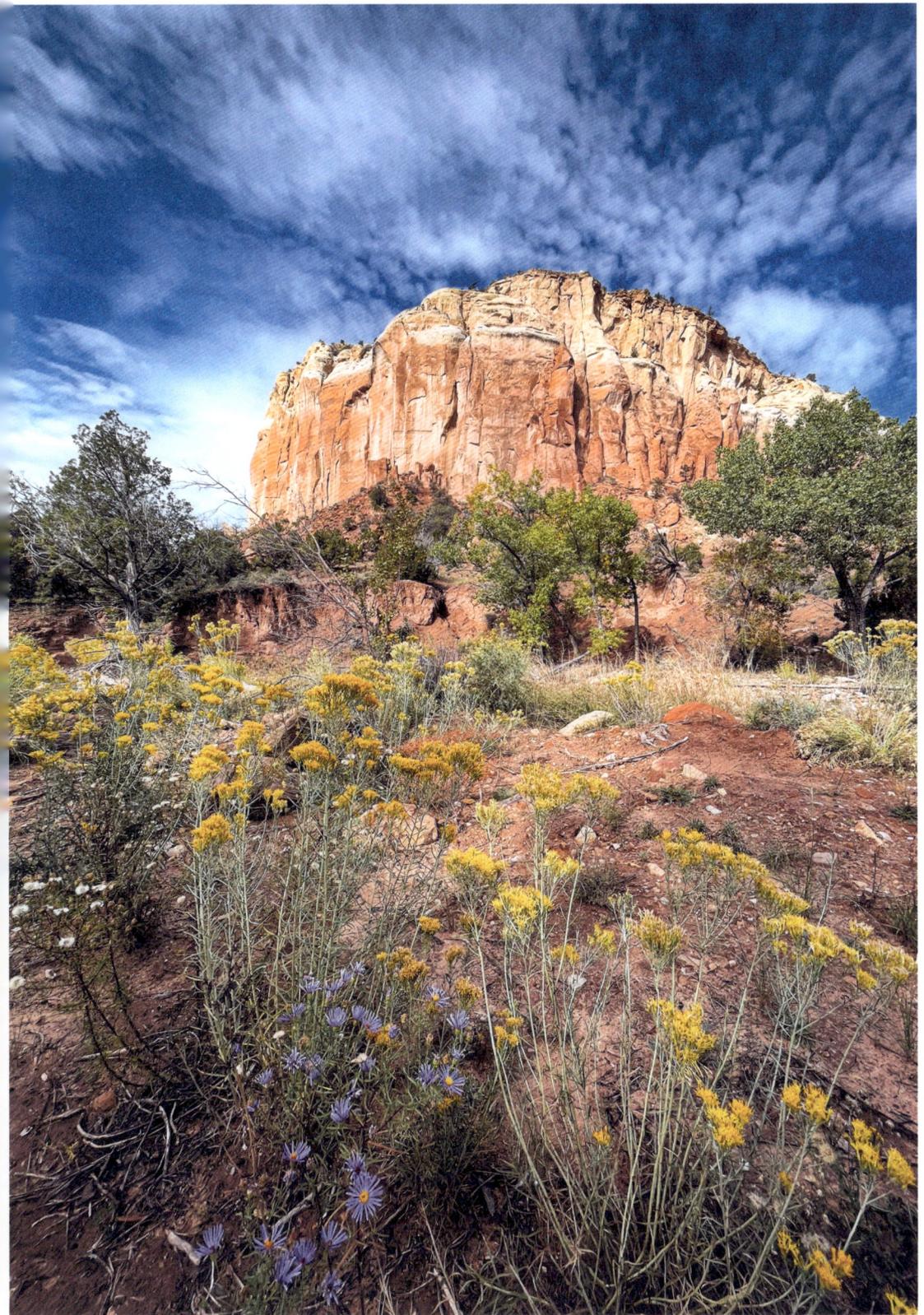

A plethora of wildflowers rises up from the desert floor.

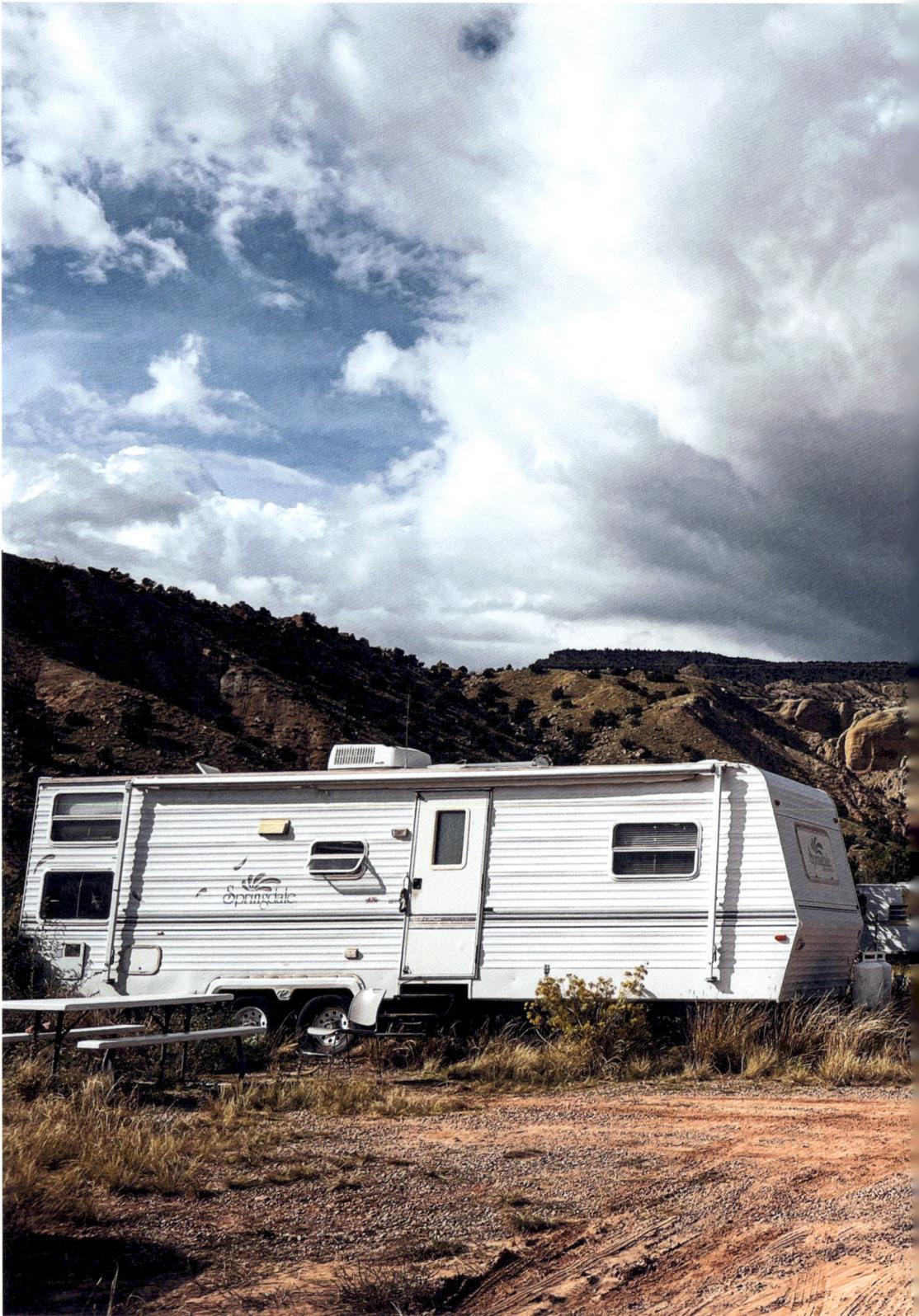

Looming rain approaches above the RV campground at Ghost Ranch.

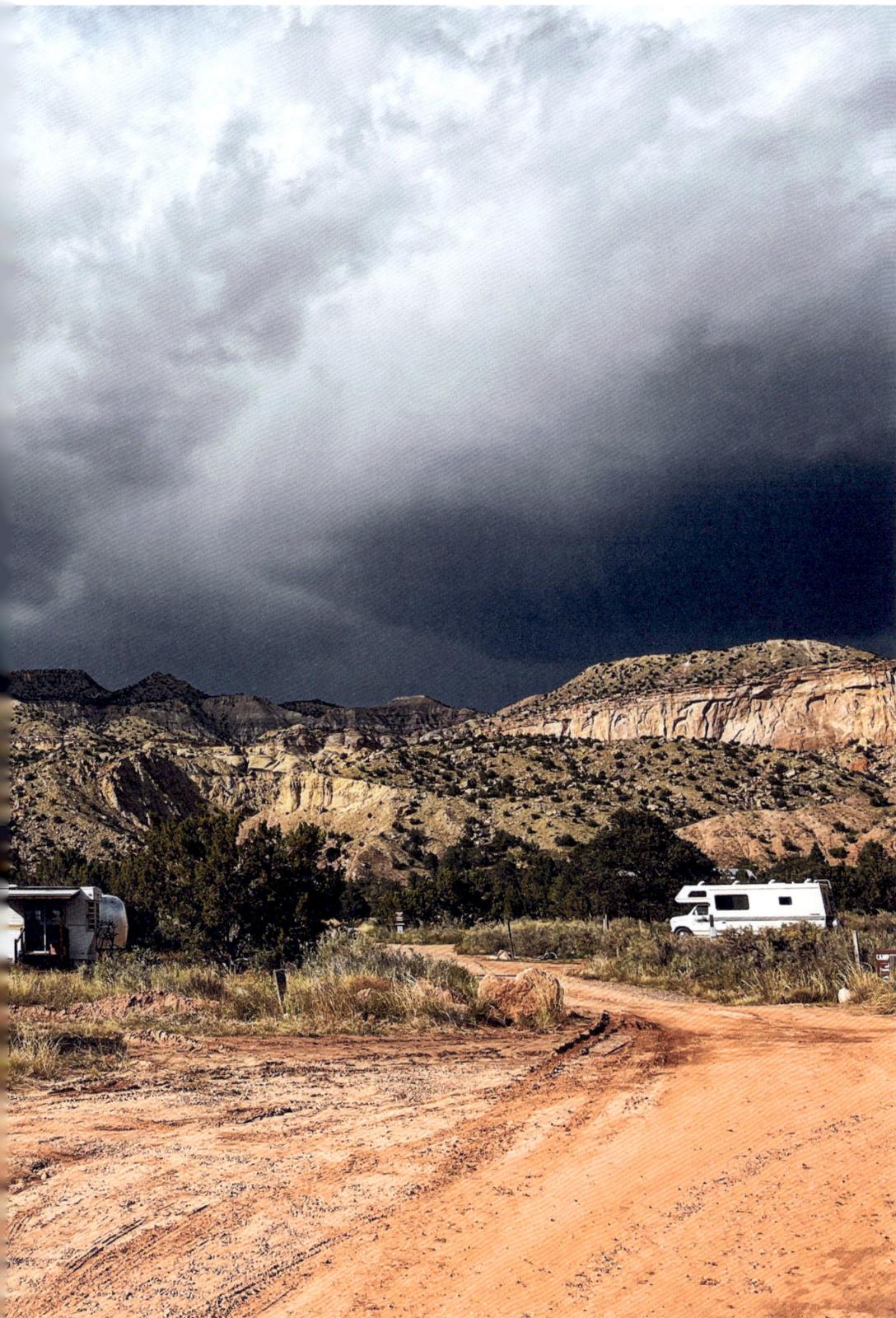

taking me into the Mesa Alta. The trail followed the gorge down a small river that would otherwise have been dry but now, after seven days of rain, was gently flowing down into the steep canyon. The sandstone cliffs on either side of me were simultaneously claustrophobic yet stunningly beautiful. Each time I dropped down a little lower, the color of the sediment changed. The gradual hue of sandstone layers changed from white to gold to orange, and eventually into deep red sandstone at the base of the cliff, lined with arteries and studded with jade green veins. The water gently flowed down through natural cuts in the clay at my feet, making my shoes heavy. Everything around me flowed in organic curves, revealing the work of water and erosion throughout the years. The trail flowed from one side of the stream to the other, and the cactus flowers seemed to sing for joy as they soaked up the sparse rain water.

Eventually, the water disappeared underground, and the trail became flat. I reached Ghost Ranch, a beautifully designed settlement of buildings from the 1930s. It was currently owned by the Presbyterian Church and run by a foundation

that offered several cabins and a dining center. There was a welcome center, a church, and two small museums with archaeological findings from the area. Unfortunately, there was no room in any of the cabins for us, as all the beds were fully booked, and although we could pitch our tents in the RV campground, I opted to crash and sleep in the laundry room, as I had had enough of cold, wet camping for a while. It had dropped to 18 °F (–8 °C) up in the San Juan Mountains, and even down in the desert, it was still quite chilly at night. But as I blew up my sleeping mat and rolled out my damp sleeping bag on the concrete floor next to the washing machine, dryer, and ice machine, I knew it would be a great night. All these machines would generate enough heat to comfort me. WoW and I bought food tickets for lunch, dinner, and breakfast at the buffet and were pleasantly surprised by the choice of healthy food offered.

As I ate, I felt my spirits rise. I forgot about the rain. I looked out over the view from the dining hall and it reminded me of a scene from the movie *Out of Africa*. The flat plain of parched grasslands was topped by the distant shape of

a plateau some 20 miles (32 km) in the distance. One of the previous owners of the site, the famous painter Georgia O'Keeffe painted the view many, many times. You could see immediately how the change in light would make the view different in every moment. Ghost Ranch really did have a special vibe—and it had a spacious setup, with sufficient room in each of its buildings to ensure the guests enjoyed their privacy. I began to see why all the cabins were fully booked and could imagine returning to Ghost Ranch one day in my retirement to enjoy the peace and views.

The famous painter Georgia O'Keeffe painted the view many, many times. You could see immediately how the change in light would make the view different in every moment.

The following morning we got a ride from a fellow hiker whose wife supported him along the way with their family's RV. She would meet to resupply him every few days when the trail intersected a road and let him rest on a real bed fairly often. I thought the ride would give me a nice 10-mile (16-km) shortcut, but instead, she drove us back to where we had left the trail. I had to readjust my mind, as I already had 13 extra miles (21 km) to walk, which I wasn't quite sure I had enough food for. But as these things go, it turned out to be a happy mistake. The path followed the Mesa Alta Rim Trail, 13 miles of stunning cliff walking over the rim, which stretched out over the Rio Chama Valley, in which Ghost Ranch lay nestled.

As we approached Chama, my navigation app told me I had just 600 miles (966 km) to go to reach the Mexican border. I was still losing toenails, but my body and mind were, for the most part, in great condition. I was excited to begin the final stretch.

The Tao of WoW

Mile 2,350

In all the days I spent hiking with WoW, I found myself in awe of his life. This uniquely positive man had been born 67 years ago in Lancaster, England, and was the second son in a family of 10 children. As he had told me so much about his spirituality, I felt curious to know more. So when we reached the next town, I looked up Sufism to better understand what he had devoted his life to. As I learned, Sufism, also known as *Tasawwuf*, is a mystic body of religious practice. It has been defined as "the mystical expression of the Islamic faith" or "the inward dimension of Islam."

Love lies at the core of the Sufi tradition. Love is the reason we are all here. Ultimately, in this tradition, we reach a stage where we no longer see the *many* and only see the *one*.

Suddenly WoW's questions made more sense to me. It was clear WoW was at one with the nature around him. As with everyone, he was no saint. WoW, who liked to joke and refer to himself as a man 'ageing disgracefully', was a very peaceful and loving person who could focus on and enjoy the present moment above anything else.

Having committed to this new spiritual path at a young age, WoW joined his Sufi community on the other side of the world, emigrating to Australia, and later settling in Tasmania. He divided his time between his work as the head nurse in an emergency ward at a hospital and his spiritual community.

He was now only 300 miles (482 km) from completing his Triple Crown: the AT, the PCT, and the CDT. Although he had enjoyed lots of time in the mountains as an alpinist in his younger

years, it had only been after turning 60 that he discovered long-distance thru-hiking.

Although we mostly hiked alone, WoW and I sometimes stopped for short breaks together, and he would always give me one of his cryptic remarks, which kept me thinking for a few hours afterward. "Each individual is unique. But no one person is more special than any other." Or another day, "On one day, you can live many lives. Each day you can choose to live again." The more time I spent with this Lancaster lad, the more I learned, so it only felt appropriate to try and capture his philosophy. Let's call it the "Tao of WoW."

WoW often talked about his *understanding*. It seemed to be the central focus of his life. I tried to grapple with what he meant by this. Was it a religious belief, an answer that he had come to, or simply a state of being? He believed in a philosophy that guided him through every aspect of life, both external and internal. I was curious to know what he had found, what this *understanding* exactly was, and what it meant to him. So one day, when we stopped for lunch, I asked him.

"My *understanding* is simply an active attitude through which I experience life with everything that comes on my path," he answered. "Life's goal is ultimately finding happiness, but what is happiness, and how do you achieve this? The absence of suffering, that is happiness." With that, he turned back to his lunch, as if it were the simplest thing in the world.

I looked puzzled, so he explained a little more. "The ultimate goal and question one should focus on is: Where do you come from in yourself? It is very simple, and in that simplicity is immense depth. A paradox, perhaps, but simple all the same. Where do you come from in yourself? To know this is my *understanding*. Your job is to take that *understanding* and make it your own," WoW continued. "The final disappointment in oneself is when I seek permanent happiness in the external world. Thinking that I can think my way there. No, no, no. It's so simple that people often can't see it. Just as you can't see your own nose. Happiness

is peace in action, and peace is happiness at rest. It's open to everyone 24/7. Happiness is within."

A section hiker happened to pass us as we chatted. "Oh, don't mind us; we're just gas-bagging," WoW said.

But the hiker was curious to chat.

"What was your favorite part of the trail?"

"Now," WoW replied. "This is my favorite part of the trail. Speaking here with you. That's my favorite part of the trail." The hiker first looked puzzled, then broke into a broad smile. WoW seemed to have a simple short answer for everything, and it was fascinating to see how powerful his words were on people, even in the shortest of encounters.

WoW was a teacher. Not by preaching, but by teaching the value of asking open questions and giving time to reflect, think, feel, and go within, enabling me to formulate my own answers, however innocent or naive. WoW guided me to search for my own understanding. Not to follow his.

We challenged each other's thoughts and beliefs. After all, nothing is simply true; it's all a matter of perspective. Being with WoW reminded me that you're never too old to learn and grow.

"On one day, you can live many lives. Each day you can choose to live again."

Each day when we found a spot to camp, we both threw down our backpacks, set up our tents, hobbled toward each other, and embraced in a big hug, thanking the other for sharing this day together. This soon became a ritual we repeated at the end of every day, just as in the mornings we greeted one another with "Good morning, young man." We were both creatures of habit, but it made me smile every time.

"Would you like to reflect on your trails?" I asked WoW one night. "After all, you are nearly at the end." WoW was on the final day of his Triple Crown trilogy walk. I could imagine that

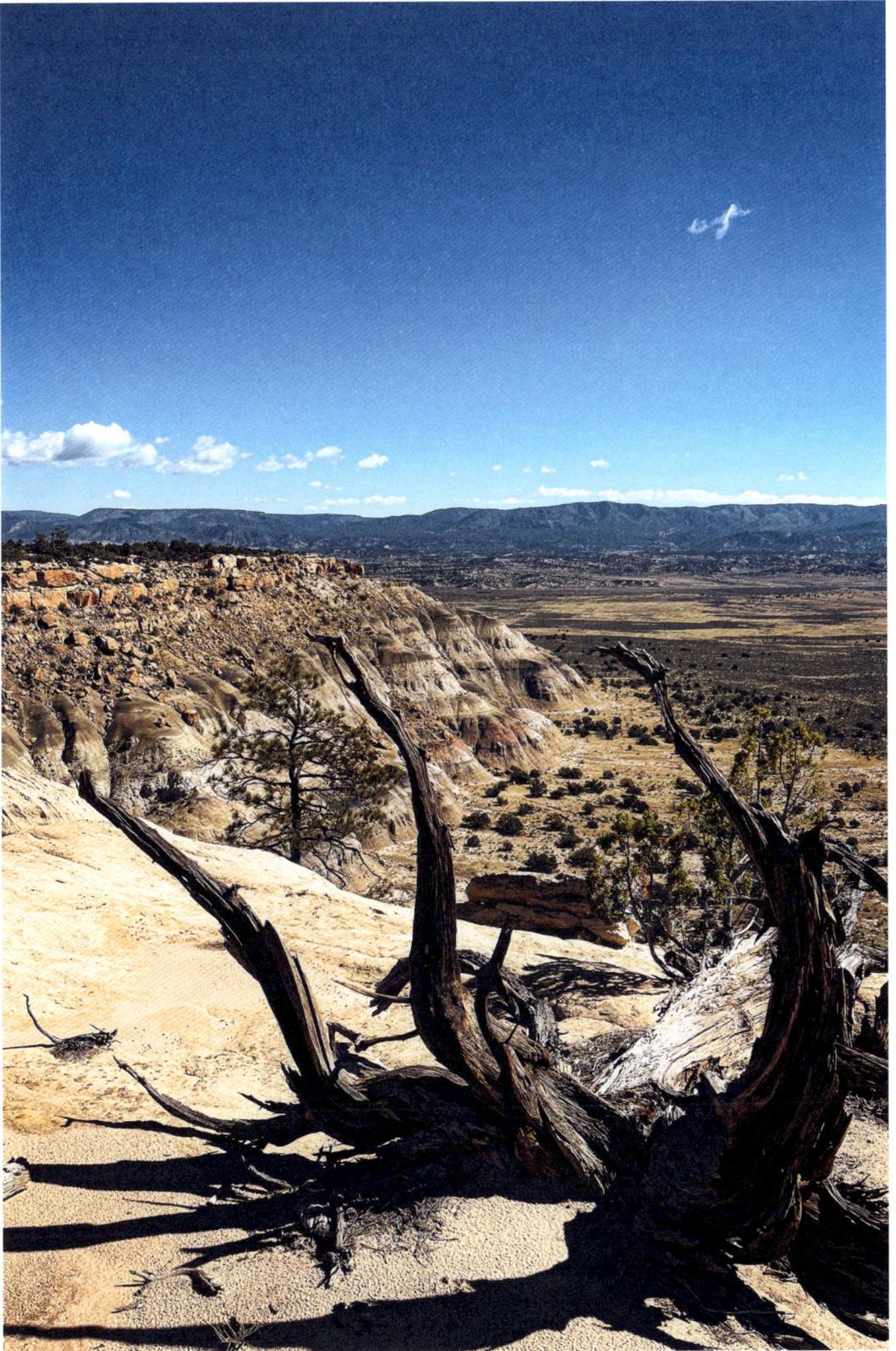

The CDT follows the Rim Vista Trail high above Ghost Ranch.

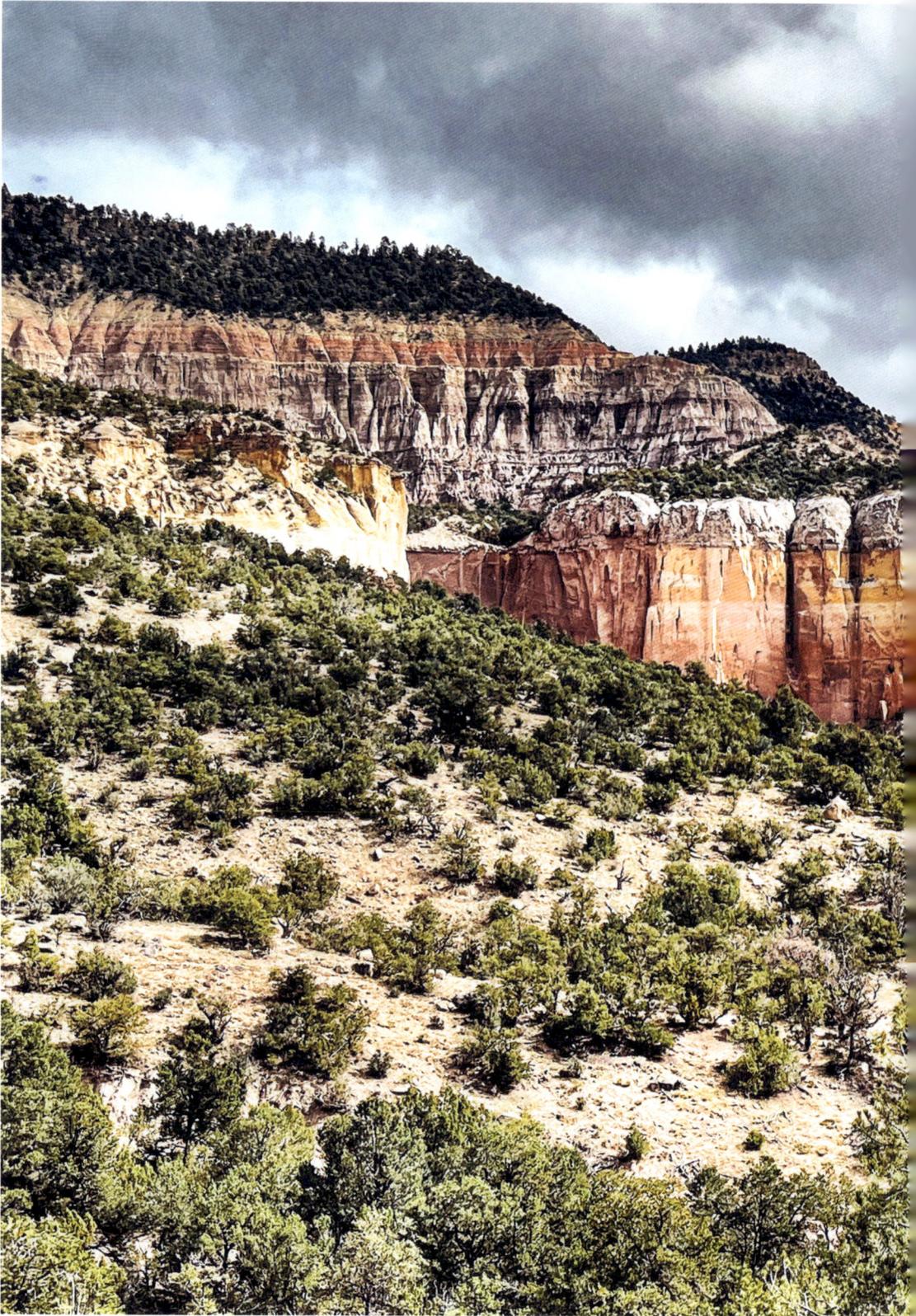

We follow the Rio Chama Valley into New Mexico.

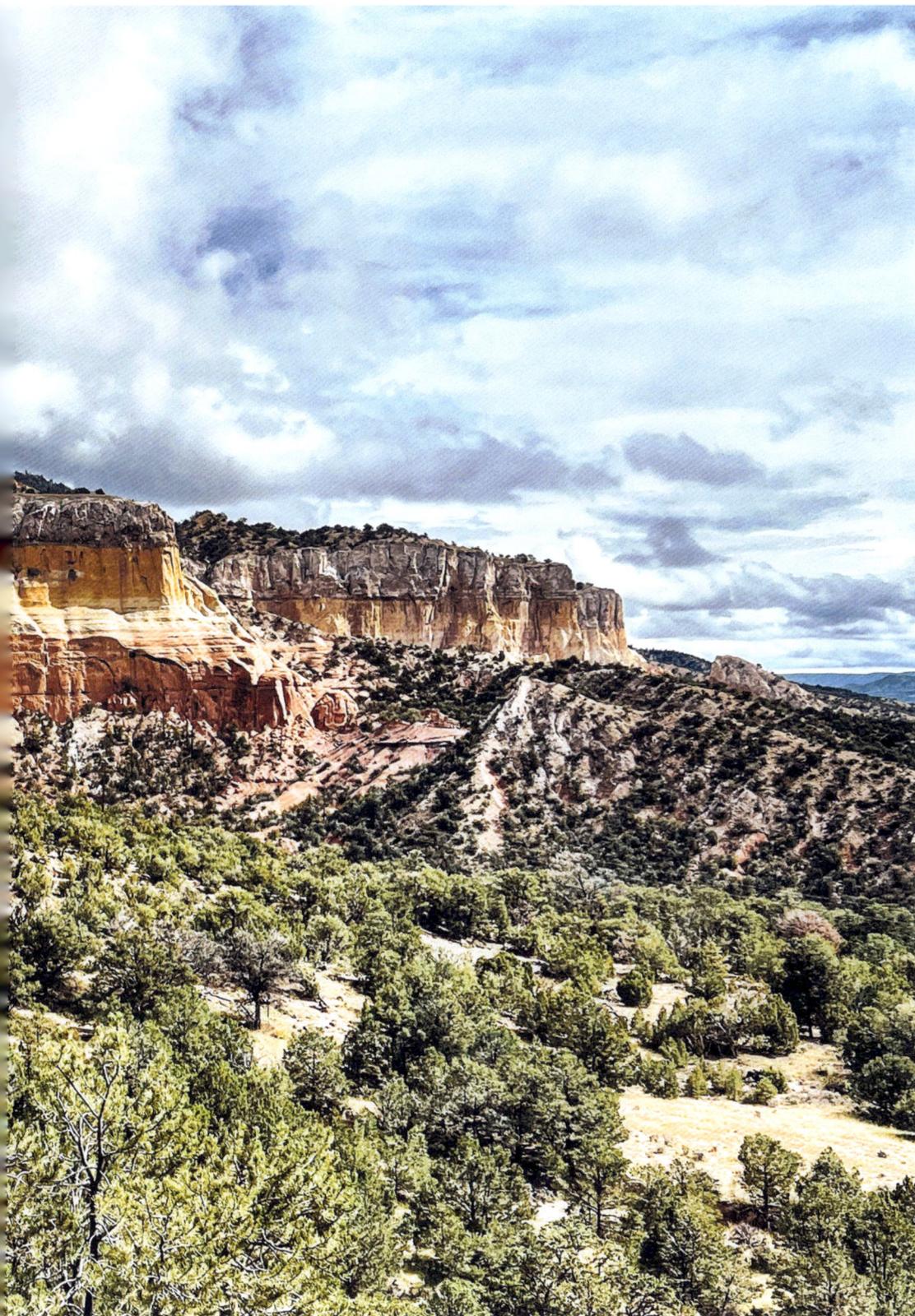

he may have enjoyed wandering down memory lane and going through a few of the highlights and challenges he had endured. But even though I knew he liked to live in the present, I was surprised by the answer I got. "No, not really," WoW replied. "I'd rather enjoy this day with you."

And this was one of the most important lessons WoW taught me. Not to let my future expectations or past achievements take hostage of my present-day happiness. It was a simple but strong insight that has stayed with me to this day.

He clearly had no desire to dwell on the past and would rather enjoy the conversation at present. Perhaps he was also enjoying our conversation because he had just revealed to me that he had never spoken about and shared his *understanding* with anyone outside of his Sufi circle. Considering that he had been involved in Sufi teaching for more than 45 years, this was quite a release. For decades, his focus had been within the community, but in recent years, he had opened up and taken a different view of the exclusive nature of some of the teachings. It felt liberating to finally share his beliefs with someone outside of his former circle.

Personally, I enjoy cherry-picking. I love cherry-picking little bits of ideas and rituals that resonate with me from all different kinds of religions and philosophies. With an open-minded attitude and by not committing to one line of thought, I feel the freedom to grow. At the same time, there is freedom to doubt and question these beliefs, as well as myself. Committing to one religion somehow feels like giving in and stopping the conscious personal quest from finding more of what resonates with me personally. After all, there is no one truth, and even if there was, I would be the last to find it.

Rhythm of the Walk (A poem by WoW):
The mind is focused on the ever-present moment.
There is the breath in, and there is the out-breath.
Then there is the crunch and munch of each footfall.
Then there is a click and clack sound of each pole
as it hits the ground.

Then there is the eek and squeak of the rucksack as the hips roll with each step.

So when the mind focused: in-breath, out-breath, crunch, munch, click, clack, eek, squeak. When they are in harmony, you have the rhythm of the walk, and your mind flows with the present moment. However, when the in-breath and the out-breath are just pure panting, and the feet are tripping over themselves, and the poles are trying to trip you up, and you are fighting your rucksack, you feel totally discombobulated. The only thing you can do is focus one yard ahead and repeat. This too shall pass.

On our final morning in Grants, WoW and I headed to the local diner for a breakfast burrito and a coffee. Not many words were spoken; we were just happy to be there. The time had come for me to head on south, complete the remaining three weeks of the CDT, and for WoW to return home to his wife in Tasmania. We had reached the point where he had left off traveling northbound. He had finished his CDT. We hugged and slipped each other a note we had both written earlier.

"Never, ever change your deep and unique way of touching people in many different ways,"

WoW wrote. "We will never know the depth to which we touch people and how that influences them. We both want to help others in a way that truly helps them. All we can do is point people in a direction—to put them before experiences and let Life/God/Consciousness do the rest. It is not about you or me as individuals. Travel well on your unique path—never stop questioning/challenging/expressing/communicating your understanding, as we will all be richer for it. It is only the end of the beginning. Yes, we are both lucky buggers to have found each other in such a unique place. Lots of Love, WoW."

In the previous town of Cuba, I had secretly created a Triple Crown for him, made of cardboard with the three badges of the trails drawn in black Sharpie.

His words touched me. I wasn't aware that I needed it, but I really needed it.

In the previous town of Cuba, I had secretly created a Triple Crown for him, made of cardboard with the three badges of the trails drawn in black Sharpie. When we finally reached the plastic *"Welcome to Grants"* sign along the highway, WoW had completed his circle. I pulled out the cardboard crown from my backpack and placed it on his bald head. WoW beamed from ear to ear and stretched out his trekking poles into the air.

"ROARR!" He uttered a mighty sound. I don't think WoW could have picked a more unromantic, unnatural, and unscenic place to end his trilogy. But he made no fuss of it. His ever-present focus on experiencing the moment fully came to the forefront once again, and I took note. I knew I would miss him dearly. But I also looked forward to walking the final three weeks of this journey alone. To be silent, reflect, and appreciate everything around me.

Alone Again

`Mile 2,450`

"Snake!" I yelled, although no one was around to hear me. There she was, the queen of the desert. I had seen plenty of snakes during the past few months, but this was the first giant snake. It was about six feet (1.8 m) long and two inches (5 cm) thick at least, with gleaming black and gold patterns striped down its back. I stopped and knelt down to take a good look. Although I had yelled, I was more excited than scared. As I looked on, it slowly slid away, raising its head like a cobra, letting me know not to come too close. Strangely, it had no rattles at the end of its tail. Some days later, I asked a hunter what it might have been, and they thought it would probably have been a bull snake, which isn't deadly but can kill rattlesnakes. It was, as always, an awe-inspiring sight and one that left me cautious for the rest of the day. I scanned the area before me for anything suspiciously snake-like.

Having lived in the woods for nearly four months, I found that I had evolved and was no longer fearful of these potentially dangerous animals. The snakes had no motivation to attack me as long as I gave them no reason to strike. However, the desert revealed many other challenges. Although I loved the lower elevation and the flat, outstretched plains, the sparse water sources meant that my pack was extra heavy due to the four liters of water I often had to carry. And although the days could be scorching under the cloudless sky, the desert nights in October dove deep below freezing. The ground was strewn with sharp lava rocks, full of pumice holes, revealing a history of volcanic explosions from bygone ages.

I manage to reach Cuba just in time to escape another storm.

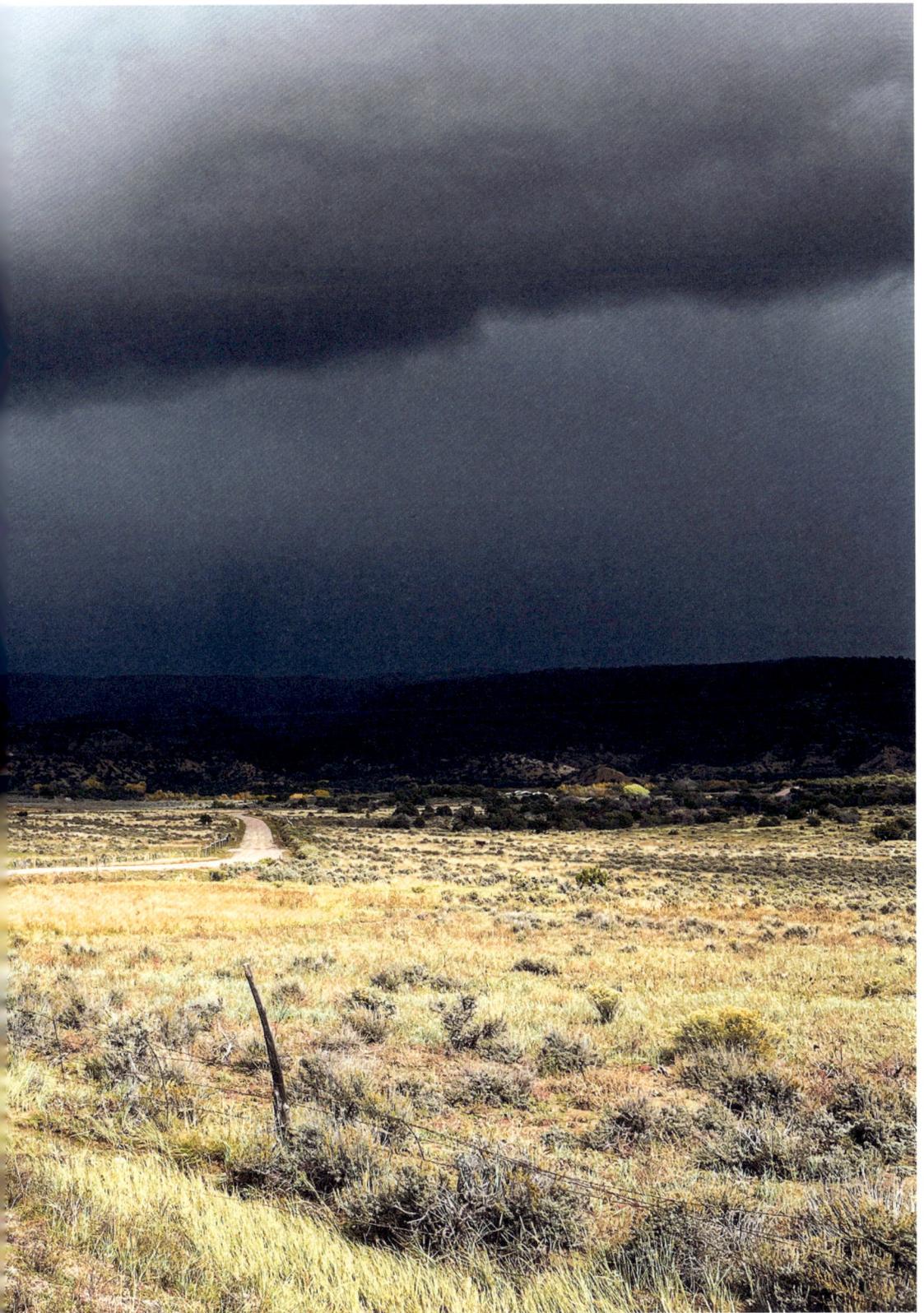

Although the days could be scorching under the cloudless sky, the desert nights in October dove deep below freezing.

It was strange to think that less than a week earlier, I could snap my frozen Snickers bar into two during the day, as it shattered like glass due to the cold temperature. It had been so cold up in the high mountains, but now down in the low plains of the desert, my Snickers was swimming in its own chocolate. Boy, it was hot! The vast expanse of the sky had not a single sign of a cloud, only beautiful blues. The flat horizon stretched all around me, only interrupted by sizeable cone-shaped volcanic rock formations, which hadn't yet been eroded by weather or time. The trail meandered through this immense expanse, sometimes taking me up and over one of the flat mesa formations and then back down into the desert floor. There were still some remnants of the past week's rain, and I felt fortunate to witness the cacti blooming with their citrus yellow flowers so late in the year. Even down in the desert, Black Angus cows were roaming the land. I wasn't always that happy with the destruction they left behind, as the trail was often a minefield of deep hoofprints in dried-up mud. The farther south I went, the shorter the days became. The sun now only rose at 7:00 in the morning and disappeared below the horizon at around 18:00. The desert nights were cold, but as I was at a lower altitude of around 7,000 feet (2,133 m), I had less trouble sleeping and breathing, making the whole experience much more pleasant.

As always, the CDT was full of surprises, and my stomach flipped once again. Or, as WoW would put it, "You've got stomach rot." It was nothing new to me, but fun, it was not. We all have our weak spots, I guess. Although it drained my energy a little for two days, I was lucky that my body healed, and it swiftly passed.

Now that I was hiking alone again, I had to hitch into towns alone every few days to resupply.

By this time, hitching had become second nature. Despite reservations about personal safety, for the past four months, I had willingly hitchhiked from the edge of trailheads to nearby towns to resupply food—alone or with a group.

When I'd waved goodbye to WoW, I had walked out of Grants early in the morning and hitchhiked to reconnect with the trail. It had been raining a little, and I couldn't have looked very attractive under my red umbrella in my rain gear. I hadn't really expected anyone to stop, but the great thing about the USA is that someone always does stop. More often than not, in these small rural towns, a car stops to offer a ride much sooner than expected.

An old white pickup truck had slowed down, and I saw the tail lights turn red as it came to a halt, some distance ahead of me. A man with a weathered face under a dusty cowboy hat rolled down the window and invited me to hop in. I threw my backpack in the back of his truck and climbed into the seat next to him as he lit up a joint.

"Care to smoke?" He'd offered me a drag of his joint. It was still only 8:00 in the morning, and I had just had a breakfast burrito and coffee with WoW. As we gently drove off, the driver enquired what I was doing out there, and I told him I was on my way down to the Mexican border.

"Well then, you'll be walking through our land for a while, that is, all that is left of it," he'd said, staring ahead into the desert road. "We're Navajo," he added.

As we drove, he told me about life for his community. "Apart from our casinos, most small shops have all closed for good due to the pandemic; we now have to shop in the towns around the reservation." He paused for a moment. "It's pretty sad, really, but that's life."

Taking another drag of smoke, his mood suddenly shifted, and with a big smile, he gave me his hand and introduced himself.

"Gary," he said. "Hopany is what they call me on the Rez. But Gary is fine too." He smiled with his joint stuck between his lips and the smoke now filling the cabin of his truck.

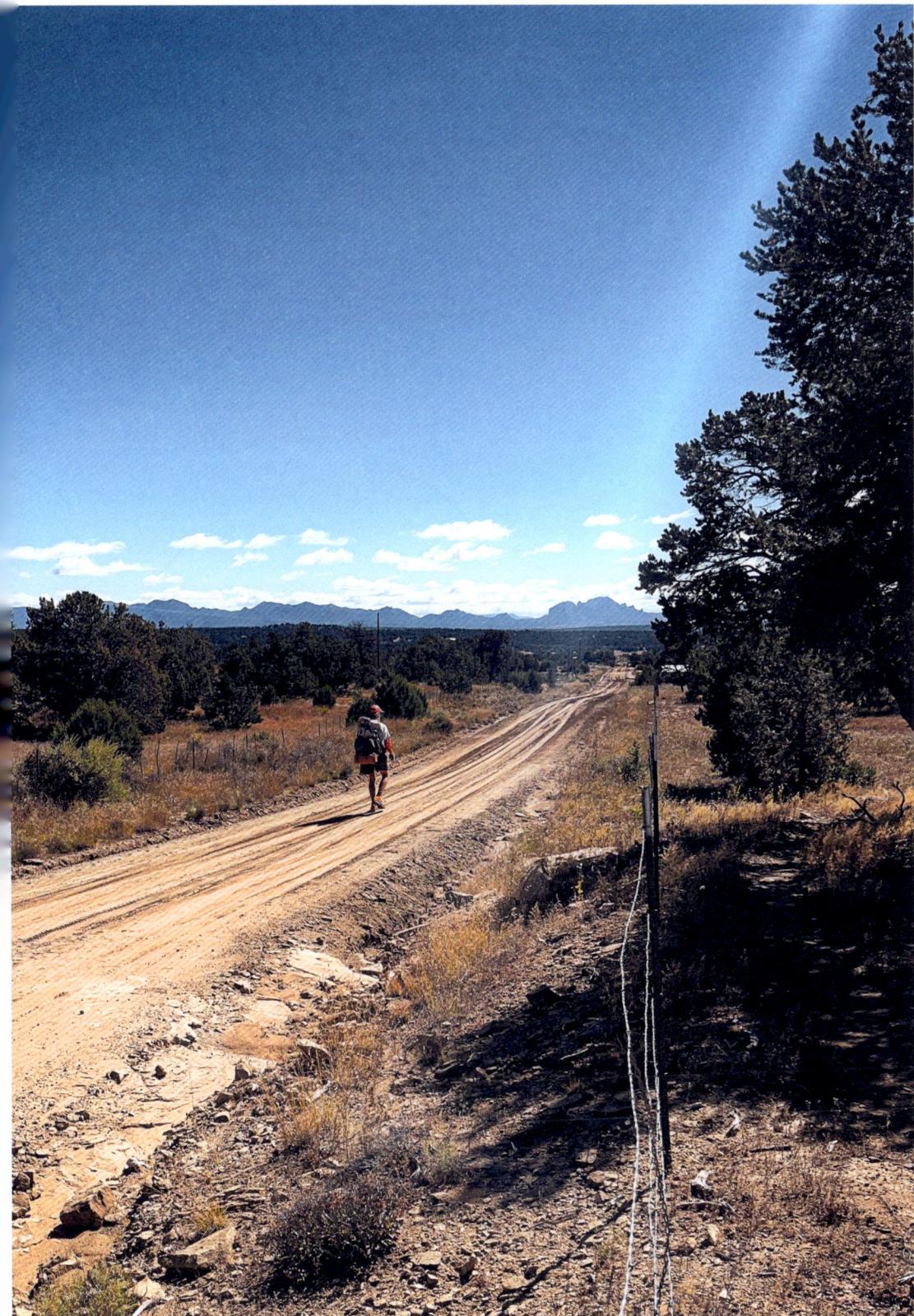

Everything is different about the New Mexico landscape:
the colors, the plants, and the lower elevation.

"Are you sure you don't want to smoke?" He offered again.

"No. I'm good; I'm from Holland," I said by way of explanation and pointed right to the junction where I had to get off to connect with another road that led to the trail. I thanked Gary for the ride, we shook hands, and we each went on our way. The funny thing was that the smell in the desert when I stepped out of the truck was very similar to that of the weed. The strong odor of sage and juniper bushes replenished in the recent rainfall had risen over the landscape. Except the living plants around me were a little sweeter.

I'd followed the white and yellow stripes of yet another asphalt road and gotten picked up by a second hitch not long after. A gentle elderly fellow in his seventies stopped and made room in his somewhat messy car to give me a ride to the trailhead several miles down the road.

"My wife will kill me if she finds out I've picked up a hitchhiker," the man said with a grin. He told me that he had hitchhiked around Europe and North Africa for 10 months when he was 25, some 50 years ago. He had loved his trip, and I could see by the twinkle in his eye that he still cherished the memories of this adventure. He was currently on a little road trip by himself to sleep under the stars again. He was slowly driving through a few states to reconnect with his wife in a few days' time. She had flown ahead to their vacation, and he was simply pitching his tent at campgrounds along the way.

"Wanderlust, it never really leaves you," he said, and I congratulated him on his adventure. Not long after, he dropped me off at the trailhead and asked me if he could take a picture of me to show his wife. We'd waved goodbye and parted ways.

For quite some miles, the trail followed the road under the El Malpais Narrows Rim, a steep sandstone cliff wall. The light poked through the rain clouds, and the sun shone in my eyes, making me sneeze. My loud achoo bounced back at me off the high sandstone wall. Instinctively, I started making more loud sounds to hear what might return from the wall. A clear sound bounced back, and I started experimenting by singing octaves. It was beautiful to hear the sounds blend and echo. I could imagine how people who rode these plains hundreds of years ago might have done the same before me. Just to have some fun.

Days later, the long dusty road walk toward Pie Town was littered with both locusts and crickets. Dead and alive. Insects in all shapes and sizes jumped around me, a glimpse into what had been the Dust Bowl. Back in the 1930s, this entire area had been scavenged and eaten dry by a grasshopper plague, resulting in thousands of acres of dust. Severe droughts reaching up to the Midwest, and a failure by settlers to prevent wind erosion in the region also strongly contributed to the years of dust. With no more fertile land, the settlers packed up and moved down south and passed through the tiny hamlet of Pie Town. Back then, the pie shop offered the only decent food in miles. Now, I was looking forward to tasting some pie when I got there in a few days.

Days later, the long dusty road walk toward Pie Town was littered with both locusts and crickets. Dead and alive.

As I plodded deeper and deeper south, the landscape had indeed finally turned into an even desert. Flat endless expanses rimmed with pale-blue hills in the far distance. There wasn't a single tree to be seen for miles; only grass, sage, and cacti survived. Finding good water had become my highest priority, as most water sources I came across were still, brown ponds filled with green algae and bacteria. My map indicated that there would be a water source every 20 miles (32 km), but these were also often cow troughs. Occasionally, I got lucky if there was a spring or a solar panel to pump fresh water from deep within the earth. It was important to keep my wits about me, as getting caught

off-guard without water out in the desert could prove fatal.

As I'm generally a deep sleeper, it still surprised me that I lay awake for a few hours each night. But come to think of it, I should not have been so surprised, as 12 hours of deep sleep is a bit too much to expect. I went to bed at hiker midnight each evening, which was 21:00. By 4:00 in the morning, my body had had enough rest. After having had a pee, I lay awake staring at the condensation slowly sliding down the roof of my tent. As the nights were getting longer each day, and it remained dark much longer, I got out my needle and thread to do some repair work while waiting for the light to return.

WoW had always teased me when I got out my needle and thread to repair my Hawaiian shirt, which was practically threadbare at this point and needed constant care and repair every time I was in town. But one night, I had other work to put my sewing attention to. I had to repair my sun gloves, which were beginning to fall apart at the seams. In the light of my headlamp, it was quite pleasant work, as I had always enjoyed needlework from an early age. Once my gloves were somewhat repaired, I took a good look at my hat. The previous day, I had found the entire wing of a swallow on the trail and was looking to find a way to attach it to the side of my hat.

"My wife will kill me if she finds out I've picked up a hitchhiker," the man said with a grin.

At least, I thought it was a swallow's wing, but the white dots on the black feathers left me with some doubt. Either way, I took a long yarn of dark red thread and carefully stitched the wing to the side of my hat. I stretched the feathers out to reveal the full glory of the bird's wingspan before sewing it to my cap. In the bright light of my headlamp, I looked at my handiwork, and although one of the feathers had been slightly damaged in the process, I was happy with the result. I put it on and felt just like the comic book character Asterix. I just hoped it would last for the last three weeks before I reached the Mexican border.

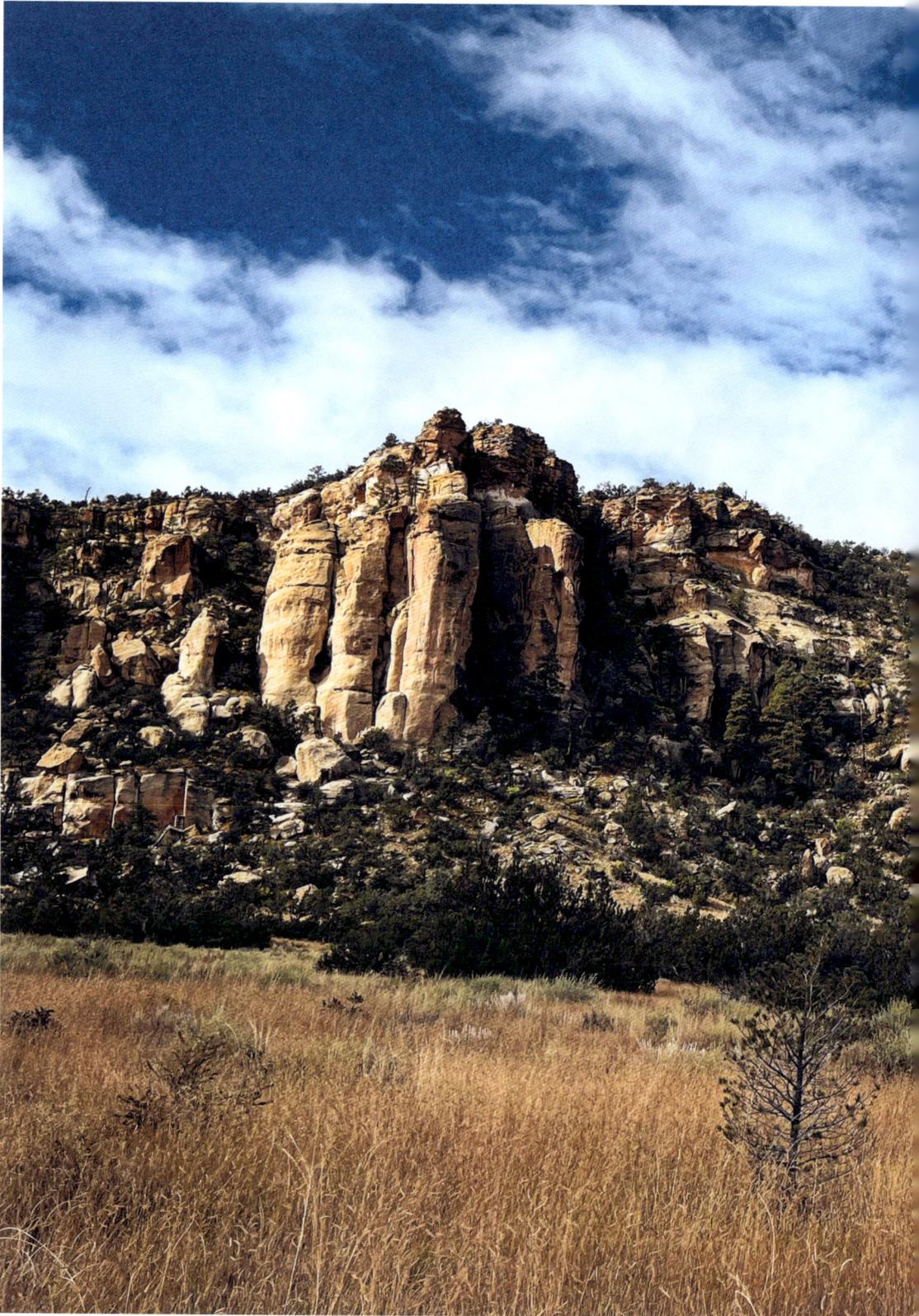

The trail follows the El Malpais Narrows Rim.

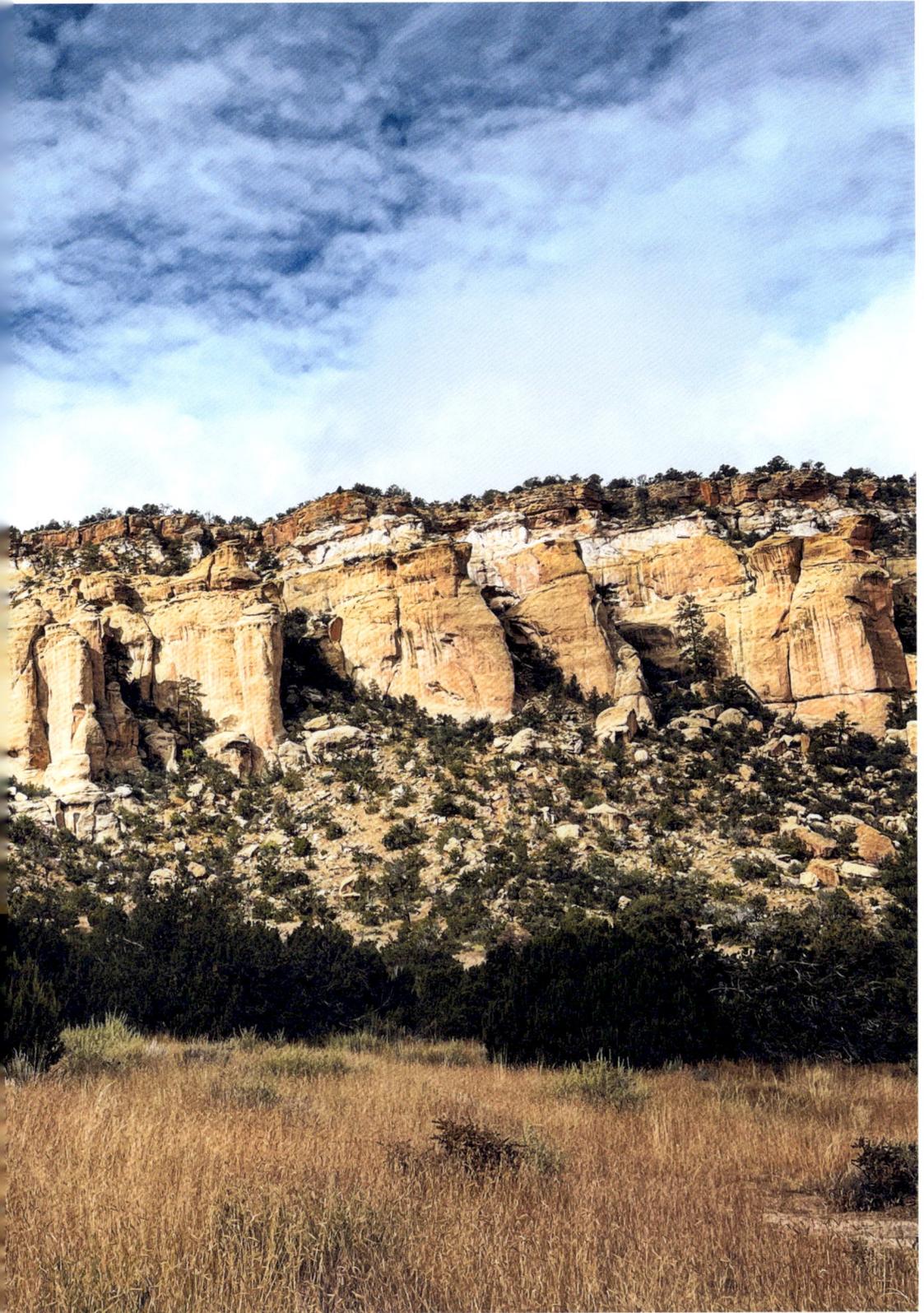

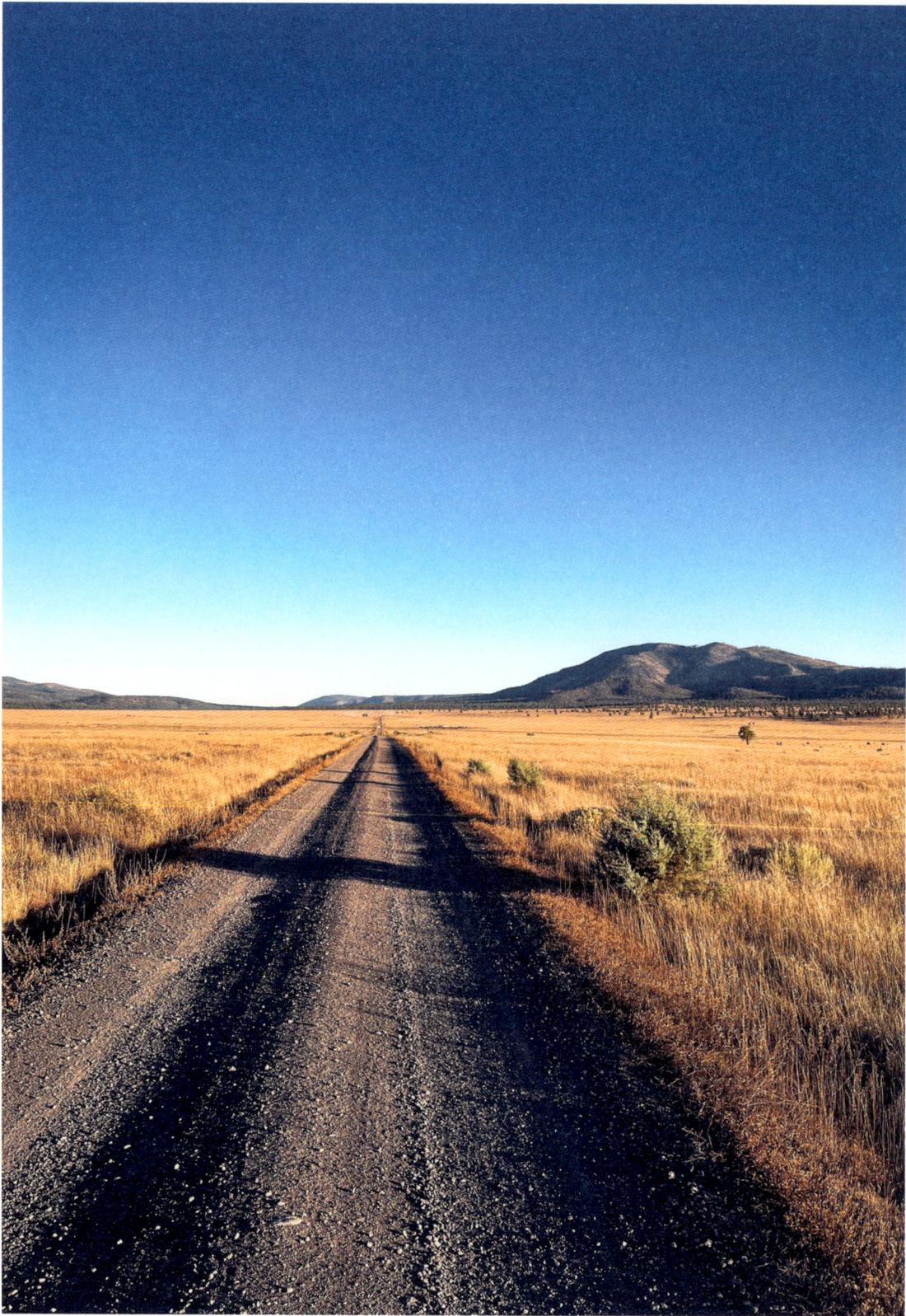

Finally the flat desert plains of New Mexico
that I have been longing for.

Winter

Mile 2,817

Just like a cinnamon roll, the high desert hills were thinly glazed with a layer of fresh ice that morning in early October. The puddles—bearing silent memories of the rainfall only days ago—had a glassy sheet of ice over them, with a few white bubbles of air underneath. It was comfortingly silent in the desert; only the gentle rustle of the golden aspen leaves broke the sound of silence from time to time. The sun rose above the flat horizon and warmed me just enough to take my gloves and layers off to enjoy another 24-mile (39-km) day of walking.

An empty land stretched out before me. Devoid of people but full of life and the elements that flowed through it. Although life was all around, the desert was a hard place to live. Blistering hot during the day and freezing cold at night, breathtaking sunsets and sunrises came and went each day. I could feel and could nearly taste that the end was near. Having walked over 2,796 miles (4,500 km), I only had a little way to go until I reached the Mexican border.

I had known that the United States is an absurdly large country, but as I looked down at my phone's step counter, I realized I was approaching seven million steps. Seven million! But it was also very simple; after all, it was just the simple act of putting one foot in front of the other. Repeat, repeat, repeat.

While Montana had embodied pain, excitement, and uncertainty, Wyoming had captured beauty. Colorado had embodied high altitude, grueling climbs that seemed never to end, and New Mexico had brought comfort, reflection, and inner joy. Walking with WoW brought introspection.

My physical body and state of mind had become strong, interwoven with each other.

By sheer coincidence, two days later a brown UPS mail truck stopped to offer me a ride and drove me the last few miles into Pie Town. I jumped in and held my backpack on my lap. It was a bumpy ride on a muddy dirt road, and the windshield wipers struggled to keep the glass clean.

"What did you say your name was, sir?" asked the driver, Michael, as he reached into the back of his brown UPS van. I gave him my birth name, and sure enough, he returned with a box with my name on it. What were the odds?

"This must be for you," Michael said. I looked down at my resupply box, sent ahead by WoW a few days earlier.

As I looked down at my phone's step counter, I realized I was approaching seven million steps. Seven million!

"Wait, do you have a moment in your schedule?" I asked. "I'd like to give you a little something." I reached down into my backpack to retrieve my painting equipment. Using the dark melancholic blue, I painted the contours of the flat mountains that jutted up out of the desert, with the characteristic shape of the delivery truck driving through the landscape. Above it, I painted a deep yellow sky to capture the day's heat and reflect the same color of the endless grass. The paint hadn't quite dried when I handed it over to Michael, and he smiled when he recognized himself in the picture, sitting behind the wheel of his van. I thanked him for everything he was doing for our little trail community, as he probably brought hundreds of parcels to Pie Town each year for the hikers who travel through. He was, in his own way, a Trail Angel, like so many others who helped us along our journey. We waved and parted ways.

With a box containing five days' worth of food clamped under my left arm, I walked into Pie Town, which was no more than 30 houses, three bars, three churches, and a Toaster House.

The Toaster House is a legend within the CDT community, an oasis for hiker trash and cyclists out in the desert. As I approached the house, I saw the fence surrounding the large log cabin covered in old breakfast toasters. The door was not locked, so I carefully opened it to see if anyone was inside. I was greeted by the smoky smell of a log fire, which was soon followed by the low voice of the cabin's host. A gentleman with balding but otherwise long white hair greeted me and showed me around the Toaster House.

The Toaster House is a legend within the CDT community, an oasis for hiker trash and cyclists out in the desert.

"Welcome," he said. "Jefferson's the name." He put on an old felt cowboy hat and stretched out a fist bump to welcome me. He explained that he was the host and caretaker for his cousin's house, which she generously offered as a sanctuary for hikers and cyclists.

"You're welcome to leave a small donation when you leave." Jefferson explained that the Toaster House was a donation-based hostel exclusively for hikers and cyclists on the CDT, and the hostel had everything you could wish for. There was a hot shower, cold laundry, a kitchen

we could use, and a comfortable lounge with soft sofas around a warm log fire.

"You can have the Penthouse if you want," Jefferson gestured to the staircase with a cardboard sign with the word *Penthouse* handwritten across it. I thanked him and installed my backpack, sleeping bag, and resupply box on one of the beds. The attic room had about four mattresses on the floor, and I put a clean sheet on the one I would be sleeping on. As I had arrived early in the afternoon, I spent the rest of the day enjoying everything that the Toaster House had to offer. I even had two hot showers, after which I sat on the porch, admiring the garden and their shoe wall, with hundreds of old beaten-up hiking shoes nailed outside on one of the cabin's walls. I hadn't been doing much painting lately, but after having painted a thank you for the UPS driver, I decided to make a big painting for Jefferson and the Toaster House as a token of appreciation.

"Oh, and there's pie in the fridge if you want any. After all, this is Pie Town!" he yelled from the kitchen.

Could it get any better? Homemade pie in a log cabin, with a garden and wood fire out in the prairie. I heated up a piece of apple chili pie and some leftover coffee in the microwave and went onto the porch to chill for a while. Life was good, and I was soaking it up.

As I continued farther south the following day, a familiar sight awaited me. I was welcomed by dozens of swallows, perched on the telephone wires alongside the trail. Once nesting season ends, swallows know it's time to party. Whether they nest as single pairs or in large colonies, adults and juveniles will gather on electrical wires by the dozen, socializing before they migrate.

Just like me, the swallows were continuing their migration south. After leaving their breeding ground up north, they often fly over 5,000 miles (8,046 km) down to South America in the winter. Twice the distance of my migration. It was always comforting to see my familiar

friends who had been with me throughout the journey, sometimes in large numbers and sometimes alone.

I knew that after the physical, mental, and spiritual journeys of the hike would come the journey home and my reintegration into society. It would be interesting to see how I could best implement the lessons and insights I had learned out on trail. Adapting to the challenges of fast city life and the questions life throws at us isn't always easy, but neither is it easy to hold on to the resolutions you make in the wilderness before heading home.

I knew that after the physical, mental, and spiritual journeys of the hike would come the journey home and my reintegration into society.

After leaving the Toaster House oasis behind me, I walked for three days through rolling flat plains, averaging 30 miles (48 km) a day. When the trail plunged down a gorge and followed the Gila River downstream, I had to really keep my wits about me. There was no point in keeping my feet dry as the trail zigzagged across the river every 50 feet (15 m). The cold water pinched at my Achilles tendon as I waded through, and I had to keep moving to retain my warmth. The trail became a real ankle twister, and there wasn't much to be said for it, really, as most of the marked path had washed away, and I had to create my own way over the boulders, rocks, and river bed.

I trudged on slowly downstream, and as the river swelled, I opted to take the high alternate route over the hills to avoid getting caught in cold currents that could prove dangerous downstream. Normally the lower Gila River route would have been quite doable, but after all the recent rain, the river had broken its banks.

After four days of hiking and only 12 miles (19 km) before reaching the outpost of Doc Campbell's, I set my tent up under a tree at around 20:30. It was already dark, and my headlamp, in dire need of new batteries, shone dimly around me as I checked an old dead tree that had been struck by lightning some years earlier. I pushed and wiggled the dead tree to see if it was strong enough and wouldn't collapse on me during the night. It had been a long day, and once I felt safe to rest, I fell into a pleasant slumber.

However, in the middle of the night, a strong howling wind woke me up, followed by multiple flashes in the sky. I began worrying whether the dead tree next to me would fall under the pressure. As the wind intensified, I decided it was not worth the gamble. This was not my night to die, and I clambered out of my tent, pulled out my six tent pegs, dragged my entire tent and its contents some distance away, and set it up again in between some juniper shrubs. This protected me from the howling wind, and I felt safer. I fell asleep again, only to wake again in the morning with my entire tent collapsed on top of me. No worries, I thought. I had to dismantle it anyway. Thinking back on the storm and the dead tree, I was reminded how fragile life can be.

For years I've been looking for a certain book to be turned into an audiobook, and finally, I found it on Audible. *Planetwalker* by John Francis is an autobiography of a man who decided to stop using motorized transportation for 22 years to walk around the world to raise awareness for environmental issues. His journey began as an environmental protest. Still, as a young Black man walking across the country in the early 1970s, his idea of the environment expanded beyond concerns about pollution and habitat loss to include how humans treat each other and how we can better communicate and work together to benefit the Earth.

In the same period, he decided to stop speaking for over 17 years, and during his silent journey, he achieved several master's degrees and

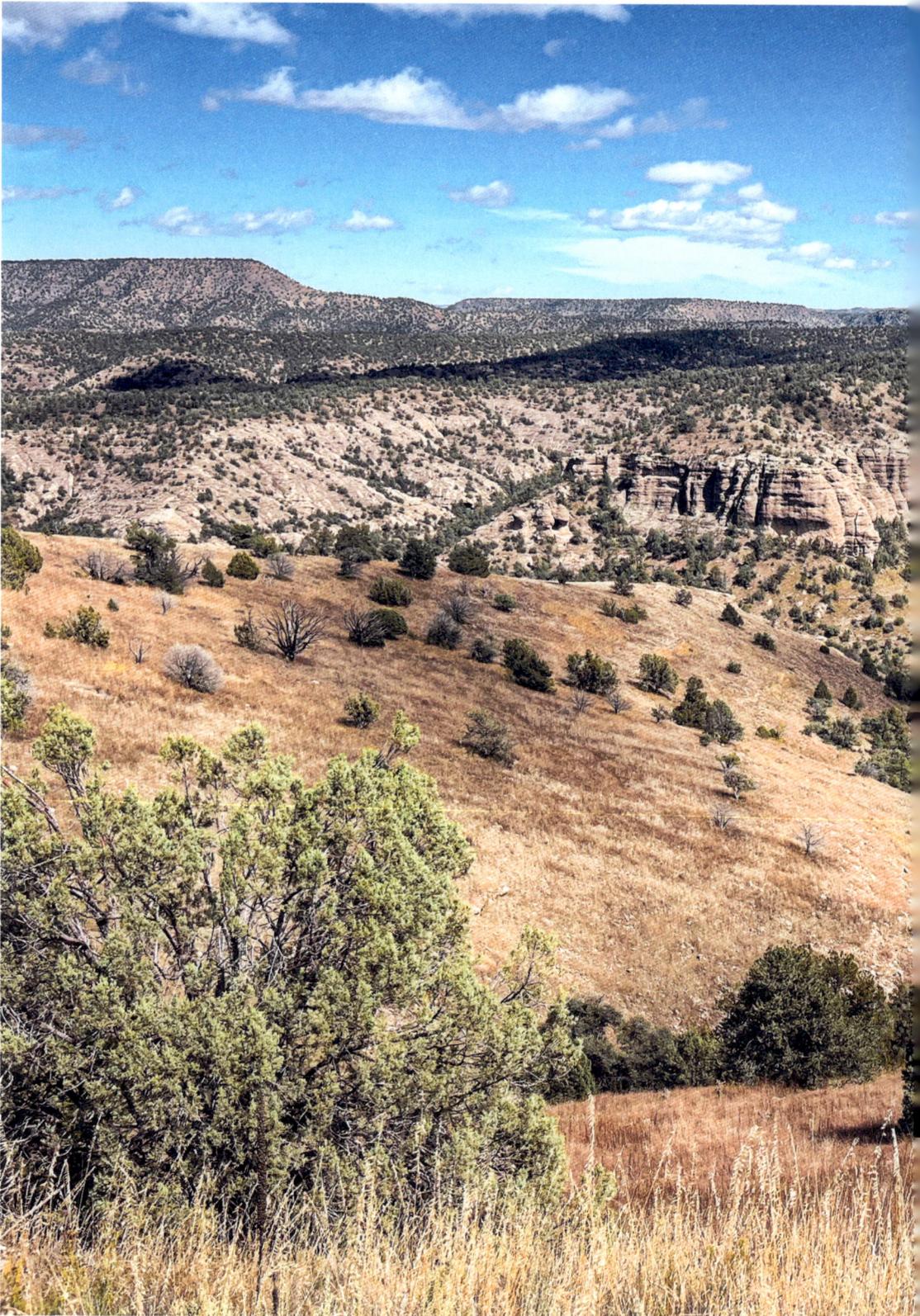

The high New Mexican mountain desert surrounds Pie Town.

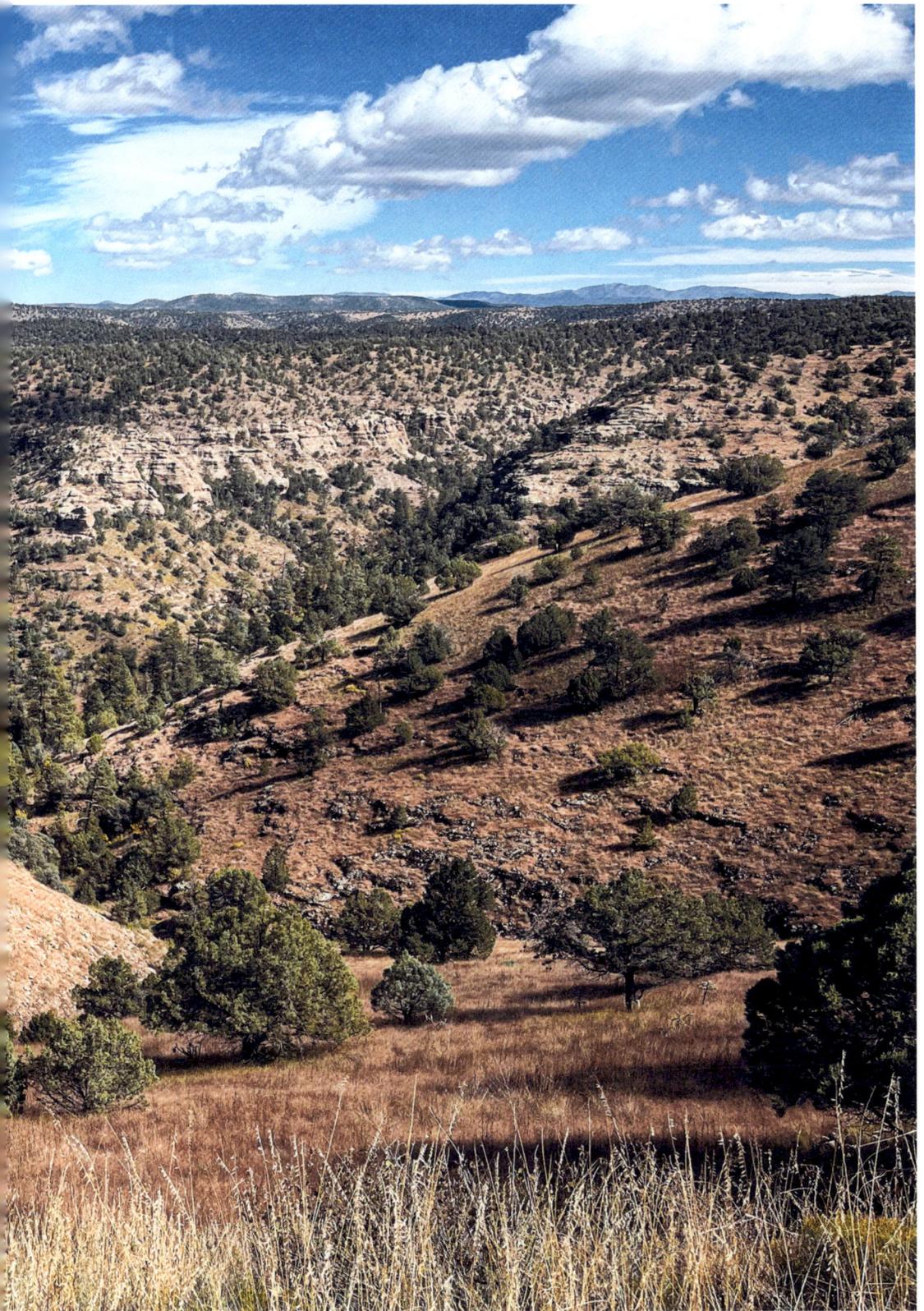

The Yucca trees, cacti, sage, and scorched
glasslands of the New Mexican desert.

a PhD. It was a remarkably inspiring story of a humble man who touched so many people's lives. He wrote about his love for the slow pace of walking through the landscape and the daily silence he found there. With no more than his backpack, a tent, and a banjo, he always found a way. The trail provides, we hikers would always say.

His silent journey reminded me of my own "word fast" some six years earlier when I decided to stop talking for a week during my hike on the PCT. In the stretch through Oregon, I decided to go silent for the first time, which I'm sure many people wished I had done a lot earlier. The short seven-day experiment showed me just how much I actually speak and how much more I could listen if I kept my mouth shut. My silence allowed others to speak their mind, and in turn, I had no opportunity to complain, argue, or tease.

Now, during the past four days on the trail through New Mexico, I had not met a single person or said a single word. I was alone—and enjoyed it. It was an empty, silent country. I felt grateful not to hear my own endless chatter for a change.

The Final Push

Mile 2,817

After leaving Silver City, I resumed my journey southward after a wonderful zero of doing absolutely nothing. I was grateful to find the trail well-trodden and clear. Something that resembled easy, happy walking.

Looking back on the CDT, it had felt like a rocky, blowdown-filled, ankle-busting, snowy, muddy obstacle course. Not that I hadn't loved it, but boy, this even trail felt good under my feet. The gentle crunch of the fine sandy gravel and the soft bounce of the pine needles under my feet were a breath of fresh air. Something to be cherished on this otherwise brutal path.

I resumed my journey southward after a wonderful zero of doing absolutely nothing. I was grateful to find the trail well-trodden and clear. Something that resembled easy, happy walking.

The last obstacle of the journey was Burro Hill, as the rest of the 100 miles (161 km) until the Mexican border would be relatively flat. I was climbing up to the summit, some 7,000 feet (2,134 m) in elevation, when I was surprised to find that the temperature suddenly dropped. I had to stop, put my down jacket back on, and soon found myself walking through fresh snowfields that had fallen only days before. Snow in the desert! My mind had to readjust, and my definition of a desert became further enriched. The yellow aspen trees had given way to golden oak shrubs turning into beautiful colors as fall fell. And soon it would be winter. The sun hung low in the sky, and I had to put on my sunglasses to protect my eyes from the bright glare of the snowfields.

I paused briefly at the top of Burro Hill, looking down into the outstretched golden desert with pale mountains in the distance. Perhaps I was fantasizing, but it felt like I could see Mexico on the horizon. I didn't know if it was physically possible to see 100 miles away, but somehow it felt like I could see the end of my journey. Everything in me, every step, every thought, every emotion, was centered around the endpoint. The endpoint at the Mexican border, which in turn was just as much a new beginning: new, unexpected adventures lay waiting ahead of me. Mexico and its purple mountains represented the start of a new journey and my return home to my family and friends.

My mind had been racing, dreaming, and creating new plans for the past few days. A bright new North Star was taking shape as a dream to

Miles and miles of road walking lead to Lordsburg.

build something. A cabin in the mountains some-where, perhaps. To build it with my own hands.

I could take up an apprenticeship with a local carpenter to learn more about woodwork and building. And I could make improvements throughout my own existing home in my quest to practice and improve my hand and machine skills. I sketched feverishly in my mind while walking. It amazed me how detailed, three-dimensional, and versatile my mind was. In this imagined cabin, I could make quick adjustments and changes between sizes, materials, countries, and budgets. I walked 12 hours a day—a lot of time to dream. But soon I knew I would be distract-ed by all the fragmented impulses that work, so-ciety, and social engagement bring to my days.

As I passed the final hundred-mile marker, which was not much more than a collection of rocks someone had placed there, I looked out over the immense desert that stretched before me and felt a smile glow on my face.

This was the land I had dreamt of for years. This was the land I came to see and live in. The rose-pink mountains around a hazy flat expanse—with just a few telephone poles dotted around—somehow comforted me. I couldn't say exactly why this type of landscape resonated so strongly within me; perhaps it was simply that it resembled the flat farmlands I live in back home. The scale was something else, though. I felt like a tiny ant in this endless emptiness, and although I was alone, nothing in me felt lonely.

Although I could see Lordsburg rise like a mirage in the distance, there were still many miles to do before I got there. The wind picked up, and I was suddenly attacked by some tumbleweeds that rolled across the trail in the strong wind.

In the final days, whenever I stopped in town, I was hearing from more and more hikers around me that they were tired. Exhausted and burned out. Living on the trail for months and months, it was possible. But compared to the mental burnout in corporate city life, this was more about physical exhaustion.

I bumped into Treeboy on the trail again, and he told me he was pretty tired of walking. By the look in his eyes, he had had enough. It made me think of the famous line in the movie *Forrest Gump*—"I'm pretty tired; I think I'll go home now." After three consecutive years of doing all three American trails, Treeboy was just looking for-ward to going home, starting work, being with his girlfriend, and converting his van. No more big walks for him for a while. Too much of a good thing is never good.

Everyone has their dip at different mo-ments along the trail. I had my big energy dip back in Wyoming when I came down with giardia and was exhausted by the altitude and climbs in Colorado. But fortunately, in these final days, my energy was fully restored, and I could enjoy myself and the beautiful emptiness of the land-scape around me. Every last step for the remainder of the journey. Only four days remained.

The Penultimate Day

Mile 2,961

As I finally walked into Lordsburg, I found all the streets empty. There wasn't a soul around, only a truck passing through occasionally. There was a strange desperation about this outpost hid-den deep in the desert. Most houses and trailers had chained dogs on their porch to protect their property. It was also one of the first small towns where I saw homeless people living on the street. I spent a night in a motel and then made my way back to the trail again.

It was good to return to the desert, but it was another hot, scorching day with no shelter from the sun. The desert was home to many Black Angus cattle, whose water troughs we shared every ten miles (16 km). The large metal basins were connected to water deep in the earth and

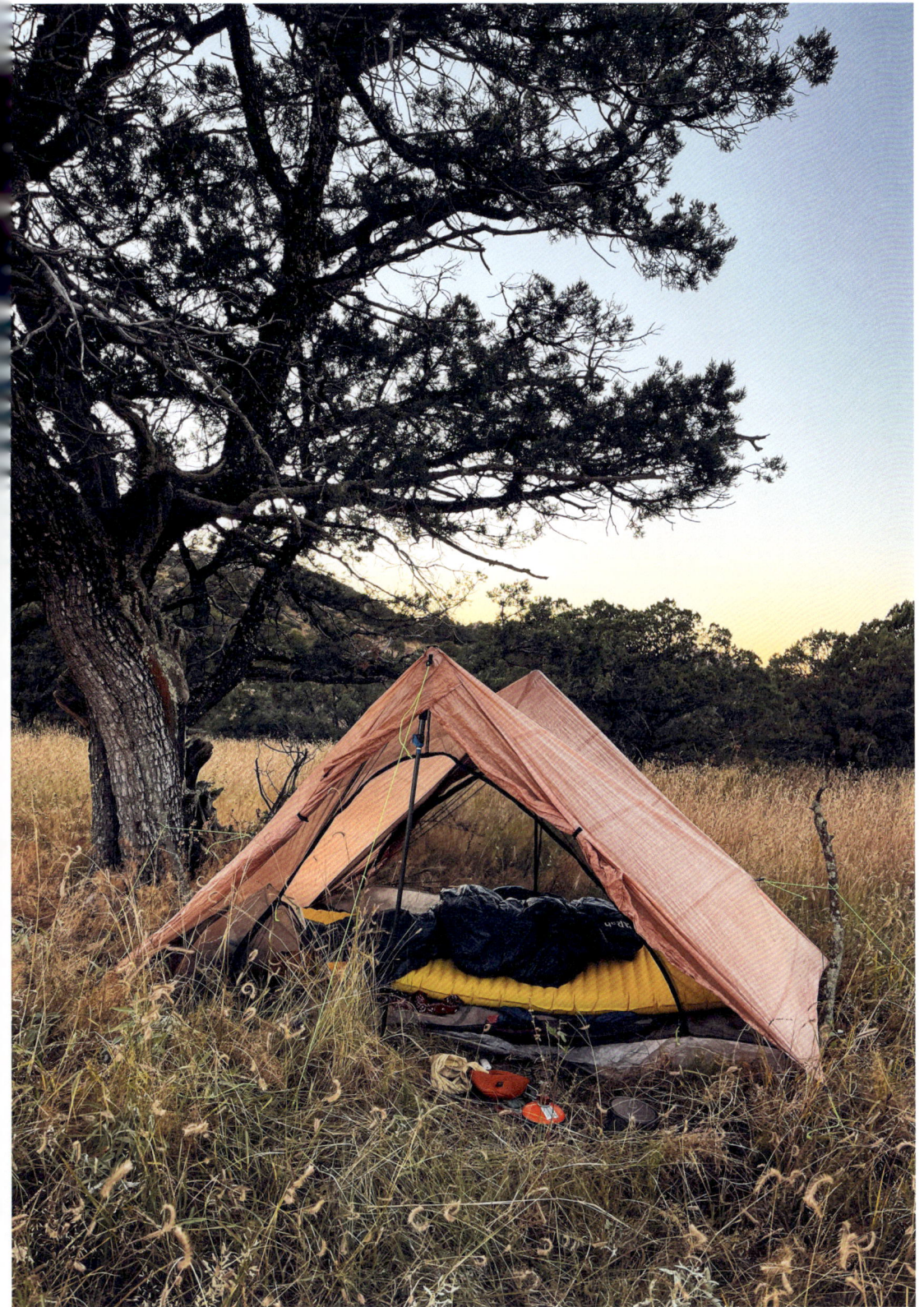

I set up camp alone under a tree in New Mexico.

In the flat plains of southern New Mexico, I bump into
a wild horse and a donkey in the middle of nowhere.

often had green algae floating on the surface. I brushed the scum and dead insects aside and lowered my bottle into the murky water. I couldn't complain, and the color wasn't that bad, but it was strange to see all the cows looking at me, no more than a few feet away. We were all drinking from the same source. Beggars can't be choosers, and I was grateful there was water. My Sawyer filter would do the rest of the work.

Beyond the cattle, the wildlife was constantly changing, and I was followed by a remarkable red-winged blackbird that flew ahead, perching on bushes and then jumping to the next each time I approached it. Seeing the bright red flash of its wings as it flew close to me was a marvel and kept me walking steadily.

As the sunset cast long shadows over the pale grass, I could see a string of tiny white trucks in the far, far distance, heading along Interstate 10 toward El Paso. The trucks looked like tiny white ants, glistening in the last sunbeams as they disappeared into the horizon's haze under the pinkish-orange, golden glow of the mountains. I pitched my tent alone in the nothingness under a tall cactus, and it struck me how comfortably heavy the silence was now that the wind had gone. Only the rhythmic singing of the crickets broke the quiet. I tried to listen intently.

As the sunset cast long shadows over the pale grass, I pitched my tent alone in the nothingness under a tall cactus.

When the crickets finally fell silent, too, it was really quiet. I don't think I'd ever been as alone as I was then, without any trees, structures, bushes, or anything apart from cacti for miles around. I was the only object apart from the distant mountains, yet I felt at home. Living in the wilderness for four and a half months had made me feel at ease with the land, and it was the

towns, motels, and beds that made me feel restless and uneasy. It had become second nature to sit on the ground to eat, to lie on the ground to sleep, to drink from the earth, and to stare up at the stars. These rituals had all become normal parts of my day.

I cracked open a pint of IPA that I had taken with me from Lordsburg to celebrate the last three days ahead of me and gave thanks for the wonderful day. Cheers.

No sooner had the sun dropped behind the horizon than the temperature dropped with it. It was a stark contrast: hiking in a Hawaiian shirt all day in the heat and then, only five minutes later, putting on my down jacket as it dropped below freezing. While I sat cooking dinner, a pack of coyotes howled to herald a new night.

At the crack of dawn, I discovered the rooster of the desert. This rooster did not have a red comb or spurs and beautiful colored feathers, but was rather a gray dog-like creature that called out the new day. It was the coyotes again. I began to notice a pattern: just as the sun disappeared behind the mountains and just as the sun appeared in the morning, there always seemed to be a pack of coyotes crying into the sky. When one started, all the coyotes in the area followed suit and echoed their cry.

As the sun rose from behind the mountains, it lit up the glistening frost in and outside my tent. I was in no rush to get up early and waited for the sun to rise and warm the air. I only had 21 miles (34 km) to do each day to reach the border, so I could pace my days at a leisurely tempo. Setting out, though, the mountains seemed even farther away than the previous day, leaving only the endless expanse of the flat desert floor around me. Without a tree in sight, only the occasional black cow or wild horse broke the horizon.

As the end grew near, my mind flashed from here to there. From the present to the future. From the trail to home. From not working to working. To future dreams and to appreciate

The hills of Mexico looms in the distance on the final miles of the CDT.

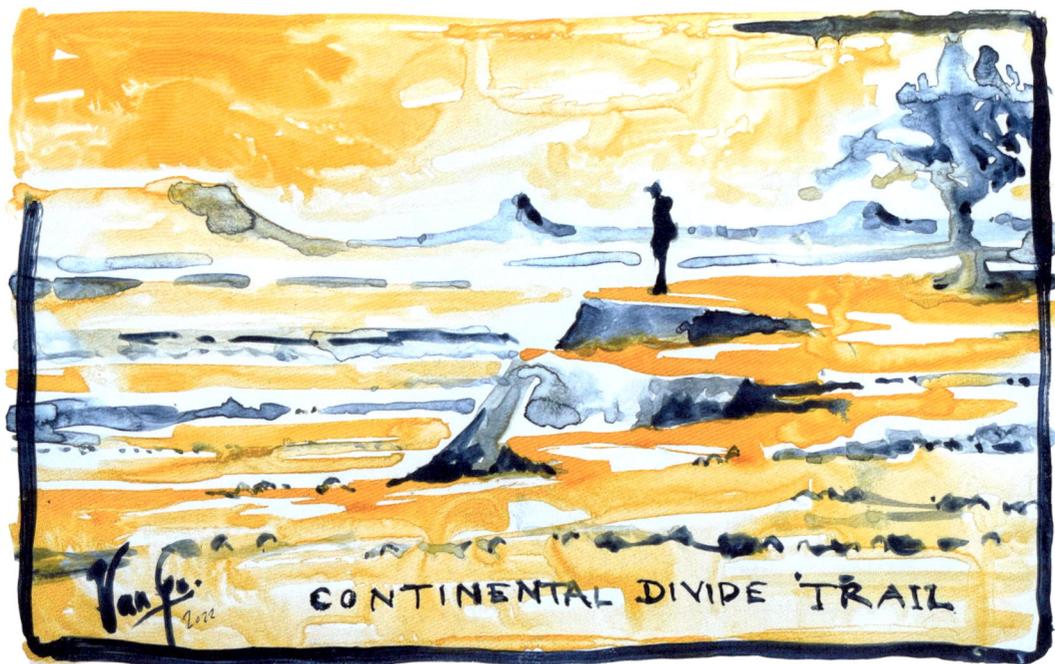

I leave some paintings at the Mexican border for my trail family.

today, the flat gravel beneath my feet, and the beautiful vast land around me. Yet, I didn't feel conflicted between all these contrasts. I felt a general peace.

It was hard to say precisely how this trail had affected me, but it was clear it had and that I had evolved, just as my family back home had evolved in my absence, and the world had continued to turn. Finding my place in it again would require time, adjustments, and patience. But I was looking forward to seeing what life would bring.

The trail was often nowhere to be found in the flat sea of grass. The only thing I could follow was a rhythmic pattern of previous footsteps that wound through the tall grass, creating a flow from right to left. The faint pattern looked a lot like a braid down a child's back. It captured the motion of those who had walked there before me, a near-hypnotic pattern that stretched out before me as far as the eye could see. Rhythmic simplicity.

Mexico

Mile 2,975

On the 127th day of my journey, I finally reached Mexico and put my hand on the cold granite stone of the Southern Terminus. The border between the United States of America and Mexico. I had been hiking alone and enjoying solitude for the past four days, but as I approached the monument, I recognized some familiar shapes and characters. Treeboy, Irish Canuck, and Doc had gotten there before me. Seeing some happy familiar faces at the border was good. I wasn't overexcited or in the least bit emotional, just delighted and grateful to have completed the journey in one piece. The others stood around, each celebrating in their own

way. Doc with a beer in his hand, Irish Canuck sipping some whiskey, and Treeboy strumming a tune on his battle-weathered five-string guitar.

"Dank, Dank, Dank." That was all I could hear: my inner voice repeating in Dutch. Thanks for having made it alive. I looked up toward the sun, moon, and stars and thanked them for watching over me.

I had made it! The Continental Divide Trail! And I'd enjoyed it! Survived it! Cursed it! Been ill on it! I had learned from it, adapted to its curveballs, and loved it.

The others had arrived at the border shortly before me, each putting the Triple Crown to their name. We hugged to congratulate one another in silence, as no words were needed. We all understood the meaning of this moment. My mind flashed back to my first trail family and all the wonderful adventures we had had together, as they would be finishing within about four days, too. Although experienced differently by everyone, we shared so many miles and landscapes. Recharge soon followed, and our finishing party was complete. We dumped our backpacks in the dust and sat in a circle in the shade of a small shelter close by.

Everyone stared in disbelief that the trail was over. I got some dried juniper and sage plants I had picked a few days earlier and lit them with my lighter to create some smoke for a little thanksgiving ceremony. A little plume of smoke swirled through our circle. The hash pipes soon came out and we all got pretty high. Irish Canuck passed around a pint of whiskey, and before long, I lost all sense of time. I strolled into Mexico to be alone for a few moments and looked back toward America and the valley I had just walked across the past four days. There were no walls, fences, barbed wire, border control, guns, or politics. There was simply a dirt road and nature on either side of the border. Borders after all are human inventions, and experiencing the borderless border there between the USA and Mexico was something very special.

The weed soon got to my head, so before I lost all sense of reality, I decided it was time for another photoshoot to mark the occasion. After taking all the mandatory finishing photos of everyone, I asked the guys to get out their tents.

After a bit of styling, getting their long hair to wave in the wind, I set up my self-timer, and we all posed staring into the distance. All pointing southward, as we had been walking for months.

Darkness fell shortly after, and we all rolled out our sleeping bags to cowboy camp around the monument in the dust. I think I managed to boil some water and eat some mashed potatoes and tuna, but honestly, I couldn't say for certain, as it was all a bit of a blur. I was about to fall asleep when a big truck with bright lights pulled up and stopped where we were sleeping. I thought at first it might be a border patrol team checking up on what we were doing, as it wasn't advised to sleep at the border itself. But it turned out to be Tim, the shuttle guy, who we had texted with my inReach to come and pick us up. We had arrived a day earlier than anticipated and hadn't expected him to turn up so soon. The prospect of sleeping in a warm motel instead of in the freezing dust made it a no-brainer. We packed up in the dark and jumped into his truck.

When I woke up the next day and realized it was finished, I suddenly felt I wasn't quite ready to be done. Honestly, I was still in the flow and could have just kept walking. My spirits were high, and I just loved living outside.

Living in the wilderness was like living in a parallel universe. I hadn't been disturbed by any incoming phone calls for five months. Sure, I had been in sporadic contact with my loved ones and clients, but only with very delayed voice messages or weekly emails. This parallel universe had, for a short period, become my home, and it was with wonder that I saw how quickly I had adapted to it. It was only six months ago that I was still worrying about snakes and bears, and by the end of that time, I was coming across a huge bull snake in front of me on the trail in the desert, and it simply didn't rattle me. My breath didn't quicken; there was no sweat or fear. I simply felt respect for its potential and awe at its beauty. Just another animal along the trail.

Could You Do the CDT?

The First Mile is the Hardest of All

"Perhaps this Continental Divide Trail is also something for me?" I hear one or two of you thinking. "Just maybe. Perhaps it's not that scary after all." But where to start?

SOBO or NOBO? Will you start next year at the Mexican border in April or June from the Canadian border? How will your partner or family react to your being away for five months? And can you convince your boss or clients that this is actually an excellent idea for both you and the company to step aside for a short period to recharge your batteries and reflect on this and that? Is there enough money in the bank, or do you need to start saving religiously, cutting restaurant trips, or changing your personal expenditures altogether? And why would you consider such a ludicrous, pointless endeavor

at all? Most people are perfectly happy coming along for the ride vicariously. Reading is a perfectly good way to experience adventures; after all, hike your own hike. But for just a few people, the questions may be racing through your head right now.

"Am I fit enough? Isn't it too dangerous? Am I too old? What about my bad leg? Can I handle being alone for that long? Will I drive myself crazy? What if nobody likes me? What if I don't have a good enough reason to go?" What if, what if, what if?

Well, perhaps you don't need a good reason to go on a long walk. Perhaps there isn't one big reason, and maybe there are multiple small reasons. Perhaps it's just an inner voice urging you to go.

The perfect timing often doesn't exist or never seems to come. So why wait for this or that important reason? Why not just say, "I'm going for a walk. A long walk." It's going to be a lot of fun, and the people that you meet will awaken important questions and answers within yourself. You will have plenty of time to think. Of course, living in the woods for five months can be wet, hot, cold, and steep and isn't everybody's cup of tea, in which case going on a walk for a few days along one of your local trails might suit you better.

But if I learned anything, it's this: just do it. Buy the ticket today. What could possibly go wrong? You will love it. I personally guarantee it. Oh, and remember to send me a postcard. I can't wait to hear about all your adventures.

Leaving Lordsburg and the CDT behind, I head back towards society.

Acknowledgments

I am eternally grateful to my family, my wife Herminia, and my children Cato, Toni, and Tom, for the support and freedom they keep giving me in my restless hunger for adventure. They never question, guilt trip, or limit my long walks, and I fully appreciate that this is not normal. Normal in our family, perhaps, but still extraordinarily and wonderfully abnormal.

I would like to thank my parents, Bons and Tijno, for being my living examples through our long camping vacations in the mountains during my youth and as they continued hiking in the mountains into their eighties.

I am so grateful that I bumped into WoW on the CDT. He made me float two inches above the trail during the four weeks we hiked together. His down-to-earth humor and inspiring attitude toward life will stay in my heart forever.

I am so happy for all the fun and moments I shared with all the wonderful hiker-trash and Trail Angels that I was fortunate enough to meet and hike with these past months. A special word of thanks goes to my trail family Chester, Rip, Misplace, and Nosh. Without them, Montana would have been a very scary place. I would like to thank JetPack for helping me out with all my thousands of questions and being my trusted friend in the USA to send all my stuff. I couldn't have done it without you, JetPack; thank you so much.

In particular, I wish to thank Luna and her family up in East Glacier Park Village for all the magic she gives in her hiker heaven. The CDT would be a boring, long, hot, and wet trail without her.

I would like to thank all the wildlife for allowing me to share their habitat with them. The bears, the moose, the chipmunks, and, of course, my trusted swallows, who were with me all the way during my migration south.

I would like to thank my mentors, René Boender and Huib Maaskant, for inspiring me to think big and strive to reach new horizons, audiences, and markets.

I would like to thank the incredible team at gestalten in Berlin for taking this journey to the next level by helping me edit, publish, and distribute this story to people around the world. On a final note, I want to take inspiration from the legendary Snoop Dogg: I want to thank me. For taking no days off, never quitting.

Hike your own hike,
Love, Van Go

Sources

Continental Divide Trail Coalition
continentaldividetrail.org
Definition of Sufism.
britannica.com/topic/Sufism
Francis, John.
Planetwalker: 22 Years of Walking.
17 Years of Silence.
New York: National Geographic, 2009.

Raz, Guy. "Headspace: Andy Puddicombe
and Rich Pierson." September 22, 2019, in
How I Built This with Guy Raz, produced by
J. C. Howard, published by NPR, podcast,
MP3 audio, 1:11:42.
wondery.com/shows/how-i-built-this/
episode/10386-headspace-andy-puddicombe-
and-rich-pierson

Homies Foundation
Across my journey, I raised money for the
Homies Foundation, whose aim is to help
homeless people. Their work is dedicated
to providing housing, work, studies, money
and more to help people get their lives back
on track. Please feel free to support their work
here. Thank you so much.
homiesfoundation.nl/doneer

USDA Forest Service
fs.usda.gov

U.S. Fire Administration Statistics
usfa.fema.gov/statistics

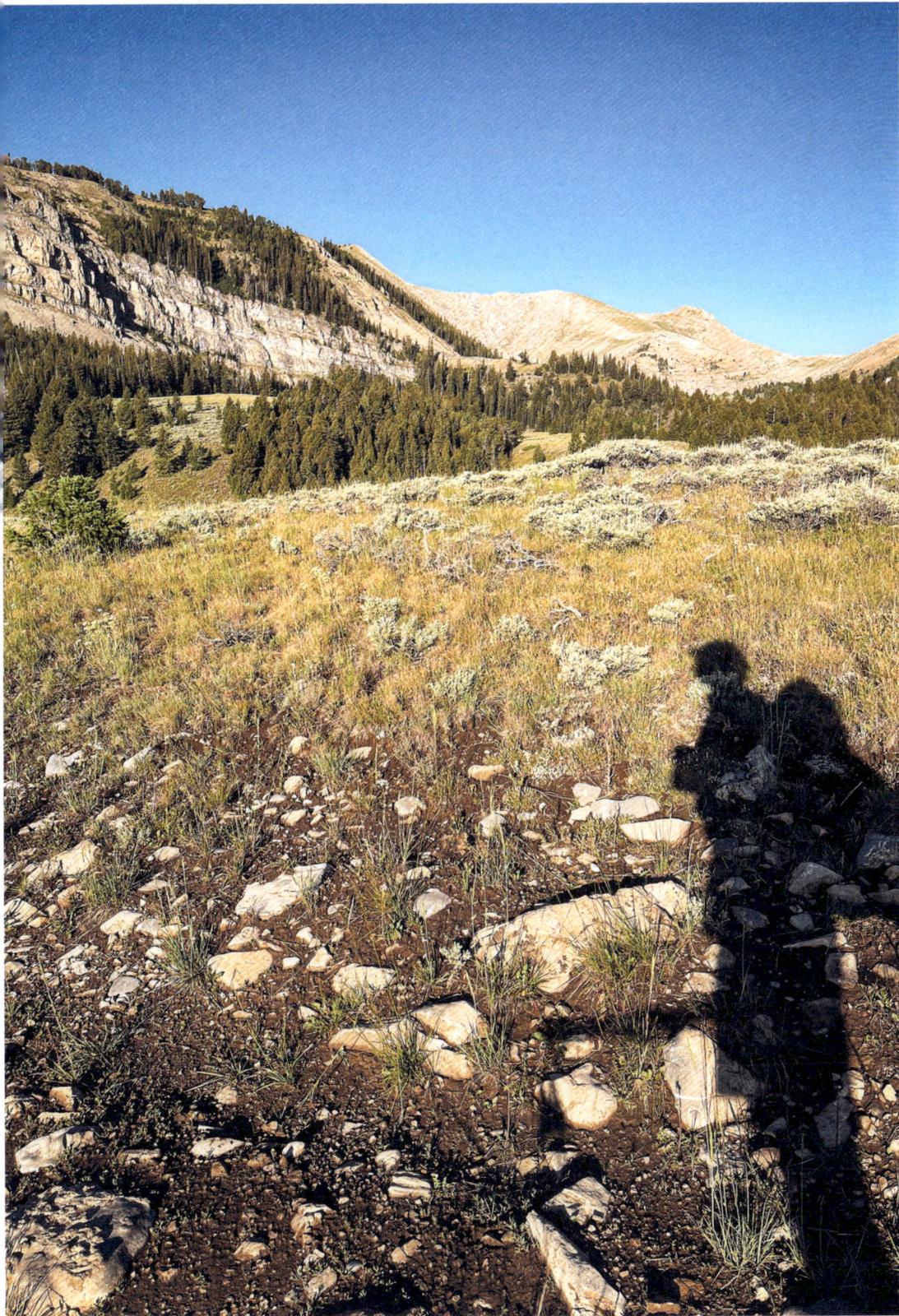

Shadows and reflections on and off the trail.

About
the Author

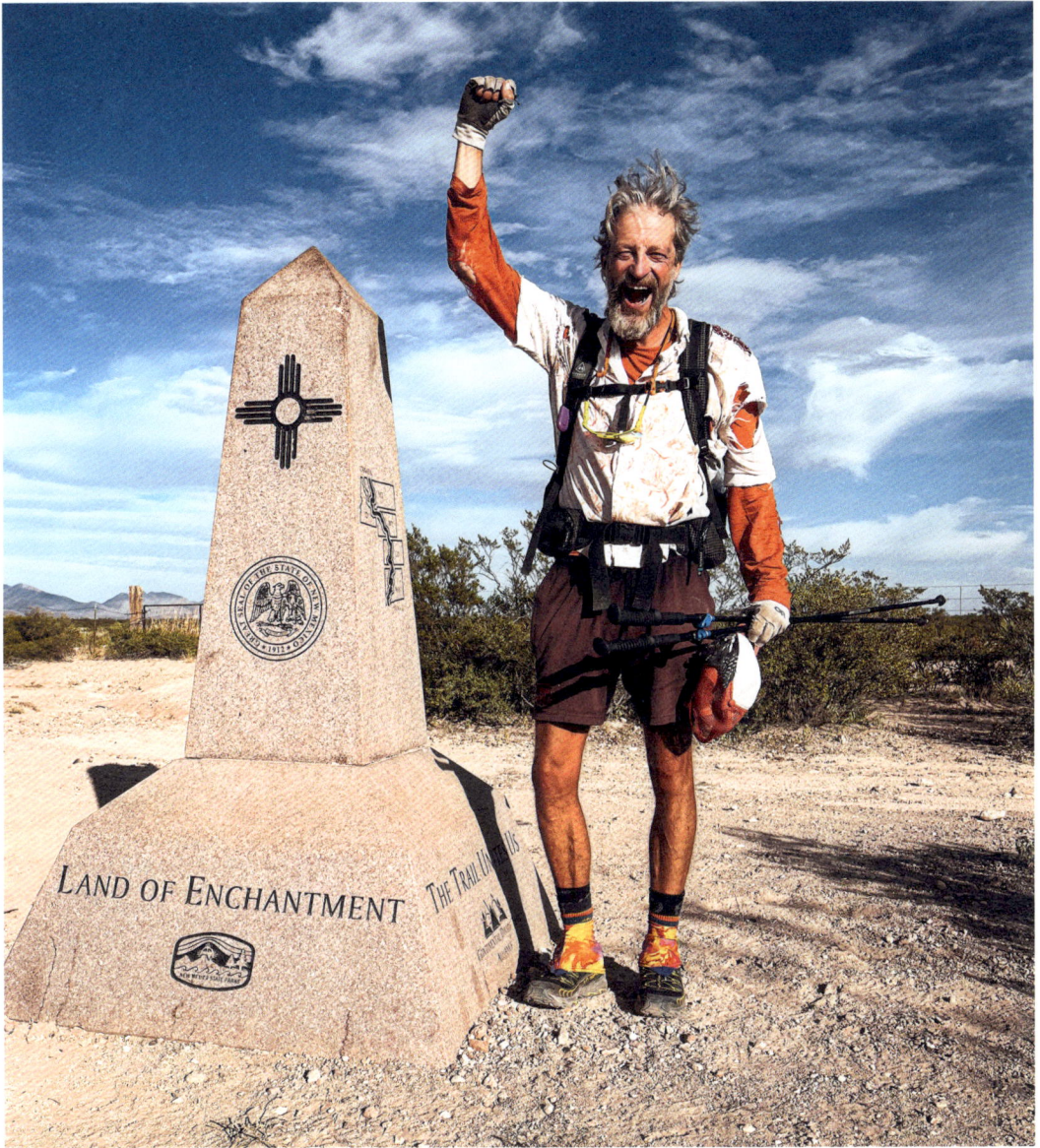

Tim Voors has walked across countries and continents into the unknown. In addition to the Pacific Crest Trail, he has walked across New Zealand on the Te Araroa Trail (1,881 mi/3,027 km), around the Japanese island of Shikoku on the ancient 88 Temples Pilgrimage (815 mi/1,312 km), and through Spain to Santiago de Compostela on the Camino de Santiago (437 mi/700 km). Tim lives near Amsterdam where he works in advertising as a creative director. He has worked for Google,

The North Face, and Nikon, among others. Tim is also a speaker and has given keynote speeches at the Creative Mornings conference and at leading companies in the Netherlands and beyond. He loves to inspire audiences with tales of ordinary people doing extraordinary things.

www.randomtrailtales.com

www.timvoors.nl

Instagram: @timvoors

Email: tim.voors@gmail.com

THE GREAT
DIVIDE

Walking the Continental Divide Trail

TIM VOORS

Text, photography, and illustrations by Tim Voors

Edited by Robert Klanten and Laura Allsop

Editorial Management by Anna Diekmann

Design by gestalten
Layout and cover by Melanie Ullrich

Photo Editor: Zoe Paterniani

Typefaces: Burgess by The Entente (Colophon Foundry) and Lars Mono by Mads Wildgaard (Bold Decisions)

Printed by Grafisches Centrum Cuno GmbH & Co. KG, Calbe (Saale)
Made in Germany

Published by gestalten, Berlin 2024
ISBN 978-3-96704-108-8

Also available:
The Great Alone
ISBN 978-3-89955-977-4

For more information or to order books, please visit www.gestalten.com.

Bibliographic information published by the Deutsche Nationalbibliothek.
The Deutsche Nationalbibliothek lists this publication in the Deutsche Nationalbibliografie; detailed bibliographic data are available online at www.dnb.de.

This book was printed on paper certified according to the standards of the FSC®.

FSC
www.fsc.org

MIX
Paper from responsible sources
FSC® C043106

Warning and Legal Disclaimer

Your own adventure is at your own risk. Always prepare well and thoroughly for any adventures. When you go out, make sure you know what to expect and that you have the fitness and equipment necessary to complete the planned hike. Familiarize yourself with the route, and make sure you can contact someone in case of an emergency. Take enough drinking water, food, and protection against the elements and be sure to take plenty of breaks. Pay attention to the tides and the weather forecast: the weather can change very quickly, especially in the mountains. Make sure you are aware of the customs and rules applicable in the country of destination, for example, with regard to wild camping, and take out good travel insurance. Go on an adventure, but don't take irresponsible risks.

The author hopes to inform and inspire others through the personal story he shares within these pages. Both he and the publisher have made every effort to ensure the accuracy of the information in this book at the time of printing, however, this publication may contain factual inaccuracies. As such, no rights can be derived from this information and the producer, publisher, and author cannot be held liable for any damages.